Surrealist sabotage and the war on work

MANCHESTER
1824

Manchester University Press

Surrealist sabotage and the war on work

ABIGAIL SUSIK

Manchester University Press

Published by Manchester University Press
Altrincham Street, Manchester M1 7JA

www.manchesteruniversitypress.co.uk

British Library Cataloguing-in-Publication Data
A catalogue record for this book is available from the British Library

ISBN 978 1 5261 5501 6 hardback

ISBN 978 1 5261 6950 1 paperback

First published by Manchester University Press in hardback 2021

This edition first published 2023

Typeset by
Servis Filmsetting Ltd, Stockport, Cheshire

For my parents, Helen and Michael

Contents

Plates

Figures

Every effort has been made to obtain permission to reproduce copyright material, and the publisher will be pleased to be informed of any errors and omissions for correction in future editions.

Acknowledgements

The work of many people made this project possible. I am grateful to past and present mentors who influenced me: Rosalind Krauss, Benjamin Buchloh, Andreas Huyssen, Penelope Rosemont, Katharine Conley, Anne Higonnet, Alan Glass, Elise Smith, Gloria Orenstein, Paul Garon, Susan Aberth, Ron Sakolsky, Effie Rentzou, Stephanie D'Alessandro, Gavin Parkinson, Mary Ann Caws, Jonathan Eburne, Sue Taylor, Rikki Ducornet, Steven Harris, David Hopkins, Jonathan Crary, Michael Taussig, Paul Buhle, and David Roediger.

At Willamette University, I am thankful for the support of my colleagues in the Department of Art History and at the Hallie Ford Museum of Art. Ann Nicgorski, Ricardo De Mambro Santos, Roger Hull, and the HFMA staff have been steadfastly enthusiastic. My friends in the Willamette Art Department, Alexandra Opie and Cayla Skillin-Brauchle, have shared many meaningful interactions over the years. Michael Chasar and William Smaldone were brilliant interlocutors at an early stage of this project, fishing with me in the afternoon and criticising with me after dinner, as Marx said. Ruth Feingold and her staff in the Dean's office offered encouragement by presenting me with the Lawrence D. Cress Award for Faculty Scholarship in May 2020. Many of my students at Willamette were involved in my writing process. Natalie Zhang worked extensively on the bibliography, and Peyton Birchler and McKenna Watkins were employed as research assistants during my sabbatical. An Atkinson Faculty Development Award supported part of the editing process.

I extend sincere thanks to Emma Brennan at Manchester University Press for her interest in this project, and also to Alun Richards and David Appleyard for assistance during the book's production. To my peer reviewers for Manchester: the book took final shape thanks to you. Dr Johanna Seasonwein, Dr Laura Napolitano, and Lila Stromer have been fantastic editors. Alex Trotter completed the book's index. Juanita Bullough saw the manuscript through to the finish line by handling the final copyedit. Gavin Parkinson, Christina Heflin, Ron Sakolsky, John Simmons, Paul Garon, Robert Green, Penelope Rosemont, and Paul Buhle all reviewed portions of the book in advance of publication. Kristoffer Noheden generously provided extensive comments. Grégory Pierrot, my dear friend, was

always there for me with advice on French translation issues, and Diane Drouin checked the French and Spanish spelling and translations for most of the manuscript. I am grateful to Samantha Kavky and Claudia Mesch, editors of *Journal of Surrealism and the Americas*, for editorial work on a version of my Marcuse section (JSA 11:1, 2020). Many other people helped out in significant ways, especially after the coronavirus pandemic posed exceptional research challenges. I thank Elliott H. King, Michael Richardson, Claire Howard, Rachel Franklin, Bernard Marszalek, Allan Graubard, Lawrence DeCoster, Beth Garon, Thom Burns, Bill Zavatsky, Peter Werbe and David Watson at *Fifth Estate Magazine*, and all of my friends in the International Society for the Study of Surrealism community.

I am also obliged to colleagues who hosted presentations of my in-progress research at their events: Jennifer R. Cohen at the University of Chicago, Peter Maravelis at City Lights Bookstore, Effie Rentzou at Princeton University, and Kris Cohen at Reed College. Offering much appreciated image and copyright support were: Dr Helen Moore; Rachel Pointer (*Industrial Worker* Editor in Chief); J. Cameron Mancini (General Secretary-Treasurer, Industrial Workers of the World); Stefan Ståhle (Moderna Museet); Constance Krebs (Association Atelier André Breton); Shaina Buckles Harkness (the Salvador Dalí Museum); Julie Herrada (Curator, Joseph A. Labadie Collection); Peter-Erwin Jansen (Herbert Marcuse Archive, Archivzentrum der Universitätsbibliothek Frankfurt am Main); Peter and Harold Marcuse; Giovanna; Penelope Rosemont; Robert Green; Mike Olson; Andrew Sclanders at BeatBooks; and, Andrew Wilson (Senior Curator, Modern and Contemporary British Art and Archives, Tate Britain).

I would also like to remember people in my life who died during the time in which this book was written: D. E. May, Bill Goring, Cayden Himes, Manuel Felguérez, Paul Hammond, and Michaelanne Foster.

Finally, there is the matter of the unbounded appreciation I have for my husband, Lawton Browning: for doing the dishes when I was still at my desk; for his stubborn failure to complain about just how much work this book about work refusal really took; for mixing me late-night post-writing drinks called 'the last word'; for showing me subject-appropriate movies like Tati's *Playtime* (1967), Sayles's *Matewan* (1987), and the cult film *L'an 01* (1973); and, most of all, for giving me courage.

Introduction

Three of surrealism's most intransigent demands were its overarching attack on the ubiquity of paid labour in modern life, its call for the total abolition of waged conscription, and its declaration of an ongoing 'WAR ON WORK' (Figure 0.1).[1] Over the course of the twentieth century, international surrealism critiqued compensated labour actively and symbolically through works of art in different media, aesthetic theories and techniques, publications, contestatory rhetoric, and direct actions meant to effect both immediate and long-term social intervention. Recognising this crucial but neglected tenet of the movement, *Surrealist Sabotage and the War on Work* documents and analyses this expansive surrealist diatribe against what André Breton called the 'most foolish prejudices imbuing modern consciousness' relating to the contested subject of compensated work, and it does so specifically in response to the role of the *work* of art in surrealism.[2]

As evidence for this premise, I chart the history of this anti-work position and its genealogy in aspects of European and American surrealism. I demonstrate the transatlantic and transhistorical continuity of this topic through an interdisciplinary art-historical analysis of a series of episodes in surrealist art and cultural production between the 1920s and the 1970s. By uncovering strategies of labour critique in surrealist activity through an examination of visual culture, archival manuscripts, and field research – in addition to artworks – this book reveals that surrealism developed effective and imaginative strategies of resistance against the wage-labour imperative. Moreover, surrealism's tireless challenge to the notion of art production as just another facet of capital holds valuable insights about the potential role of art in social resistance practices. Surrealism, it turns out, concerned itself with much more than just the confoundingly elusive question of limitless desire; it must also be seen as one of the most compelling theoretical precursors to contemporary debates about the post-capitalist transformation of work and the affirmation of idleness.

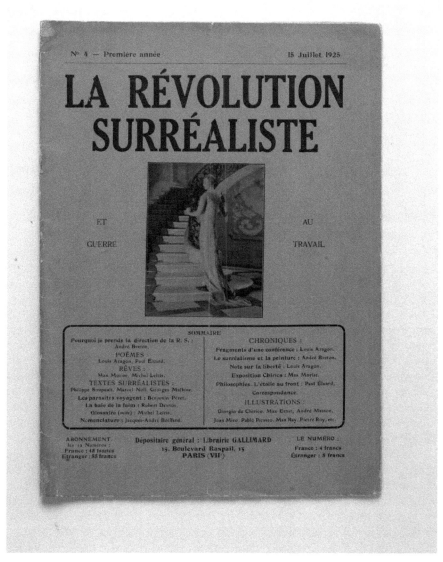

Figure 0.1 Man Ray, Paris Surrealist Group, cover of *La Révolution surréaliste* 4 (15 July 1925)

Most of the individuals who contributed to the formation of surrealism in France in 1924 were white, middle-class or upper middle-class veterans of World War I. Although their backgrounds were privileged to varying degrees, most of them could not afford to survive without some form of employment. Several

future surrealists had been preparing to enter professional careers in law or medi-cine prior to 1924, while others were already employed in white-collar positions. They returned to Paris from the war front only to face the task of continuing their studies or finding work in a world that had been technologically and culturally transformed over the space of just a few years. The labour market they entered took on a unique character during the reconstruction period. The surrealists confronted high inflation rates and the newly instated, bitterly contested eight-hour workday and six-day work week, which had only just been voted into law after a rash of dev-astating wildcat and general strikes across France between 1917 and 1920.[3]

While most of the veterans who would soon become surrealists needed employment as much as employers needed them, they nevertheless repudiated economic obligation and necessity whenever possible, literally and symbolically. Their refusal had nothing to do with a lack of available jobs. Despite prevalent strikes and inflation, finding work was not an insurmountable challenge in France during the years following the armistice of 1918. There were, in fact, too many jobs available in the wake of the war's decimation of the population, the massive loss of lives in the influenza pandemic of 1918–19, and the continuation of France's historically low birth rate during this era.[4] Unlike the coronavirus pandemic in the new millennium, in which mass shutdowns and redundancies resulted in unemployment for millions of workers, in the influenza pandemic immediately following World War I there was no rhetorical distinction between 'essential' and 'non-essential' workers, though certainly labour itself was divided in many other ways – along lines related to class, gender, race, nationality, pay, and skill set, among other complex intersectional factors.

French women were already a key population in domestic service and had also entered the textile industry in record numbers during the nineteenth century. The development of wartime mass production and telecommunications resulted in the feminisation of new areas of labour, such as machine building and office work. France had also begun to rely on mostly male immigrant labour from southern and eastern Europe, North Africa, and Southeast Asia as a way of compensating for wartime and post-war labour shortages, the nation's immigrant popula-tion doubling to three million during the 1920s.[5] Yet, even with the addition of these substantial worker sectors and the hard reality of unemployment for many workers, France's post-war labour shortage persisted. More workers were needed.

Defying social pressures about contributing to reconstructionist efforts, the surrealists refused to serve their country further by playing their part in the reactivation of the national economy after having fought a war they denounced. The surrealist condemnation of the repressive ontology of abstract labour, their disavowal of careerism, and their call for the abolition of wage labour were not merely reactions against the regimented segmentation of time that resulted from the industrial standardisation of work hours. Nor was it an endorsement of a new leisure ethos that ideologically exceeded the reformist fight for *les trois huit* (eight hours each of work, rest, and free time). An escape into a recreational lifestyle or bohemian reclusiveness was not the goal, nor was progressive reformism.[6]

Instead, their joint work and career refusal was a principled form of protest based on ethical ideas about the purpose and quality of human life and the role of society in determining them. They proclaimed that the right to work was only conceivable in balance with an equivalent right of refusal to work. As Frankfurt School philosopher Herbert Marcuse reminded readers in his 1955 book *Eros and Civilization: A Philosophical Inquiry into Freud*, the surrealist critique of what Sigmund Freud called the reality principle is at the same time an impassioned embrace of potential and possibility, a refusal of what *is* to enable what *can be*.[7] Whereas Freud had only briefly accounted for what he termed 'the significance of work for the economics of the libido' in his 1930 book *Civilization and Its Discontents*, Marcuse sought to fully excavate the shared continuum between work and pleasure.[8] In his formulation of the widely influential concept of the 'Great Refusal', which is the 'protest against unnecessary repression, the struggle for the ultimate form of freedom – to live without anxiety', Marcuse focused on the surrealist 'refusal to accept as final the limitations imposed upon life and happiness', and included a quotation from André Breton's 1924 *Manifesto of Surrealism*.[9]

Soon after their return from military service in World War I, the vehemently anti-nationalist and anti-statist future surrealists embraced a position comparable to Vladimir Lenin's concept of revolutionary defeatism – a tenet that war led by an imperialist, capitalist state exploited the masses and should not only be resisted but militated against. Looking to Lenin's defeatism, the surrealists deserted the post-war cause and their budding professional careers by consciously failing to mobilise as good workers during the reconstruction.[10] In the earliest stages of surrealism's inception, a condemnation of participation in the scheme of paid labour became firmly established in their milieu as a form of protest against the commodification of human life – and the capitalist class dynamic of surplus accumulation founded upon dispossession – processes of reification under capitalism wherein nearly every aspect of the quotidian submitted to the logic of capital.[11] The sparks of anti-work dissidence were already embedded in the future surrealists' established interest in anarchism, illegalism (a philosophy that espoused criminal activity as a lifestyle), and leftist resistance in the years immediately following the war, and were also reflected in their approach to dada.[12] In their *principled desertion* of the national reconstruction effort, surrealists therefore attempted to abstain from complicity in many aspects of the capitalist system in which they paradoxically lived and produced, although that endeavour was rarely straightforward, and the results were often far from satisfactory. When money was sought, it was usually procured through temporary white-collar labour or speculation on the art market. Although they stood in solidarity with the proletariat, they did not face the same obstacles that confronted workers on the factory floor. They rarely struggled to secure basic subsistence needs. Most surrealists never fully achieved their desired class treason.

Yet, the nascent politicisation of surrealism during the mid-1920s was inherently linked to surrealism's critique of capitalism, its condemnation of class

privilege, and its demand for the abolition of wage labour in society. This call for the end of *travail salarié* was, according to the surrealists, the only acceptable resolution for a corrupt system in which workers, as human capital monitored by the state, exchange their labour power for money in a marketplace operating to their disadvantage. In terms of their work critique, the surrealists did not make a strict distinction between proletarian labour in the factory and white-collar jobs in the office, although their protest statements, aligned with the Communist Party, focused on blue-collar labour. All waged work was alienated for the surrealists. This implicit surrealist attitude can be traced in the many works of art that refer to office jobs, some of which I detail in Chapters 2 and 3. The surrealists concurred broadly, therefore, with theories that Karl Marx popularised in his writings from the previous century about the social alienation of workers who produce and reproduce value in subordination to bourgeois employers. According to this theory, the worker loses agency and experiences a general disaffection when hired by a boss to work in conditions often characterised by a division of labour (the separation of work into a series of tasks in order to increase efficiency). The worker is alienated from the use-value of products made and services rendered; from other workers, who become competition on the labour market; and from their own process of self-actualisation in the act of such abstracted production.[13]

However, though the surrealists rejected with hostility their rationalised, wage-based society as dehumanising, they did not condemn the basic idea of *desirable work*, or engaged, creative activity as a form of self-motivated and self-rewarding making or producing. They valued unproductive over productive labour. Rather than fetishising indolence, they sought self-elected engagement in the realms of both work and non-work. Nevertheless, their work critique also applied to the realm of their own intellectual and creative labour. Surrealists made art across media in abundance. In principle, if only sometimes in practice, that creative activity operated in the strictest surrealist fashion when it was not commissioned, priced, or sold as an artwork and when it refused to operate under the yoke of any ideology. Rather than simply replicate Kantian notions of the artist as a non-mercenary transcendental subject and art as a form of exceptional freedom, surrealist anticapitalist hostility sought to destroy the myth that art could not be subsumed into capital. They knew all too well that intellectual labour and art-work could become abstracted and alienated just like any other type of value production.

Nor, by any means, did surrealists ignore the organisation of workers under the labour cause for social reform. As was the case in other European nations at this time, France's labour movement had remained vigilant, despite some post-war diminution of activity as compared with the wave of industrial radicalism that swept the United States during the first decades of the twentieth century.[14] Although the vast majority of surrealists were neither syndicalists nor labour union members, most became significantly invested in Marxist theory and the communist call for revolution during the late 1920s and early 1930s. Already in 1925, core members attempted alignment with the Parti communiste français (PCF),

signalling their support of the proletarian struggle. In this the surrealists agreed with Leon Trotsky.[15] The ascendancy of the Bolsheviks with the October Revolution of 1917 also arguably influenced surrealism's pursuit of revolutionary fervour, despite the surrealist movement's failure to collaborate closely with proletarian activists.[16]

How the negation of the wage-labour system would be achieved or, for that matter, what work in a post-revolutionary society might look like, with or without the persistence of surrealism in the future, took on greater definition over the course of surrealism's negotiations with the PCF. Surrealism's critique of wage labour under capitalism was substantially influenced by the theory of class struggle and bourgeois domination through exploitative labour that Karl Marx and Friedrich Engels had put forward in texts such as their 1848 pamphlet *Manifest Der Kommunistischen Partei*. Between the late 1920s and 1935, the means of insurrectionary revolt were repeatedly professed by the surrealists to be complementary, though far from identical, to those of the Communist Party. For the surrealists, a projected proletarian revolution would overthrow the market economy. They believed that after a prolonged, difficult, and painful transition of wealth redistribution, the abolition of private property, and the transformation of labour relations, a classless, collectivist society in which willing adults worked, but much less and for themselves, would supersede such a market economy. A transformation in the fundamental quality and purpose of life would follow. In the meantime, surrealist saboteurs, always pessimistic about the nature of societal machinations, intended to practise forms of cultural sedition against bourgeois hegemony in every manner possible. They also experimentally cultivated the potential character and scope that human sociality might take following the fall of the wage-labour imperative and the demise of the work ethic. Soon enough, however, it became clear that surrealism's post-work imaginary was largely incompatible with that of the Communist Party, although several surrealists continued to engage Trotskyist and non-PCF communist positions well into the post-World War II period.[17] Following the war, many in the movement turned towards anarchist, utopian socialist, and worker self-management ideas to nurture and develop surrealism's anti-work demand and its call for the liberation of humanity in a new form of stateless and classless society.

Why work? The purpose and rationale of this book

Although, as we have seen, the surrealist war on work historically exceeds its alignment with the Third International during the inter-war period, my argument is nevertheless influenced by many aspects of surrealism's engagement with the proletarian cause under communism. In particular, my survey of the surrealist work polemic is relatable to what Louis Aragon termed the 'three modalities of surrealist action' in his 1931 declaration of the surrealist commitment to dialectical materialism and the proletarian revolution.[18] In this statement, written shortly

before Aragon's departure from the movement to become a luminary in the PCF, surrealism's role is to battle capitalist exploitation and dehumanisation with critical activity, surrealist experimentation, and protest manifestations.[19] My account of the surrealist work refusal echoes the structure of Aragon's categories in that I analyse many of the numerous parapolitical instances of rhetorical opposition to wage labour or proletarian solidarity in surrealist artworks, pamphleteering, and proclamations alongside instances of the limited but significant protest demonstrations, strikes, industrial sabotage, and civil unrest connected to the movement's history. Rather than establishing a complete survey of surrealist work repudiation on an international basis, I examine select scenarios of surrealist critical-artistic activity, experimentation, and protest actions through an initial theoretical overview and three in-depth case studies. Along with chronicling the history and background of surrealist voluntary unemployment, the primary purpose of these chapters is to assess how the surrealist war on work affected the very nature of the workings of art as such – the purpose and role of art and the artist in society.

While I have taken the notion of an overarching surrealist 'war on work' from the cover of the fourth issue of *La Révolution surréaliste* in 1925, my designation of 'surrealist sabotage' is a more general encapsulation of Aragon's three modalities of critical action as linked forms of cultural opposition. The term 'sabotage' arises frequently in various surrealist texts, particularly in the writings of Breton, which I discuss in Chapter 1, but I apply it here not as a result of any specific citation in the primary literature. Instead, I am interested in anchoring the highly distinctive surrealist work refusal in relation to the thriving contemporaneous discourse about labour critique and the subversion of exploitation in France, the United States, and to some degree greater Europe during the early twentieth century. This amounts to an extensive contextualisation of surrealism within its era. To understand the historical significance of the surrealist work refusal, we must also comprehend some of the conditions of labour at this time and also the broad cultural impact of those non-participation protest tactics most vital to the post-World War I labour cause. These resistance strategies – most notably, direct-action sabotage and strike – were first theorised and systematically implemented by anarchist activists at the end of the nineteenth century.

Sabotage tactics, including one type of sabotage known as the strike or the walkout, gained immense international notoriety for the first time in the years just before World War I. Although the practice of undermining work is ancient and geographically dispersed, tied as it is to histories and discourses of resistance to chattel slavery, the word 'sabotage' is of more recent coinage.[20] As is frequently discussed in the literature on this subject, the French word *sabotage* is etymologically related to the wooden sabots sometimes worn by European workers.[21] *Saboter* and *saboteur* appear in French argot at least as early as the beginning of the nineteenth century, around the time of the 1811–13 Luddite textile rebellion in England. Skilled artisans undertook widespread machine breaking in a largely organised protest against early automation, the rise of deskilled labour,

and the demise of craft. The word 'sabotage', however, is not directly related to this historical event.[22] An 1808 dictionary of French slang defines the verb *saboter* as 'to do something roughly in haste' and the noun *saboteur* as 'a deprecating nickname given to a bad worker who does everything sloppily and in haste'.[23] The silk weavers' strike in Lyon in 1834 (*la révolte des canuts*) also purportedly contributed to the use of this term, since workers smashed industrial property with sabots.[24] Today's common association of the saboteur as a workplace mutineer, whose actions approach propaganda of the deed (catalytic actions for revolution) in their radical symbolism, did not arise as a substantial tradition in France until the mid-1890s, when labour activists such as the syndicalist Émile Pouget began theorising policies of deliberate employee sabotage.

In 1897 the Confédération générale du travail (CGT) officially adopted the tactic of sabotage for the labour struggle. Yet sabotage only manifested as a form of criminalised direct-action protest in France after 1903, finally gaining notoriety in 1909 with the destruction of telegraph and telephone lines in the postal and telecommunications workers' strike that year.[25] In 1908, the revolutionary syndicalist Georges Sorel had published *Réflexions sur la violence*, which theorised the general strike (*grève générale*) as the mythic force that would unite the working class in the destruction of bourgeois culture.[26] In 1909 the revolutionary socialist Gustave Hervé began to conceptualise how sabotage could be applied to defeatist actions against France, and more generally to treasonous actions against the state, through anti-militarist strategies that could prevent possible war mobilisation.[27] Émile Pouget's ideas about 'clandestine degradation of the quality of work', purportedly based on pace-slackening techniques used by Scottish dock workers, were collected into the book *Le Sabotage* in 1911. Pouget also advocated the use of sabotage by the greater public as a method of defence against the authoritarian state.[28] His book reviews various tactics of industrial vandalism and the disruption or obstruction of processes of production. Worker sabotage is distinguished from the money-saving sabotage of product quality by capitalists themselves (a process known as adulteration).[29]

Dominique Pinsolle has shown how the concept of sabotage began to appear in American discourses following the international media attention granted to the French railway workers' strike of 1910, which involved substantial destruction of railway equipment tantamount to violent direct action.[30] The Industrial Workers of the World union (IWW) began to promote and pursue workplace sabotage by name in 1912, frequently, but not exclusively, emphasising non-violent or non-destructive sabotage as a formula of poor work for poor pay rather than anti-militarist, treasonous sabotage.[31] A cartoon drawn around 1910 by IWW illustrator Ralph Chaplin demonstrates the rapid rise to prominence of this term in an American context. *Don't Wear Sabots; It Hurts the Snake* ironically magnifies the worker's power in relation to the frailty of the capitalist (Figure 0.2). IWW texts and speeches on sabotage as a social weapon activated in the service of human life by writers such as William E. Trautmann, Walker C. Smith, and Elizabeth Gurley Flynn appeared between 1912 and 1913. Despite

DON'T WEAR SABOTS; IT HURTS THE SNAKE

Figure 0.2 Ralph Chaplin (Bingo), *Don't Wear Sabots; It Hurts the Snake. Solidarity* (7 April 1917)

this campaign for passive resistance sabotage, the IWW began to be criminalised as anti-patriotic on the local and national levels in 1915 in relation to its sabotage discourse, a trend that became concrete after the passing of the Espionage, Sabotage, and Sedition Acts in 1917 and 1918. These new laws resulted in the mass trial of IWW militants in Chicago in 1918 and the sentencing of ninety-three IWW leaders and members to prolonged federal prison terms.[32] By 1919 the American economist and sociologist Thorstein Veblen preferred to define sabotage not as malicious mischief that would simply provoke managerial discipline but, following statements made by the IWW and French syndicalists, as an industrial action characterised by 'the conscientious withdrawal of efficiency'.[33] The essential idea behind strike and sabotage (Veblen also asserted that the 'strike was a typical species of sabotage') was that labour power would negate the work contract and value production on a temporary basis. To demand wage increases and other benefits, workers themselves had the ability to cause the cessation or obstruction of production in a demonstration of either violent or non-violent protest.

In many ways, sabotage tactics were practical embodiments of an ideological work refusal and an abdication of the work ethic, although neither turn-of-the-century leftist political groups, including anarchists, nor organised labour

uniformly advocated sabotage, given its highly controversial and often destructive nature.[34] From the point of view of an antagonised employer, even working with indifference or without enthusiasm could be considered workplace sabotage.[35] Non-violent sabotage could also be an effective if dangerous way of slowing down the work of strike-breakers and scabs or of undermining the efforts of *agents provocateurs* to get workers convicted as criminals.[36] This is perhaps why, like Friedrich Engels in *The Condition of the Working Class in England in 1844*, communist writer and activist Paul Lafargue opposed destructive sabotage as a tactic in the labour struggle: 'Worker sabotage is, unfortunately, a handheld weapon which, more often than not, wounds the worker who is using it', he wrote in 1907, the period when a young André Breton saw his first strikes.[37]

By the 1920s, when surrealist saboteurs were gaining momentum for their cultural attack, the idea of slowing down work or interfering with industrial property as a means of forcing labour reform or bargaining for gains was widely known in France and the United States. In 1912 Frank Bohn, writing on behalf of the Wobblies – the popular nickname for members of the IWW – had summarised the recommended resistance tactic of sabotage as the 'excessive limitation of output'.[38] In response to practices of workplace control or exploitation by employers, such as the over-acceleration of production, high job turnover, mass layoffs, disciplinary humiliation, wage reduction, mandatory overtime, forced transfers, and factory idling and shutdowns, workers pursued a vast array of sabotage strategies beyond wrecking machinery and pilfering on the shop floor. A primary category was based on work time: stealing time on the job (cheating the clock, or the tactic of filling paid work hours with non-work tasks, which Michel de Certeau referred to as *la perruque* (the wig) – 'the worker's own work disguised as his employer's'), lateness, soldiering (a reduction of productivity akin to slacking, shirking, or goldbricking), mass slowdowns (*le ralentissement*; *le freinage*), working to rule (malicious compliance to the point of inefficiency; *l'obstructionnisme*; *la grève du zèle*), malingering (faking illness), and work stoppages.[39] Another category sought to arrest production for periods of time through the withholding of labour via absenteeism, boycotts, walkouts, sit-ins, occupations, blockades, job turnover, and strikes of various kinds.

It is important to note that the repudiation of paid work altogether, also known as *voluntary unemployment* (*le refus du travail*; *le chômage volontaire*), was understood to be one of these sabotage protest methods.[40] The interference with production processes was another tactic. It encompassed making frequent mistakes or poor and clumsy workmanship (*la grève perlée*; drop strike; irritation strike), refusal to co-operate or follow orders, tampering with equipment, pranking, and failure to adulterate or construct shabby or planned-obsolescence products (desired by the employer to stimulate purchases; also called constructive sabotage). Modes of exposing exploitation to the greater public were also prevalent. These included façade vandalism (*le badigeonnage*), picketing, whistle-blowing to customers, word-of-mouth campaigns to discredit low-quality goods (*la bouche ouverte*), and other forms of principled civil disobedience.[41]

The general strike was by far the most widely used sabotage approach for demanding the redress of grievances during the Third Republic and the era of surrealism's formation and early development. A series of nationwide strikes across France between 1917 and 1920 established first the *semaine anglaise*, or English week, which first granted all workers Saturday afternoons and Sundays off, and then the eight-hour workday.[42] In summer 1936, there was a massive general strike in France, with over a million French workers participating in roughly 12,000 factory occupations to fight successfully for a 12 percent wage increase, a forty-hour work week, and the country's first paid holidays.[43]

Surrealists were acutely cognisant of these struggles and results. However, even major advancements in the reduction of hours in the work week, which many societies still accept as the norm, were by no means an appeasement for writers such as Breton, Aragon, André Thirion, and several of their friends. Despite the surrealists' 1927 statement to the communists that they supported the defence of wages, the enforcement of the eight-hour workday, and the fight against unemployment and inflated costs of living, key members never gave up their stance in favour of the total abolition of wage labour.[44] Although it is possible that they might have agreed with members of the IWW that the utopian demand for a four-hour workday – or, for that matter, Paul Lafargue's sensational late nineteenth-century proposal for a three-hour day – would have been a substantial advancement during the interwar period, the surrealists ultimately took an ultra-left position on the subject of wage labour, seeking its full abolition rather than endless arbitration in the short-time movement.[45] Although the surrealists were not neo-Luddites, despite their reservations about progressivist apologies for technology, an ongoing programme of cultural sabotage and *voluntary unemployment* became the chosen approach for their collective attack on the institution of *travail salarié*. This attack, it must be remembered, was an important part of surrealism's general critique of other societal institutions, such as religion, the capitalist-imperialist state, and the patriarchal family unit. Thus, sabotage, in both its anti-industrialist and defeatist or anti-military applications, is relevant to the movement's orientation and goals.

In my reading of significant examples of surrealism's work refusal, all three of Aragon's aforementioned modalities of revolutionary aesthetic action in surrealism – critical activity, surrealist experimentation, and protest manifestations – can be understood as forms of symbolic, rhetorical, or direct-action sabotage of a productivist, pro-work ideology in society.[46] We have seen that sabotage refers to the sometimes oblique or camouflaged and sometimes overt obstruction of productivity and efficiency, since these are the manifestations of the work ethic's authority and a reflection of the necessity of waged work for preservation in a capitalist state. By direct action, I mean the contemporary definition of this phrase, which refers to any individual or collective action that attempts to achieve a concrete end or result by the most immediate means and without negotiation with or appeal to outside parties, especially bodies of authority, such as the state. Present-day usage of 'direct action' is an expansion from

its early twentieth-century meaning, which Bohn clarified in 1912 as 'any action taken by workers directly at the point of production with a view to bettering their conditions'.[47] Of course, surrealist sabotage can also be understood much more generally as a repudiation of the status quo at large, a vast superstructural undertaking that Walter Benjamin would admiringly call in 1930 the 'evident and effective' effort to 'sabotage ever broader regions of public and private life', even while he admonished Breton's failure to 'realize that diligence has its magical side'.[48]

Although my focus is on surrealism's artistic and theoretical critique of the institution of wage labour and society's work ethic, this investigation relates fundamentally to surrealism's pursuit of a wide variety of critical subcultural practices such as *détournement* (an aesthetic concept of critical transformation or rerouting, pioneered by Aragon and Breton in relation to the collages of Max Ernst decades before the Situationist International deployed it), appropriation, parody, inversion, and more.[49] Although surrealism's work refusal and surrealist sabotage are just aspects of its broader critique of bourgeois systems, and although not all surrealist art can be described as critical, my account nevertheless highlights these understudied phenomena of artistic *negation*, overt or camouflaged *subversion*, and *demand* as important ongoing tactics in the movement's history.

Along with broadly aligning aspects of this surrealist resistance with labour critique and protest strategies, I also incorporate labour-history and theory components into my analysis. As a means of theoretically and contextually situating the surrealist critique of wage labour in Chapters 2 and 3, my analysis engages in an experimental art-historical hermeneutics in which I excavate and magnify under-studied or previously overlooked aspects of surrealism in relation to French women's productive and sometimes reproductive labour histories from the nineteenth and early twentieth centuries. I look to the general example of social art history in these analytical choices as a way of challenging previous scholarly tendencies to depoliticise and decontextualise surrealism for the sake of its theoreticisation or formalisation. On a more specific level, theoretical and activist perspectives about issues of class and gender in women's work offered by intersectional social reproduction feminism underpin my discussion as a whole.[50]

Ultimately, I assert that surrealism's persistent war on work was not only a unique and highly effective form of social critique that retains immense relevance in our wired surveillance society. Its permanent protest also has been part of a passionate struggle to ensure the survival of emancipatory art practices and communities in a world that increasingly devalues the role of art in favour of a totalising life of work for the subjected *animal laborans* that Hannah Arendt warned of in *The Human Condition* (1958). Surrealism protested compulsory wage labour in a monopoly capitalist system that enforces participation in its system through the suppression of alternatives, just as it rejected the recuperation of art into capital or its instrumentalisation into agitprop. Surrealism's dual intractability to the co-optation of life and art into various realms of control therefore should not be qualified in terms of teleological or qualitative success or failure. Must the valuation of the surrealist critique of production likewise be subject to

a productivist mindset? Rather, this position can be understood as an explosive set of strategies for *ongoing* aesthetic sabotage and cultural agitation for a vast horizon of resistance. Accordingly, my study invites overarching considerations of contemporary discourses of post-Fordist labour theory, issues related to the financialisation of contemporary art, the neoliberal indistinction between leisure and labour, questions about affective, caring, and immaterial labour, women's double work day, resistance to biopolitical control, strategies of cultural activism, and post-work imaginaries that can optimise our understanding of surrealism past and present – and vice versa.[51] The flourishing present-day discourse of work critique stands to gain significant insights from this under-acknowledged surrealist history.[52] Surrealism's lineage of work-refusal actions, artworks, and theories, spanning from 1920s France to transnational exchanges during the 1930s to New Left resistance in the United States – not to mention its unique work-abolitionist genealogy that I discuss in Chapter 1 – is too rarely acknowledged or comprehended as a key example of protest strategy against the economic coercion of humans into a life of value-production.[53]

Finally, since this book comprises an exploration of the surrealist sabotage of the work ethic and the societal imperative of wage labour as just one prominent example of the movement's many strategies of cultural critique, my discussion does not revisit or exhaust all of the related areas that promise further insight into these matters, some of which scholars have already addressed extensively. Nor is this a study of surrealism's relation to the proletariat and the labour struggle in general. Surrealism studies have begun to address in significant detail a generous range of related issues – for instance, surrealism's attempt at collaboration with the PCF; its underlying anarchist orientation, sanction of crime, and development of voluntary play; the importance of surrealist games and toys, *disponibilité* (availability), *errance* (wandering), the gift, and the found object as counter-tactics to productivity and instrumentalisation; and its complicated relationship to the professional art world, consumerism, shopping, advertising, and commodity culture.[54] In addition to these studies, which have been foundational for this research, several other relevant areas of enquiry are incorporated here but not treated in depth. Although in various places throughout this book I discuss the profound influence that Charles Fourier's early nineteenth-century writings on the relationship between work, passion, and play exerted on surrealism, I did not have the space to delve sufficiently into this vast subject. Chapter 1 mentions the French surrealists' association with proletarian authors and their publications, such as Maurice Wullens and his literary journal *Les Humbles*. In Chapter 3, I touch on the relationship of surrealism's machines to those of dada, Benjamin Péret's solidarity with working-class dispossession and his ties to autonomist syndicalism and anarchism, and George Bataille's critique of work and productivity in dialogue with his theories of excess and unproductive expenditure. In Chapter 4, I comment on Louis Janover's council communism and his polemical account of surrealism, links between post-war surrealists and the French Marxist group Socialisme ou Barbarie, and the Situationist International's affiliation with

surrealism's war on work and concept of the art strike. Finally, Nora Mitrani's trenchant critique of technocracy and capitalist reification during her sociology career in the 1950s is summoned in the Epilogue. These topics and several others related to surrealism, technology, rationalisation, and wage labour invite more extensive research elsewhere.[55]

Summary of the book

Surrealist sabotage and the war on work investigates key instances of surrealist work refusal over the course of the twentieth century through a preliminary conceptual genealogy, three roughly chronological case studies, and an Epilogue. Chapter 1, 'Genealogy of the surrealist work refusal', reviews the development of a surrealist discourse of anti-capitalist work abolitionism in French surrealist texts and statements primarily from the 1920s and 1930s by writers such as André Breton, Louis Aragon, and André Thirion. The discussion proceeds by outlining the key historical sources from the nineteenth through the twentieth century that influenced this position, including texts by Marcel Duchamp, Arthur Rimbaud, and Paul Lafargue. Connections with contemporary debates about post-capitalist work critiques are also brought to the fore.

In Chapter 2, 'Surrealist automatism as symbolic work sabotage', I extrapolate the concept of surrealist sabotage in life and art by establishing a labour theory of surrealist automatism during the 1920s in France. In my reading, surrealist automatism becomes a form of symbolically subversive anti-work that undermines rationalisation and its effects through tactics that resemble work-to-rule sabotage. These tactics subverted efficiency through minimal effort and exaggerated compliance to regulations. The first section of the chapter examines a series of landmark photographs of the Bureau of Surrealist Research in Paris taken by Man Ray in 1924. Utilising reception-based and historiographic methodologies, I argue that Simone Breton, wife of André Breton, performs symbolic labour in a photograph by Man Ray when she poses at a typewriter to take automatist dictation. Reviewing the scholarly debate on the role of women in surrealism that occurred in the 1980s and 1990s, I initiate an embodied discourse about my own scholarly labour to tie the often previously invisible work of the female surrealist and her image to the performative labour of the surrealist automatist in general. This exposition considers how scholarly understandings of the surrealist automatist medium can be modulated in light of the dawning information age during the interwar period, but also seeks to distinguish the rise of the earliest stirrings of *l'informatique* (computer science) from the automatic. I discuss a rarely noted but quite prevalent leitmotif in French surrealist texts of the 1920s that typified automatism as a form of stenographic transcription. Addressing the performative training of the body in the process of its compliance with regulated work, I compare surrealist automatism to the feminised boom in the secretarial industry in the Allied nations during the reconstruction period after World War I.

Chapter 3 demonstrates how surrealism applied its sabotage to the realm of visual art production through an extended case study of artworks in different media from the 1930s by the Canarian surrealist Óscar Domínguez. I claim that the surrealist subversion of disciplined, rationalised labour in their performative theory of automatism was expanded and adapted by Domínguez into a form of imaginative transformation of the work tool during the period in which surrealism turned away from attempted collaboration with the PCF and towards temporary partnership with Leon Trotsky's Fourth International. In the first section of the chapter, I situate my analysis of Domínguez's representations of work tools in the context of surrealism's final overtures to the PCF and its participation in protests against fascism in 1934, as well as the June Strikes that shook France in 1936, just as the Spanish Civil War was about to erupt. This contextual framing anchors my argument that Domínguez's preoccupation with representing the subverted work tool during the 1930s can be seen as part of a surrealist critique of ideologies of productivism and authoritarianism. Domínguez accomplished this through a valorisation of worker and artist autonomy and self-management (*autogestion*) via themes of autoeroticism and occasionally autodestruction.

The second section of the chapter consists of an extended iconographic and contextual reading of Domínguez's striking painting *Machine à coudre électro-sexuelle* (1934–35) in relationship to cultural histories of female sexuality and the material culture of the sewing machine. Undertaking a formal analysis of this oil on canvas, I reveal the presence of a quasi-covert set of sexual references about women's sewing-machine work. These references are corroborated by a substantial nineteenth-century historical discourse tied to the garment industry and unpaid reproductive or domestic labour forces, in which the sewing machine figures as an involuntary autoerotic device for the secondary labour force of hyper-exploited female workers. The image of the female worker sabotaging her task through masturbatory eroticism can thus be read as emblematic of the ways in which theories of defiant autonomy became paramount to the surrealist war on work during the 1930s.

In Chapter 4, 'Direct action surrealism in Chicago', my historical focus shifts to the United States in the post-World War II period. I contend that surrealism's war on work can be more easily understood when considered in light of the labour activism, cultural sabotage and protest, and theoretical inquiries carried out by the Chicago surrealists during the 1960s and 1970s in conjunction with surrealists overseas. In the first section, '"Incendiary time bomb": *The Rebel Worker* (1964–66)', I employ extensive archival and fieldwork research and apply social movement theory to argue that the Chicago surrealists pioneered a form of direct-action cultural practice meant to stimulate collective indiscipline and activate civil disobedience at large. Surrealist aesthetics were juxtaposed with and compared to union theories and practices of workplace sabotage and strike in a mimeographed underground press publication, *The Rebel Worker*. Providing a history of the journal's founding and an overview of its sabotage theories, I show how this publication spoke to the concerns of international surrealism even while

it identified as an organ of the Industrial Workers of the World. For the Chicago surrealists, the struggle for workers' rights, with deep foundations in the Chicago labour movement, was fully synchronous with surrealism's validation of work-lessness and vindication of the right to be lazy.

The final two sections of the chapter explore how Chicago surrealism conceptualised direct action artistically and rhetorically. I begin with a discussion of artworks by the Chicago surrealist and labour activist Robert Green that were constructed with 'sabotaged' machines and exhibited in 1968 in Lincoln Park. I then proceed to an analysis of the Chicago surrealists' encounter with Herbert Marcuse at the 1971 *TELOS* Conference in Buffalo, New York, and their communications with him thereafter. Chicago surrealists were influenced by Marcuse beginning in the early 1960s, and their surrealist-activist approach to the war on work was substantially determined by Marcuse's post-Freudian theories of the performance principle and the pleasure principle. Analysing some of Marcuse's final writings and letters, I affirm that unlike his Frankfurt School colleagues, Marcuse maintained lasting confidence in the effective and influential radicalism of surrealism in the process of social transformation.

In the Epilogue, I return to a discussion of Breton's 1965 essay on the German painter Konrad Klapheck, which I briefly discuss in Chapter 3, as a means of delineating a more concrete picture of what surrealism might have wanted in its generative thought about a future post-work society. I also revisit the site of the 1965 exhibition *L'Écart absolu* (*Absolute Deviation*) in Paris, with its series of artworks about domestic and waged work and its outcry against a society based on what in the mid-1950s Breton termed 'miserabilism'.[56] Building on Breton's suggestion of the necessity of human–machine collaboration in a mutual overriding of functionality as the ultimate goal of life's potential, I undertake a cursory examination of relevant artworks by Klapheck, Giovanna (Anna Voggi), and others. Although surrealism did not stipulate its demands for work remuneration or the reduction of the workday and work week – or, for that matter, discuss societal solutions such as the idea of a universal basic income and the three-day weekend – the movement's increasing interest in the work of Charles Fourier and Herbert Marcuse after World War II provides a provocative glimpse of what a society without wage labour might look like in the surrealist imaginary.

Notes

1 This declaration was first articulated in a combative slogan on the cover of the fourth issue of the journal *La Révolution surréaliste* in 1925.
2 André Breton, 'La Dernière grève', *La Révolution surréaliste* 2 (15 January 1925): 1; my translation.
3 Michael Torigian, *Every Factory a Fortress: The French Labor Movement in the Age of Ford and Hitler* (Athens: Ohio University Press, 1999), 4. The eight-hour workday and six-day work week were approved by the French Parliament on 23 April 1919. Gary

S. Cross, *A Quest for Time: The Reduction of Work in Britain and France, 1840–1940* (Berkeley: University of California Press, 1989), 128–9, 154–61; and Christopher K. Ansell, *Schism and Solidarity in Social Movements: The Politics of Labor in the French Third Republic* (Cambridge: Cambridge University Press, 2008), 198–227. On the strikes between 1917 and 1919, see Jean-Louis Robert, *Les Ouvriers, la patrie et la révolution: Paris 1914–1919* (Paris: Les Belles Lettres, 1995).

4 Laura Levine Frader, *Breadwinners and Citizens: Gender in the Making of the French Social Model* (Durham, NC: Duke University Press, 2008), 15.

5 Matt Perry, *Prisoners of Want: The Experience and Protest of the Unemployed in France, 1921–45* (Burlington, VT: Ashgate, 2007), 14, 19, 35–8; and Frader, *Breadwinners and Citizens*, 3 and *passim*.

6 Cross, *Quest for Time*, 128–9. The editors of André Breton's *Œuvres complètes* have noted that in mid-October 1924, at the very same moment in which Breton's *Manifeste du surréalisme* was published, leftist politicians struggled to instate a strict application of the *loi de huit heures*. André Breton, *Œuvres complètes*, ed. Marguerite Bonnet et al. (Paris: Gallimard, 1988), 2:1450n7.

7 Herbert Marcuse, *Eros and Civilization: A Philosophical Inquiry into Freud* (Boston, MA: Beacon Press, 1966), 149.

8 Sigmund Freud, *Civilization and Its Discontents*, trans. James Strachey (New York: Norton, 2005), 58n5.

9 Marcuse, *Eros and Civilization*, 149.

10 Donald Wendell LaCoss, 'The Revolutionary Politics of Surrealism in Paris, 1934–9' (PhD dissertation, University of Michigan, 2001), *passim*.

11 I am here influenced by Kathi Weeks's discussion of the power relations involved in the process of the privatisation and reification of work and the subjected nature of workers' lives as a result of this naturalised work imposition. Kathi Weeks, *The Problem with Work: Feminism, Marxism, Antiwork Politics, and Postwork Imaginaries* (Durham, NC: Duke University Press, 2011), 2–8.

12 Theresa Papanikolas, *Anarchism and the Advent of Paris Dada: Art and Criticism, 1914–1924* (Burlington, VT: Ashgate, 2009). Papanikolas has argued that following the example of dada, surrealism was founded with a substantial anarcho-individualist orientation, although she also weighed the influence of anarcho-communism upon both movements. In 1921, Paris dadaists staged a photo with a worker.

13 See István Mészáros, *Marx's Theory of Alienation* (London: Merlin Press, 1970).

14 John Horne, 'Labor and Labor Movements in World War I', in *The Great War and the Twentieth Century*, ed. Jay Winter et al. (New Haven, CT: Yale University Press, 2000), 187–227; and Peter N. Stearns, *Revolutionary Syndicalism and French Labor: A Cause Without Rebels* (New Brunswick, NJ: Rutgers University Press, 1971).

15 André Breton, 'Second Manifesto of Surrealism' (1929), in *Manifestoes of Surrealism*, trans. Richard Seaver and Helen R. Lane (Ann Arbor: University of Michigan Press, 1972), 156–7. André Thirion confirmed the synergy between surrealism's and communism's revolutionary determinism in relation to the projected abolition of wage labour in *Revolutionaries Without Revolution*, trans. Joachim Neugroschel (New York: Macmillan, 1975), 186–7, 192. It is important to note that in his 1952 essay devoted to anarchism, 'Tower of Light', Breton clarified that the surrealists could never forget the brutality of the Bolshevik termination, led by Leon Trotsky as head of the Red Army, during the 1921 Kronstadt Rebellion in Russia. André Breton, 'Tower of Light', in

Free Rein = *La Clé des champs*, trans. Michel Parmentier and Jacqueline d'Amboise (Lincoln: University of Nebraska Press, 1995), 276.

16 In 'Tower of Light', Breton wrote, 'A whole new change in perspective was brought about by what was believed to be the triumph of the Russian Revolution and the advent of a workers' State … around 1925, only the Third International seemed to have the requisite means of transforming the world' (266). Michael Richardson has discussed the apparently minor impact of the Bolshevik Revolution upon surrealism during its formation in 1924 but also mentions that the synergy of the surrealist designation of their movement as a revolution should be considered. 'Communism', in *The International Encyclopedia of Surrealism*, ed. Michael Richardson et al. (London: Bloomsbury, 2019), 1:189–90. See also Simon Baker, *Surrealism, History and Revolution* (Oxford: Peter Lang, 2012).

17 Carole Reynaud Paligot, *Parcours politique des surréalistes, 1919–1969* (Paris: CNRS Éditions, 1995), 178–9.

18 Louis Aragon, 'Le Surréalisme et le devenir révolutionnaire', *Le Surréalisme au service de la révolution* 3 (1931): 7.

19 *Ibid.*, 7–8.

20 On sabotage and slavery in the United States, see Robert William Fogel, *The Slavery Debates, 1952–1990: A Retrospective* (Baton Rouge: Louisiana State University Press, 2003), 36–9. On strike and slavery in the Atlantic colonies, see C. L. R. James, 'The Atlantic Slave Trade and Slavery: Some Interpretations of Their Significance in the Development of the United States and the Western World', in *Amistad 1*, ed. John A. Williams and Charles F. Harris (New York: Vintage Books, 1970), 134–5, 152–3; and David Roediger, 'Gaining a Hearing for Black-White Unity: Covington Hall and the Complexities of Race, Gender and Class', in *Towards the Abolition of Whiteness: Essays on Race, Politics, and Working Class History* (New York: Verso, 1994), 127–80. On sabotage among African American wage workers, see Robin D. G. Kelley, *Race Rebels: Culture, Politics, and the Black Working Class* (New York: Free Press, 1994). My reading of surrealist sabotage has been influenced by the concepts of Black waywardness in Saidiya V. Hartman, *Wayward Lives, Beautiful Experiments: Intimate Histories of Social Upheaval* (New York: W. W. Norton & Co., 2019).

21 Thorstein Veblen, *On the Nature and Uses of Sabotage* (New York: Oriole Editions, 1971), 1. This text is reprinted in Gerald Mars, *Work Place Sabotage* (Burlington, VT: Ashgate, 2001), a volume of essays about sabotage.

22 Kirkpatrick Sale, *Rebels Against the Future: The Luddites and Their War on the Industrial Revolution: Lessons for the Computer Age* (Reading, MA: Addison-Wesley, 1995).

23 Charles-Louis D'Hautel, *Dictionnaire du bas-langage ou des manières de parler usitées parmi le peuple; ouvrage dans lequel on a réuni les expressions proverbiales... les sobriquets... les barbarismes...* (Paris, 1808), 325.

24 W. E. Trautmann et al., *Direct Action & Sabotage: Three Classic IWW Pamphlets from the 1910s*, ed. Salvatore Salerno (Chicago, IL: Charles H. Kerr, 1997), 7.

25 Sébastien Albertelli, *Histoire du sabotage: de la CGT à la Résistance* (Paris: Perrin, 2016); Dominique Pinsolle, 'Du Ralentissement au déraillement: le développement du sabotage en France (1897–1914)', *Histoire, Économie & Société* 4 (2015): 56–72; and Dominique Pinsolle, 'Sabotage, the IWW, and Repression: How the American Reinterpretation of a French Concept Gave Rise to a New International Conception of Sabotage', trans. Jesse Cohn, in *Wobblies of the World: A Global History of the IWW*, ed. Peter Cole et al. (London: Pluto Press, 2017), 44–58.

26 Georges Sorel, *Reflections on Violence*, trans. Thomas Ernest Hulme, ed. Jeremy Jennings (1908; New York: Cambridge University Press, 1999). In a 1921 essay, Walter Benjamin weighed the question of the inherent violence of the strike as a form of engaged withdrawal or non-action and followed Sorel in his praise for the proletarian general strike. See 'Critique of Violence', in *Reflections: Essays, Aphorisms, Autobiographical Writing*, trans. Edmund Jephcott (New York: Schocken Books, 1986), 277–300.

27 Albertelli, *Histoire du sabotage*, 56–72; and Pinsolle, 'Sabotage, the IWW, and Repression', 45–7, 54. Pinsolle has clarified that Hervé's application of sabotage to the state came close to a form of terrorism.

28 Pinsolle, 'Sabotage, the IWW, and Repression', 44.

29 Émile Pouget, *Sabotage* (Chicago, IL: Charles H. Kerr, 1913); and John Spargo, 'Sabotage as a Revolutionary Weapon', in *Syndicalism, Industrial Unionism and Society* (New York: B. W. Huebsch, 1913), 148–54.

30 Pinsolle, 'Sabotage, the IWW, and Repression', 45–7.

31 *Ibid.*, 45 and *passim*.

32 Trautmann et al., *Direct Action & Sabotage*, 6.

33 Veblen, *On the Nature and Uses of Sabotage*, 1. Veblen reminded readers that employers could also resort to sabotage against workers with lockouts and other tactics. His overall argument is that capitalism could benefit from the application of necessary sabotage as a remedy for deflation caused by overproduction.

34 Michael Seidman, 'Towards a History of Workers' Resistance to Work: Paris and Barcelona during the French Popular Front and the Spanish Revolution, 1936–38', *Journal of Contemporary History* 23, no. 2 (1988): 191–220; Pinsolle, 'Sabotage, the IWW, and Repression', 61; Spargo, 'Sabotage as a Revolutionary Weapon', 139–78; and Veblen, *Nature and Uses of Sabotage*, 5.

35 Mars, *Work Place Sabotage*, 10 and *passim*.

36 Rudolf Rocker, *Anarcho-syndicalism* (1938; London: Pluto Press, 1989), 126–7.

37 Paul Lafargue, 'Le sabotage', *L'Humanité*, 8 April 1907, 1; my translation. See also Friedrich Engels, *The Condition of the Working Class in England in 1844; with Preface Written in 1892*, trans. Florence Kelley Wischnewetzky (Cambridge: Cambridge University Press, 2010), 213–15; and Pierre Dubois, *Sabotage in Industry* (Harmondsworth: Penguin, 1979), 98–102.

38 Frank Bohn, 'Some Definitions: Direct Action – Sabotage', in *Theories of the Labor Movement*, ed. Simeon Larson and Bruce Nissen (Detroit, MI: Wayne State University Press, 1987), 85.

39 Michel de Certeau, *The Practice of Everyday Life*, trans. Steven Rendall (Berkeley: University of California Press, 1984), 25.

40 Dubois, *Sabotage in Industry*, 55–6.

41 Spargo, 'Sabotage as a Revolutionary Weapon', 139–78.

42 Frader, *Breadwinners and Citizens*, 10; and Mary Lynn Stewart, *Women, Work, and the French State: Labour Protection and Social Patriarchy, 1879–1919* (Kingston, ON: McGill-Queen's University Press, 1989), 3–13.

43 Julian Jackson, *The Popular Front in France: Defending Democracy, 1934–38* (Cambridge: Cambridge University Press, 1988), 85–7, 132–3. France's current 35-hour work week was introduced at the new millennium.

44 'Aux communistes', in *Tracts surréalistes et déclarations collectives: 1922–1939*, ed. José Pierre (Paris: Le Terrain Vague, 1980), 76.

45 David R. Roediger and Philip S. Foner, *Our Own Time: A History of American Labor and the Working Day* (New York: Greenwood Press, 1989), 181.

46 Gavin Grindon has spoken of the 'cultural transposition' of sabotage in dada in 'Surrealism, Dada, and the Refusal of Work: Autonomy, Activism, and Social Participation in the Radical Avant-Garde', *Oxford Art Journal* 34, no. 1 (2011): 93. Robert Short, 'The Politics of Surrealism, 1920–36', *Journal of Contemporary History* 1, no. 2 (September 1966): 3–25. The militant communist activist André Thirion stated in his memoir that core surrealists had always 'shown a highly characteristic willingness to take part in direct action and a manifest taste for violence'. Thirion, *Revolutionaries Without Revolution*, 187.

47 Bohn, 'Some Definitions', 85. Fernand Pelloutier coined the term 'direct action' in 1897 to refer to syndicalist resistance practices. Trautmann et al., *Direct Action & Sabotage*, 6–7; and David Graeber, *Direct Action: An Ethnography* (Oakland, CA: AK Press, 2009).

48 Walter Benjamin, 'Paris Diary', in *Selected Writings*, ed. Michael W. Jennings et al., vol. 2, *1927–1930* (Cambridge, MA: Belknap Press of Harvard University Press, 1999), 350–1.

49 Abigail Susik, 'Aragon's Modern Mythology and Surrealist *Détournement*', unpublished paper.

50 Tithi Bhattacharya and Lise Vogel, eds, *Social Reproduction Theory: Remapping Class, Recentering Oppression* (London: Pluto Press, 2017).

51 I cannot undertake here a detailed comparison of how a more nuanced understanding of the history and import of surrealism's war on work might in turn contribute to the recent discourse in art history and criticism about art as a form of labour. See, for instance, Helen Molesworth et al., *Work Ethic* (Baltimore, MD: Baltimore Museum of Art, 2003); Maurizio Lazzarato, 'Immaterial Labor', in *Radical Thought in Italy*, ed. Paolo Virno and Michael Hardt (Minneapolis: University of Minnesota Press, 1996), 133–47; and Julia Bryan-Wilson, *Art Workers: Radical Practice in the Vietnam War Era* (Berkeley: University of California Press, 2009). On immaterial and affective labour in relation to the Foucauldian concepts of biopower and the biopolitical, see Michael Hardt and Antonio Negri, *Empire* (Cambridge, MA: Harvard University Press, 2000). Also see the final two books in their trilogy for an analysis of how the multitude of all kinds of waged and unwaged workers under capitalism can refuse the command of work in favour of a commons of value: *Multitude: War and Democracy in the Age of Empire* (New York: Penguin, 2004); and *Commonwealth* (Cambridge, MA: Harvard University Press, 2009).

52 My account of surrealism's work refusal – as one of the earliest and most sustained applications of this protest stance in twentieth-century aesthetics – is substantially influenced by now-prominent theories developed by *operaismo* autonomists, traceable in texts such as Antonio Negri's 1977 essay about sabotage as a form of productive self-valorisation for workers of all kinds. See Antonio Negri, 'Capitalist Domination and Sabotage' (1977), in *Working Class Autonomy and the Crisis: Italian Marxist Texts of the Theory and Practice of a Class Movement, 1964–79* (London: Red Notes, 1979), 93–117. Also see the discussion of the transformative power of 'living labor' as a resistant and generative anti-capitalist undercurrent inherent to the labour force in Michael Hardt and Antonio Negri, *Labor of Dionysus: A Critique of the State-form* (Minneapolis: University of Minnesota Press, 1994).

53 See, for example, Bob Black, 'The Abolition of Work', in *The Abolition of Work and Other Essays* (Port Townsend, WA: Loompanics Unlimited, 1986), 17.

54 Some of the studies devoted to surrealism and these subjects include the following: PCF: Reynaud Paligot, *Parcours politique*. Anarchism: Alix Large, *L'Esprit libertaire du surréalisme* (Lyon: Atelier de Création Libertaire, 1999); José Pierre, *Surréalisme et anarchie: les 'billets surréalistes' du 'Libertaire', 12 octobre 1951–8 janvier 1953* (Paris: Plasma, 1983); and Ron Sakolsky, *Dreams of Anarchy and the Anarchy of Dreams: Adventures at the Crossroads of Anarchy and Surrealism* (New York: Autonomedia, 2021) (I have not yet reviewed this forthcoming publication). Crime: Jonathan P. Eburne, *Surrealism and the Art of Crime* (Ithaca, NY: Cornell University Press, 2008). Play and toys: David Hopkins, *Dark Toys: Surrealism and the Culture of Childhood* (New Haven, CT: Yale University Press, 2021) (I have not yet reviewed this forth-coming publication); and Susan Laxton, *Surrealism at Play* (Durham, NC: Duke University Press, 2019). Museums, markets, and commodity culture: Julia Drost, Fabrice Flahutez, Anne Helmreich, and Martin Schieder, *Networking Surrealism in the USA: Agents, Artists, and the Market* (Heidelberg: arthistoricum.net, 2020); Ghislaine Wood, Museum Boijmans Van Beuningen, and Museo Guggenheim Bilbao, *Surreal Things: Surrealism and Design* (London: V&A Publications, 2007); and Sandra Zalman, *Consuming Surrealism in American Culture: Dissident Modernism* (New York: Routledge, 2018). On surrealism's critique of commodity fetishism, see, for instance, Johanna Malt, *Obscure Objects of Desire: Surrealism, Fetishism, and Politics* (Oxford: Oxford University Press, 2004). On the outmoded as a commodity category, see Abigail Susik, 'The Vertigo of the Modern: Surrealism and the Outmoded' (PhD dissertation, Columbia University, 2009).

55 On Péret's connections to Socialisme ou Barbarie, see Paligot, *Parcours politique*, 175–86. On Péret and anarcho-syndicalism, see Benjamin Péret, *A Menagerie in Revolt: Selected Writings* (Chicago, IL: Black Swan Press, 2009). Extended considera-tions of surrealism's interest in the theories of both Henri de Saint-Simon and Charles Fourier, as related to the role of work in society, are also relevant (despite Saint-Simon's productivist techno-optimism).

 Although I mention Bataille's concept of unproductive expenditure from time to time, I do not undertake an analysis of his critique of surrealism as paradoxically productive negation or critical negation put to work as an engine for liberation. Nor do I discuss the relevant topics of Bataillian negativity, sacrifice, and *désœuvrement* (unworking). Jean-Paul Sartre's critique of surrealism in *What Is Literature?* (1948) took on a similar tone to Bataille's attack, with an added emphasis on the need for engaged socio-political action. On these subjects, see Bruce Baugh, *French Hegel: From Surrealism to Postmodernism* (New York: Routledge, 2003); William Plank, *Sartre and Surrealism* (Ann Arbor, MI: UMI Research Press, 1981); and Jean-Paul Sartre, '*What Is Literature?' and Other Essays* (Cambridge, MA: Harvard University Press, 1988). On Mitrani's critique of technocracy, see Jonathan P. Eburne, 'Approximate Life: The Cybernetic Adventures of Monsieur Wzz…', in *Surrealism, Science Fiction and Comics*, ed. Gavin Parkinson (Liverpool: Liverpool University Press, 2015), 62–81.

56 André Breton, 'Away with Miserabilism!' (1956), in *Surrealism and Painting*, trans. Simon Watson Taylor (Boston, MA: MFA Publications, 2002), 348.

1 Genealogy of the surrealist work refusal

In the post-World War I period, the surrealists were not alone in their position of needing to work and yet promoting work avoidance – or, for that matter, in their intention to support a proletarian revolution while maintaining a stance antagonistic to the productivism of the Communist Party in France and the USSR. The human desire to find meaning and purpose in life within and beyond the sphere of work, especially waged work, was not necessarily a question of political or class affiliation in France during this era. In Michael Seidman's account of 'workplace utopianism' in twentieth-century French working-class culture, he argued that since the nineteenth century, certain French workers had led the struggle against the dominance of the work ethic with a substantial if undocumented culture of workplace sabotage. Seidman has confirmed that this culture not only survived into the inter-war period but actually thrived, even within the ranks of communist adherents who were aware of the Party's idealisation of the work ethic and promotion of industrial rationalisation.[1] The principled abdication of participation in the capitalist system of wage labour or the conscientious withdrawal into voluntary unemployment, therefore, could and sometimes did exist alongside the political causes of labour reform, workers' rights, and even communist radicalism in this era.

The surrealists, too, recognised that although waged work was required for survival in a capitalist sphere even for members of the bourgeoisie like themselves, the work ethic could nevertheless be undermined from the inside. Rather than being seen as a paradox, given their simultaneous desire between 1925 and 1935 to rally alongside the cause of the French Communist Party, this recognition was understood by the surrealists to be an opportunity for continual revolt against passive conformity to the wage-labour imperative. This imperative existed due to the necessity of a life of gainful employment in a capitalist market.

At the same time, the surrealists were cognisant that their critique of the wage-labour system was inherently different in substance and purpose from that of the working class. Surrealism advocated the despecialisation and democratisation of art into an activity for all, even while for many years it supported the communist and proletarian cause of a workers' revolution. The attempted alignment with

proletarian resistance persisted in surrealism until the advent of World War II despite the class divide, the surrealist critique of proletarian literature, and the surrealist desire for the total reconstruction of work's meaning and role in life.[2] The question of surrealism's work refusal was thus intimately connected to its fundamental query about how waged labour relates to the role of the artist in society – and in turn how the artwork itself functioned when confronted with the material demands of everyday life and processes of reification. Communist agitator and surrealist André Thirion summarised the surrealist viewpoint in his 1972 memoir:

> Nearly all material support was condemned: work was scorned, and journalistic or quasi-artistic activities amounted to treason. Everyone's associations were closely examined, and troublemakers, spies, or pigs were found everywhere. Max Ernst and Miró were insulted for agreeing to do ballet sets. Artaud was reproached for being an actor, and Vitrac for writing and producing plays, a privilege accorded only to Raymond Roussel. Surrealism closed itself off in a world of poverty. The only commercial operations were the episodic dealings for artworks and for the publication of one's own works. Buyers and publishers had to offer guarantees of morality.[3]

Rather than perpetuating the hierarchical division between manual and intellectual or creative labour (what some aestheticians summarise as the separation of autonomous art from life), the surrealists agitated for a society in which all work, including 'art-work', would be desirable and unalienated (the fusion of art and life, rather than art's disappearance into life).

In this initial section, I establish the context and background – the genealogy, if you will – of the French surrealist declaration of the war on work in 1925 in relation to the inter-war writings of surrealist theorists such as André Thirion, André Breton, and others. I also evaluate surrealism's efforts in the 1920s and 1930s towards synergy with the proletarian cause despite their commitment to voluntary unemployment. While the surrealist discourse of work refusal ultimately concerned questions of material existence during the post-World War I period, I primarily track aspects of this context and its genealogy as they appear across the span of the French Third Republic (1870–1940). My discussion contextualises the violation of the work ethic and its ramifications for the figure of the artist in relation to a range of references related to nineteenth- and early twentieth-century elected predecessors such as Karl Marx, Arthur Rimbaud, Paul Lafargue, and Marcel Duchamp. Finally, this genealogy takes into account relevant aspects of present-day theoretical discourses of work critique and the ways in which these relate to and often overlook the historical example of surrealism's anti-work stance. As a European movement inherently connected to the goal of societal revolution, surrealism's political and social ideologies are inseparable from its aesthetic theories and artistic activities. Surrealism's work refusal is therefore arguably most fully activated when its application is traced in the expansive arc of the movement's multifaceted artistic production.

Those 'who do not accept': the development and significance of surrealism's work refusal

In his 1924 *Manifesto of Surrealism*, André Breton addressed the problem of the alienation of paid work and the cycle of consumption that results. For him, production and consumption are inherently tied to the oppressive malaise of modern life and the material world in industrial capitalism. Breton linked the ubiquitous disenchantment of existence to the stultification of the imagination's freedom by forces of rationalisation, logic, positivism, utility, and 'practical necessity'.[4] Although the belief in the meaning and value of life is strong, Breton explained, humans are nevertheless alienated from the objects they have 'been led to use', even though they have 'agreed to work' and therefore earned these objects by their own 'efforts'.[5] The result of this consent is dissatisfaction with one's fate and diminishment of the purpose of life and the reason for living it. According to Breton, to combat a general sentiment of meaninglessness, surrealism cultivates the liberty of the imagination and the experience of the marvellous in everyday life through automatism, ludic practices, and a stance of 'complete *nonconformism* … at the trial of the real world'.[6] In opposition to the acceptance of the existing state of society and its enforced order as given, surrealism stubbornly advances a vision of what '*can be*'.[7]

Breton's *Manifesto* does not explicitly reference mid- to late nineteenth- and early twentieth-century Marxist, Weberian, or Durkheimian theories of *Entfremdung* (estrangement; sometimes translated as alienation), *Entzauberung* (disenchantment), or *anomie*. However, his surrealist viewpoint arguably resonates with such conceptualisations about the negative effects of the capitalist-industrialist mode of production and the bureaucratisation of daily life. The surrealist critique of practical necessity and rationalisation likewise primarily assigned human alienation to manufactured causes rather than ontological or existential ones. For the German sociologist Max Weber, for instance, in books such as *Die protestantische Ethik und der Geist des Kapitalismus* (*The Protestant Ethic and the Spirit of Capitalism*) (1905) and the World War I-era texts that were later translated into the volume *Theory of Social and Economic Organization* (1947), the institutionalisation of the work ethic and the enforcement of administrative authority in the division of labour fundamentally contributed to collective disenchantment with modern life. Although for Weber the bureaucratic apparatus was not an inherently negative societal force, its adamant reliance upon abstract rules and a hierarchy of legitimatised authority tended toward dominance and depersonalisation.[8]

French industry had been aggressively transformed during World War I in order to accommodate the need for mass production, and artisanal craft manufacturing was quickly replaced by unskilled or semi-skilled labour and by mechanised production infrastructure imported from the United States.[9] A hyper-regulated work environment quickly took hold in France during and after World War I, with Frederick Winslow Taylor's time and motion studies subdividing workers' movements into controlled 'phasing' and Henry Ford's assembly

line ensuring surplus production and minimising fatigue.[10] As Jacques Rancière has explained, this mechanisation was not just a question of more work, but of working faster: 'Mechanisation was not reducible to the substitution of skilled handiwork by machines: it reorganized the worker's relationship to his labour by intervening in the performance of the labour process in the form of an absolute imperative of output.'[11]

In France, Fordist-Taylorist approaches to work science were also paired with theories of organisational management and bureaucracy from business engineers such as Henri Fayol, whose ideas about centralised, top-down workplace administration became widely known and applied as Fayolism.[12] Fayol's *L'Administration industrielle et générale* (*General and Industrial Management*) (1916) unabashedly extended the division of labour to the separation of superiors from workers, making it clear that the functions of control, command, and authority were essential for the efficient operation of the workplace to exact obedience and eliminate incompetency among personnel.[13] The efficiency of production depended upon the unification of directives and information in the scalar chain of management hierarchy: it was the bureaucracy's strategic consistency which supported the profusion of the worker's *esprit de corps*, the crucial social force that ensured loyalty to the enterprise. During the interwar years, French workers and labour-movement theorists mounted significant resistance to the deskilling, surveillance, and discipline that rationalisation entailed. However, scholars such as Gary Cross have also shown that Taylorism was crucial to the French labour movement's persuasive rhetoric on behalf of the reform movement for shorter work hours.[14]

Surrealism was born of a desire to subvert obedience to such authority and practical necessity through systematic nonconformism. Following the publication of Breton's *Manifesto*, the initial issue of surrealism's new journal *La Révolution surréaliste* in December 1924 prominently forwarded two possible 'solutions' to the dilemma of the modern human condition: (1) actively undermining the rationalist rule of waking existence in capitalism by replacing the 'trial of knowledge' with dreaming and surrealist automatism, for dreams make one 'indifferent' to the meaning of life, and (2) refusing complicity in a compromised life altogether by considering suicide as a viable solution to the problem of a demeaning reality.[15] Oneiric sleep was thus rendered a replacement for a wage-earning existence (in the *Manifesto*, Breton's example is the poet Saint-Pol-Roux, who hung a sign saying 'The poet is working' outside his bedroom door when he was sleeping). Self-inflicted death became an absolutist substitution for the endless toil of the conscription of waged labour. These extreme precepts of somnolent subterfuge, refusal of consciousness, and strike-by-death (suicide as strike) were accompanied by a selection of surrealist automatic texts from current members of the group that demonstrated how the practice of surrealist techniques could promote the interpenetration of dream and waking life.[16] Also included was an all-too-earnest questionnaire for readers about their opinion of suicide as a type of *acte gratuit* solution to the problem of subsistence in capitalism, paired with several examples of recent suicides taken from tabloids.

The second issue of *La Révolution surréaliste* bolstered this extremist discourse in its opening pages with yet another brazen proposal proffered in Breton's essay 'La Dernière grève' ('The Last Strike'), which was illustrated with an anonymous photograph of a gloomy factory window. In his essay, Breton claimed that artists, scholars, and what are today sometimes called knowledge workers should emulate anarchist and syndicalist stratagems by launching a year-long 'art strike' in which no new intellectual work would be produced or published. He urged this ban for artworkers in order to demonstrate solidarity with labour disputes and commitment to the 'principle of human freedom'.[17] He also meant to demand society's financial support of artistic and intellectual work and to force the removal of all censorship, intellectual persecution, and ideological servitude from the sphere of intellectual expression. Although Breton agreed that artists and scholars are 'hardly workers', especially in the eyes of 'our friends the true workers',[18] he nevertheless regretted the distance between manual and intellectual work that had developed in modern society. He urged the proletariat to abandon their devotion to the valorisation of the work ethic and finally take up arms against the employing class in a revolutionary overthrow. The ultimate point for Breton is not that the artist or writer desist altogether from creative and intellectual work in a neo-aristocratic celebration of dandified laziness or an anti-aesthetic disappearance of art into life. Rather, Breton argued that artists and scholars should remove themselves as completely as possible from the wage system, which limits and determines artistic production under the vicissitudes of contracted activity and the impositions of the market. The purpose of art, according to Breton, is not to barter transactionally for the exchange value of an artist's endeavours but to contribute to social transformation and the process of human emancipation. The surrealists' aim, therefore, is to become 'specialists in revolt' who 'employ' any means of 'action' to disrupt the social order, as a group statement from early 1925 declared.[19]

By the time the fourth issue of *La Révolution surréaliste* appeared in July 1925, Breton's 'Last Strike' essay had become the starting point of a durational strike for surrealism, in that the movement's resistance to wage labour persisted as a crucial rhetorical stance and life praxis for many adherents of international surrealism. The cover of *La Révolution surréaliste* 4 was blazoned with the words 'ET GUERRE AU TRAVAIL' ('And War on Work') that typographically framed a photograph taken by Man Ray of a mannequin wearing a Paul Poiret couture gown at the Exposition Internationale des Arts Décoratifs et Industriels Modernes in Paris (see Figure 0.1). As Ulrich Lehmann has explained, Man Ray had been hired by Poiret to undertake a fashion photo shoot at the Exposition Internationale that year, and soon one of the editors at *Vogue* asked permission to publish the photograph on the title page of its August 1925 issue.[20] The surrealists no doubt took delight in appropriating Man Ray's paid labour in the fashion industry for their own inflammatory purposes, transforming an image of elegance and art-deco design into a wooden caricature through the addition of their anti-bourgeois protest slogan. Paired with Man Ray's photograph, the surrealist 'war on work' resembles an absurdist gesture. Labour is abandoned

for luxury and *loisir* (leisure), and yet this conspicuous consumption is quickly revealed to be lifeless and empty – merely a mannequin wearing a designer dress in the midst of a sham publicity set. The meaning of life, the surrealists suggested, lies neither in work nor in the escape from work in the enjoyment of prosperity.

Elsewhere in *La Révolution surréaliste* 4, Louis Aragon's discussion of 'gross work', the 'undisputed god who reigns in the West', in the printed version of an agitational, anti-occidental lecture he delivered to students in Madrid in April 1925, reflects this general approach. Aragon, for whom the conceptual value of a radical liberty was of paramount importance during this early period of surrealism, likened wage labour to prostitution. He bitterly exclaimed:

> The man who has finally consented to work in order to assure his means of living, the man who has dared to sacrifice his outlook and all that remained in him of the divine to the childish desire to survive, should go down within himself and should recognise within himself that which is the true form of prostitution. Ah! Bankers, students, workers, functionaries, servants, you are the fellators of the useful, the wankers of need.[21]

According to Aragon, male wage workers are hustlers and laziness is the 'only homeland of true thought'.[22] A short report by surrealist poet Paul Éluard on the recent activities of the Philosophies group organised by Henri Lefebvre and others concludes this fourth issue of *La Révolution surréaliste*. Echoing Aragon's acrimony and critiquing the Philosophies group for its optimism about communism, the report denounces the 'repugnant and all too easy order of work' under the 'regime of capitalism' and calls for the incessant waging of a war on behalf of those 'who do not accept'.[23]

Surrealism's foundational stance of absolute nonconformism was activated as a political issue when the group formulated its first coordinated protest statement in support of the 1925 Rif Rebellion in the Rif region of Morocco. France had entered the colonial conflict on behalf of Spain to assist in the violent suppression of the rebellion of Berber tribes, an invasion the surrealists adamantly opposed. For the surrealists, the system of wage labour in capitalism was inherently linked to their anti-nationalism and condemnation of the imperialist subjugation of civilisations, and thus they rallied for the rewriting of humanist histories and the demise of Western dominance.[24] In Breton's 'Introduction to the Discourse on the Paucity of Reality' (1924) he condemned 'Latin civilization', saying that the West was 'the last rampart of bad faith, senility, and cowardice' and that between military dictatorships and the 'eight-hour day' there was nothing left to do but 'kick the ladder' and leave it all behind (*lâchez tout*).[25] In the contemporaneous surrealist tract, 'The Revolution First and Always!', the surrealists proclaimed:

> Wherever Western civilization reigns, all human attachment but that motivated by self-interest has ceased, 'money is the bottom line'. For over a century, human dignity has been reduced to the level of exchange value. It is already not only unjust but monstrous that those who do not own property should be subjected by those

who do, but when this oppression goes beyond the bounds of simple wage labor, and assumes the form of slavery inflicted on populations by international high finance, it becomes an iniquity for which no massacre could begin to atone. We do not accept the laws of economy or exchange, we do not accept the slavery of work, and on an even wider scale we proclaim ourselves in revolt against history.[26]

The surrealist rejection of wage labour was, as a form of ongoing dissent, an adamant non-acceptance of complicity in the capitalist-colonialist system that profited from the domination of the conquered or disciplined subject through the system of finance capital. This denunciation of exploitative and involuntary labour and the abstraction of value forms in capitalism was again voiced in the surrealist diatribe against the International Colonial Exposition in Paris in 1931. After formulating their Rif Rebellion protest, the surrealists attempted to reconcile their revolution of the mind with the Marxist call for a proletarian overthrow. Breton's attitude towards work, as expressed in the *Second Manifesto of Surrealism* (1929), combined a flat objection to wage labour with a professed commitment to the repudiation of his own bourgeois class designation. This was to be accomplished through manoeuvres of strike and subversion against cognitive labour or intellectual production. Breton also made clear his simultaneous position of solidarity with workers and the working class from a revolutionary Marxist point of view.[27] This complicated stance, which was by no means acceptable to the Parti communiste français (PCF) and its concern for the social responsibility of the artist, had been a consistent position in the movement since the surrealists attempted to collaborate with the leftist endeavours of the *Clarté* group from autumn 1925 onwards. Already that year, Breton had written in his review of Trotsky's biographical writings on Vladimir Lenin (1924) that although surrealism maintained what he called the 'legitimate' stance of the 'non-acceptance of work', he nevertheless found in the Communist Party the only promising means available for social transformation.[28]

Such assertions were re-emphasised in Breton's response to Pierre Naville's 1926 critique of surrealism.[29] To briefly summarise this already well-documented exchange, Naville's *La Révolution et les intellectuels: que peuvent faire les surréalistes?* (*The Revolution and the Intellectuals: What Can the Surrealists Do?*) confronts the movement's so-called idealism and insistence on artistic autonomy as a fatal flaw in what he saw as their opportunistic desire to join the PCF. Naville furthermore believed that intellectualising was useless in the face of the exploitative conditions of wage labour under capitalism.[30] Breton's reply in his *Légitime défense* (*Legitimate Defence*) of 1926 regarding this last point was trenchant:

In the realm of facts, as we see it, no ambiguity is possible: all of us seek to shift power from the hands of the bourgeoisie to those of the proletariat. Meanwhile, it is nonetheless necessary that the experiments of the inner life continue, and do so, of course, without external or even Marxist control. Surrealism, moreover, tends at its limit to posit these two states as one and the same, making short work of their so-called practical irreconcilability by every means.

Shortly afterwards, Breton continued:

> I am convinced, with the author of the pamphlet *The Revolution and the Intellectuals*, that 'wages are a material necessity which three-fourths of the world's population are constrained to live by …' but I cannot share his conclusion that 'the disputes of the intelligence are absolutely futile before this unity of condition'. I believe, on the contrary, that man must less than ever abandon his discriminative power … *wages* cannot pass for the efficient cause of the present state of affairs; that it would admit another cause for itself, in search of which intelligence, in particular our intelligence, is entitled to be applied.[31]

For Breton, wage labour was a symptom of capitalism rather than the cause of it. Therefore, the surrealist non-acceptance of the discipline of waged employment was one crucial component of their class betrayal and their call for the social irresponsibility of the artist. Their diatribe against society was not limited to a materialist enquiry, although it depended on historical materialism. The consistency of this distinctive point of view in Breton's thinking – and in the general spectrum of surrealism's history both before surrealist membership in the PCF was established and after it was abandoned – is astonishing. For the surrealists, the revolution to abolish capitalism and its oppression of the proletariat through the system of life-long wage labour would be realised through a fusion of insurrectionary materialist and experimental intellectual and artistic schemas.

'One can understand why surrealism was not afraid to make for itself a tenet of total revolt, complete insubordination, of *sabotage according to rule*, and why it still expects nothing save from violence', Breton wrote in the opening pages of the *Second Manifesto*.[32] Such a fusion of emancipatory art and cultural sabotage entailed a rejection, to the fullest degree that was feasibly possible for subsistence in a capitalist sphere, of the system of wage labour in a protest of *permanent strike*. This permanent strike, a form of non-action as action, or the attempt whenever possible at maintaining ongoing non-employment or purposeful job precariousness, was accompanied by continual experiments that battled the effects of the regulated work regime upon psychic and quotidian life.

Breton's poetic-documentary account *Nadja* (1928) offers the most complete statement of his personal theory of work refusal. There, Breton detailed his relationship with a destitute woman, Léona Delcourt (Nadja), and while doing so decried the trap of wage labour and the proletariat's passive submission to its demands. As Raymond Spiteri has clarified in an essay about the role of the political in *Nadja*, Breton's text also provides an account of his process of joining the PCF, which began in 1925 and resulted in his Party membership in 1927.[33] Yet, it is the unhinged nature of Delcourt's vagrancy that inspired Breton's most politicised thoughts about the nature of wage labour in relation to the meaning of life. Delcourt, who renames herself Nadja, deals with the onset of schizophrenia and turns to occasional prostitution after she fails to find steady work and falls victim to sexual harassment by an employer, among other trials. Another woman featured in *Nadja* is the Moldovan Jew Fanny Beznos, whose poem about workers

was published in *La Révolution surréaliste* 9–10 in autumn 1927 and included lines such as 'And the woman? You / want to interrupt, laughing! The woman / within the home / always busy, not a slave / altogether, but … / the woman? Half of a free being. / Bad Man!'[34] Beznos was a cultivated flea-market *vendeuse* (saleswoman), communist activist and poet, and former *dactylo* (typist) whom Breton befriended over a conversation about Rimbaud.[35] Both these women Breton wrote about in *Nadja* struggled to survive, meeting early deaths during World War II – Beznos as a victim of the Nazi Holocaust and Delcourt as an incarcerated psychiatric patient living under the Vichy government.

Breton's ultimate concern was how the lives of these precariously working women, precisely because of their tentative means and peripatetic trajectories as members of a gendered underclass, symbolise a spark of liberatory promise beyond the banal satisfaction of materialistic necessity. Breton denied the moral value of paid work, even while he called for labour reform.[36] Nadja's appearance in Breton's life, he wrote, is justified by the fact that neither of them were working when they met nor were they seeking to find meaning in their lives through work.[37]

Another concern voiced in certain moments of the text is the general condition of the proletariat and how the means to unfettering (*désenchaînement*) their submission and servitude can be awakened.[38] Breton clarified in *Nadja* that it is not the endured work of the worker that should be celebrated but rather the worker's wresting free from the chains of labour and resignation. Breton told Nadja:

> People cannot be interesting insofar as they endure their work, with or without all their other troubles. How can that raise them up if the spirit of revolt is not uppermost within them? … How I loathe the servitude people try to hold up to me as being so valuable. I pity the man who is condemned to it, who cannot generally escape it, but it is not the burden of his labour that disposes me in his favor, it is – it can only be – the vigor of his protest against it. I know that at a factory furnace, or in front of one of those inexorable machines which all day long, at a few seconds' interval, impose the repetition of the same gesture, or anywhere else, under the least acceptable orders, in a cell or before a firing squad, one can still feel free: but it is not the martyrdom one undergoes which creates this freedom. It is, I mean, a perpetual unfettering: yet for this unfettering to be possible, constantly possible, the fetters must not crush us, as they do so many of those you mention. But it is also, and perhaps, in human terms, much more, the relatively long but marvelous series of steps which man may make unfettered. Do you suppose these people capable of taking such steps? Have they even the time for them?[39]

For Breton, the possibility of an unending horizon of liberation for humanity starts with immediate actions towards emancipation in the present. This includes not just the unseating of the dominant work ethic in the understanding of self-worth but also daily resistance to the repetitive work routine and the rote nature of standardised labour. The mass desertion of jobs in a super-strike that would destroy capitalism's systems cannot be achieved until the proletariat collectively abandons the immediate value and necessity of work, according to Breton. In

this regard, acts of public resistance such as the 1927 summer protests against the execution of the American anarchists Sacco and Vanzetti, in which some of the surrealists participated, were not indicative of the failure of past and present revolutionary acts but rather symbols of ongoing resistance.

It is thus not surprising that in the *Second Manifesto* of 1929, Breton felt the need to spend nearly as much time explaining this surrealist position to the PCF as he did formulating rebuttals against surrealism's critics. He clarified once again at the conclusion of the 1920s that surrealism counted 'only upon the proletarian revolution for the liberation of mankind' and gave 'completely, without any reservations' its 'allegiance to the principle of historical materialism'.[40] Nevertheless, he asserted that his exegesis on surrealism in the manifesto is primarily meant for 'pure young people who refuse to knuckle down' in the (*lycées*, even in the workshops, in the street, the seminaries and military barracks ... It is to them and them alone that I am trying to defend surrealism against the accusation that it is, after all, no more than an intellectual pastime like any other.' Surrealism aims to reach all insurrectionary youth, both working-class and bourgeois, who are willing to revolt against the authority of capitalism. Breton was careful to add in the footnote that accompanies these reflections that, as a result of surrealism's ultimate goal of emancipation, it 'refrains from deflecting ... that part of the youth which *drudges* while the other, more or less cynical, part watches it drudge'. In addition to insurrectionary youth from all classes, surrealism would not reject outright diligent members of the youth who have not yet arrived at an ethos of rebellion: 'Our fondest desire is to keep within the reach of these people a nucleus of ideas which we ourselves found astounding.' This is so because surrealism is well aware of its own status as a bourgeois intellectual group; they must continually commit treason against their class status while simultaneously empowering the proletariat and the youth. Breton stated that the surrealists seek the 'total elimination of the claims of a class to which we belong in spite of ourselves and which we cannot help abolish outside ourselves as long as we have not succeeded in abolishing them within ourselves'. Their ideological solution is to engage in systematic class treason through a range of means, including the rejection of careerism, ambition, and professional employment; the creation of subversive artworks; and, whenever possible, survival only through means of intermittent, independent profit. Additionally, Breton confirmed the crucial importance of the proletarian struggle when he stated that 'it is up to us to move, as slowly as necessary, without any sudden fits or starts, towards the worker's way of thinking'.[41]

The class stratification and division of labour that surrealism sought to undermine nevertheless remained a daunting impasse for the movement to negotiate in its interactions with the PCF. Breton confessed in the *Second Manifesto* that he could not compel himself to fulfil the task of writing a factual, statistical report requested by the PCF gas workers' cell. Following the theories of Leon Trotsky, he was also unable to imagine the possibility of a thriving proletarian art or literature in advance of the revolution.[42] In an answer to a newspaper enquiry on the relation of *travail intellectuel* (intellectual work) to capital in 1930, he asserted that

the establishment of unions or professional associations for knowledge workers was impossible in advance of the revolution because the use and exchange value of intellectual labour was not comparable to 'the common measure of an hour of work'. The labour theory of value that equated economic value with the process of labour itself did not apply to works of art, and this hinted at the possibility of a future obsolescence of art and the artist in society. Despite this conclusion, Breton professed that knowledge workers who produce 'social use values' rather than saleable commodities suffered under the same conditions as the proletariat, the 'crushing debt' owed by capitalism's exploitation. Intellectuals should therefore join the 'admirable cause of the proletariat' in the push for a revolution against capital.[43] As a result of these viewpoints, alliances were eventually formed and limited collaborations initiated with proletarian writers and their advocates, such as Maurice Wullens and his literary journal *Les Humbles*, Henry Poulaille, and Marcel Martinet.[44]

As an intransigent form of protest demand, the surrealist work refusal gave the Paris group few liveable options in a society in which those who are not independently wealthy must either work to survive or resort to criminal means. This uncompromising ethos, as a core precept of surrealism, was however never retracted by Breton. Such avoidance of duty and shirking of expectations remained persistent, notwithstanding occasional accusations, both personal and general, of hypocrisy, false radicalism, political evasion, and profiteering from a range of critics both intimate and removed. The manner in which the group ethos of austerity played out in the lives of surrealists remained unresolved. As several scholars and critics of surrealism have noted, the fact that surrealists did ultimately have to earn money to survive (typically via part-time or contingent white-collar jobs) and often sold works of art as commodities can be perceived as an egregious contradiction.[45] Although many of the surrealists came from privileged backgrounds and pursued advanced educations, most of them, including Breton, needed to work for a living and could not in reality afford to subsist under the premise of a permanent, lifelong strike against wage earning.

Certain surrealists were attacked by their comrades for lucrative activities, while other infractions of the kind were perplexingly tolerated. André Breton – who, like his surrealist friends Louis Aragon and Jacques-André Boiffard, abandoned his training for a professional career (in medicine) – maintained a job as an assistant to the wealthy collector Jacques Doucet during the 1920s. He was also involved in commercial gallery and artwork sales at this time, as he was for most of the interwar period.[46] Meanwhile, advertisements for surrealist books (including luxury and limited editions), gala events, and spectacular exhibitions were placed in the back matter of surrealist magazines, while wealthy benefactors funded projects, sometimes forestalling employment. Surrealist galleries came and went, works of art were bought and sold at auction to augment private collections and artists' pay cheques, or simply to pay the rent, and – unavoidably – various forms of precarious and even full-time employment were procured. And, as the well-known story goes, while mercenary collaborations with major corporations or

institutions were condemned, significant financial success and popular acclaim ultimately beset the surrealist movement despite itself.

Given these complexities, the surrealist work refusal is best understood as a core precept of the movement that developed on a long-term basis rather than as a set of biographical facts. During the interwar period, the surrealists' views on wage labour were profoundly shaped by their extended study of Hegelian dialectics as transformed within Marxist materialism, their adherence to Bolshevik-Leninist concepts of working-class self-emancipation, and their admiration for Trotsky's theory of permanent revolution. At the same time, surrealism also retained much of its interest in and affinity for anarchist autonomy and anti-statism, which it had previously found in the works of writers such as Max Stirner and Pierre-Joseph Proudhon. Surrealism's anti-work stance was, in fact, one of the main reservations that the PCF held regarding the movement's attempt at adherence to the Third International, along with the surrealist interest in what was considered deviant sexuality. Despite this fundamental antinomy with Moscow, the surrealists insisted that their war on work, which eventually shifted its locus over time, could be understood as a revolutionary tactic for the present moment meant to resist capitalism, politically organise radical intellectuals, and contribute to the cause of a proletarian overthrow.[47] This is what ex-surrealist Antonin Artaud railed at in his 1927 critique of surrealism when he wrote, 'Did surrealism, in order to survive, need to take the form of a material revolt, to identify itself with various demands concerning the eight-hour day or the readjustment of wages or the struggle against the high cost of living?'[48]

By 1934–35 it became clear to the surrealists that collaboration with Stalin's Comintern would never be possible or desirable and that communism's move into authoritarianism now echoed in certain regards the rise of fascism. The surrealists' long-time interest in Trotskyist concepts of working-class self-emancipation and workers' control roused them to action. This resulted in the short-lived International Federation of Independent Revolutionary Art (FIARI) in 1938, organised by Breton and Trotsky in Mexico. Surrealism's investment in collectivism and theories of worker self-management (*autogestion*), seen in combination with its condemnation of Stalinist and fascist tyranny during the second half of the 1930s, resonates with a libertarian-socialist or an anarcho-communist orientation.[49] Although the start of World War II and the assassination of Trotsky brought the artistic-syndicalist endeavour of FIARI to its rapid demise, the surrealist war on work, as a counterpart of the broader surrealist liberatory agenda, continued its struggle for the remainder of the twentieth century. If the surrealists' desire for an immediate proletarian revolution was suspended following Trotsky's assassination, Stalin's seizure of the Communist Party, and World War II, surrealist support of the ongoing workers' struggle was strengthened, as the tract 'Inaugural Rupture' of 1947 made clear.[50] This important document stated that the surrealist solidarity with the workers' movement was, in the wake of the mid-1930s break with communism, now allied with an anarchist orientation which in the future would commence with a proletarian overthrow and then

proceed beyond economic liberation from capitalism to more complete stages of materialist and metaphysical renewal.

The urgency of the surrealist work refusal increased during the 1960s and 1970s in France and the United States. This later stage of the surrealist work critique focused on Charles Fourier's utopian socialism and Herbert Marcuse's critical theory even while the surrealist attraction to anarcho-communist concepts of mutual aid, collectivism, cooperative behaviour, and a stateless society persisted. All of these concerns witnessed further development with Chicago surrealism and its investment in direct-action militancy, as tied to their alignment with the Industrial Workers of the World union (IWW; founded in Chicago in 1905) and Vietnam-era New Left oppositional culture, as I discuss in Chapter 4.

'Down with work!': André Thirion and other surrealists on work refusal

> And that's why we say *shit* to those who would be ashamed to be the bad workers under this regime, *shit* to those who despise the temporarily unemployed … *shit* for them and all the counter-revolutionaries and their miserable idol, WORK.
>
> – André Thirion, 'À Bas le travail', in "Le Surréalisme en 1929", ed. André Breton and Louis Aragon, special issue, *Variétés* (June 1929): 46[51]

During French surrealism's communist period in the early 1930s, a number of leftist intellectuals who were also surrealists contributed to the continued development of the movement's work refusal, attacks which also sometimes functioned as criticisms of the PCF. Marcel Fourrier, one of the editors of the leftist journal *Clarté* during the 1920s and Breton's frequent interlocutor, added his voice to surrealist views on labour with essays published in *La Révolution surréaliste*. 'Imputing Opportunism' of 1926 discussed the general strike led by English miners in May that year, and 'Hands Up, Police!' of 1929 focused on the subject of self-emancipation and self-governing of workers in opposition to the authoritarianism of the police force.[52] Another key surrealist collaborator was the communist activist and writer André Thirion. Together with his friend Georges Sadoul, Thirion initiated acquaintance with the surrealists in 1925, becoming more active in the group towards the end of that decade and into the next following his habitation during the late 1920s with the Rue du Château group of Jacques Prévert, Yves Tanguy, and Marcel Duhamel.[53] Given Thirion's experience as a long-time ally of the proletariat, and his close involvement with surrealism's negotiations with the PCF, his writings constitute a major contribution to the theory and practice of surrealist work abolitionism.

Thirion's most important commentary on surrealist work refusal was the essay 'Down with Work!', which appeared in a special issue of the Belgian journal *Variétés*, edited by Breton and Aragon and published in Brussels during the summer of 1929.[54] Thirion, who was a militant member of the PCF from

1925 to 1934 and then a Trotskyist member of the Socialist Section française de l'Internationale ouvrière (SFIO) from 1934, began his essay by squarely critiquing communist writers.[55] Thirion accused Party journalists of revelling in hyperbolic praise of the virtue of work and the nobility of workers. For Thirion, these writers emulated naturalist writers of the nineteenth and twentieth centuries in their descriptions of the physical act of labour, while having no real understanding of the actual nature of proletarian reality on the Fordist production line. Although, according to Thirion, communist authors praised the USSR and lionised the contributions of Taylorist rationalisation with their constant apologies for work, he countered that neither the Bolshevik reclaiming of work nor time-saving scientific management are enough to uproot the cultural baggage attached to the cult of the work ethic. Even reductions in the length of the workday are not sufficiently reformist. The supposed moral value of a life of labour, Thirion argued, is an ideology of false consciousness crafted by the ruling classes of Western Europe to guarantee their privilege following the demise of widespread chattel slavery. 'This has no other purpose than to discredit all *unproductive* activity undertaken by those who are exploited', Thirion explained. Deploying the social control of religion and a paternalistic system of small incentives and rewards, bosses and *dirigeants* (directors) secure diligent servants for the most repugnant, 'stupid', filthy, exhausting tasks, which are reduced to infinite repetition due to specialisation and the division of labour.[56]

Manual workers barely have time to live, according to Thirion. The day labourer building a road blindly continues working with his *brouette* (wheelbarrow) and *pelle* (shovel) so that he can buy refreshment and find some distraction from the taskmaster at the end of the day. In his essay, Thirion attested that even as a communist revolutionary adhering to Marx's dictum that work is a necessary part of survival, he understood wage-based society to be fundamentally immoral and underlined the need to safeguard '*our imprescriptible right not to work*'.[57] Concluding that humankind's daily toil itself assures the steady process of technological development, by which machines will eventually reduce most of the need for a human conscription to employment, Thirion nevertheless warned that life will never be fully free of necessary servitude. Maligning the ubiquity of workerist mentalities of all stripes, Thirion's techno-optimism, largely exceptional as it was within surrealism, argued that advancements in industry should be fostered at all costs in order to spare as much bloodshed as possible in future class conflict and warfare. Although this conclusion parallels Paul Lafargue's projections in *Le Droit à la paresse* (*The Right to Be Lazy*) (1883) that the surest path out of the stronghold of work is technological acceleration, Thirion later claimed that he had not yet read this text when he wrote 'Down with Work!'[58]

A few months after 'Down with Work!' appeared in the surrealist special issue of *Variétés*, Thirion's 'Note sur l'argent' ('Notes on Money') was published in the twelfth and final issue of *La Révolution surréaliste*. Building on the denunciation of foundational societal systems launched in his previous essay on labour, Thirion's subsequent diatribe focuses on the subject of exchange and surplus value in capitalism to

argue that the universal equivalent of money is not merely an effect of this system but rather a primary agent of exploitation. The compulsory act of earning money by trading one's abstracted labour as a commodity and achieving accumulated wealth for the capitalist class is tantamount to collusion in the bourgeois domination of the proletariat: 'Not content with reducing almost all human beings to work, it [the capitalist class] steals from workers the ridiculous value it attributes to this work, enriching itself in the act and leaving its workers only the promise of recommencing their exhausting labours the following day.'[59] The unavoidable obligation of work also meant a mandatory participation in the tainted systems of production and consumption via currency and the dead labour of the commodity.

Sweeping critical views such as these, which condemned modern society as a whole, enabled Thirion's alliance with surrealism's strain of anti-capitalist unrest, despite his largely orthodox Third International views at this time. Soon afterwards, surrealism sought to activate Thirion's critique of money and work in a revitalisation of the role of the artist and the artwork in modern society. In 1930, after the publication of these essays, Thirion assisted Breton in the conceptualisation of a trade union for artists, writers, and scientists from the radical left – an idea that helped pave the way for the PCF organisation AEAR (Association des Écrivains et Artistes Révolutionnaires; Association of Revolutionary Artists and Writers), to which I briefly return in Chapter 3. The manifesto that Thirion and Breton wrote in support of their original idea deplored the economic vulnerability of the artist and rallied to the proletarian cause:

> The artist, who by definition cannot submit today to the ideology of the ruling class, is barely tolerated by that class, and his means of survival in the capitalist regime are the most precarious … But in this transitional period, the proletariat cannot be reckoned as a buyer. Unless he organizes, the artist has no chance whatsoever of improving his economic situation, a situation as bad as, if not worse than, the proletariat's. His only means of safeguarding the independence of his work is to struggle side by side with the exploited workers against capitalist society.[60]

Along with the acerbic socio-political critiques of remunerated work voiced by Breton, Fourrier, Thirion, and others in the pages of French surrealist journals and tracts between the mid-1920s and the 1930s, humour and satire were also frequently deployed by surrealist writers in relation to the issues of proletarian literature and culture, problems of unemployment and wage labour, and the cultural approbation of the submission to duty. Humour was a way of lambasting not only the extremist rhetoric of the French Right but also what the surrealists thought were the all-too-evident limitations of the Left. Consider the trenchant anti-capitalist and anti-nationalist essays by Georges Sadoul on subjects such as the relationship between sports and unemployment that were published in *Le Surréalisme au service de la révolution* (*LSASDLR*; *Surrealism in the Service of the Revolution*) during the early 1930s. Sadoul's short piece in *LSASDLR* 3 in 1931, 'The Problem of Unemployment Solved in a Half an Hour', feigns a conservative tone to vilify France's reliance on cheap immigrant labour to fill its most

dangerous and disagreeable professions. The essay also berates France for its use of patriarchal rhetoric to pressure the female workforce to retire to the private sphere to do the supposedly unproductive work of uncompensated reproductive labour, such as housework and care-giving, thus providing men with more jobs.[61] In the 1930s, France's labour shortage shifted and unemployment rates began to rise. France had no mature relief system in place until the 1950s, and thus protests and strikes by jobless citizens increased between 1931 and the start of World War II.[62] Sadoul's farce ironically recommends that France send its vast numbers of unemployed, manual labourers and *sténodactylos* (secretaries) alike to the colonies, so as to rid itself of the dilemma of welfare. He concluded with sarcasm that France should start a new war to provide an income for all, or, 'Another solution might be better. Millions of women work … Back to the home, women! The workshop depraves you and debases you, whereas God intended you for noble tasks, namely: peeling carrots, emptying chamber pots, and taking care of the kids. So go home, serpentess, let the man work and live on his salary. It does not matter if this salary does not feed you, make children in any case; France needs it.'[63]

Influences on the surrealist work refusal

The surrealists' decades-long attack on compulsory wage labour and the idolisation of work originated in their absorption of French and German discourses and histories of proletarian unrest and revolution, anti-capitalism, ethical social reform, and utopianism from writers such as Henri de Saint-Simon, Charles Fourier, Pierre-Joseph Proudhon, Karl Marx, Friedrich Engels, and Paul Lafargue. The ideological foundation for such a refusal is therefore to some degree culturally diffuse. Factors such as the development of anarchist and socialist political theories and their political outcomes, the *mouvement ouvrier* and trade unions in France, and the myriad protest strategies that resulted from the ongoing struggle for fair and humane working conditions and compensation – all contribute to the background of surrealism's war on work.

Given the sheer breadth of surrealism's anti-work intertexts, it is tempting to excavate these genealogies in relation to a larger international bibliography of work abolitionisms, paeans to idleness and sloth, or post-work projections dating from the eighteenth to the early twentieth centuries. However, straying too far from surrealism's professed sources poses more of a hermeneutic problem than it does a solution. There is a substantial tradition of English-language texts about indolence as undisciplined work refusal, for instance, in which pre-World War II French surrealism was not evidently deeply invested: Samuel Johnson's series of essays entitled *The Idler* (1758–61), Robert Louis Stevenson's essay 'An Apology for Idlers' (1877), Edward Bellamy's utopian science fiction novel *Looking Backward: 2000–1887* (1888), and Bertrand Russell's *In Praise of Idleness and other Essays* (1935), among several other examples. William Morris's utopian vision of a future society in which alienated labour and commerce have been

abolished, *News from Nowhere* (1890), garnered somewhat more notice in the movement given that the Belgian surrealist E. L. T. Mesens titled his 1944 collection *Message from Nowhere/Message de nulle part* after this text. However, even more proximate sources such as Eugène Marsan's 1926 essay 'Éloge de la paresse' ('In Praise of Laziness') were only a peripheral concern for surrealism.[64]

Beyond the question of explicit references, we must consider surrealism's complex, agonistic self-positioning within histories of the avant-garde. Surrealism retained much of the critical social agenda of certain aspects of nineteenth-century French realism, but it discarded realism's sometime embrace of the mythology of the noble labourer – just as it preserved the symbolist movement's refusal of capitalism even while it sought to integrate that refusal back into a socio-politically engaged art practice and lifestyle. These mutual forces of synergy and separation with nineteenth-century avant-garde predecessors were replicated in surrealism's rapport with contemporaneous movements. Futurism's nationalist techno-optimism was nullified in surrealism, while F. T. Marinetti's destructive relationship to the machine was pursued to a significant degree. Constructivism's productivist transformation of the artist into worker was denied, although surrealism itself attempted to operate under the Communist Party for a number of years (Malevich's early 1920s homage to laziness is another, unrelated story). Finally, the dada disdain for work was augmented in surrealism, as we will see in Chapter 2, although Paris dada's generally apolitical orientation was abandoned. Certainly, other aesthetic movements, such as purism, with its sympathy for a functionalist machine aesthetic, can also be discussed in this context.

Between the late 1950s and the early 1970s, the Situationist International (SI) voiced a comparable protest against the system of wage labour, although the SI's conflicted indebtedness to surrealism tempers this commonality.[65] The situationist critique of surrealism occurred just in advance of the development of *opera-ismo* (workerist) autonomist Marxist thought in Italy, in texts from the 1960s and 1970s by Mario Tronti, Antonio Negri, and other radical writers.[66] Partly in response to autonomist discourses about work refusal as a mode of constructive social transformation, an enormous amount of critical literature has emerged in the twenty-first century addressing the restructuring of work systems and ontologies in post-Fordist and neoliberal economies.[67] As Kathi Weeks has asserted, for instance, rather than just amounting to a negation or renegotiation of work terms, work refusal today can be understood as 'both a practical demand and a theoretical perspective', a creative practice of imagining and invention that 'challenges the mode of life now defined by and subordinated by work'.[68] Despite the urgency of such contemporary issues, surrealist work refusal remains obscure in this recent literature, as does the unique nature of the movement's work-refusal genealogy.

While the topic of work refusal has not been widely discussed in relation to surrealism, it has been explored in relation to an artist often associated with this movement, Marcel Duchamp. Some scholars who are influenced by Marxist and autonomist discourses about the various kinds of labour entailed in art

production have proclaimed that Duchamp's life and work must be seen as one of the most important examples of work refusal or artistic critique of productive labour in the twentieth century. As tied to his study of immaterial labour in contemporary neoliberal societies seeking total control of populations as human capital, Maurizio Lazzarato has expanded upon the research of Duchamp scholars such as Bernard Marcadé and Helen Molesworth to build the case that Duchamp 'encourages us to conceive of and exercise a "refusal of work" which constitutes an ethical-political principle that goes beyond work, which frees us from the enchanted circle of production, productivity and producers'.[69] For Lazzarato, Duchamp's lifelong espousal of laziness is tantamount to direct action at the point of production via strike, in that his symbolic renunciation of action and optimal output is 'a *non-movement*, a radical *désœuvrement*, an unworking or inaction, and a suspension of production of the factory's division of labor'.[70] Positioning Duchamp's aestheticised work refusal as both a 'socio-economic critique' and a philosophical category, Lazzarato has clarified that the artist's concerted 'demobilisation' is close to Jacques Rancière's concept of aesthetic idleness or inaction. Such aesthetic inaction stems from an early nineteenth-century European genealogy of deskilled art pursuing the anti-authoritarian practice of relinquishing mastery. Duchamp's laziness, therefore, is not a revival of classical *otium* (leisure) or even a subversion of the humanist concept of the domination of nature by *Homo faber*.[71] Nor does it resonate with Giorgio Agamben's discussion in his *Homo Sacer* series of the 'inoperative' as a fundamental ontological quality of human nature as a functionless state of being and potential, according to Lazzarato.[72] Instead, Duchamp's stance is both politically and ethically radical; it is an explicit critique of 'slavery's democratisation through waged labor'. 'He invites us to develop and experiment with all the possibilities that "lazy action" creates in order to carry out a reconversion of subjectivity, to invent new techniques of existence and new ways of living time', Lazzarato has claimed.[73]

Marcel Duchamp's example as an *artiste désœuvré* (idle artist; or literally, unworked artist) was a focal point in the development of surrealism's work refusal, but his precedent must also be understood as just one key element in a panorama of references and precursors. Breton inherited a dadaist strain of combative rhetoric against obedient work, service, functionalism, and productivity following his service in World War I, and together with his friends, he gradually developed this theme into a more precise protest against necessary wage servitude in surrealism. Already in 1920, Breton would state in the prose piece published in *Littérature* 13, 'Dada Geography', that 'DADA does not give itself to anything, neither to love, nor to work.'[74] Before the arrival of dada, Breton was pivotally influenced by the ethos of aesthetic indifference espoused by Jacques Vaché and had nurtured a fascination with anarchism and criminal revolt since he was a teenager.[75] Breton's affinities for anarchist individualism and aesthetic *paresse* were augmented by the Paris dada homage to indolence and anti-utilitarianism in texts, artworks, actions, and performances.[76] Works such as the erotic poem by Clément Pansaers, *L'Apologie de la paresse* (*Apology for Laziness*), published

shortly before the Belgian author's death in Paris at an early age, were influential.[77] Breton's acquaintance with Duchamp from the early 1920s onwards furthered this attraction.[78]

However, more than the simultaneous critique of and fascination with *oisiveté* (idleness), ennui, and monotony that Breton found in dada – all of which are primary effects of alienation – Breton's acute attention from his teenage years to certain *fin-de-siècle* aesthetic legacies were the forces that proved most pivotal for the early development of the surrealist work refusal – an oppositional stance that sought to deracinate the core *cause* of such alienation. Revolutionary romanticism, symbolism, the Mallarméan concepts of autonomy and nothingness (*néant*), and most of all the work and life of the poet Arthur Rimbaud took on symbolic significance for Breton and many surrealists thereafter. Between the 1920s and the 1960s, a series of surrealist statements referred to Rimbaud's abhorrence of employment and *métier* (recall that Rimbaud's anti-work statements later gained further prominence during the general strikes and university occupations of May 1968).[79] Rimbaud's sentiments could be traced in a number of pieces, such as the 1871 poem 'Qu'est-ce pour nous, mon coeur' ('What Do We Care, My Heart') ('And never will we work, O waves of fire!') and a letter about the visionary role of the poet to Georges Izambard from May of that year ('Work, now? Never, never. I am on strike'). These sentiments are also palpable in 'Mauvais sang' ('Bad Blood') ('I have a horror of all trades and crafts') and the 'Délire I' ('First Delirium') in *Une Saison en enfer* (*A Season in Hell*) of 1873 ('"I will *never* do any work …"').[80]

Perhaps most prominent of the surrealist tributes to Rimbaud's work refusal is the entry for 'travail' in the *Dictionnaire abrégé du surréalisme* (1938), which quotes Rimbaud's aforementioned 1871 letter to Izambard. The 'travail' entry also mentions the most celebrated of nineteenth-century French anti-work texts, the quasi-farcical pamphlet *Le Droit à la paresse* (1883) by Paul Lafargue, which was expanded from a previously published 1879 newspaper article while Lafargue was in prison on a charge of inciting violence.[81] The *Dictionnaire abrégé du surréalisme* highlights how Rimbaud's work refusal was inherently linked to his desire to transform the role of the poet into that of the seer and his eventual abandonment of poetry altogether. On the eve of World War II, Rimbaud's principled refusal was connected to the 'disalienation' project of poetry and remained a catchphrase for the surrealists: 'Work now, never never; I am on strike … I want to be a poet, and I work in order to become a *seer*.'[82] The poet's strike against wage labour is part of the struggle to activate poetry's transformative power as an oppositional strategy for social change.

In an essay that links Rimbaud's work refusal to his celebration of subaltern, adolescent, or non-European *vagabondage* (wandering) and Lafargue's roughly contemporaneous text, Kristin Ross wrote that the poet's 'strategy of resistance, even flight – from *métier* … should in no way be confused with a quasi-Mallarméan denegation of the social, that canonical avant-garde doctrine according to which self-realisation can only be attained outside the functioning of the social. Rimbaud's

flight is at all times a profoundly social investment; it opens at every step out onto a sociohistorical field.'[83] Following the strategic position proposed by their elected precursor, Rimbaud, the surrealists advocated neither the absolute leisure of the bourgeoisie nor the sequestered retreat of hermetic modernists but rather what Ross called in her analysis a 'third term outside of the programmed dyad of labour and leisure'.[84] On this subject, Donald LaCoss's observation that the surrealists emulated bohemian predecessors like Charles Baudelaire and Rimbaud in their projection of 'revolutionary energies onto the experience of the *lumpenproletariat* rather than workers' is telling. LaCoss pointed out that in the 1930s the surrealist interest in 'streetwalkers, criminals, the unemployed, homeless war veterans, rag-pickers, flea-marketeers, and drug addicts' would have stood in sharp contrast to the Stakhanovite workers in Stalin's Soviet Union, who competed with one another to achieve the maximum amount of labour possible.[85]

Both Rimbaud and Lafargue remained important predecessors in surrealism's work-refusal discourse for the remainder of the twentieth century, and Lafargue assumed acute symbolic significance for the Chicago surrealists. References to the 'right to be lazy' and Lafargue's infamous late nineteenth-century manifesto of work abolitionism began to appear in surrealist texts in the early 1930s, when the movement was at the height of its engagement with Marxism. It is also possible that surrealists knew about Lafargue before this time, since *Le Droit à la paresse* became a lifelong influence on Marcel Duchamp from 1912–13, as Bernard Marcadé has shown.[86]

Although many future surrealists supported the Marxist call for the end of capitalism and thus wage labour during World War I, it is unlikely that they were aware of those aspects of early Marxist materialism that contemplate the possibilities for and advantages of a post-wage labour society – for instance, *Die deutsche Ideologie* (*The German Ideology*) by Marx and Friedrich Engels, written in the mid-1840s but not published until the early 1930s and not translated into French until the late 1930s. Among other concerns in *Die deutsche Ideologie*, Marx and Engels juxtaposed the concepts of private property and communism, contrasting a society based on ownership and self-interest with a communist system of non-specialised labour, shared wealth, and common interest. As opposed to the capitalist society, which augments the foundational 'latent slavery' of women and children in the patriarchal family unit through the division of labour and social stratification, the future communist society will, for Marx and Engels, allow for variation and volition to become characteristic of future work: 'society regulates the general production and thus makes it possible for me to do one thing today and another tomorrow, to hunt in the morning, fish in the afternoon, rear cattle in the evening, criticise after dinner'.[87]

Marx voiced numerous criticisms of the demeaning nature of overwork and rote production and tied the achievement of freedom to the reduction of hours, despite his valorisation of work as a quintessentially human activity.[88] Furthermore, Marx's *Grundrisse* had provided for the *operaismo* autonomists a platform for reinterpreting materialist history as one in which workers are

antagonists to capital rather than its passive victims.[89] Given the obscurity of the *Grundrisse* for the surrealists during the 1920s, their discovery of Lafargue's exaggerated rhetoric in *Le Droit à la paresse* some time before the mid-1930s must therefore have provided a useful bridge between their own anti-work orientation and historical Marxism at a time when such connections were sorely needed in their contested exchange with the PCF. A communard in the 1871 coup d'état, the son-in-law of Karl Marx, and a co-founder of the Parti ouvrier français with Jules Guesde, Lafargue possessed a uniquely internationalist outlook in his approach to socialism.[90] Lafargue's orthodox adherence to Marx's concept of class struggle was a result of his economic determinism, and yet such an outlook did not hinder his support of syndicalism towards the end of his life. He was perfectly positioned, as Kristin Ross has shown in her comparison of Lafargue's and Rimbaud's anti-work rhetoric, to create a 'parodic refutation' of the demand that helped ignite the 1848 revolution in France, what writer and theoretician Louis Blanc referred to as 'le droit au travail' (the right to work).[91] Ross has revealed that both Rimbaud and Lafargue wanted to construct alternative histories to the cultural construction of the *travailleur* (worker) that had developed in France since the 1789 revolution. This had shifted from a right-wing discourse of the 'good worker' to a left-wing ideology of workerism following the Paris Commune in 1871.[92] The result was a novel refutation of the milieu of bourgeois use-value and a reversal of class tendencies. Lafargue reassigned the ideological imperative of productivism to the *patronat* class of bosses who project their demand for overproduction onto the deskilled, beleaguered labour force. If technology is harnessed for increased efficiency and the reduction of work hours, Lafargue claimed, rather than its capitalist use as another means of labour-saving and cost-cutting in surplus production or for technocratic hegemony, workers could regain control of their own lives.[93] The 'vice' and 'dogma' of overwork rampant among the proletariat should be outlawed, just as the relentless acceleration of capital must be resisted. According to Lafargue, the leisure class of capitalist supervisors must be made to work their share, and this distributed sphere of work needs to be limited to a maximum of five or six hours a day, although his jocose pamphlet advocated for as little as three.[94]

By the 1930s, the proposal for the transformation of everyday life through cultivation of the slackened pace of indolence outlined in Lafargue's *Le Droit à la paresse* would become a crucial mediator between surrealism's permanent work refusal and the Third International's pro-work platform at a time when surrealism was still attempting to prove its eligibility for the communist revolution to the PCF. Lafargue's name appears on a 1931 'lisez/ne lisez pas' (read/do not read) list of surrealist recommendations for fifty or so authors approved by the movement. Thereafter, Lafargue is listed from time to time in surrealist texts, such as the preface to Breton's 1935 *Position politique du surréalisme* (*Political Position of Surrealism*), where the author is cited in conjunction with other Marxist theorists.[95]

* * *

Surrealism largely built its work refusal upon the aesthetic lifestyle of Marcel Duchamp, the poetic principles of Rimbaud, and the experimental political ideas of Paul Lafargue. Yet, during surrealism's first two decades, members of the Paris group such as André Breton, André Thirion, and others nevertheless developed a distinctive iteration of this passive-resistance stance that spoke to the specific ethical concerns of the surrealist goal of total social revolution. We can discern in French surrealist texts from the interwar period a series of core tactics: a constant rhetoric of pointed critique and virulent condemnation; experimental and often extreme intellectual propositions such as the concept of permanent strike or life absenteeism; catalytic and persuasive outreach, instigation, and protest language; and satirical humour. Alongside this discourse and praxis, surrealism cultivated the political activism and artistic collectivism that it increasingly pursued between the late 1920s and the advent of World War II, as I describe in Chapters 2 and 3.

Notes

1 Michael Seidman, *Workers Against Work: Labor in Paris and Barcelona during the Popular Fronts* (Berkeley: University of California Press, 1991).
2 André Thirion emphasised the culture shock that the surrealists experienced in their few interactions with the working class. Thirion, *Revolutionaries Without Revolution*, 112–14.
3 *Ibid.*, 92–3.
4 André Breton, 'Manifesto of Surrealism', in *Manifestoes of Surrealism*, trans. Richard Seaver and Helen R. Lane (Ann Arbor: University of Michigan Press, 1972), 4.
5 *Ibid.*, 3.
6 *Ibid.*, 47; original emphasis.
7 *Ibid.*, 5; original emphasis.
8 Max Weber, *The Theory of Social and Economic Organization*, trans. A. M. Henderson and Talcott Parsons (New York: Oxford University Press, 1947).
9 Torigian, *Every Factory a Fortress*, 1–24.
10 *Ibid.*, 8–14.
11 Jacques Rancière, 'Off to the Exhibition: The Worker, His Wife and the Machines', in *Staging the People*, trans. David Fernbach (London: Verso, 2011), 67.
12 Jackie Clarke, *France in the Age of Organization: Factory, Home and Nation from the 1920s to Vichy* (New York: Berghahn, 2011).
13 Henri Fayol, *General and Industrial Management*, ed. Irwin Gray (1916; New York: Institute of Electrical and Electronics Engineers, 1984).
14 Torigian, *Every Factory a Fortress*, 5 and *passim*. Cross, *Quest for Time*, 105–20.
15 *La Révolution surréaliste* 1 (1 December 1924): 1, 2, 32; my translation.
16 See Jonathan Crary's discussion of Breton's notion of a future anti-capitalist collaboration between work and dreams: Jonathan Crary, *24/7: Late Capitalism and the Ends of Sleep* (London: Verso, 2013), 108–110. Belgian surrealist Louis Scutenaire countered this notion of sleep as oppositional in his statement 'Vous dormez pour un patron'

(you sleep for the boss) from his text *Mes inscriptions*, 1945–1963. The situationists adopted Scutenaire's maxim after Belgian surrealist Marcel Mariën started a journal called *Les lèvres nues*, made by stealing time and materials from his job as a typist.

17 Breton, 'La Dernière grève', 2; my translation. For another surrealist take on *travail intellectuel*, see Louis Aragon, 'Le Prix de l'esprit' (1926), in *Chroniques, 1918–1932*, ed. Bernard Leuilliot (Paris: Stock, 1998), 265–70.

18 Breton, 'La Dernière grève', 2–3; my translation.

19 'Déclaration du 27 janvier 1925', in Pierre, *Tracts surréalistes et déclarations collectives*, 35; my translation.

20 Ulrich Lehmann, 'Assimilation: Objects; Commodities; Fashion', in *A Companion to Dada and Surrealism*, ed. David Hopkins (Hoboken, NJ: Wiley Blackwell, 2016), 441–2.

21 Louis Aragon, 'Fragments d'une conférence', *La Révolution surréaliste* 4 (15 July 1925): 24; my translation.

22 *Ibid.*

23 Paul Éluard, 'Manifestation philosophies du 18 mai 1925', *La Révolution surréaliste* 4 (15 October 1925): 32; my translation.

24 'La Révolution d'abord et toujours!', *La Révolution surréaliste* 5 (15 October 1925): 31. This statement also appeared in *L'Humanité* on 21 September 1925.

25 André Breton, 'Introduction to the Discourse on the Paucity of Reality', in *What Is Surrealism?: Selected Writings*, ed. Franklin Rosemont (New York: Monad Press, 1978), 27.

26 'The Revolution First and Always!', in *Surrealism Against the Current: Tracts and Declarations*, ed. Michael Richardson and Krzysztof Fijałkowski (London: Pluto Press, 2001), 95.

27 Breton, 'Second Manifesto of Surrealism', 132–3. Also see Grindon, 'Surrealism, Dada, and the Refusal of Work', 79–96. On the subject of surrealism's categorical critique of work, also see Alastair Hemmens, *The Critique of Work in Modern French Thought: From Charles Fourier to Guy Debord* (New York: Palgrave Macmillan, 2019). Hemmens's genealogy of the surrealist work refusal addresses several influences and figures that I do not discuss here, such as the anti-work views of the Belgian surrealist Louis Scutenaire and those of Tristan Tzara writing in the early 1930s. Also see Reynaud Paligot, *Parcours politique*, 319–29; Jean-Michel Pianca, 'Et Guerre au travail', *Mélusine* 5 (1983): 37–50; and Laxton, *Surrealism at Play*, 20–7.

28 André Breton, 'Léon Trotsky: Lénine', *La Révolution surréaliste* 5 (15 October 1925): 29; my translation.

29 Helena Lewis, *The Politics of Surrealism* (New York: Paragon House, 1988), 37–71. After World War II, Naville published several books related to his research on the sociology of labour, which was informed by his long-time investment in Trotsky's Fourth International. For Naville's studies in the Groupe de Sociologie du Travail, see, for example, Pierre Naville, *La Vie de travail et ses problèmes* (Paris: Armand Colin, 1954).

30 Pierre Naville, *La Révolution et les intellectuels* (1926; Paris: Gallimard, 1975). Jack J. Spector, *Surrealist Art and Writing, 1919–1939: The Gold of Time* (Cambridge: Cambridge University Press, 1997), 18, 70–94.

31 André Breton, 'Legitimate Defense', in *What Is Surrealism?* 39–40; original emphasis.

32 Breton, 'Second Manifesto of Surrealism', 125; emphasis added.

33 Raymond Spiteri, 'Surrealism and the Political: The Case of *Nadja*', in *The Invention of Politics*, ed. Sascha Bru and Gunther Martens (Amsterdam: Rodopi, 2006), 183–200.

34 Fanny Beznos, 'Untitled', *La Révolution surréaliste* 9–10 (1 October 1927): 22; my translation.

35 José Gotovitch, *Du Rouge au tricolore: Les Communistes belges de 1939 à 1944: un aspect de l'histoire de la Résistance en Belgique* (Brussels: Labor, 1992), 479.

36 Breton, 'Second Manifesto of Surrealism', 59.

37 André Breton, *Nadja*, trans. Richard Howard (New York: Grove Press, 1960), 59–60.

38 *Ibid.*, 68–9. Margaret Cohen, 'The Ghosts of Paris', in *Profane Illumination: Walter Benjamin and the Paris of Surrealist Revolution* (Berkeley: University of California Press, 1993), 77–119, 161.

39 Breton, *Nadja*, 68–9.

40 Breton, 'Second Manifesto of Surrealism', 153, 142.

41 *Ibid.*, 132–3; original emphasis in all quotations.

42 *Ibid.*, 143, 155–7.

43 André Breton, 'Rapports du travail intellectuel et du capital', *Le Surréalisme au service de la révolution* 2 (October 1930): 2; my translations.

44 Reynaud Paligot, *Parcours politique*, 68–9, 104–5, 160, 169–70, 179.

45 See, for example, Clifford Browder, *André Breton: Arbiter of Surrealism* (Geneva: Droz, 1967), 49; Wood et al., *Surreal Things*, 5–6, 113; Roger Vailland, *Le Surréalisme contre la révolution* (Brussels: Éditions Complexe, 1988), 77ff; and Jules-François Dupuis (Raoul Vaneigem), *A Cavalier History of Surrealism*, trans. Donald Nicholson-Smith (San Francisco, CA: AK Press, 1999), 28, 74–8, 95–6. For a critique of surrealism's political engagement and perpetuation of the alienated division between manual and intellectual labour, see Louis Janover, *Surréalisme, art et politique* (Paris: Éditions Galilée, 1980).

46 Norbert Bandier, *Sociologie du surréalisme* (Paris: La Dispute, 1999), 271–345.

47 I therefore disagree with Helena Lewis when she claimed that the surrealists' 'glib declaration of war on work had nothing to do with the proletariat; it was merely another expression of their hatred of middle-class values'. Lewis, *The Politics of Surrealism*, 40. Alan Rose echoed Lewis in his claim that 'the surrealist attitude to work constituted a fundamental illustration of their non-materialist philosophy'. Alan Rose, *Surrealism and Communism: The Early Years* (New York: Peter Lang, 1991), 310, 311–23.

48 Antonin Artaud, 'In Total Darkness, or The Surrealist Bluff', in *Antonin Artaud, Selected Writings*, ed. Susan Sontag (New York: Farrar, Straus & Giroux, 1976), 141.

49 In this I concur with Donald LaCoss. See LaCoss, 'The Revolutionary Politics of Surrealism', 20 and *passim*.

50 'Inaugural Rupture', in Richardson and Fijałkowski, *Surrealism Against the Current*, 41–9; and Raymond Spiteri, 'Surrealism and the Question of Politics, 1925–1939', in Hopkins, *Companion to Dada and Surrealism*, 122.

51 Original emphasis and capitals; my translation.

52 Marcel Fourrier, 'L'Opportunisme impuissant', *La Révolution surréaliste* 7 (15 June 1926): 29–30; and 'Police, haut les mains!', *La Révolution surréaliste* 12 (15 December 1929): 38–40.

53 Thirion, *Revolutionaries Without Revolution*, 71–4, 84–95, and *passim*.

54 André Thirion, 'À Bas le travail!', in "Le Surréalisme en 1929", ed. André Breton and Louis Aragon, special issue, *Variétés* (June 1929): 43–6.

55 Thirion, *Revolutionaries Without Revolution*, 85, 369.

56 Thirion, 'À Bas le travail!', 43–4; original emphasis; my translation.

57 *Ibid.*, 44–6; original emphasis; my translation.

58 Thirion, *Revolutionaries Without Revolution*, 170.

59 André Thirion, 'Note sur l'argent', *La Révolution surréaliste* 12 (15 December 1929): 27; my translation.

60 Thirion, *Revolutionaries Without Revolution*, 263–4.

61 I take my understanding of reproductive labour from Silvia Federici, *Revolution at Point Zero: Housework, Reproduction, and Feminist Struggle*, 2nd ed. (2012; Oakland, CA: PM Press, 2020).

62 Perry, *Prisoners of Want*, 14, 21–31, and *passim*.

63 Georges Sadoul, 'Le Problème du chômage résolu en une demi-heure', *Le Surréalisme au service de la révolution* 3 (1931): 34; my translation.

64 For a cultural history of idleness and *acedia* (melancholic apathy) in Europe, contextualised in relation to nineteenth-century discourses on fatigue and Marx's concept of labour power (*Arbeitskraft*), see Anson Rabinbach, *The Human Motor: Energy, Fatigue, and the Origins of Modernity* (Berkeley: University of California Press, 1992).

65 Peter Wollen, 'Bitter Victory: The Art and Politics of the Situationist International', in *On the Passage of a Few People Through a Rather Brief Moment in Time: The Situationist International, 1957–1972*, ed. Elisabeth Sussman (Cambridge, MA: MIT Press, 1989), 20–61; and Mikkel Bolt Rasmussen, 'The Situationist International, Surrealism, and the Difficult Fusion of Art and Politics', *Oxford Art Journal* 27, no. 3 (2004): 365–87.

66 Grindon, 'Surrealism, Dada, and the Refusal of Work', 81; and Sylvère Lotringer and Christian Marazzi, eds, *Autonomia: Post-political Politics*, Semiotext(e) Intervention Series 1 (Cambridge, MA: MIT Press, 2007).

67 For instance, see David Graeber's analysis of the culture of overwork as a form of political oppression by the ruling classes in *Bullshit Jobs* (New York: Simon & Schuster, 2018). Also see Franco Berardi, *The Soul at Work: From Alienation to Autonomy*, trans. Francesca Cadel and Giuseppina Mecchia (Los Angeles, CA: Semiotext(e), 2009). Dave Beech, *Art and Postcapitalism: Aesthetic Labour, Automation and Value Production* (London: Pluto Press, 2019).

68 Weeks, *The Problem with Work*, 99, 102. Weeks's bibliography provides an excellent overview of the contemporary literature on work refusal, which is too extensive to review here. My discussion is also influenced by contemporary ultra-left theories of refusal and withdrawal such as the Invisible Committee's notion of the destituent gesture as both desertion and attack. Comité invisible, *Now*, trans. Robert Hurley (South Pasadena, CA: Semiotext(e), 2017).

69 Maurizio Lazzarato, *Marcel Duchamp and the Refusal of Work*, trans. Joshua David Jordan (Los Angeles, CA: Semiotext(e) and the Whitney Biennial, 2014), 6. See also Bernard Marcadé, *Laisser pisser le mérinos: la paresse de Marcel Duchamp* (Paris: L'Échoppe, 2006); and Helen Molesworth, 'Work Avoidance: The Everyday Life of Marcel Duchamp's Readymades', *Art Journal* 57, no. 4 (1998): 50–61. John Roberts's labour theory of the readymade and discussion of Duchamp in the context of industrial deskilling has influenced my study. Roberts's conception of delay as the sabotage of artistic production is also relevant. See *The Intangibilities of Form: Skill and Deskilling in Art after the Readymade* (New York: Verso, 2007). See also Robert Harvey, 'Where's Duchamp?: Out Queering the Field', *Yale French Studies* 109 (2006): 82–97. Franklin Rosemont has wondered whether Duchamp was influenced by the IWW's slogan of

the passive resistance of 'folded arms' during his time in New York during World War I. Franklin Rosemont, *Joe Hill: The IWW and the Making of a Revolutionary Workingclass Counterculture* (Chicago, IL: Charles H. Kerr, 2003), 472–3.

70 Lazzarato, *Marcel Duchamp*, 6–7; original emphasis.

71 *Ibid.*, 8, 9, 43.

72 *Ibid.*, 43. Jacques Rancière, *Aisthesis: Scenes from the Aesthetic Regime of Art* (New York: Verso, 2013). See, for example, Giorgio Agamben, *Sovereign Power and Bare Life, Homo Sacer*, trans. Daniel Heller-Roazen, vol. 1 (Stanford, CA: Stanford University Press, 1998); and Giorgio Agamben, *The Use of Bodies, Homo Sacer*, trans. Adam Kotsko, vol. 4, no. 2 (Stanford, CA: Stanford University Press, 2015). In distinguishing Duchamp's work critique from Agamben's 'inoperative', Lazzarato also therefore distanced Duchamp's art production from the ontological questions that concerned Maurice Blanchot in his exploration of *désœuvrement*, or unworking, in literature and language. Maurice Blanchot, *The Space of Literature*, trans. Ann Smock (1955; Lincoln: University of Nebraska Press, 1982); and Maurice Blanchot, *The Unavowable Community*, trans. Pierre Joris (1983; Barrytown, NY: Station Hill Press, 1988). For a discussion of unworking in relation to surrealism as 'a practice of life and writing' and Breton's text *Nadja*, see Maurice Blanchot, 'Tomorrow at Stake' and 'The Absence of the Book', in *The Infinite Conversation*, trans. Susan Hanson (1969; Minneapolis: University of Minnesota Press, 1993), 417–34. I return to Blanchot's 'Tomorrow at Stake' in Chapter 2. On Georges Bataille's exchange with Alexandre Kojève about Hegel and *désœuvrement* as a mode of undermining totalising homogeneity and the subsequent transformation of this idea in the work of Blanchot and Agamben, see Aaron Hillyer, *The Disappearance of Literature: Blanchot, Agamben, and the Writers of the No* (New York: Bloomsbury Academic, 2013). Other relevant texts in this discourse include Jean-Luc Nancy, *The Inoperative Community* (1983), trans. Peter Connor et al. (Minneapolis: University of Minnesota Press, 1990); and Georges Bataille, *Inner Experience*, trans. Leslie Anne Boldt (1954; Albany: State University of New York Press, 1988). For a brief commentary on how this discourse of unworking relates broadly to surrealism, see Raymond Spiteri, 'Community at Play', in *Surrealism: Key Concepts*, ed. Krzysztof Fijałkowski and Michael Richardson (London: Routledge, 2016), 118–19; and Michael Stone Richards, 'Failure and Community: Preliminary Questions on the Political in the Culture of Surrealism', in *Surrealism, Politics and Culture*, ed. Donald LaCoss and Raymond Spiteri (Burlington, VT: Ashgate, 2003), 300–36.

73 Lazzarato, *Marcel Duchamp*, 8, 7.

74 André Breton, 'Géographie Dada', *Littérature* 13 (May 1920): 18.

75 On Jacques Vaché and counterproductivity, see Franklin Rosemont, *Jacques Vaché and the Roots of Surrealism: Including Vaché's War Letters & Other Writings* (Chicago, IL: Charles H. Kerr, 2008), 144–5, 151–5. Richard David Sonn, *Sex, Violence, and the Avant-garde: Anarchism in Interwar France* (University Park: Pennsylvania State University Press, 2010), 72–98. André Breton, 'André Breton n'écrira plus', in Breton, *Œuvres complètes*, 1:1214–16.

76 Joyce Suechun Cheng, 'Paris Dada and the Transfiguration of Boredom', *Modernism/ modernity* 24, no. 3 (2017): 599–628. For an early assertion of Rimbaud's importance to surrealism's work refusal, see Ferdinand Alquié, *The Philosophy of Surrealism*, trans. Bernard Waldrop (Ann Arbor: University of Michigan Press, 1965), 42–83.

77 Clément Pansaers, *L'Apologie de la paresse* (Anvers: Ça ira, 1921).

78 Mark Polizzotti, *Revolution of the Mind: The Life of André Breton* (New York: Da Capo, 1997), 165.

79 See the following text about Rimbaud's work refusal: 'Permettez!', in Pierre, *Tracts surréalistes et déclarations collectives*, 84–8.

80 Arthur Rimbaud, *Complete Works*, trans. Paul Schmidt (New York: Perennial, 2000), 96–7, 113–14, 220–5, 227–31; original emphasis.

81 André Breton and Paul Éluard, eds, *Dictionnaire abrégé du surréalisme* (Paris: Galerie Beaux-Arts, 1938), 28; my translation.

82 *Ibid.*; original emphasis; my translation.

83 Kristin Ross, 'Rimbaud and the Resistance to Work', *Representations* 19 (Summer 1987): 83. In *The Emergence of Social Space*, Ross also discussed other nineteenth-century examples of work critique, including Lautréamont, Nietzsche, and Élisée Reclus. Ross's argument, prompted by Rancière's 1970s discussion of the process of emancipation, radicalisation of 'atomization', and serialisation of work servility through the swarm has also been influential for me. *The Emergence of Social Space: Rimbaud and the Paris Commune* (Minneapolis: University of Minnesota Press, 1988), 20–1. Roland Barthes, 'Osons être paresseux', *Le Monde Dimanche* (Sep. 1979).

84 Ross, 'Rimbaud and the Resistance to Work', 74.

85 LaCoss, 'Revolutionary Politics of Surrealism', 34. Kathi Weeks comments on Lenin's enthusiasm for Taylorism: Weeks, *The Problem with Work*, 83–5.

86 Marcadé, *Laisser pisser le mérinos*, 38–40, 47–50.

87 Karl Marx and Friedrich Engels, *The German Ideology. Part One: With Selections from Parts Two and Three, Together with Marx's 'Introduction to a Critique of Political Economy'*, trans. C. J. Arthur (New York: International Publishers, 1970), 53. For a detailed reading of Marx's vision of work time in a post-capitalist society and the contradiction of capitalism's reduction of production time through industrialism in the face of its demand (through abstract domination) of surplus labour, see Moishe Postone, *Time, Labor, and Social Domination: A Reinterpretation of Marx's Critical Theory* (Cambridge: Cambridge University Press, 1993). On the problematic comparison of chattel slavery to wage earning, see Mary Turner, ed., *From Chattel Slaves to Wage Slaves: The Dynamics of Labour Bargaining in the Americas* (Bloomington: Indiana University Press, 1995).

88 Weeks, *The Problem with Work*, 84–7, 97–9. Also see Hemmens's discussion of *Wertkritik*, the 'critique of value' school of Marxist thought associated with Robert Kurz, Jean-Marie Vincent, Anselm Jappe, and Moishe Postone. Hemmens, *Critique of Work*, 7–33, 186–188.

89 Weeks, *The Problem with Work*, 93–4; and Antonio Negri, *Marx Beyond Marx: Lessons on the* Grundrisse, trans. Harry Cleaver et al. (New York: Autonomedia, 1991). I am influenced here by Mario Tronti, 'The Strategy of Refusal', *Semiotext(e)* 3, no. 3 (1980): 28–35. See also Mario Tronti, *Operai e Capitale* (Turin: G. Einaudi, 1966) and Franco Berardi, *After the Future*, eds Gary Genosko and Nicholas Thoburn (Oakland, CA: AK Press, 2011). There remains some debate between scholars about how Marx's views on the abolition of labour versus the shortening of the workday shifted over time. For instance, see Avner Cohen, 'Marx and the Abolition of the Abolition of Labor – End of Utopia or Utopia as an End', *Utopian Studies* 6, no. 1 (1995): 40–50; and Uri Zilbersheid, 'The Idea of Abolition of Labor in Socialist Utopian Thought', *Utopian Studies* 13, no. 1 (2002): 21–42.

90 Bernard Marszalek, 'Introduction', in Paul Lafargue, *The Right to Be Lazy* (Oakland, CA: Charles H. Kerr & AK Press, 2011), 3–22.

91 Ross, 'Rimbaud and the Resistance to Work', 73.

92 *Ibid.*, 74–5.

93 Marszalek, 'Introduction', 10–11.

94 Lafargue, *Right to Be Lazy*, 32, 35, 44, 47.

95 The editors of Breton, *Œuvres complètes* have suggested that Breton may have known about Lafargue as early as 1928, when his diatribe against wage labour was published in *Nadja*. They also added that Breton owned two copies of Lafargue's *Le Droit à la paresse*, one of which was an original edition from 1883. Breton, *Œuvres complètes*, 1:1540n3.

2 Surrealist automatism as symbolic sabotage

Simone Breton and the gendered labour of the surrealist automatist

Work hazards

My preoccupation with reading surrealism's psychic automatism as a subversive form of gendered labour begins by chance, while I am at work, teaching an introductory undergraduate art history class. I am looking with my students at a reproduction of the cover of the first issue of the journal *La Révolution surréaliste* from December 1924 (Figure 2.1). There are three images of black-and-white photographs by the American surrealist Man Ray on the lecture-hall screen: some of the earliest representations that surrealists self-consciously constructed for the movement in those early moments of its inauguration. My students and I are discussing psychic automatism for the first time together, and my presentation quotes the key line from André Breton's 1924 *Manifesto of Surrealism*: automatic writing (*l'écriture automatique*) expresses the 'actual functioning of thought', and moreover, automatism is 'dictated by thought in the absence of any control exercised by reason'.[1] Under the photographs on the cover of the journal is also a caption, translated from French: 'IT IS NECESSARY TO STRIVE FOR A NEW DECLARATION OF HUMAN RIGHTS'.[2]

Our classroom examination of Man Ray's three photographs allows us to glimpse most of the members of the surrealist group as they were in 1924, upon the opening of the Bureau de recherches surréalistes on rue de Grenelle in Paris – also known as the Centrale surréaliste, or simply 'le Bureau central' – or, most provocatively, 'la Centrale' (the Powerhouse).[3] This office, open six days a week from 4.30 to 6.30 p.m., briefly served as the editorial headquarters for the production and dissemination of *La Révolution surréaliste* and as a reception desk for associates and members of the public bearing news, information, and data relevant to the surrealist movement and its many interests.[4]

One of the photographs featured on the cover centres on the image of Simone Collinet, née Kahn. At the time, she was known as Simone Breton, wife of André Breton. She is seated at a small wooden desk, paused in a supposedly candid

Figure 2.1 Man Ray, Paris Surrealist Group, cover of *La Révolution surréaliste* 1 (1 December 1924)

Figure 2.2 Man Ray, the surrealists at the Centrale surréaliste, 1924. *Left to right*: Jacques Baron, Raymond Queneau, Pierre Naville, André Breton, Simone Breton, Jacques-André Boiffard, Max Morise, Giorgio de Chirico, Mick Soupault, Roger Vitrac, Paul Éluard, Philippe Soupault, Robert Desnos, Louis Aragon. Published on the cover of *La Révolution surréaliste* 1 (1 December 1924)

moment of typing, surrounded by eleven or so men (Plate 1). All of the members of the group are watching intently as Robert Desnos holds an unidentifiable object, except for Paul Éluard and Giorgio de Chirico, who are fixated on Man Ray and the flashbulb of his camera. We also study a second shot showing Simone sitting in the middle of the group of a dozen adherents, all gazing directly at the camera (Figure 2.2). There is no available detail of the third photograph, which shows André Breton involved in some interaction with one of the male surrealists in the group (most likely the writer Robert Desnos), possibly lighting a cigarette or doing something else during one of Desnos's hypnotic slumbers.[5]

Accustomed as they are to closely scrutinising reproductions of artworks during our class sessions, the students linger on disparate details in the photographs. They notice the urbane dress of the men (Max Morise's gloved hand resting on a carved cane), the pair of keys dangling from the hand of an unseen surrealist on the right, André Breton's barely visible monocle, and Simone Breton's short 'new-woman' haircut and fashionable smock with pointed sleeves. I am absorbed most of all in the photograph featuring the typewriter, and Simone's look of concentration as she stops typing halfway down the sheet of paper. Her hands rest on the keyboard of the small portable typewriter, and her overcoat is draped behind her on the chair.

This last view is the emblematic image in Man Ray's photo shoot that garnered its own title as a stand-alone work of art: *Séance de rêve éveillé* (*Waking Dream Séance*). Waking dream. Since all of these surrealists are apparently 'awake' in the shot, one student asks, who is the automatist? Is it Simone Breton, the one sitting at the writing machine? Or is it Robert Desnos, crouching in the right foreground in Man Ray's photograph? Or is this a case of simultaneous automatism, with one person writing (Simone) and one person talking (Desnos)? When I tell them that this is ultimately unclear, but Desnos is usually thought to be the automatist pictured, someone notes that Desnos is not in fact shown in the act of speaking 'direct' automatist language, but instead appears to be silently exploring a box-like object with his fingertips, while Simone types as if taking dictation.[6]

If psychic automatism is a form of dictation directly apprehended from the unconscious, according to the aesthetic theory of Breton and other surrealists at the time, one student asks, why does Simone need to transcribe waking-dream dictation? Why take dictation from the already dictated? Even if Simone is not in fact taking dictation from Desnos as he channels his unconscious through the object, but is engaging in her own, parallel automatic activity, why does she sit alert and ready at the typewriter? Why does the woman have to be the one at the typewriter?

Such photographic gendering of Simone is everywhere apparent in Man Ray's photo shoot from that day in 1924. There are additional photographs that were not initially published, showing Simone in the midst of other actions: leaning her head on her hand, caressing her boa (Figure 2.3), or sitting at the typewriter, pulling out her lorgnette to look at a page of a notebook resting on a pillow that Desnos is showing the group (Figure 2.4). These pictorial roles set her apart from the male surrealists who surround her and also link her to the other woman pictured in this photo shoot, Marie-Louise (Mick) Soupault, Philippe Soupault's wife, who is seated at the desk in two of the shots.[7] In that case, my students ask, what exactly was the nature of Simone's role as a woman in surrealist automatism?

There is no easy response to these questions, as the vast scholarly literature on the subject of automatism reveals. The dominant strains of interpretation in the secondary scholarship on surrealist automatism have focused, for good reason, on a wide range of topics, from World War I-era Freudian psychoanalysis to *fin-de-siècle* dynamic psychiatry in Europe, psychical research, and twentieth-century spiritualism – not to mention subject areas such as poetics and feminism. This research shows that surrealist automatism is relatable to a broad cultural turn in industrialised nations in the nineteenth and twentieth centuries towards an interest in disembodied and re-embodied language, among other things. What has been less clear, however, is how exactly surrealist automatism connected, if at all, to surrealism's critiques of capitalism, nationalism, imperialism, and authoritarianism. As scholars such as Helena Lewis, Carole Reynaud Paligot, Raymond Spiteri, and others have shown, surrealism's revolution of the mind was

Figure 2.3 Man Ray, the surrealists at the Centrale surréaliste, 1924. *Left to right*: Jacques Baron, Raymond Queneau, Pierre Naville, André Breton, Simone Breton, Jacques-André Boiffard, Max Morise, Giorgio de Chirico, Mick Soupault, Roger Vitrac, Paul Éluard, Philippe Soupault, Robert Desnos, Louis Aragon

Figure 2.4 Man Ray, the surrealists at the Centrale surréaliste, 1924. *Left to right*: Max Morise, Roger Vitrac, Simone Breton, Jacques-André Boiffard, Paul Éluard, André Breton, Pierre Naville, Robert Desnos, Giorgio de Chirico, Philippe Soupault, Jacques Baron

manifestly conjoined with protest actions and the goal of a libertarian-socialist revolution by 1925.[8] Although I do not review the detailed history of the surrealist negotiation with the Parti communiste français (PCF) during the 1920s that scholars have already laid out, these events are nevertheless crucial to my reading. This is so because my historiographic account tracks the gender politics of surrealist automatism in relation to relevant social and materialist factors, questioning how both the division of gender and the division of labour inform this practice.

Submission as subversion

From the 1940s on, French surrealists championed the views of the nineteenth-century utopian socialist Charles Fourier, an advocate for women's rights and equality, but their attitude in the 1920s towards issues of women's suffrage, reproduction, and labour rights was by no means obvious.[9] In 1924, André Breton called for surrealists to end the 'servitude' (*servage*) of language.[10] Eleven years later, in his 1935 *Position politique du surréalisme* (*Political Position of Surrealism*), he affirmed the surrealist 'hatred of all servitude'.[11] But, before World War II, there was no specific surrealist demand for the rights of women, as many scholars have noted.[12]

Given surrealism's resolute attitude in the 1920s towards wage labour, if not yet women's suffrage and other issues related to women's rights, what is the significance of Simone posing as a typist for Man Ray that day at the Centrale, either enacting a stenographic recording of automatism as a trained operator, or conversely, operating as an automatist herself? In an attempt to answer this question, I outline a materialist theory of surrealist psychic automatism in France during the interwar period that describes this practice, in one aspect of its complex operations, as a critical *re-performance* that reproduces the performance of value-productive labour of different kinds. By repeating, re-signifying and re-performing the trappings of gendered work performance, surrealist automatism emerges as a mode of agency whereby subjects sabotage compliance. Concrete oppositional socio-political significance therefore arises as a result of surrealist automatism's theory and practice of autonomous thought. Although it is typically the verbal residue of supposed contact with the unconscious that has been the main subject of previous scholarly enquiry, my discussion emphasises the mechanisms of surrealist automatism. Automatism's technique of embodied submission to dictation thus becomes a tool for liberation – a form of sabotage meant to unfetter subjection of different kinds.

This predilection for fashioning strategies of resistance out of replicated submission has not always garnered applause for surrealism. Towards the end of his life André Breton published an unusual volume of automatist material, 'Le La' (1960). In the preface, Breton reflected on *l'écriture automatique* as one primary impetus of early surrealism and admitted that he always struggled in the act of taking dictation from the unconscious. The surrealists, he confirmed, sought to 'submit' (*se soumettre*) themselves to the 'dictation of thought' (*dictée*

de la pensée), which required a dialectic of 'active-passive' in the waking state.[13] I consider this curious surrealist position of submission quite literally, in order to recast the power dynamics of psychic automatism and its dialectics of active and passive in relation to the professional arts of dictation in the secretarial world. Therefore, in one sense I concur with media theorist Friedrich Kittler when he writes of André Breton and the various procedures involved in psychic automatism, that 'automatic writing is anything but freedom'.[14] Although automatism did offer practitioners a substantial experience of a certain kind of linguistic and psychic emancipation, such liberation was arrived at dialectically through symbolic processes of submission and performative compliance.

In other words, the surrealist critique of instrumentalisation was an immanent one, embedded within scenarios that bore significant resemblance to routines of rationalised productivity. *Subversion through compliance* was also a key tactic for certain forms of workplace sabotage pursued by activists, union members, and anarchists at the turn of the twentieth century, such as the slowdown technique of 'work-to-rule' (described in the Introduction), where workers follow workplace regulations and quota demands to such an exaggerated degree that production is thwarted. In my reading, surrealist automatism functions much like 'work-to-rule' sabotage. Surrealist automatists aim to become fully obedient to what Max Morise called, in the same first issue of *La Révolution surréaliste* where we see Simone at the typewriter, 'the dictation of thought', or dream directives.[15] The automatist becomes a perfect machine of the unconscious and therefore, despite this submission, ultimately useless as a vessel of instrumentalised communication.

By proposing such an interpretation, I am also recalling a polemical lineage of the reception of surrealism and surrealist automatism in twentieth-century French theory. According to Georges Bataille at mid-century, the 'rigorous will to insubordination' that characterises surrealist automatism ultimately remains bound to 'servitude' because the surrealists look for paths to 'emancipation' through the mediation of instrumentalised language, or language based on a structure of utility.[16] Thirty years later in 1975, during the heyday of poststructuralism, Roland Barthes echoed this critique that psychic automatism was plagued by a paradox because the idealist inner subject that surrealism supposedly sought was fully reducible to code, i.e., stereotypes.[17] Barthes's analysis finds an echo in the sentiments of Gilles Deleuze and Félix Guattari in *Capitalism and Schizophrenia*. Their characterisation of the 'fantastic subjugation' of the surrealist group is accentuated by their general discussion of the 'death of writing' in capitalism[18] and the dominance of the 'order-word' in a human language that is neither communicative nor intersubjective (shared between subjects), but rather a subjectified, indirect, and redundant 'murmur' running free within the self.[19]

Yet, the trappings of submission performed in the act of surrealist automatism are one of its most successfully subversive aspects. As theorised by Maurice Blanchot in the wake of André Breton's death in 1966, in 'Tomorrow at Stake', the 'surrealist project' can be articulated in part as an experience of the real based in a Rimbaldian '*dérangement*', and an experiment of work based in '*unworking*' or

'undoing' (*désœuvrement*).[20] Blanchot wrote, 'Worklessness is always outside the work: that which has not let itself be put to work, the always un-unified irregularity (the non-structure) that makes it so that the work relates to something other than itself.' This concerted experimentation with work as the absence of work, and also the absence of the artwork, is a playful and aleatory act of *'disarrangement, disarray'*– not without *'risk'* and *'danger'*.[21] Surrealism itself is a deregulated 'game' of sabotaged dislocation which opens onto a horizon of plurality, future possibility, open encounter, and the unknown.[22]

How does Blanchot's surrealist *désœuvrement*, an experimental game of unworking as an experience of becoming, speak to surrealist automatism? The secretarial associations sometimes buried in, or often scattered across, surrealist discourse and representations of automatism suggest that the surrealists marked as symbolic and emblematic the disciplined labour of women as waged workers and uncompensated domestic servants in the immediate post-World War I period. By frequently evoking certain behaviours related to the performative training of the body and its compliance with productive labour – the body as demonstratively managed and made docile by certain types of work (what Michel Foucault called 'dressage') – the surrealists reveal their take on automatism to be intertwined with contemporaneous cultural debates about the sweeping ramifications of different kinds of gendered labour under mass production.[23]

Such a hypothesis stems directly from the historical context. Issues of work, gender roles, and fertility were particularly fraught in France and many other industrialised nations during the interwar era. France needed women workers during the war, but the country's ongoing demographic crisis and low birth rates, compounded by the overwhelming mortality rates of deployed soldiers and influenza pandemic victims, meant that women's bodies also became the site of governmental and popular pressures about childbearing and social reproduction, as well as worker productivity.[24] While parenting and women's nurturant reproductive labour was heavily incentivised by the French government during interwar reconstruction, workplace rationalisation continued to be a key factor across the French labour market as it had been since the advent of Taylorism in France, shortly after the appearance of Frederick Winslow Taylor's *The Principles of Scientific Management* in 1898.[25]

Building on the research of Anson Rabinbach, which analysed the French and German discourse surrounding the idea of the body as a thermodynamic human motor, historian Laura Levine Frader has demonstrated that rationalisation remained a dominant aspect of labour of various kinds in France after the war. Frader also asserted that surveillance and managerial authority over the body of the worker and the observance of gender divisions in labour became even more pronounced during and after World War I.[26] Michael Torigian has confirmed that by the time the worldwide Depression reached France in 1931, rationalisation and the deskilling of work had further developed in that country and thus 'generalized Taylor's managerial reforms and Ford's mass-production strategy'.[27] According to Torigian, the craft worker was soon marginalised, as 'the traditional links between

man, his tools, and his work were, in other words, irreparably severed in this new system'.[28]

The *dame dactylographe*, or female typist, with her disciplined and trained body and mind, was a textbook case of Weber's 'rationalisation' in the early twentieth century.[29] As seen in the realm of office employment, typically gendered female by the time of World War I in Western Europe, England, and the United States, the workplace discipline of secretaries, stenographers, and typists was one of utmost regulation. In the background of this process of reckoning with the alienation of gendered and belaboured subjectivity in an industrial and increasingly postindustrial context, the surrealists also bore witness to the destabilisation of the dominance of the phallic male during World War I, while the working woman stoked her energies and modelled new subjectivities, even from within her expected role of submission.

Repetitive tasks: historiography as context

Man Ray's *Séance de rêve éveillé*, featuring Simone Breton at the typewriter, was at the centre of a scholarly debate about the role and representation of women in surrealist automatism during the 1990s in texts such as: 'Photography in the Service of Surrealism' and 'Corpus Delicti' by Rosalind Krauss (1985); Rudolf Kuenzli's 'Surrealism and Misogyny' (1990); Robert Belton's *The Beribboned Bomb: The Image of Woman in Male Surrealist Art* (1995); and Katharine Conley's *Automatic Woman: The Representation of Woman in Surrealism* (1996). As I do, Krauss, Kuenzli, Belton, and Conley began their discussions of surrealism by reproducing *Séance de rêve éveillé* or one of surrealism's other visual representations of automatism-as-woman.[30] In the politicised readings of Kuenzli and Belton, who followed in the footsteps of earlier feminist statements about surrealism such as *Surréalisme et sexualité* by Xavière Gauthier (1971), among other texts, surrealist representations of woman were evidence of the movement's fundamental misogyny. For Krauss and Conley, in their cultural hermeneutics, some but not all aspects of surrealism offered a potential point of connection to either feminism (in the case of Conley) or a blurring of the patriarchal enforcement of gender binaries (Krauss).

More than twenty years after the appearance of these publications, it came as something of a surprise to find myself answering what Mary Ann Caws once hailed as 'a call to re-reading' the 'problematics of the surrealist woman' by ruminating on these divergent and sometimes dichotomous interpretations so foundational to surrealism studies.[31] My historiographic framework for analysis in this chapter, which repeatedly summons past scholarship on these subjects, attempts to understand how the role of women in surrealist automatism has been read by scholars as much as it does the nature of automatism itself. Such a metadiscourse about the role of woman in the automatist murmur is inherently recursive; it returns again and again to the chorus of scholarly voices, allowing them to interrupt, conflict, and shape the context for interpretation.

The outcome of this synchronic methodological approach is encapsulated to some degree in the productive contrast between the arguments of Robert Belton and Katharine Conley in the books mentioned above: theses that absorbed earlier tensions voiced by Kuenzli against Krauss. Whereas Belton found surrealist automatism and the movement's representations of it to be confirmation of a patriarchal 'misapprehension' and 'misappropriation' of women in general,[32] Conley demonstrated that the potential for 'shock and dynamic change' in the trope of the 'Automatic Woman' paved the way for the agency of women surrealists as creators – and, later in the twentieth century, for the development of a feminist *écriture féminine*.[33]

My reading arises in the fissures between these opposing arguments. Throughout this book I broadly contemplate theories of work *performance* under capitalism in comparison with surrealist experimentation of different kinds.[34] I assert that the societal signification of power hierarchy in certain female-gendered labour roles in France during the 1920s – a process called the *feminisation of labour* in sociological historical discourses – is what is appropriated and critically re-performed by surrealists of different genders. This re-performance manifested not as an essentialist identification with any supposed inherent quality of femininity, but rather as an undermining of the very societal essentialism that would equate gender with power in the first place. More specifically in relation to the interwar period, I read surrealist automatism as a politicised appropriation of what Pamela Thurschwell aptly called, in relation to late nineteenth-century Europe and America, 'cultural fantasies of transmission' that allowed for conceptualisations of gender interpenetration.[35] As Thurschwell explained, some of the anxieties and hopes that surrounded the advent of new communication technologies and habits at the *fin-de-siècle* attracted 'shifting models of the permeability and suggestibility of the individual's mind and body' and cultivated 'gender flexibility'.[36]

In my account, surrealist automatism, as an intermediary between an internalised dictator and externalised receiver, is framed as an enacted or performed 'misapprehension' or appropriative misreading of gender essentialism. This amounts to a non-essentialist fantasy of gender entanglement possessing the potential to destabilise and unfetter certain regulatory systems that inform authoritarian or patriarchal structures – resulting not in a universalising ungendering but in gender-transgressive dissonance and denaturalisation.[37] In this regard my thesis about surrealism's orientation towards gender construction and deconstruction is linked to Krauss's application of poststructuralism's binary critique in *L'Amour fou* (1985). I am also influenced to a certain extent by Julia Kristeva's psychoanalytic reading (1992) of André Breton's 1924 automatic text *Poisson soluble*, in which she explored the Mallarméan dimensions of Breton's automatism through a discussion of the figure of the veil as hymen.[38] For Kristeva, Breton's desire to make phallocentrism soluble, so that masculinity dissolves into the folds or skin of woman, was a regression fantasy that manifests the Oedipal desire for the mother and the phantasm of occupying the jouissance of the other.[39]

Conley built the foundation for this discussion with her interpretation of surrealist automatism as gendered 'feminine' in both its performance and representation.[40] In this case, I think of René Crevel, the queer surrealist author, *adepte* of spoken automatism, and later communist militant who first brought the idea of the séance to André Breton. Crevel asserted in an important statement of 1930, 'The Period of Sleeping Fits', that surrealism was 'dialectical in essence' with its application of automatism, and so surrealism could be said to condemn dualism in general. He wrote, 'Surrealism intends to sacrifice neither dreaming to action nor action to dreaming, but instead to foster their synthesis … To draw frontiers between the different psychic states is no more justifiable than to draw them between geographical states. It is for surrealism to attack both, to condemn every kind of patriotism, even the patriotism of the unconscious.'[41]

Therefore, paramount to my project are the sentiments espoused by Conley in her project devoted to the surrealist Robert Desnos, whom she termed a 'Sybil', following a letter written by Simone Breton in October 1922, in which Desnos is compared to a woman. Conley explained, 'The generalization could be made that the male surrealist response to the cultural anxiety swirling around gender was to shore up a potentially threatened masculine heterosexuality – and at the same time refute bourgeois notions of patriotism … while concurrently examining his own interior sense of femininity, as revealed under the influence of automatism.'[42] Conley captured the conflicted nature of the surrealist critique of French society in the post-World War I era, in which the attack on nationalism carries within it a rapprochement with femininity that paradoxically takes place within the confines of a coterie of cisgender men. Likewise, following the work of Eve Kosofsky Sedgwick in publications such as *Between Men: English Literature and Male Homosocial Desire* (1985), Raymond Spiteri has written of the homosocial masculine rivalry in surrealism's 'collective' or 'community' and the ways in which women and modes of femininity circulated in the group as symbolic 'objects of exchange' that might at the same time offer escape routes of 'alterity'.[43]

Recording psychic automatism

How can surrealist automatism be contextualised in relation to Marx's notion of capital as a deeply troubling form of 'automatic expansion', reproduced by the worker under capitalism who 'converts his whole body into the automatic, specialised implement of that operation'?[44] This question speaks to the nature of the separation of the body from the mind in surrealist automatism, and also the separation of the body from the tools of transcription. Man Ray's photograph of Simone Breton typing was probably not an actual surrealist somnambulist session but rather a restaged *mise-en-scène* that self-signified the experimental objectivity of live psychic automatism in the midst of double documentation by camera and typewriter.[45] In the image, Simone labours to take dictation either from Desnos or from her own mind; the automatist receives (or at some point in the recent past, received) 'magic *dictation*' from the unconscious, as Breton termed this process in

'The Mediums Enter' from 1922.[46] A dialectical interaction between Simone and Desnos arises, a dual performance that emphasises the importance of inscription as the crucial form of *enregistrement*, or recording, in automatism.

Clément Chéroux has argued that one of the three photographs – the enigmatic shot of two male surrealists interacting in some indeterminate manner – is a staged pastiche of the Christian practice of taking communion, a surrealist mockery of religion in the name of revolution. Leaving this interesting hypothesis aside but maintaining its structural idea of pastiche and satirical performance, where does that leave the other two photographs, likewise orchestrated to varying degrees? Chéroux distinguished between four types of photographic portraits in surrealism: posed, composed, in action, and performed. For the sake of this discussion, I collapse these constructs into a single paradigm of constructed performativity in Man Ray's surrealist representations of automatism in 1924. Is not the portrait *'en acte'* (in action), to use Chéroux's words, of Simone Breton at the typewriter and surrounded by surrealists more than a mirroring of the other automatic operation performed by Desnos?[47] It is at once 'in action', performed, and entirely composed by the photographer. Man Ray's *mise-en-scène* sets up a reverberation between devices, operators of devices, and different kinds of recording: machinic typewriting, photographic exposure, and automatic dictation to the mind.[48] Typewriter, camera, and mind are triplet recorders of automatism, a rapid means by which to seize and document the fleeting.

The camera records the typewriter's registering of automatic thought on the sheet of paper. But more than that, the communication between these 'devices' also suggests that the automatist receives and records at once, in a single motion that melds the immediacy of reception with the mediation of written registration. Automatism results from a dually functioning machinic device or tool that combines the receptive indexicality of the instant with the recording of the transmission, creating, in Marguerite Bonnet's words, 'two directly antagonistic states' of 'passivity' and 'vigilance' in the 'recording of results' (*enregistrer les résultats*) – a counterpoise of 'incessant tension' and 'game'.[49]

The initial recording of those results is typically 'autographic', or written by the hand of the self, as Barnaby Dicker has pointed out.[50] For Dicker, following the theories of communications theorist Walter J. Ong, this autographic recording of an interior voice brings writing to the limit where immersive orality, as spoken and aural speech, meets interiorised literacy, as written and read language. While there is no doubt that the immediacy and authenticity of the graphic trace, as drawn line or inscribed language, is privileged in surrealism before World War II in particular, the re-recording or registration (*enregistrement*) of graphic automatism as typed transcript or autographic facsimile is also of immense concern. Surrealism aims to remove automatism from the individuation and interiorisation that Ong saw unfolding progressively in society as a result of the 'technologizing of the word' via the rise of print culture. This *enregistrement* or technologising of surrealist automatism in its dissemination is arguably crucial to the depersonalisation of writing sought by its practitioners as an antidote to

bourgeois literature. The fetish of autography, handwritten surrealist automatism, typically gives way to published typescripts of this material in surrealist journals. The comparable immediacy of the written word thus becomes the mediated transcript of automatism, in which typographic writing promotes anonymity.

Man Ray contemplated affinities between the typewriter and the camera well before the founding of the Centrale. In a 1921 letter to Katherine Dreier, he wrote, 'I am trying to make my photography automatic – to use my camera like a typewriter – in time I shall attain this and still avoid the irrelevant for which scientific instruments have such a strong penchant.'[51] The camera and the typewriter both produce 'desublimated texts', to quote Rubén Gallo, in which authorship is dissociated and dematerialised through the automatic device.[52] As Gallo noted, the typewriter copies spoken or written speech through typographic characters in ink, imprinted by the serial striking of so many keys, while the camera captures reality through indexical traces on emulsion-coated film, resulting from a single click of the shutter.

The indexical recording of the camera as a 'blind instrument' (*un instrument aveugle*), according to André Breton in an essay from 1921, is therefore the perfect correlate for the fantasy of immediacy in surrealist automatism.[53] Maurice Blanchot wrote in 1949 of this impossible surrealist desire for 'prodigious continuity' between feeling and the perception and transcription of feeling.[54] Meanwhile, what the typewriter's employment of typified language through imprinted typographic characters lacks in immediacy it gains in the newfound legibility of transcription and registration.[55] As Michel Foucault observed in *L'Archéologie du savoir* (*The Archaeology of Knowledge*) (1969), although the sequence of letters AZERTY on French typewriter keyboards possesses no sense as word or phrase, this formation nevertheless makes an impactful statement about the way language is supervised by society. The typewriter instantly orders the flow of thought as prescribed language and therefore captures, records, and registers thought as regularised lines of words.[56]

In his 1921 essay on the artist Max Ernst, André Breton called automatic writing a 'veritable photography of thought' (*véritable photographie de la pensée*).[57] This statement has prompted scholars such as Tessel Bauduin to characterise this practice as an overarching 'technique' for immediacy of contact in surrealism, resulting in a primacy of product rather than a secondary tracing from the unconscious.[58] Breton's claim, based on his reading of Théodore Flournoy's accounts of the Swiss medium Hélène Smith, that surrealist automatists were 'simple receptacles of so many echoes, modest *recording instruments* [*appareils enregistreurs*]', has also been emphasised by scholars.[59] Breton partly developed this idea based on a passing comment made by Jacques Vaché in one of his last letters to Breton, in which Vaché claims more than ever to be an 'unconscious recorder of many things' (*enregistreur inconscient*).[60] Sigmund Freud's conception of the 'psychic apparatus' (*psychischer Apparat*), which first appeared in *Die Traumdeutung* (*The Interpretation of Dreams*) in 1900, also possesses resonance with Breton's notion of the automatist as a camera or recording device.[61]

In her detailed discussion of the influence of dynamic psychiatry practitioners such as Pierre Janet on André Breton, Jennifer Gibson has privileged the construction of the automatist as simultaneously 'transmitter and recorder'.[62] Man Ray's staged shot in the Centrale depicts automatic writing as a broadcast signal as well as copied dictation, a live feed of immediacy and also feedback that is the 'blind' transcription of thought. Photography reveals the machinic mediation of the 'inner voice', which dominates the self in the act of automatism through transcription as *enregistrement* and storage of data.

Simone Breton, automatist

If, in the construction of Man Ray's photograph, Man Ray, Robert Desnos, and Simone Breton are all operators of automatic devices that receive/record by the same process, what is the significance of Simone's part of the composed performance? It is not only the question of her differentiated gender performance that is striking but also the highly gendered nature of her work performance. Secretarial labour, already a feminised social role by the interwar period in France, modulates a symbolic understanding of the typewriter as an early device of communication technology or even as proto-information technology. The typewriter itself is associated with femininity to the degree that it feminises its interwar users. As Fredrich Kittler summarised, the typewriter 'inverts the gender of writing'.[63] Moreover, I concur with Bauduin that psychic automatism is a 'radical transgression of gendered categories' and that in its practice – as influenced by the nineteenth- and early twentieth-century history of automatic writing in the hands of the spiritualist medium or the female hysteric – male surrealists 'appropriated a "feminine" practice for themselves *as men*'.[64] Just as clerical work was feminised at the turn of the twentieth century, surrealists feminised the labour of writing as instant recording. This occurred in the act of submitting to what Brian Rotman labelled the temporary dominance of the '*para-self*' produced by the disembodying fragmentation that characterises mediatised language.[65] It is this act of recording and receiving in a performance of mediated language that links the surrealist automatist to the hysteric and the medium – as well as the female secretary. The automatist *feminises* labour in order to privilege a different 'self-enunciating agency' that appears as a result of the 'ghost effect' stemming from the abstraction of inscribed language as a registered mediation of orality.[66]

For Robert Belton in *Beribboned Bomb*, in a section called 'Automatism as a Secretarial Science', surrealism is fully consumed by patriarchy's instrumentalisation of woman as corpus and symbol, and in surrealist automatism, woman is exclusively a 'catalyst' for male agency and individuation.[67] Belton examined the same Man Ray photograph of Simone at the typewriter and concludes that it captures the essence of the feminine gender caught in the machinations of phallocentrism: 'It appears that the role of women in the new revolution was simply an analogue of that in the workaday world … Here Kahn passively acted as a bridge between the surrealist supply and the surrealist demand.'[68] Likewise, Ruth

Brandon's history of surrealism accords Simone Breton the same limited capacity: 'Her assigned role was that of helper and amanuensis.'[69]

Yet, things become more complicated as soon as biographical and textual details related to Simone Breton are examined, not to mention the broader context of women entering the workforce and finding access to certain kinds of agency through paid labour. Simone Kahn came from a haut-bourgeois Jewish family in Strasbourg who made their fortune in the rubber industry in Peru and returned to Paris to invest their capital.[70] She had a privileged upbringing at exclusive schools in Paris and, after France instituted a women's baccalaureate in 1919, she studied philosophy and literature at the Sorbonne in the early 1920s.[71] Involved with dada and avant-garde literary circles since the war years and possessed of strong opinions about aesthetics, she met André Breton in 1920 as a result of her connection to Adrienne Monnier's La Maison des Amis des Livres, where she was a regular.[72] She married Breton soon thereafter and quickly became a respected intellectual and a practising automatist in the emerging surrealist group.[73]

By the early twentieth century in France, many women pursued secretarial training in a professional academy or through classes offered by stenographic societies, typewriter manufacturers, or civic centres.[74] However, the typewriter in the Man Ray photograph was probably not Simone's personal machine. While Simone acquired her typing skills during her schooling (possibly as a requirement during her studies, since she did not depend upon remunerated employment), the only keyboard she touched with any great frequency was the piano.[75] The device she uses in the photograph is likely the *machine à écrire* (typewriter) donated by surrealist Pierre Naville that Simone inventoried in a handwritten 'État des lieux' note included in the Centrale log during the first week the office was open.[76]

It was André Breton, not Simone, who was much closer to the role of secretary, although the word *secrétaire* has a different connotation in French – indicating a male executive assistant. This remained a traditionally male work role during the World War I era. Likewise, Robert Desnos must have been an experienced typist, having served part of his military service during the war as a secretary and for a period after the war in a similar trade.[77] André Breton served as adviser and librarian to the fashion couturier, bibliophile, and art collector Jacques Doucet from early 1921 onwards.[78] In a letter from July 1921 to her cousin Denise Lévy, Simone described her future husband's employment as an executive *secrétaire* for the 'multi-millionaire collector' as 'rather agreeable and not very demanding'.[79] André seems to have found the job quite boring and sometimes frustrating.[80] The couple lived on the position's fairly generous salary until early in 1926. They were also assisted financially by the dowry provided by her affluent parents.[81] Like many surrealists, Simone did not work for a wage.

Simone was a confident producer of surrealist automatism, both individually and collectively during the *rêve éveillé* séances of 1922 and 1923 in Paris. Yet she published just one automatic text during her lifetime. It appeared in the same inaugural issue of *La Révolution surréaliste* published on 1 December 1924

that featured her photograph twice on the cover with other surrealists. Printed alongside twelve other examples of automatic writing by male surrealists such as Breton and Desnos, Simone's text is signed with the initials 'S. B.' rather than a full name, as was the case with most of the other texts by men, although Renée Gauthier's dream narration in the same issue bears her full name.

In *Surrealist Women: An International Anthology* Penelope Rosemont noted that Simone Breton was 'an enthusiastic player of surrealist games', such as the *cadavre exquis* (exquisite corpse), but added that Simone's role in the surrealism of the 1920s, before her divorce from André Breton in 1929, was in large part a relational one tied to group dynamics – significant though that role certainly was in the cenacle of surrealism.[82] Much like Man Ray's photograph, which arguably fashions her as a participant in automatism, although in a supporting role, the signing of her text as 'S. B.' in *La Révolution surréaliste* corroborates the thesis that her prominence as a core producer of surrealist automatism was publicly minimised at times.[83] Nevertheless, André Breton was privately proud of his wife's publication in the surrealist journal. In a letter to her of 4 February 1925, written on official journal stationery, he reports a review of the first issue of *La Révolution surréaliste* by a writer from *Le Radeau* (*The Raft*), who singled out Simone's initialled automatic text as notable. 'There's one for the scrapbook of my little Simone', he wrote in the typically tender tone he took with his wife in letters.[84]

Simone's lone published automatist foray is set in 'springtime'.[85] Moving between subjects that include the contest of love between men and women, maritime scenes with oceanic fauna, and evocations of death, Simone's entry in the first issue of *La Révolution surréaliste* is indicative of the tropes towards which the nascent surrealist group had already begun gravitating since the publication of *Les Champs magnétiques* by Breton and Philippe Soupault in 1920. At the same time, aspects of the text resonate with the query at hand, since they elide automatism with gender difference, sexual desire, and power roles:

> 'You wish my breast to be a snowball', said the young woman. 'Very well, I agree. But what will you do for me in return?'
>
> 'Make a wish, my divine! And I hope I can fulfill it!'
>
> 'I wish you to have, for seven days, as many sexes as you have fingers on your right hand.'
>
> And it happened that the young man was instantly transformed into a starfish. The girl leaned over to him, smiling contentedly.
>
> She thought, 'What am I to do? I did not know it was so easy to get rid of an overeager suitor. I am left with the trees and their majestic embraces.'[86]

A poetic metaphor for the female body's available utility (breast as snowball) folds over into her suitor's metamorphosis into an intersex animal. The female therefore places herself safely outside the male's desire to possess. Georgiana Colvile cites the influence of Robert Desnos on Simone Breton in this regard. Desnos often compared his love affair with the Belgian singer Yvonne George

to the image of a polysexed starfish.[87] Like many female surrealists, Simone was drawn to ideas of interspecies exchange between humans and animals as one way of questioning the gender binary and its associated hierarchies.

This notion of the transformative potential of sexuality is reminiscent of the way in which Simone Breton, writing in 1975 as Simone Collinet, described the automatism of the *cadavre exquis*. The exquisite corpse was an '*unfettering*' (*déchaînement*), an 'astonishing amalgam', an 'unpredictable combination of three or four heterogeneous minds'.[88] The exquisite corpse was a powerful method of surrealist automatism, she goes on to say, that facilitated the release of inhibitions, like 'even, perhaps, a kind of drug'. Most telling, she explained that with the exquisite corpse game, 'we were at once recipients of and contributors to the joy of witnessing the sudden appearance of creatures none of us had foreseen, but which we ourselves had nonetheless created'.[89] To be simultaneously recipient and creator is a highly feminising metaphor that relates back to statements published by André Breton during the 1920s about the necessity of falling into a passive, receptive, and available state in body and mind when deploying automatist techniques of different kinds.[90] In *L'Amour fou* (1937), Breton emphasised the importance to surrealism of the related term *disponibilité*, or openness and availability. *Disponibilité* recalls a common metaphor in his writings about the notion of automatism as impregnation and birth, such as in a notable passage about the *cadavre exquis* from 1948, which describes 'engendering' or 'producing' monsters not with one brain but with many.[91] If we see similar traces in Simone Breton's 1975 essay of this feminised metaphor of surrealist automatism as a collectively fashioned pregnancy followed by a birth of unknown creatures, it is also apparent that at least in some capacity she viewed it simultaneously as a tool of liberation, a delirious unfettering. Such a sentiment is reflected graphically in a 1924 notebook of automatic writing and cut-up poems by Simone.[92] In the 24-page text, Simone's handwritten dream account concludes with the hurried, enlarged scrawl, 'I Will be Free'.[93]

Simone Breton engaged in many proto-surrealist and surrealist automatist activities, including exquisite corpses and questionnaire games, between 1921 and until the end of the decade. She employed automatism on an individual basis during this period, in the form of cut-up poems made with newspaper fragments and handwritten automatist texts.[94] She was a major presence during the period of trances, which commenced in September 1922 – *l'époque des sommeils* (the era of slumbers) – as a rapt observer and note-taker, if not a hypnotic performer herself. It was Simone's notes on the surrealist séances that formed the basis for André Breton's description of this period, 'Entrée des médiums' ('The Mediums Enter') in the sixth issue of the journal *Littérature* in November 1922.[95] Simone was a key player during those soirées, and her presence had a potent effect on trance participants such as Desnos, who insistently inscribed her name onto paper while under hypnosis.[96]

Simone was a core contributor to the collection of the 42 rue Fontaine Paris atelier and apartment she shared with her husband. She was also a knowledgeable

art collector in her own right, who assisted in the organisation of surrealist art exhibitions and assisted various members of the group as an intermediary in art sales negotiations.[97] As a documenter of and correspondent for surrealism, Simone Breton was in a sense working to archive surrealism and its development. She sometimes assisted with the layouts for the journals *Littérature* and *La Révolution surréaliste*.[98] She also contributed in a more straightforward manner to the administrative business of running the Bureau of Surrealist Research in its first months. She reported to its office on Wednesdays and Saturdays with Jacques-André Boiffard, typing, transcribing, dealing with correspondence, and tackling other business. Her husband, André, joined Aragon at the Centrale on Mondays to accomplish the same kinds of tasks.[99] As a transcriber of surrealist manuscripts during this era, Simone played a key role as a 'first reader' of early automatist texts.[100]

On the Centrale's second day, 12 October 1924, its activity log indicates that the gift of a typewriter from Pierre Naville was received by the two surrealists on duty, Simone Breton and J. A. Boiffard.[101] Subsequently, correspondence and even typing were completed by the various male surrealists on duty at the Centrale.[102] However, by December 1924, Simone was doing more and more transcription of longer texts, such as the interviews that were being published in *La Révolution surréaliste*.[103] Meanwhile, André Breton recorded his frustration in the Centrale log with other members who were not maintaining the album of press clippings.[104] On at least one occasion, Simone expressed exasperation with such work imbalance. On 7 January 1925, she recorded a note in the Bureau log about 'the procedures employed with certain female members who come to handle certain chores and [are] treated like machines [*instruments*]' (Figure 2.5).[105] Her regular presence at the Centrale diminished thereafter.

Items in the Association Atelier André Breton online collection reveal something of the group dynamic and Simone's negotiation of it during this period. Consider the undated rating game (game of scores) devoted to the subject of women's sexual roles, women's professionalisation, and other gendered subjects that Simone participated in some time during the early 1920s with André Breton, Robert Desnos, Max Morise, Paul Éluard, and Benjamin Péret. Simone gave *ouvrières* (working women) a score of –1 out of a maximum of 20 and a minimum of –20. The group was evenly divided on this question: Breton wrote 5, Péret gave 3, Éluard gave the highest score of 20, and both Desnos and Morise said –20.[106] The only category of women on the list that Simone favours are streetwalkers (score 4) and brothel workers (score 5), while married women, virgins, and sophisticated women of the 'world' all receive –20. To attempt to classify Simone Breton's feminism or her views on women's professionalisation is necessarily a fraught and incomplete endeavour.

Even when other women were present at surrealist gatherings during the mid-1920s, Simone was one of the few who repeatedly engaged in written automatism, an isolation that would eventually change over the course of that decade.[107] When Man Ray's photo shoot for the cover of the first *Révolution surréaliste* took place,

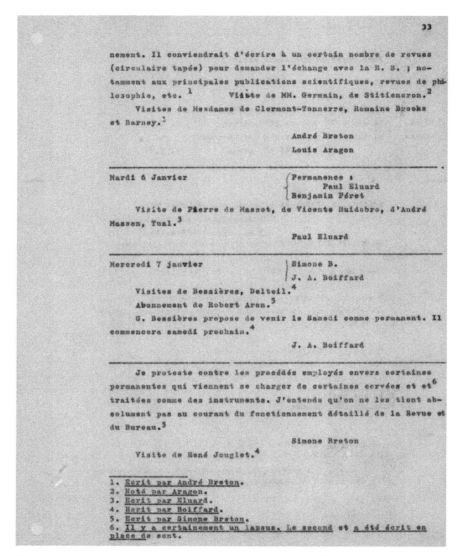

Figure 2.5 Simone Breton, *Cahier de la Centrale surréaliste*, 1924–25, typed transcript, p. 33

Simone was prepared to sit down in front of the typewriter much like a typical *dame dactylographe*, or female secretary.[108] As Georgiana Colvile has eluci-dated, 'In this photo one can see the young wife of Breton as much a queen as a subordinate, or perhaps in a situation of antinomy, a combination of the two.'[109] However, if Simone Breton did pose as if taking dictation on the typewriter from either Desnos or her own mind, it was not because, as a woman, she was the only

trained typist in the room, nor because she was not an automatist herself – nor necessarily because she was a subservient female symbolically instrumentalised by the masculine symbolic order. Surrounded by a nimbus of suited men, Simone types 'second state' murmurs, words written in a trance, in part because surrealist automatism sought to emphasise its bureaucratic significance as a transmission of information, mediated and recorded directly from the unconscious and linked with the positivism of psychical research and the talking cure of Freudian psychoanalysis.

If there was ever a typed version of Desnos's trance shown in Man Ray's photographs, it may have been transposed onto official Bureau stationery, as was often the case with surrealist automatist texts in the mid-1920s. The flow of unhindered language received from the unconscious is therefore also processed, filed, and registered, and technologised by the Bureau. Sven Spieker perceptively detailed this aspect of early surrealism in *The Big Archive: Art from the Bureaucracy* (2008), which discussed the activities of the Centrale as 'The Bureaucracy of the Unconscious'. Characterising the image of Simone typing, he proffered, 'Nowhere was early surrealism as close to the office as in the practise of automatic writing … that most clichéd of all office situations whereby the boss dictates a letter to the secretary, who types away as fast as she can with her thoughts elsewhere, oblivious to the meaning of the words.'[110] Remaining unaddressed, however, is the question of the female gendering of this automatist labour and the relational aspect of dominance and submission implied therein. What are the gendered power dynamics that built and maintained the surrealist archive?

Tracing stenographic surrealism and the dame dactylographe

Perfect transcription

If we go beyond sexist and reductive tropes about female secretaries and explore some of the myriad cultural references that synchronise World War I secretarial industries with some aspects of surrealist automatism, a subtle picture of the nature of surrealism's appropriation of bureaucratic office culture begins to coalesce. Aspects of early surrealism are relatable to things such as the burgeoning secretarial trade after World War I in Western Europe, England, and the United States; occupational sex-typing and the segregation of labour based on gender; and the widespread use of typewriters and other automatic devices for mechanised writing and copying during this early stage of postindustrial capitalism. In other words, surrealism arises at the nascence of the information age.

The surrealist inclination towards office tasks, paperwork and information machines started well before the movement was officially declared, and therefore was substantially shaped by dada in this regard, and in turn, by dada's own interest in futurism. Marcel Duchamp's early readymade *Traveler's Folding Item* (1916), a vinyl cover for an American-made typewriter on a stand, exhibits the ubiquity of this device in Western European and American culture at this time, although it is

unlikely that news of Duchamp's gesture made it to Paris from New York during the war. There were more proximate associations. André Breton included a letter from 1917 by his friend Jacques Vaché in *Anthologie de l'humour noir* (*Anthology of Black Humour*) (1940) mentioning the zoomorphic 'octopus typewriter', the preferred instrument of the practitioner of what he called 'umor' in opposition to poetic aestheticism. Erik Satie and Jean Cocteau incorporated the noise of a *machine à écrire* into the score for their ballet *Parade* that year, probably influenced by F. T. Marinetti's earlier debut of a chorus of typewriters at a futurist soirée in Italy.

That the surrealists themselves saw an explicit, if often ironic, link between the practical mechanics of secretarial science and surrealist automatism is telling. In 'Entrée des médiums', André Breton stated that he had planned to start recording his dream narratives 'stenographically' to avoid literary stylisation in the writing, but his faulty memory of his dreams posed a problem.[111] The precedent for this shorthand form of notation was his completion, with Philippe Soupault, of the collaborative automatic text *Les Champs magnétiques* over six days in spring 1919.[112] In that context, surrealist stenography initially was understood to be a specific type of anti-aesthetic writing. Breton noted that they wrote 'with such speed that *we had to resort to abbreviations* in order to get them all on paper'.[113] They did so in both pencil and ink cursive written on the cheap paper of school composition books and in a range of three different speeds, not unlike secretarial drills: from fast to very fast to the fastest handwriting possible.[114] David Gascoyne has emphasised the 'discipline involved in automatic writing', which involved a sensitive apperception of the voice of the unconscious while simultaneously resisting the background noise of conscious thoughts.[115] Breton underlined this in 'Entrée des médiums', describing the 'self-sufficient murmur' of 'our own unconscious' as requiring an 'obedience' to '*dictation*'.[116] This also calls to mind what Michel Butor terms the incorporation and obsfucation of the role of the scribe into the body of the author in the era of the typewriter, the era of writing's 'ideal continuity', and the era of surrealist automatism: nothing stands in the way of the transference of the dictation to the sheet of paper, 'not even the body'.[117]

On at least a couple of occasions Breton and Soupault's writing sessions for *Les Champs magnétiques* filled the length of a normal work shift in that era, eight to ten hours long, with the writers sometimes seated directly across from one another, passing sheets back and forth.[118] Neither writer had full-time employment in this era; moreover, their activities were limited given that the influenza epidemic was still raging in spring 1919. There was something viral about their automatist composition method. Individual authorship was blurred by what Marguerite Bonnet has called a 'montage' process of reordering sections, as well as redacting, selecting, and correcting words and passages.[119] Deletions and additions made by hand were ultimately disguised through the manuscript's transference into typography for its 1920 publication by Au Sans Pareil.

Jacqueline Chénieux-Gendron has convincingly juxtaposed the editorial 'labour' of automatism as a form of transcribed dictation in 1919–20 with the 'play' of automatism by 1930,[120] underlining the notion of 'travail automatique'.[121]

The conception of surrealist automatism as stenographic notation, processed code rather than *écriture*, is just one aspect of a trope that had a subtle but persistent life in the development and history of the movement.[122] The association of secretarial work as female gendered labour was also paramount in broader modernist examples in France in the World War I era. In his poem 'Zone', published in the 1913 book *Alcools*, surrealist mentor Guillaume Apollinaire (pioneer of the typographic *calligramme*, a form of poetic *dactylogramme* composed on the typewriter) had already written of a typical morning in urban Paris, describing 'les directeurs les ouvriers et les belles sténo-dactylographes' (the directors the workers and the beautiful lady secretaries) heading to their jobs.[123] Thereafter, the typist-as-automatist comes into being as a subtle thread that runs throughout Paris dada, proto-surrealism and surrealism during the 1920s and, to a lesser degree, surrealism of the 1930s.

The typist-as-automatist trope initially appeared around 1919, the same year that Breton experienced his first hypnagogic phrases and delved into *l'écriture automatique* with Philippe Soupault. This was also the era in which George Grosz, Walter Mehring, and others staged a speed race between a sewing machine and a typewriter at a Berlin dada performance: a starting gun was fired and the sewing machine eventually won.[124] Yet, if surrealism absorbed its preoccupation with the speed of the typewriter from dada's escapades with this apparatus, it also took cues from futurism on how best to amplify the cacophony of the typewriter. In Aragon's first volume of poetry, *Feu de joie* (1919), the poem 'Soifs de l'ouest' ('Thirsts of the West') explains how revolvers and typewriters compete for explosive power: 'Ah if I had my revolver / to interrupt the music / the polyphonic song / of a hundred typewriters'.[125] A year later, Soupault's prose piece, 'Machine à écrire dada' ('Dada typewriter') from *Littérature* 13 (May 1920) sarcastically proclaimed, 'Ever since we were born some lazy gits have been trying to convince us that there's such a thing as art. Well we're even lazier and today we're gonna say it loud and clear: "Art is nothing".'[126]

Breton and Soupault's four-act play *S'il vous plaît* (*If You Please*), which debuted in March 1920, is replete with automatic passages. It features a 'dark' and 'pretty' typist, who takes dictation from her employer, Monsieur Létoile, a middle-aged man with glasses and a Legion of Honour rosette on his lapel.[127] In Scene 11, Létoile and the typist pursue an intimate automatic dialogue, tinged with erotic sentiments, in front of a map of France that hangs on the wall. In the midst of the typist asking for the afternoon off and telling her boss about the 'contradictory orders' he gives her, Létoile says, 'You are beautiful, my child … are you afraid of me? Do you understand what goes on here?' The 'dark' and 'pretty' typist responds with a lilting automatic passage, rare in its performative embodiment in surrealism as a working woman's speech:

> There are other whirlwinds – the intoxication of parties and the contradictory orders that you give. It's like when one is lying in the arms of pleasure close to midnight, when the concern of mother and brothers doesn't count anymore; one

loses all sense of wrongdoing and leans back with closed eyes against the comfort of a tree. The department stores could catch fire; all the prayers could be prayed; the early paradise is far. For the time being one returns to the brightly lit bars and in one's heart broods about the barbarous acts which are being committed all over the world.[128]

Debuting so close on the heels of *Magnetic Fields*, the appearance of the contemporary female type of the *sténo-dactylo* in the theatrical *S'il vous plaît* positioned her as a figure for automatism going forward, between the period of proto-surrealism and surrealism, as even a glimpse at a partial selection of references reveals. In 1922, which saw the efflorescence of spoken automatism in *l'époque des sommeils*, André Breton published in the first issue of the new series of *Littérature* an early version of his 'Récit de trois rêves' ('Story of Three Dreams'), the prose piece which opened his volume of poetry published a year later, *Clair de terre* (*Earthlight*), with the credit, 'stenography by Mademoiselle OLLA'.[129] In the same year Francis Picabia brandished a staccato prose text, 'Dactylocoque', in the seventh issue of the new series of *Littérature* in December, and in 'Au 125 Boulevard Saint-Germain', Benjamin Péret anticipated his own trance experience in his description of '*dactylographes*' in a brightly lit room who 'were typing feverishly on machines from which writings were emerging automatically [*automatiquement*]'.[130]

In André Breton's automatic text *Poisson soluble* (written 1921–22; published 1924), an 'ordinary little *dactylo*' appears in conjunction with a 'famous séance in the printing plant'.[131] Desnos featured young, female typists in both *Les Pénalités de l'enfer ou les nouvelles hébrides* (*The Penalties of Hell or the New Hebrides*) (1922) and *La Liberté ou l'amour!* (*Liberty or Love!*) (1924). By 1927, the trope of the secretary automatist was apparently familiar enough for Louis Aragon to make a jab at writers who employed the secretarial science in a self-conscious manner; 'people who dictate … typists of poetry, stenographers of anguish' are among the list of literary types that Aragon blasts in his barbed polemic, *Traité du style* (*Treatise on Style*).[132]

In the 1924 *Manifesto*, André Breton described how to achieve the 'written surrealist composition', which is both a 'first and last draft', an instantaneous record.[133] 'After you have settled yourself in a place as favourable as possible to the concentration of your mind upon itself, have writing materials brought to you. Put yourself in as passive, or receptive a state of mind as you can.'[134] Speed of writing sustained through the duration of work sessions, relentless avoidance of careless mistakes in perfect receptivity and accurate recording, abbreviation of words, and certainly abandonment of punctuation and syntax – all these efforts were factored into the technique.[135] Discipline, submission, and endurance are required rather than talent – but at the same time, the surrealist automatist must balance keen listening and heightened perception with involuntary openness, a 'complete state of distraction'.[136] What Peter Bürger called the compulsion (*der Zwang*) to follow pre-set rules in his discussion of surrealist automatism is also the freeing (*die Befreiung*) of volition.[137]

'This is very difficult', Breton asserted.[138] The automatist is consumed in the act of hearing *'the surrealist voice'* without a 'filter', as 'simple receptacles of so many echoes, modest *recording instruments* who are not mesmerized'.[139] To do this, Breton wrote in the *Manifesto* of 'sleeping' or 'surrendering' (*se livrer*) so as to 'stop imposing' the 'conscious rhythm of my thought' and thereby quieting 'interference'.[140] At various points throughout the *Manifesto*, Breton asserted the dominance and 'inexhaustible nature' of this voice, which 'instructs' and dictates in a 'monologue spoken as rapidly as possible'.[141]

In André Breton's recorded interviews with French National Radio reporter André Parinaud in 1951, he explicitly linked stenography or 'shorthand notation' to automatic writing.[142] Breton differentiated the surrealist practice of 'hypnotic slumber' from 'automatic writing' as distinct methods that seek the similar goal of reaching pre-cognitive *'trance-like states'* through auto-hypnosis – what he called 'états seconds'.[143] Both hypnotic slumber, as a type of lucid dreaming, and the discipline of automatic writing attempted to free or dissociate the mind from the 'parasitic nature' of the body by blocking external stimuli so that an internal murmur could be heard by individual people *'in themselves'* and not *'elsewhere'*.[144] This 'state of total receptivity' to the murmur required an 'extremely sustained tension or effort' in order to 'have ears only for "what the mouth of shadows says"'.[145] Despite the surrealist 'hatred' of the 'sacred value' of bourgeois 'work',[146] Breton insisted that surrealist automatism is not *'laziness'*. Instead, the 'extremely sustained tension or effort' of surrealist automatism has to fight against an 'undeniable monotony' by varying velocities from 'calm' to 'so fast that we could hardly read it'.[147]

For Breton, the faster the pace of automatism, the more profound the 'discoveries'. This realisation led him to the idea of employing shorthand in automatic writing.[148] Such a development is echoed by the first 'general secretary' of the Bureau de recherches surréalistes, Francis Gérard,[149] who wrote in his short essay 'L'État d'un surréaliste' in the initial issue of *La Révolution surréaliste* that there are three states of automatism, the most desirable of which achieves a perfect fluidity of speed.[150] By the time the second issue of the journal was published in January 1925, Antonin Artaud had taken over the direction of the Bureau from Gérard and its doors closed to the public. The last page of that issue, however, reasserts the importance of the office to the surrealist enterprise with its publication of the statement 'Le Bureau de recherches surréalistes', which is accompanied by a found photograph of the disembodied head and hands of a female mannequin displayed in a box (Figure 2.6). The surrealist fascination with shop-window mannequins is well documented, but in the context of the essay on the Centrale's surrealist office work, the photograph of the boxed mannequin also recalls the image of the young *dactylo*, who disassociates hands and mind to more effectively reach the *vitesse* quotas of her rationalised touch-typing.

In a commentary on *Les Champs magnétiques* written in 1930, André Breton included a detailed 'tableau des vitesses' he claimed 'necessary' for comprehending the writing technique utilised, which, he asserts, 'undeniably' influenced what

BUREAU DE RECHERCHES

Figure 2.6 Unknown artist, untitled photograph. Published alongside 'Le Bureau de recherches surréalistes', *La Révolution surréaliste* 2 (15 January 1925): 31

was composed.[151] He lists five different speeds used in the various sections of the text: v, v', v'', v''', v'''' – all corresponding to desired 'atmospheres', such as 'despair', or in some instances, mnemonic states of mind beneficial for recalling childhood.[152] The problem for Breton was the fact that his automatic shorthand was often taken after the fact of hearing the murmur of the unconscious, from memory – which is, according to him, 'profoundly deficient … and not very reliable'.[153] In response to this shortcoming, the surrealists instead often focused their attention on taking notes of the automatic trances by *other* surrealists who recited aloud what the unconscious dictated, thus creating a second stage of transcription – copying and recording. The desired immediacy became mediation. Such was the case with the notes taken by Simone at an early trance session on which André Breton at least partially based 'Entrée des médiums'. This fact is further recorded by Giorgio de Chirico in a caustic account of *l'époque des sommeils* in his memoirs: 'Breton would give orders and issue instructions; scribes and stenographers would rush up with paper and shorthand pens so that they would not lose a single word of all the idiocies which the pseudo-medium rattled off.'[154] Although de Chirico sought to ridicule this practice in his statement, surrealism's desire for the accelerated registration of the automatic trace was an earnest one. In the first issue of *La Révolution surréaliste* dating from 1924, the cover of which

brandishes the very scene of Simone Breton's transcription of automatism, Max Morise declared in his essay about automatism, 'Enchanted Eyes', 'Let's admire the fools, the mediums, who find a way of fixing their most transient visions just as the artist devoted to surrealism tends to do for slightly different reasons.'[155]

As is evident from Morise's statement, the secretarial aspects of surrealist automatism often literally went hand in hand with the mediumistic associations in the group's discourse, the stenographic nature of its transmission and documentation modulating the oracular components. Likewise, a surrealist secretarial trope resonates with the fetishised passivity that the surrealists perversely identified with in the figure of the *femme nerveuse*, the hysteric. Although the secretarial aspect of surrealist automatism is manifestly less overt in the movement's rhetoric of this period than were associations with the medium and the hysteric, the contemporaneous trope of the interwar secretary nevertheless emanates powerful significations in relation to issues that were of dire consequence for the surrealists, such as the war, nationalism, and mores of the bourgeois lifestyle like the work ethic. Seen in Man Ray's cover photographs for *La Révolution surréaliste*, Simone's performance as a *dame dactylographe* underlines the profound contextuality of surrealist automatism.

The sténo-dactylo during the World War I era

As the Bretons and their associates collected energies for a break with dada, the visual trope of the modern secretary, *la dactylo*, sexualised as much as mechanised, was catching eyes and stimulating fantasies across France. The mass feminisation of secretarial work, a result of the division of labour into genders as well as tasks, occurred roughly concurrently with the mobilisation of men in World War I.[156] As early as 1914, nine out of twelve government offices had a female typing pool to produce the tide of papers required for a complex system of commercial and governmental bureaucratic communications.[157] The feminisation of secretarial labour quickly solidified in Western Europe and the United States at the turn of the century, and what had been a man's position of clerk, copyist, scrivener, or amanuensis in France during the mid-nineteenth century became, for the most part, a woman's role, that of the *sténo-dactylographe*, by the advent of World War I.[158] By 1919, a modern office in the United States (and to a lesser degree in France) featured typewriters as well as a wide array of other devices and tools: telephone, telegraph, dictating machine (Dictaphone), stenotype, copy press, carbon paper for copies, typesetting machines, and so on.[159] This process of automation was heightened following the mass commercial marketing of the typewriter in the 1880s – a machine that soon evolved into a metonym for woman herself as a professional 'typewriter'. Before his death, Christopher Latham Sholes, one of the American inventors of the commodified typewriter, spoke with pleasure of the typewriter as an emancipatory device for women. In the late 1870s, Sholes posed his daughter in front of one of his early typewriter models. Later in life, he referred to his portable model with a disturbing metaphor, the 'little abortion'.[160]

In France as elsewhere, the typewriter itself became associated with feminin-ity through its demand for delicacy and accuracy in careful but rapid handiwork, often related at the time to the dexterous skills of sewing or playing music. In France, a so-called *femme de clavier* might have her hands on either kind of keyboard.[161] Typewriters could also be linked with another type of machine asso-ciated with women: the sewing machine. Delphine Gardey has explained how the earliest typewriter models available in France in the 1880s were strikingly similar to sewing machines: pedal-operated, decorated with the same flourishes, and even assembled in Remington sewing-machine workshops.[162]

Efficiency and productivity of output were major concerns of the Taylorist sci-entific management of labour that sought to maximise the surplus value of work through frontline micro-management and the subjection of workers to increases in the speed of production, often managed by specialised time-management per-sonnel (*chronométreurs*) hired by factories to conduct studies of worker efficiency on the assembly line.[163] Taylorism was at its peak in industrialised nations by the first decade of the twentieth century and was widely applied in office work.[164] But in the realm of writing and transcription, stenography and typewriting pre-dated Taylorist time-saving methods – and may have even inspired them to some degree in terms of the efficiency of movement required in their execution. Velocity and accuracy were the main goals of secretarial transcription and information pro-cessing, and the incredible pace of world typing competition champions were regularly touted in *dactylographie* manuals. One French teaching manual on the method of stenography from 1917 accosted the working subject with the management declaration 'PRÉCISIONS! PRÉCISIONS! PRÉCISIONS!'[165]

The stenography manual's original owner, a certain Lucienne Marchal, signed her name on the cover. One wonders how well she obeyed the direc-tives in the manual urging students to practise the suggested 'exercices de vitesse'.[166] Resonances with surrealist automatism abound in this regard. The 'vitesse' exercises indicated three different speeds of stenographic transcription, from the slowest speed of 80 words per minute for copying from notes to the higher pace of 100 and 120 words per minute for taking voice dictation from a Dictaphone machine or an employer. The Prévost-Delaunay system, a geometric shorthand based on circles, curves, and straight lines that register language pho-netically, is a script that resembles nothing so much as abstract doodles. It also happens to recall the tracings of somnambulistic 'Martian' language pioneered at the turn of the century by the spiritualist medium admired most by the surreal-ists, Hélène Smith (Figures 2.7 and 2.8).[167] 'Avoid nervousness, uncontrolled and jerky inscriptions, as well as useless gestures', the manual directs, as if in response to the extravagant flourishes of Lucienne's calligraphed signature appearing time and time again throughout its pages.[168]

By the first decade of the twentieth century, the typewriter was popular enough a writing tool in France that stenography expert Albert Navarre and others in the field attempted to improve the still-imperfect AZERTY keyboard that had been inherited from American machine design (and was preferred in France over the

Figure 2.7 Hélène Smith, text no. 28 (8 October 1898): Martian language copied under visual hallucination. Published in Théodore Flournoy, *Des Indes à la planète Mars: étude sur un cas de somnambulisme avec glossolalie* (1899)

Figure 2.8 Example of Prévost–Delaunay stenography. Ernest Olriau, *Cours élémentaire et supérieur de sténographie* (Paris: Berger-Levrault, 1917), 66

QWERTY keyboard).[169] In a 1926 French typing manual, 40 to 60 words per minute is the recommendation for the ten-finger method of touch-typing, in which typists are taught to discipline their corporeality by imagining their fingers inscribed with corresponding letters of the keyboard. The letters were literally at their fingertips, with the keys acting as a prosthetic extension of their alphabetised bodies. Typists are told to 'pay attention to disorganised gesticulations' that result from the 'ignorance' of certain practitioners.[170]

Above all, the student of secretarial science in France sought to achieve flawless *automatisme*. Students were told to control themselves and '*éviter les mauvaises habitudes et gagner l'automatisme désirable*' (avoid bad habits to cultivate a desirable automatism).[171] A 1916 American secretarial manual written by Ellen Lane Spencer advises how to handle workflows in a tone that resembles the surrealist dictates for *l'écriture automatique*: 'While in the private office of your employer, forget your personality and the things that concern you. Shed them like an outer wrap on the threshold when he calls you to take dictation, and go in with an adaptability and pliability of mind that will enable you to fall in with the mood of the man whose letters you take.'[172] Blankness of affect was key to taking good dictation. The fourth lesson of the 1926 typing manual from Albert Navarre proposes an almost surrealist automatist writing exercise for the student, involving copying the following phrases out of the manual onto the typewriter: 'You are always wise. The war is sad. The pretty toys. Suffer. Die. Marie is always sad. The orchard's apples'. Or, 'He went to the beach. The hussars of death. Catch the pink flower. Tie down the murderers. Scratch your skin and make it red. He must go to hitch up the mare and leave.'[173]

Connotations of the secretary as a femme fatale, rather than an *ingénue*, began to surface by World War I, possibly because the American company Remington Arms manufactured the first typewriters and remained for decades the leading seller of both typewriters and, of course, firearms. However, this was also the case because the sub-machine guns used by American gangsters during Prohibition made a sound that later gave them their nickname, the 'Chicago typewriters'. Such details are partly why Friedrich Kittler fixated on the typewriter as 'a discursive machine gun', although this evocation of violence is inseparable from the lens of gender and sexuality in his argument.[174]

Pulp books such as *Maud, dactylo* (1926) by Paul de Granier, with its sexualised cover illustration, *Jolie dactylo* (1927) by Paul Dancray, and even the lascivious *La Dactylo perverse* (1927) by René Virard, peppered with erotic illustrations, paved the way for a broader spectacle culture of the *dactylo* in French popular cinema, beginning in the late 1920s with *Sa Dactylo* (1928) and followed by examples such as the feature-length comedy *Dactylo* (1931) by Wilhelm Thiele. A postcard that circulated in France in the early to mid-1920s shows a female worker more interested in casual sex than marital bliss, with her open legs, provocatively resting on the table, acting as metonymic replacements for typing fingers poised on the keyboard (Figure 2.9). Some versions of this scenario, prevalent in French postcards after the war, also display the female 'typewriter' straddling the table as she

Figure 2.9 Unknown artist, untitled postcard photograph, *c.* early 1920s

works, legs dangling on either side, her sex on the same level with the machine.[175] The implication is not so much that typing is a form of self-gratification – the tactility of the actions stimulating the fingers towards self-caress, with the machine as a pleasure device – but rather that typing creates an erotic submission of the worker to the penetration of labour and also, by implication, to the supervisor. Accordingly, Rosemary Pringle investigates the fetishism of 'sexy secretary' fantasy images and scenarios, with the typewriter serving as a phallic object that 'empowers' the castrated woman while simultaneously rendering her an available object, receptive to the touch.[176]

It is important to remember that the situation of working women in France was markedly different from those in other Allied nations, such as the United States, a distinction which may have fuelled the surrealist attraction to the media image of the secretary in their national context. France, like the United States, promoted the mass mobilisation of women for factory work during World War I: roughly half a million women aided in the war effort, and in 1918 they counted for 46 percent of the labour force.[177] In the interwar labour market, reconstruction propaganda advocated for the removal of women from the workplace so that demobilised veterans could return to wage labour and gender divisions could be restored: women would be sent back to the home to provide unpaid reproductive labour, or to lower skill and wage levels.[178] Thousands of women lost their jobs, although many women also managed to retain positions.[179]

The increase of women in some but not all areas of the French workforce during World War I did not have an immediate impact upon reforms in women's labour rights, which only evolved in the final quarter of the twentieth century.[180] Maternity leave for working mothers had already been established before the war, and women were banned from night work in 1892 (the French labour code extended these rest hours in 1925).[181] But the question of equal pay for equal work was far from being resolved. Despite their unionisation (beginning in 1899 under the modestly sized Syndicat des femmes sténographes et dactylographes, with necessary authorisation by a husband until 1920), French *sténo-dactylos* confronted significant obstacles in the labour struggle.[182]

In 1920, the year that American women won the right to vote, French women faced a new set of pro-natalist anti-abortion and anti-conception laws: one to six months' imprisonment and a fine of 100 to 500 francs for anyone found promoting birth-control information or facilitating contraceptive use.[183] Another law of 1923 battled neo-Malthusianism by punishing abortions. Anyone procuring or participating in an abortion as a doctor, nurse, or midwife could be jailed for one to five years; a woman who obtained an abortion could be imprisoned for six months to two years and fined. Guillaume Apollinaire anticipated the extent of these societal tensions in his wartime play, *Les Mamelles de Tirésias* (*The Breasts of Tiresias*) (1917), in which his new concept of *surréalisme* is dramatised as gender reversal: a dissatisfied wife decides to become male and forces her husband to assume the female role, following which he gives birth to over 40,000 babies in one day.

While World War I did stimulate the entry of women into the labour force in France as it had in other Allied countries, these fertility laws of the 1920s created an even more fraught situation for women aspiring to work than had existed before the war.[184] Professional employment for women was discouraged, while bearing children and carrying out free reproductive labour in the domestic space was endorsed as a patriotic cause. In 1920 a Family Medal award was established for mothers of five or more children, as were state-funded birth bonuses.[185] Moreover, it was not until 1965 that France's Napoleonic Code, which legally required women to obtain permission from their husbands to gain employment, was overturned.[186] The final page of the aforementioned 1917 stenography teaching manual in my collection states, 'The condition determining the married woman's role as *commerçante* (shopkeeper) is to be authorised by her husband.'[187] A 1926 Parisian typing instruction manual proclaims the necessity of 'morality' for the *dame dactylographe*, who must be 'conscientious above all' and should 'execute with docility the orders that are given'.[188] If a woman wanted to be a shorthand typist for government offices in 1926, official rhetoric stated that she needed to procure a 'certificate of morality' from the mayor or the police chief of her district.[189]

Given these conditions, most cultural clichés of employed women in France, whether *ouvrière* (industrial worker) or *employée* (white-collar worker), were embattled signifiers during the first half of the 1920s. The secretary was one of the most visible, sexualised, and controversial icons of the working woman at this time, as compared with the female factory worker or even the fetching *laitières* (milkmaids), *vendeuses* (shopgirls), and *midinettes* (seamstresses in haute-couture shops) that Marcel Proust longingly describes in the fifth volume of *À la Recherche du temps perdu: La Prisonnière* (*The Prisoner*; 1923). The secretary's refashioning from aspiring wife in prewar American culture to sexually aroused and arousing 'new woman' in interwar French culture meant that, in certain capacities, secretaries engaged in a type of rebellion against nationalist programmes at that time.

Moreover, the female secretary as stenographer or typist was not a prominent wartime symbol of heroism in France, as she sometimes was in the United States. During World War I, typewriters were in high demand, leading to their sudden scarcity. The typewriter was still largely an American product, although some European companies and factories had been established. Allied forces used thousands of typewriters in the trenches and elsewhere, and Axis powers also relied on them as crucial correspondence and data-tracking tools.[190] One 1916 American propaganda poster displays an illustration of a young woman working on a typewriter, while a spectre of the Kaiser with a bloodied sword backs away in fear. The poster's caption reads, 'Stenographers! The Kaiser is Afraid of You!' The text continues, 'He knows that as long as this shortage exists, the war preparations of the United States Government will be delayed … Uncle Sam wants you and 4,999 other capable stenographers to go to Washington NOW …' An American war poster from 1917, *Stenographers! Washington Needs You!*, shows a female secretary seated at her desk, looking at the shadow of an American soldier stalking the

battlefield that emerges as a projection from her own body, the hairpin holding her bun echoing the blade of his rifle's bayonet (Plate 2). In contrast, the explicit elision of soldier and secretary was uncommon in France during World War I, although this nation issued official calls for its women to take up *travail* (work) on behalf of men who went to the field of *bataille* (battle).[191]

A discursive formation in surrealism can be excavated in relation to these controversial cultural associations of the female typist, whose image modulates the surrealist anti-nationalist and anti-bourgeois stance. I posit that an extended surrealist imaginary of the secretary based on this interwar version of a young, single woman is apprehensible largely on a subtextual and associative plane. Man Ray's 1924 photographs of Simone Breton performing at the typewriter are an exception to this rule, however (see Plate 1). By associating surrealist automatism with the quality of transcribed *vitesse* (speed) on the cover of their new magazine, the surrealists were not only positioning automatism as a critique of embodied labour in a capitalist system. They were also understanding automatism to be, in part, a stigmatised response to gendered labour of various kinds.

Automatisme psychique pur and media histories

Such a prominently displayed photograph of a woman engaged in a professional skill recently acquired on a mass level by women takes on new significance when considered in relation to the surrealist caption: 'IT IS NECESSARY TO STRIVE FOR A NEW DECLARATION OF HUMAN RIGHTS'. In Man Ray's photograph *Séance de rêve éveillé*, Desnos crouches before Simone as she sits at the machine. The female's mechanised labour at the service of the unconscious is allied with the male surrealist's anti-labour, which erases writing in the act of dictation – akin to Blanchot's *désœuvrement*, or 'unworking' – in surrealism.[192] As Christopher Keep has demonstrated in the case of the American 'Type-writer Girl' trope so culturally entrenched by World War I, 'the very unknowability of her place between masculinity and femininity … could be strategically adopted' by working women themselves for various kinds of self-gain, and thus this cultural category was doubly marked as one of 'contestation and resistance'.[193]

Scholars have already explored the rich connections between surrealist automatism and technologies of writing, hearing, and tracing in spiritualism and psychical research. Some of these analyses link surrealism's interest in paranormal research to its investment in physiology, neurology, dynamic psychiatry, and psychology. Detailed studies on surrealism's *automatisme psychique pur* (pure psychic automatism) have been published in recent years by scholars such as David Lomas, deepening these areas of enquiry and providing a rich reservoir of research that expands our understanding of the surrealist take on the broad cultural trend of automatic writing in late nineteenth- and early twentieth-century Europe and the United States.[194] The surrealists were generally interested in areas of culture such as mesmerism, possession, psychographic writing, and convulsionaries, which sometimes conflated the medium with the hysteric. Théodore

Flournoy, a pioneer of psychodynamics, is a notable case in point with his interest in the area of subliminal psychology and the related subjects of glossolalia, imaginative multiple personalities, and gender switching, as evidenced in his study of medium Hélène Smith.[195] Pierre Janet (who thought automatism was a spontaneous activation of an 'inferior' cognitive tendency), Charles Richet, and Frederic Myers also applied aspects of science to spiritualism. In the case of Richet and Myers, the focus was on the subject of cryptaesthesia, or extra-sensory perception.

Likewise, David Lomas has allied the broad affiliation of surrealist automatism with the widespread scientific and medical practice of the 'graphic method' in the late nineteenth and early twentieth centuries, in which devices such as the myograph traced somatic movement as inscription.[196] Lomas and David Bate, building on the earlier work of Bernard-Paul Robert, also detailed how André Breton's idea of *pensée parlée* (spoken thought) was influenced by prewar notions of *langage intérieur* (interior language) or *endophasie* (endophasia) – an aural inner speech with no audible vocalisation, as developed by French physicians and psychologists such as Alfred Maury, Victor Egger, and Jean-Martin Charcot.[197] A few contemporaries of the surrealists living in Paris after World War I had direct experience with these ideas. For instance, Gertrude Stein, who as a young woman worked as a secretary in the United States, studied automatic writing with William James while at Radcliffe College and Johns Hopkins School of Medicine in the 1890s.[198] Her published results highlighted the non-unified experience of self that became perceivable in the split between motor reflexes and auditory stimuli – how writing by hand or using a planchette (a small raised board often used for automatic writing) can feel divorced from individual consciousness, causing an experience of the '*extra personal*' in automatism.[199]

Studies such as Bauduin's *Surrealism and the Occult* (2014) have clarified the ways in which the spiritualist medium and *femme folle* (madwoman) were to some degree collapsed into a single cultural reference of anti-patriarchy and poetic performance for the surrealists. The figures of the hysteric and medium shared roles related to feminised telepresence in a dawning age of telegraphy, telephony, and wireless communication technologies such as the radio.[200] Indeed, the topic of secretarial labour is thoroughly embedded in the scholarly discourse on literary spiritualism, coalescing around categories such as writing instruments, copying or transcription, and dictation. For instance, as Anthony Enns has shown, nineteenth- and early twentieth-century spiritualist practices were heavily influenced by telecommunications methods and technologies such as stenography, telegraphy, and the typewriter. Enns has elaborated how certain spiritualist practices employed these tools in the act of mediumship – a history that surrealism acknowledged at least to some degree in its own automatism, in particular through the oft-repeated metaphor of the telegraph.[201]

Christopher Latham Sholes was an avid spiritualist and may have had spiritualist table 'rapping' in mind when he invented his machine.[202] 'Typists paralleled spirit mediums, and indeed some women took "dictations" in both the office and the séance', explained Jill Galvan, who has considered today's concept of the

posthuman in relation to the transmission of information by mediums.[203] On this subject, Christopher Keep has written, 'Indeed, the idea that the typewriter was already a quasi-magical medium for the transcription of another's thoughts was apparent enough that many investigators searching for evidence of "supraliminal" intelligences removed the human medium altogether and replaced her with an operator-less typewriter.'[204]

The surrealists did not devote extended attention to a comparison of secretarial work to automatism, as they did in the case of the spirit medium or the psychiatric patient. Nevertheless, the secretary held a prominent role in the broader cultural history of automatic writing in modernism in general and therefore has been substantially explored in scholarship, in cases such as that of Henry James and his secretary, Theodora Bosanquet.[205] Influenced by these prominent examples of secretarial spiritualism in literary studies, I argue that we cannot fully comprehend the interwar surrealist mediation of the spiritualist medium or the hysteric unless we acknowledge the ways in which the figure of the secretary interacts with and even modulates these tropes. Thus, my examination of the secretarial side of automatism does not evoke a field of greater affinity as compared with the discourses of the parapsychological and the psychiatric, which were explored with simultaneous curiosity and reserve by the surrealists. Instead, I outline yet another area of lively contention for this group – revealing once again the manner in which surrealism 'integrated' into itself, to repeat Walter Benjamin's words, the milieu that produced it.[206]

The secretarial side of surrealist automatism encompasses a materialist popularisation of the poetic, paranormal, or hysteric experience of the unhindered babble of the 'inner voice'. This accessibility of automatism was of fundamental importance to the surrealists, as discussed by André Breton in his 1933 essay from *Minotaure*, 'Le Message automatique' ('The Automatic Message').[207] While spiritualist mediums, such as one Miss X mentioned by Breton, wrote about taking 'dictation' and the active motor impulse of stimulated mechanical writing – and at times used apparatuses like the typewriter – for Breton the spiritualist was nevertheless fully distinct from the surrealist.[208] This is not only because the voice that dictates to the spiritualist medium is external, but also because the medium is the sole receiver of this external dictation – they are unique in their mediumship. In contrast to this, Breton wrote, 'Every man and every woman deserves the personal conviction that they themselves can, by right, have resource at will to this language which is not in any way supernatural, and is the vehicle, for each and every one of us, of revelation. They must therefore necessarily turn their backs on the narrow, mistaken conception that privileged vocations are reserved for artists and mediums.'[209]

In the field of media studies, Lisa Gitelman's book *Scripts, Grooves and Writing Machines: Representing Technology in the Edison Era* (1999) set a precedent for this line of questioning. Gitelman outlined discursive connections between the secretary and the spiritualist at the turn of the twentieth century in the United States, showing how the cultural desire for various kinds of

inscriptions or recorded media intersected with gender anxieties about autho-rial agency, visibility/invisibility, and audibility/noiselessness.[210] As a movement embedded in both theory and praxis, the everyday life of its own contempora-neous present as well as that of the past, surrealism's rapport with the media technologies and behaviours that directly and indirectly modulate its produc-tion can illuminate the question of the instrumentalisation of subjectivity – reification – at the heart of the movement's conceptualisation. For instance, the well-known surrealist interest in eighteenth-century spectacular writing automata, such as the Pierre Jaquet-Droz 'Écrivain' clockwork mechanism, or the various automata celebrated by Péret in his 1933 essay in *Minotaure* 3–4, 'Au Paradis des fantômes', are pre-eminently relatable to secretarial automatism in surrealism. Nevertheless, the surrealist attraction to automated writing encom-passed a contemporary technological and social context as well as a historical one. Following Jonathan Eburne's call for a study of 'surrealist cybernetics' due to the movement's playful and experimental approach to the deregulation of systems within twentieth-century technocracies, I concur that such questions of surrealism's sources also need to be thought forward in history. How does the Enlightenment-era automaton writer reflect the hypnotic repetition of work tasks in the technologised body of the twentieth-century secretary?[211]

A mass commercialised form of spiritualism in the form of the wartime Ouija board craze of 1919–20 in the United States, England, and, to a lesser degree, France, might be considered in relation to surrealist automatism as both a game and a form of memorialisation of the war dead. Surrealist memorialisation occurred in cases such as Jacques Vaché, who died either by accident or suicide while still a soldier, and Guillaume Apollinaire, who died of war-related injuries exacerbated by the Spanish influenza pandemic that swept the globe between 1918 and 1919.[212] Surrealists were interested in the development of planchette writing through Victor Hugo, but probably never engaged in the internation-ally popular Ouija board fad, a revival of a late nineteenth-century game, during this brief period. An example of a contemporary popular trend in Allied nations during wartime that could have interested the surrealists is that of posthumous dictation of texts to the living by the dead, such as the 1922 *Lettres de Pierre* by Cécile Monnier, mother of a young veteran killed in battle.

The widespread presence of such a commercialised and popularised version of spiritualism in most Allied nations in the early interwar years suggests the manner in which access to an 'inner voice' of the unconscious had contemporary correlations and historical ties to the female medium and the hysteric. A Norman Rockwell cover for a 1920 *Saturday Evening Post* reveals the consultation of the Ouija board to be as much about the romantic life of the 'new woman' as it is about contacting the dead. With her hands positioned correctly for touch-typing and her eyes averted towards other attractions, she willingly submits to the male player's control, allowing the planchette to slide over the board to 'YES' and simultaneously brushing against her partner with her legs, fingers, and the tips of her toes. A popular song about the irresistible forecasting of future romance,

Figure 2.10 Albert W. Barbelle, *Weegee (Ouija) Weegee (Ouija) Tell Me Do. 1920.*
Illustration for sheet music booklet. Music by Harry Von Tilzer; lyrics by William Gerome

called 'Weegee (Ouija) Weegee (Ouija) Tell Me Do (The Craze of the Country;
The Great Ouija Board Song)' was published that year, featuring a cover illustra-
tion of a young couple engaged in the game that took more than a little inspiration
from Rockwell's scene (Figure 2.10).

In this regard, the *dame dactylographe* can be seen as a contemporary echo,
symbolic descendant, and at times in surrealist discourse, a burlesque foil of the
popularised female spiritualist medium – and more remotely, for the girl *hysté-
rique* who writhes for the camera – although the somewhat subterranean nature
of this complex genealogy requires further spelling out. All of these associations
come together in a demonstration of what Lomas and Stubbs have recently high-
lighted as an overarching surrealist concept: simulation as a replication of states
of being, which in some instances approaches pastiche through operations of
mimicry. Simulation resulted in the fabricated delirium of *L'Immaculée concep-
tion* by André Breton and Paul Éluard in 1930 and bore similarities to Salvador
Dalí's 'active' paranoiac-critical method. Therefore, a rigid binary between

what Michel Murat has deemed 'passive' automatism and surrealist simulation may be misleading, since the dictation of the unconscious in 1920s surrealism also involves a conceptual fabrication of the subjective voice as 'a doubling' (*dédoublement*) into projected speaker and listener.[213]

Psychic automatism and feminisation

Dictation and dominance

Already in 1924, the *sténo-dactylo*, young and female, was a ubiquitous type in Paris. As Robin Walz has argued, the surrealists were particularly attuned to pulp trends in mass print culture during the 1920s.[214] The years 1923 and 1924 alone saw the publication of popular novels in France such as *Denise, dactylo* by Jean Petithuguenin, *La Dactylo du major* by Henri Danguy, and *La Dactylo qui purge Homère* by Marc Daubrive. The 1924 debut of a new foxtrot song with a clever staccato rhythm, 'La Dac-Dac-Dactylo!', followed an already established tradition of vaudeville *opérettes* and piano *chansonnettes* about ladies and gentle-men who rhythmically type on a machine or secretarial pools that transcribe in unison (Figure 2.11). Pierre Larrieu's (alias Harry W. Hampton) foxtrot 'Chanson de la machine à écrire', also known by its English title, 'Typewriting Machine Romance', was released in Paris that year, featuring a cartoonish illustration of a woman with a typewriter torso. Surrealism, too, seemed quite saturated with signs of the female typist in 1924. When Simone Breton's photograph as a typist was featured on the cover of the first issue of *La Révolution surréaliste*, the final page reported news of another secretary in the *faits-divers* 'Suicides' section taken from Paris newspapers: 'Mademoiselle Marguerite Rochas, 21 years old, *sténo-dactylo*, living with her father at 225 rue de Charenton, killed herself with a revolver shot to the heart when she found she had contracted an incurable illness. She is dead.'[215]

Three years later, this topos for surrealist automatism remained prominent. In October 1927 – quite long after the publication of the inaugural issue of *La Révolution surréaliste* showing Simone Breton at the typewriter, and during the period in which the marriage of Simone and André was beginning to break up due to extramarital affairs on both sides – the cover of that journal was once again emblazoned with the image of a woman taking dictation (issues 9–10) (Figure 2.12).[216] This time it was not Simone Breton surrounded by male surrealists but rather an anonymous *garçonne* (boyish flapper; bachelorette), somewhat androgynous, with a vampish bob, heavy eye make-up, and a school-girl's outfit.[217] Captioned 'L'ÉCRITURE AUTOMATIQUE', the photograph is by an English commercial artist. The image was most likely found by the surrealists in the form of an erotic postcard.

In its position on the cover of *La Révolution surréaliste* and its obvious echo of the Man Ray photograph of Simone from a few years earlier, the appropriated photograph is an important variation on the surrealist theme of taking dictation,

Figure 2.11 Roger de Valerio, *La Dac-Dac-Dactylo!* 1924. Illustration for sheet music booklet. Music by Charles Borel-Clerc; lyrics by Albert Willemetz and Jacques-Charles

as Robert Belton and Katharine Conley both pointed out in their books from the mid-1990s. For Belton, the photograph provided more evidence about the surrealist 'misuse' of the sign of woman. He explained, 'She is clearly not an example of automatic writing, but she signifies its nature as a pulsional process. She represents the object of a schoolboy's daydream … She can do nothing but write, responding mechanically to the promptings of the adolescent unconscious. Like the very real Simone, this unreal, imaginative, even mythic young schoolgirl is only a means to an end.'[218] In contrast, Conley described the *femme-enfant* as possessing clairvoyance as well as the passivity and blankness required for successful automatic writing. 'The woman's body inspires automatic writing and represents it.'[219]

The divergent readings of Belton and Conley can be juxtaposed again to unpack the idea that surrealist automatism exhibits a desire for gender elision, a fetishised longing for femininity that is paradoxically at once objectified and identified.[220] This argument finds kinship in more recent, feminist analyses of

Figure 2.12 Cover of *La Révolution surréaliste* 9–10 (1 October 1927)

surrealism, such as Natalya Lusty's *Surrealism, Feminism, Psychoanalysis* (2007), which speculated that 'feminine sexuality inspired the male artist to unleash his own desires in order to transcend a rational, masculinised subjectivity'.[221] Conley also argued as much in *Automatic Woman*. I follow and develop Conley's claim that 'the woman's body inspires automatic writing and represents it' to argue that the male-gendered surrealist position in relation to this image of the *femme-enfant* can be read not only as one of desirous erotic possession of the female body, but also as imagined projection onto that body in a process of feminisation. Paradoxically, the scene undermines the division of gender through an evocation of the divided feminised labour of taking dictation.

A surrealist stance of satirical humour is essential in such a reading because such a blurring of gender identifications takes place on an associative level partly through the movement's often campy visual representations of this practice. Michel Poivert has suggested that Breton may have appropriated a French post-card of around 1920 by Albert Wyndham for the cover of the surrealist journal because the model looked like Simone (Figure 2.13).[222] The *femme-enfant* on the

Figure 2.13 Albert Wyndham, untitled photograph, *c.*1920

cover of *La Révolution surréaliste* 9–10 is not fully readable, therefore, unless her synergy with Man Ray's prior example of Simone Breton's gendered labour at the Bureau in 1924 is taken into consideration. Simone's performance of the dual roles of attractive wife and trained typist functions as part of surrealism's camp awareness of the Centrale's pastiche of bureaucratic management and administrative hierarchies, as well as its association of automatism with the subversive undertones of secretaries and those aspects of secretarial labour that could have been viewed as empowering for women at the time. Parallel to this game of auto-representation is the sardonic association of surrealism with another kind of bureaucratic space – the school.[223]

For these hybrid fetish images of scribbling student and typing secretary to be understandable as imagined projections for a defeatist masculinity in the framework of surrealism, the power dynamics of the dictation featured in each must be examined. These dynamics include the mechanics of producing/receiving and speaking/listening that occur in the construction of surrealist automatism itself. In a 1935 photograph by Man Ray, for example, the teenage Gisèle Prassinos stands and reads automatic writing copied onto a sheet as five surrealists and her brother look on in a huddle that includes the seated Paul Éluard and André Breton (Figure 2.14). Prassinos, who became a stenographer three years later at the age of 18, was a celebrated automatist.[224] Her book *La Sauterelle arthritique* (*The Arthritic Grasshopper*) was published in 1935 and featured a preface by Éluard; it was followed by eight more volumes over the next four years. The threefold act of mediation is again evident in Man Ray's photograph of Prassinos and her listeners, yet another staged scenario. Prassinos has taken dictation from the unconscious and copied faithfully; she then read this transcription to her audience, who received a tertiary level of recitation. Prassinos's automatism is therefore not just about her own process of receiving. Her audience also transforms into a collective of silent receivers.

Surrealist automatism destabilises subjectivity on an individual and collective level. What Raymond Spiteri has designated the 'pooling' or collectivising of labour in surrealist games such as the exquisite corpse is thus relatable to the fission of the subject in automatism, which occurs through the division of labour between attention and motor movements.[225] Such a fission of the subject relates to French sociologist Émile Durkheim's term *anomie*, in the manner that he first used it in *De la division du travail social* (*The Division of Labour in Society*) (1893) as a communication breakdown in society. This operates in the sense that the surrealist automatist takes dictation from the mind to performatively heighten the *anomie*, or individuation and desocialisation, of the subject – and ultimately subvert that condition through that subject's unfettering. Automatism is an imaginative projection of the self as virtually and desirously attempting to experience disempowerment in that act of 'typed' gender, the feminised receiving and copying of dictation. In my use of 'feminisation' and 'feminised' I am of course thinking of the sociological term for the gendering of specific forms of labour. However, I also invoke their more recent adaptation by Donna Haraway in

Figure 2.14 Man Ray, Gisèle Prassinos reading her poems to the surrealists, 1935. Published in Gisèle Prassinos, *La Sauterelle arthritique* (*The Arthritic Grasshopper*), 1935. *Left to right*: Mario Prassinos, André Breton, Henri Parisot, Paul Éluard, Benjamin Péret, René Char, Gisèle Prassinos

'A Cyborg Manifesto' (1984), in which feminisation is also the process of making someone extremely vulnerable to exploitation of different kinds.[226]

If the formulation of automatism as feminised routine labour can be constructed in part through the genealogy of its visual representations created by the surrealists, the examples of Simone Breton at the typewriter and the *femme-enfant* at the school desk reveal that the process of feminisation moves back and forth between submission and shades of self-mastery. While surrealism was defeatist in its positions related to France's role in the war, it was also radicalised in this defeatism, employing such a stance to heighten already explosive frustration. Bearing the imprint of surrealist defeatism, these images of industrious women, who are nonetheless also glamorised 'new women', signal the claustrophobically narrow options for agency. That the surrealists chose as a symbol of automatism the image of an instrumentalised *femme moderne* beginning to negotiate the possibilities of agency within patriarchy reveals not an idealisation of woman, but a politicised reckoning with the reality of this sexist confinement to submissive power positions.

Chicago typewriters and surrealist microscopes:
André Breton, *L'Écriture automatique*, circa 1930

The idea that surrealist automatism's re-performance of submission roles can also construct the conditions for a symbolic power reversal is suggested by yet another representation of surrealist automatism: André Breton's photomontage *L'Écriture automatique* (Figure 2.15). According to Lomas and Stubbs, Breton constructed this work around 1930 (note that there is also a second version on paper with an inscription from 1938).[227] It was later published in the *Dictionnaire abrégé du surréalisme* (1938) and reproduced elsewhere with different captions. Conley has described the scene: 'Breton, in the foreground, looks directly at the viewer. From the microscope he holds in his hand escapes a fantastic image of a horse-drawn carriage, showing that he is in touch with alternate realities. Looking out at him from behind a metal gate stands a woman. The implication is that she represents his unconscious, she is the female *voyante* or muse of the automatic writing process who inspires him and prompts his connection to his own inner life.'[228] The 'new woman' in the background is sprouting from Breton's bipartite body, although she is separated from him by a grid of bars and his focus is on the microscope, which Martine Antle here interpreted as the 'medium of artistic writing'.[229] The handwritten caption under the image, an integral part of the montage, emphasises the composite nature of Breton's projected identity in this self-portrait: 'Judgement of the author by himself. Dying Heraclitus, Pierre de Lune [moonstone], Sade, the cyclone with a millet-seed head, the anteater: his greatest desire would have been to belong to the family of great undesirables'.[230] This is a self-aware and self-critical identity, at once displaced from individuality and identified with a disparate array of objects, animals, and predecessors – all 'undesirables'. According to Dickran Tashjian, the doubling of the subject into man and woman in this montage also suggests wishful androgyny.[231]

The image of the woman holding the bars is taken from a publicity shot of the actress Phyllis Haver from the 1927 American silent film *Chicago*. Produced by Cecil B. DeMille and directed by Frank Urson, this feature-length comedy-drama was the earliest film version of a play, initially titled *The Brave Little Woman*, written by Maurine Dallas Watkins, a reporter for the *Chicago Tribune*. The play debuted on Broadway in 1926 to great success and later evolved into the popular musical *Chicago*. Watkins was inspired to write the play based on the sensationalised murder trials, which she covered for the *Tribune* in 1924, of two Chicago women, Beulah Annan and Belva Gaertner, the beauties of that city's infamous 'Murderess Row'. Belva Gaertner was a cabaret singer who shot and killed her boyfriend. Beulah Annan, a bookkeeper at a Chicago laundry, obliterated her lover with a bullet in the back.[232] Both Annan and Gaertner were acquitted, and they became famous media icons in the process, partly thanks to Watkins's coverage from a self-consciously female point of view. This media coverage in turn catalysed a sensationalised murderess epidemic in Chicago, with attendant press

Figure 2.15 André Breton, *Self-Portrait: Automatic Writing* or *L'Écriture automatique*, 1930. Photocollage

coverage of the cases of nearly a dozen women in Chicago jails charged with murdering husbands or male lovers.[233] In the play *Chicago*, Watkins depicted Roxie Hart as a money-hungry manipulator of men who is frustrated with her work as a secretary and stenographer and by the lack of money provided by both her husband and lover.[234] Hart trades her Remington typewriter for a Remington revolver in a disobedient protest against the men who regulate her flow of cash. In the 1927 Urson film, *Roxie Hart*, played by Phyllis Haver, is acquitted of murder thanks to her own gender-based manipulations of sexist culture and the interventions of various men who play into that system on her behalf.

It is well known that André Breton and the surrealists venerated working-class women who murdered people in positions of power. Surrealists paid homage to female criminals such as Germaine Berton, the French factory worker and anarchist-syndicalist who assassinated Marius Plateau, an ultra-right-wing leader, in 1923. Much like *Séance de rêve éveillé*, Man Ray's photograph of Simone Breton surrounded by male surrealists from the cover of *La Révolution surréaliste* 1, Berton's photograph is featured in the same issue of this journal, similarly positioned amid the headshots of male members of the group and also those of influential men admired by the surrealists. The Papin sisters, a live-in cook and a housekeeper who murdered their haut-bourgeois employers in north-western France in 1933, were also celebrated by the surrealists.[235] Breton was likely familiar with the plot of the film *Chicago*, given his joint avidity for cinema and women who vengefully kill patriarchs and bosses. The surrealists may also have had a special interest in the actress Phyllis Haver, as they did with other American film stars of this era, such as Charlie Chaplin. Another photograph of Haver appeared in the third issue of *La Révolution surréaliste*, published in April 1925, adjacent to a text by Péret.

Surrealists often engaged or at least enabled multiple strata of signification in their collage, montage, and appropriation practices, which typically – although not exclusively – employed a more motivated type of selection and placement than the dada approach to these media.[236] Whether or not Breton was aware of the full range of the iconography of Phyllis Haver as the secretary and murderess Roxie Hart in *Chicago*, his selection bears consideration. When associated head-on with the triumphant and laughing signification of Roxie Hart, working-girl stenographer and acquitted murderer, Breton's image of surrealist automatism can be seen as a visceral attack on phallocentric logic and power. Her disempowered position is modulated by her composite identity as a cheerful steno-murderess from the town famous for Al Capone's 'Chicago typewriters'. She got away with it in the end.

Like surrealist automatism itself – which poses the paradox of liberation through submission to method – the imprisoned femme fatale emits explosive vibrations from her cell.[237] As a subliminal emblem of androcide, she is an icon of surrealist automatism's identification with femininity as an attack on patriarchal power structures. This resistance is the critical underbelly of what, in an analysis of the Medusa or femme fatale figure in paintings by Salvador Dalí, Steven Harris has termed surrealism's 'feminizing strategy', which he aligns with automatism's

joint operation of passive–active.[238] The simmering rebellion encapsulated in the images of the surrealist secretary and the surrealist student – who bow to the labour of taking dictation despite their status as new women – begins to merge and mesh with this even more shadowy incarnation of the surrealist murderess, the enraged avenger of her instrumentalisation, who stands somewhere in the background of automatism's operations.

Amy Lyford has presented automatism as part of a larger crisis in masculinity after World War I, when most of the soon-to-be surrealists returned to Paris from the front, jobless and haunted by memories of the war and its fatal turn for friends such as Guillaume Apollinaire and Jacques Vaché.[239] To that degree surrealist automatism may be as much about existential anxiety and fears of emasculation as it is about reaching a new level of consciousness through the supposed unhinging of instrumentalised thought patterns. This idea is key for understanding the disruptive potential of the surrealist secretary as a discursive construction in the formation of the movement. As Lyford pointed out, the soldier's mortality on the battlefield corresponds to the productivity of the woman as worker/reproducer and to her heightened but regulated fertility. The surrealist secretary's embodied productivity is a counterpart and goad to the performative death of the male surrealist through the passive slumber and catalepsy of masculinity, or, automatism as androcide. The fluid voice of automatism becomes audible through the prostrate male body, the symbolic death of male agency, and what Steven Harris has called, in relation to Claude Cahun's automatist objects, 'the refusal to accept sexual difference'.[240]

Conclusion: 'surrealism is writing denied'

Simone Breton was one of several female automatists during the first two decades of surrealism who practised written automatism and participated in surrealist games and séances. A few of these women were active in the spoken automatism of group sessions, as was the case with someone named Suzanne, friend of Roger Vitrac, whom Simone describes in a letter to her cousin.[241] Others, such as Gisèle Prassinos, published their automatist texts. Many female-identified surrealists also pursued automatism in other visual or material formats – in particular, that of the exquisite corpse and the surrealist object.

While my historiographic account stressed the dynamism of Simone Breton's automatist practice and role in surrealism, my main preoccupation has been how male surrealists during the 1920s represented automatism through the image of a labouring new woman. The cisgender male surrealist, frequently a war veteran, identified with, projected onto, and emblematised not only the more familiar tropes of the female spiritualist medium and the incarcerated girl hysteric. The male surrealist also looked to the fetishised stereotype of the sexualised secretary – the pop-culture type of the *sténo-dactylo*.

On a more fraught level of connotation, we have seen how in post-World War I European and American culture the female secretary and her secretarial

tools were associated with either nationalism or anti-patriotism, depending on the context: soldiers on the front line, weaponry, and mortal battle itself; the prosthetic replacement of males by females in the workforce during the wartime labour shortage; the refusal of some women to give up their new jobs to demobilised *poilus* (World War I infantry soldiers) after the war; and the resistance of some working women to pro-natalism, in a revival of the turn-of-the-century idea of *'grève des ventres'* (wombs on strike).[242] Emerging from this heady set of affiliations, the surrealist secretary resists the imperative of nation and economy, engaging in anti-labour, engendering anti-production.

In surrealism, the unconscious must translate itself through the limiting yoke of language, a theory wherein the unconscious is knowable as just that, a fountain of thought that moves autonomously despite its inescapable mediation through coded and typified language, containing both decipherable and indecipherable signs that invite attempts at translation.[243] This linking of surrealist automatism to the 'death of writing' and the displacement of the voice of the writing subject is one way to interpret the message of the surrealist *papillon*, or flyer, that was issued by the Centrale in 1924–25, along with fourteen others, advertising the hours and address of the working office: 'LE SURRÉALISME: c'est l'écriture niée. Bureau de recherches. 15, rue de Grenelle, Paris' (Surrealism is writing denied). Surrealist automatism is permission as a means of refusal; a defeatist embrace of instrumentalisation that seeks the scraps of some other formulation of agency in the spaces between the words and pauses in the dictation. This sentiment of passive resistance also conjures Man Ray's assemblage *De quoi écrire un poème* (*Something to Write a Poem With*) (1923), a reproduction of which was published in the third issue of *La Révolution surréaliste* in April 1925: a writing quill becomes a dart piercing the blank spaces of writing, converting tool and toy to weapon.

As Jacqueline Chénieux-Gendron has written regarding surrealist automatism, 'We should let ourselves be carried along, finally, by the pleasure of feeling touched by a code always promised and never given; and we may thus enjoy some lucky "find" capable of creating an image by projecting onto it, contagiously, our own fantasies.'[244] The reader of automatism, like Simone Breton taking dictation at the typewriter in Man Ray's photo, hears and records automatic writing's *lisibilité* (readability), stumbling upon projected *trouvailles* (surrealist found objects) along the way. For the surrealists, the belief in the everyday presence of a constant current of unproductive thought, manifested as coded language and running parallel to our lived experience of co-optation into work, tasks, and conditioned behaviours, hints at autonomy through – and in spite of – subjection.

Notes

1 André Breton, 'Manifesto of Surrealism', 26.
2 *Ibid.*; my translation.

3 Julia Kelly, 'Centrale', in *Bureau of the Centre for the Study of Surrealism and Its Legacy*, ed. Mark Dion et al. (Manchester: AHRB Research Centre for Studies of Surrealism and its Legacies, 2005), 111.

4 Paule Thévenin, ed., *Bureau de recherches surréalistes: cahier de la permanence, octobre 1924–avril 1925* (Paris: Gallimard, 1988). See also 'Bureau de recherches surréalistes', *La Révolution surréaliste* 2 (15 January 1925): 31.

5 Clément Chéroux, 'La Photographie par tous, non par un', in Quentin Bajac et al., *La Subversion des images: surréalisme, photographie, film* (Paris: Éditions du Centre Pompidou, 2009), 26.

6 For a recent reading of this photograph as depicting Simone transcribing a verbal declaration by Desnos, see Katia Sowels and Jules Colmart, *Au grand jour: lettres (1920–1930): un album: André à Simone Breton* (Paris: Rue d'Ulm, 2020), 117. The authors also state that in the other shots by Man Ray that day, Simone can be seen 'reading, writing, or retranscribing'. *Ibid.*; my translation.

7 Susan Rubin Suleiman has pointed out that there was a third 'woman' in the room during Man Ray's photo shoot: a headless and armless odalisque mannequin hanging on the wall. Susan Rubin Suleiman, *Subversive Intent: Gender, Politics, and the Avant-garde* (Cambridge, MA: Harvard University Press, 1990), 21.

8 Lewis, *Politics of Surrealism*. Paligot, *Parcours politique*. Spiteri, 'Surrealism and the Question of Politics', 122.

9 In *Arcane 17*, which was published in the year that women were finally granted suffrage in France, 1944, Breton explicitly called for the destruction of patriarchy and the empowerment of women. André Breton, *Arcanum 17* (Los Angeles, CA: Sun & Moon Press, 1994), 80–1. On surrealism's extended engagement with Fourier, see Claire Howard, 'Passionate Attraction: Fourier, Feminism, Free Love, and *L'Écart absolu*', in *Radical Dreams: Surrealism, Counterculture, Resistance*, ed. Elliott H. King and Abigail Susik (University Park: Penn State University Press, 2022).

10 André Breton, 'Introduction to the Discourse on the Paucity of Reality', 25.

11 André Breton, 'Political Position of Surrealism', in Breton, *Manifestoes of Surrealism*, 213.

12 Breton, 'Introduction to the Discourse on the Paucity of Reality', 25. On Breton's brief comments about female emancipation in 1948, see LaCoss, 'The Revolutionary Politics of Surrealism in Paris', 359n23. For an overview of Breton's proto-feminism, see Penelope Rosemont, 'Introduction: All My Names Know Your Leap, Surrealist Women and Their Challenge', in *Surrealist Women: An International Anthology*, ed. Penelope Rosemont (Austin: University of Texas Press, 1998), xxix–lvii, xlvi–xlvii.

13 André Breton, 'Le La', in *Signe ascendant: suivi de Fata Morgana, les États généraux, Des Épingles tremblantes, Xénophiles, Ode à Charles Fourier, Constellations et de Le La* (Paris: Gallimard, 1968), 174.

14 Friedrich A. Kittler, *Discourse Networks 1800/1900*, trans. Michael Metteer and Chris Cullens (Stanford, CA: Stanford University Press, 1990), 228.

15 Max Morise, 'Les Yeux enchantés', *La Révolution surréaliste* 1 (1 December 1924): 26. Max Morise, 'Enchanted Eyes', in *The Sources of Surrealism: Art in Context*, ed. Neil Matheson (Aldershot: Lund Humphries, 2006), 325.

16 Georges Bataille, 'On the Subject of Slumbers', in *Absence of Myth: Writings on Surrealism*, trans. Michael Richardson (London: Verso, 1994), 49–51.

17 Roland Barthes, 'The Surrealists Overlooked the Body', in *The Grain of the Voice: Interviews, 1962–1980*, trans. Linda Coverdale (Berkeley: University of California Press, 1991), 243–5.

18 Gilles Deleuze and Félix Guattari, *Anti-Oedipus: Capitalism and Schizophrenia*, trans. Brian Massumi (1972; Minneapolis: University of Minnesota Press, 1983), 240–1; 349. See also Georges Sebbag, *Foucault Deleuze: Nouvelles impressions du surréalisme* (Paris: Les Éditions Hermann, 2015).

19 Gilles Deleuze and Félix Guattari, *A Thousand Plateaus: Capitalism and Schizophrenia*, trans. Brian Massumi (1980; Minneapolis: University of Minnesota Press, 1987), 84.

20 Blanchot, 'Tomorrow at Stake', 417; original emphasis.

21 *Ibid.*, 420–1; original emphasis.

22 *Ibid.*, 421.

23 Michel Foucault, *Discipline and Punish: The Birth of the Prison*, trans. Alan Sheridan, 2nd ed. (1975; New York: Vintage Books, 1995), 136. See also Alan McKinlay and Ken Starkey, eds, *Foucault, Management and Organization Theory: From Panopticon to Technologies of Self* (London: Sage, 1998). Sebbag, *Foucault Deleuze*.

24 Sebbag, *Foucault Deleuze*.

25 Frederick Winslow Taylor, *The Principles of Scientific Management* (New York: Harper & Bros, 1923).

26 Frader, *Breadwinners and Citizens*, 10 and *passim*. Rabinbach, *The Human Motor*, 70–110.

27 Torigian, *Every Factory a Fortress*, 9.

28 *Ibid.*

29 Max Weber, *Economy and Society*, ed. Guenther Roth and Claus Wittich. Vols 1 and 2 (1922; Berkeley: University of California Press, 2013).

30 Rosalind Krauss, 'Photography in the Service of Surrealism' and 'Corpus Delicti', in Rosalind E. Krauss and Jane Livingston, *L'Amour fou: Photography and Surrealism* (New York: Abbeville, 1985), 15–42; 55–100; Rudolf E. Kuenzli, 'Surrealism and Misogyny', in *Surrealism and Women*, ed. Mary Ann Caws, Rudolf E. Kuenzli, and Gwen Raaberg (Cambridge, MA: MIT Press, 1990), 17–26; Robert J. Belton, *The Beribboned Bomb: The Image of Woman in Male Surrealist Art* (Calgary: University of Calgary Press, 1995), 73; Katharine Conley, *Automatic Woman: The Representation of Woman in Surrealism* (Lincoln: University of Nebraska Press, 1996), 1. There were several other texts of note during the 1980s and 1990s that discussed the role and subject of women in surrealism by authors such as Gloria Orenstein, Whitney Chadwick, Erika Billeter, Susan Rubin Suleiman, Renée Riese Hubert, and Jacqueline Chénieux-Gendron. Also see important recent additions to the literature on women and surrealism: Patricia Allmer, ed., *Angels of Anarchy: Women Artists and Surrealism* (New York: Prestel, 2009); Ilene Susan Fort, Teresa Arcq, and Dawn Ades, eds, *In Wonderland: The Surrealist Adventures of Women Artists in Mexico and the United States* (New York: Prestel, 2012); Jennifer Mundy, Vincent Gille, and Dawn Ades, eds, *Surrealism: Desire Unbound* (Princeton, NJ: Princeton University Press, 2001).

31 Mary Ann Caws, 'Seeing the Surrealist Woman: We Are a Problem', in *Surrealism and Women*, 16.

32 Belton, *Beribboned Bomb*, 82.

33 Conley, *Automatic Woman*, 19, 141.

34 Along with my interest in Foucauldian perspectives as an underlying orientation, I am more distantly influenced by recent discussions by Judith Butler and others about the performance of gender as coded signification and the subversive potential for performativity in political enactment. Judith Butler and Athena Athanasiou, *Dispossession: The Performative in the Political* (Cambridge: Polity Press, 2013); Judith Butler, *Notes Towards a Performative Theory of Assembly* (Cambridge, MA: Harvard University Press, 2015). My concept of surrealist performativity is influenced by Effie Rentzou's discussion of erotic rhetoric in surrealism. Effie Rentzou, *Littérature malgré elle: Le surréalisme et la transformation du littéraire* (Paris: Éditions Pleine Marge, 2010).

35 Pamela Thurschwell, *Literature, Technology and Magical Thinking 1880–1920* (Cambridge: Cambridge University Press, 2001), 7–8.

36 *Ibid.*, 2, 4.

37 Foundational influences for this essay include: Whitney Davis, 'Gender', in *Critical Terms for Art History*, ed. Robert S. Nelson and Richard Shiff, 2nd ed. (Chicago, IL: University of Chicago Press, 2003), 330–4; Jennifer Doyle, 'Queer Wallpaper', in *A Companion to Contemporary Art since 1945*, ed. Amelia Jones (Malden, MA: Wiley Blackwell, 2006), 343–53. Also see Laura Doyle, ed., *Bodies of Resistance: New Phenomenologies of Politics, Agency, and Culture* (Evanston, IL: Northwestern University Press, 2001).

38 Julia Kristeva, 'L'Inquiétante étrangeté de l'automatisme: à propos de *Poisson soluble*', in *Une pelle au vent dans les sables du rêve: les écritures automatiques*, ed. Michel Murat and Marie-Paule Berranger (Lyon: Presses Universitaires de Lyon, 1992), 113–24.

39 *Ibid.*, 124.

40 Conley, *Automatic Woman*, 9–19.

41 René Crevel, 'The Period of Sleeping Fits', *This Quarter* 5, no. 1 (1932): 181–8.

42 Katharine Conley, *Robert Desnos, Surrealism, and the Marvelous in Everyday Life* (Lincoln: University of Nebraska Press, 2003), 26. Also see Katharine Conley, '"Not a Nervous Woman": Robert Desnos and Surrealist Literary History', *South Central Review* 20, nos 2/4 (Summer/Winter 2003): 111–30.

43 Raymond Spiteri, 'Community at Play', 117.

44 Karl Marx, *Capital: A Critique of Political Economy*, ed. Friedrich Engels, trans. Samuel Moore and Edward Aveling (Moscow: Progress Publishers, 1887), 1:107, 238. Sohn-Rethel's notion of real abstraction and his materialist critique of Kantian idealist epistemology is relevant to this discussion, in that the division between intellectual and manual labour in capitalism is at the root of the thing-ification of human thought. Surrealist automatism might be considered an attempt to disrupt the real abstraction of thought. Alfred Sohn-Rethel, *Intellectual and Manual Labour: A Critique of Epistemology* (London: Macmillan, 1978).

45 Tessel M. Bauduin, *Surrealism and the Occult: Occultism and Western Esotericism in the Work and Movement of André Breton* (Amsterdam: Amsterdam University Press, 2014), 53.

46 André Breton, 'The Mediums Enter', in *The Lost Steps*, trans. Mark Polizzotti (1996; Lincoln: University of Nebraska Press, 2010), 91; original emphasis. First published as 'Entrée des médiums', *Littérature* 6 (1 November 1922): 2.

47 Chéroux, 'La Photographie par tous', 27.

48 On *mises-en-scène* in surrealist photography, see Michel Poivert, 'Images de la pensée', in *La Subversion des images*, 309–13.

49 Marguerite Bonnet, *André Breton: Naissance de l'aventure surréaliste* (Paris: Librairie José Corti, 1975), 353–5; my translation.

50 Barnaby Dicker, 'André Breton, Rodolphe Töpffer and the Automatic Message', in Gavin Parkinson, ed., *Surrealism, Science Fiction and Comics* (Liverpool: Liverpool University Press, 2015), 40–61. Walter J. Ong, *Orality and Literacy: The Technologizing of the Word*, 2nd ed. (London: Routledge, 2002).

51 Man Ray, 'Letter to Katherine Dreier, February 20, 1921', in *Man Ray: Writings on Art*, ed. Jennifer Mundy, Andrew Strauss, and Edouard Sebline (Los Angeles, CA: Getty Research Institute, 2016), 61–2. Also see Susan Laxton, '"Flou": Rayographs and the Dada Automatic', *October* 127 (Winter 2009): 25–48. Laxton also mentions Christian Schad's dactylographic *Typewritten Picture, A Dada Portrait of Walter Serner* (1920).

52 Rubén Gallo, 'Typewriters', in *Mexican Modernity: The Avant-garde and the Technological Revolution* (Cambridge, MA: MIT Press, 2005), 109.

53 André Breton, 'Max Ernst', in *The Lost Steps*, 60.

54 Maurice Blanchot, 'Réflexions sur le surréalisme', in *La Part du feu* (Paris: Gallimard, 1949), 93.

55 On the subject of the typification of printed language, see the arguments by Flusser and Heim, which built on earlier themes explored by Friedrich Nietzsche, Marshall McLuhan, Walter Ong and Martin Heidegger: Vilém Flusser, *Does Writing Have a Future?*, trans. Nancy Ann Roth (Minneapolis: University of Minnesota Press, 1987). See also Michael Heim, *Electric Language: A Philosophical Study of Word Processing* (New Haven, CT: Yale University Press, 1987).

56 Michel Foucault, *The Archaeology of Knowledge*, trans. A. M. Sheridan Smith (New York: Pantheon Books, 1972), 85–6.

57 Breton, 'Max Ernst', 60.

58 Tessel M. Bauduin, 'The "Continuing Misfortune" of Automatism in Early Surrealism', *communication +1* 4 (2016): n.p.

59 Breton, 'Manifesto of Surrealism', 27–8.

60 Jacques Vaché, letter of 11-14-18, in Rosemont, *Jacques Vaché and the Roots of Surrealism*, 352.

61 Note that Freud's *Die Traumdeutung* was not translated into French until 1926.

62 Jennifer Gibson, 'Surrealism before Freud: Dynamic Psychiatry's "Simple Recording Instrument"', *Art Journal* 46, no. 1 (Spring 1987): 57–8.

63 Friedrich A. Kittler, *Gramophone, Film, Typewriter*, trans. Geoffrey Winthrop-Young and Michael Wutz (Stanford, CA: Stanford University Press, 1999), 183.

64 Bauduin, *Surrealism and the Occult*, 58.

65 Brian Rotman, *Becoming Beside Ourselves: The Alphabet, Ghosts, and Distributed Human Being* (Durham, NC: Duke University Press, 2008), 9; original emphasis. See also Tim Armstrong, 'Distracted Writing', in *Modernism, Technology, and the Body: A Cultural Study* (Cambridge: Cambridge University Press, 1998), 187–219.

66 Rotman, *Becoming Beside Ourselves*, 8.

67 Belton, *Beribboned Bomb*, 71–82. Georgiana Colvile also pointed out Simone's conflicting roles of 'pouvoir' and 'service' as 'dactylo' at the Bureau. Simone Breton, *Lettres à Denise Lévy*, ed. Georgiana Colvile (Paris: Gallimard, 2006), 13–15. Roger

Cardinal speculated in a footnote that 'we might be tempted to situate the short-hand typist beside the medium and the madman as forerunners of surrealism'. Roger Cardinal, 'André Masson and Automatic Drawing', in *Surrealism: Surrealist Visuality*, ed. Silvano Levy (New York: New York University Press, 1996), 90. See also Spector, *Surrealist Art and Writing*, 20, 162, 181–2. My account is influenced by Susan Rubin Suleiman's discussion of Luce Irigaray's use of the concepts of mimicry and performance in relation to surrealist women. Suleiman, *Subversive Intent*, 30.

68 Belton, *Beribboned Bomb*, 73.
69 Ruth Brandon, *Surreal Lives: The Surrealists 1917–1945* (New York: Grove Press, 1999), 385.
70 Polizzotti, *Revolution of the Mind*, 141. Sowels and Colmart, *Au grand jour*, 20.
71 Marguerite Bonnet, 'Introduction Chronologie', introduction to Breton, *Œuvres complètes*, 1: xli; Françoise Thébaud, 'The Great War and the Triumph of Sexual Division', in *A History of Women in the West*, ed. Françoise Thébaud (Cambridge, MA: Belknap Press of Harvard University Press, 1992), 70.
72 Jean-Michel Goutier, introduction to *Lettres à Simone Kahn: 1920–1960*, by André Breton and Simone Breton, ed. Jean-Michel Goutier (Paris: Gallimard, 2016), 10. See also Unda Hörner, *Die realen Frauen der Surrealisten: Simone Breton, Gala Éluard, Elsa Triolet* (Berlin: Suhrkamp Taschenbuch Verlag, 2002).
73 Youki Desnos, *Les Confidences de Youki* (Paris: Fayard, 1999), 119.
74 Linda L. Clark, *Schooling the Daughters of Marianne: Textbooks and the Socialization of Girls in Modern French Primary Schools* (Albany: State University of New York Press, 1984), 122. See also: Delphine Gardey, 'La Standardisation d'une pratique technique: la dactylographie (1883–1930)', *Réseaux* 1, no. 87 (1998): 83; Delphine Gardey, *La Dactylographe et l'expéditionnaire: histoire des employés de bureau: 1890–1930* (Paris: Belin, 2002), 82; Sylvie Schweitzer, *Les Femmes ont toujours travaillé: une histoire de leurs métiers, XIXe et XXe siècles* (Paris: Éditions Odile Jacob, 2002), 214–15.
75 Simone Breton, *Lettres à Denise Lévy*, 10 and *passim*.
76 Thévenin, *Bureau de recherches surréalistes*, 17.
77 Conley, *Robert Desnos*, 16, 217. In the late 1920s, while still a surrealist, the writer Michel Leiris also envisioned a career as a typist.
78 Sowels and Colmart, *Au grand jour*, 55.
79 Simone Breton, *Lettres à Denise Lévy*, 86; my translation. Luce Irigaray wrote about how the social hierarchy of the male over the female gender in society is reflected in the French language, with both professional positions and their assigned tools bearing the imprint of this hierarchy: 'le secrétaire d'état/parti' and 'un ordinateur' for men; 'la secrétaire sténo-dactylo' and 'une machine à écrire' for women'. Luce Irigaray, 'Linguistic Sexes and Genders', in *je, tu, nous: Towards a Culture of Difference* (New York: Routledge, 1993), 63–4.
80 Breton and Breton, *Lettres à Simone Kahn*, 208 and *passim*.
81 Keith Aspley, 'Simone Kahn', in *Historical Dictionary of Surrealism* (Lanham, MD: Scarecrow Press, 2010), 276.
82 Penelope Rosemont, 'Simone Kahn', in Rosemont, *Surrealist Women*, 16–17.
83 Simone Breton, *Lettres à Denise Lévy*, 253.
84 Breton and Breton, *Lettres à Simone Kahn*, 234.
85 Simone Kahn, 'Surrealist Text: This Took Place in Springtime', trans. Guy Ducornet, in Rosemont, *Surrealist Women*, 17.

86 Kahn, 'Surrealist Text: This Took Place in Springtime', 17.
87 Georgiana Colvile, introduction to Breton, *Lettres à Denise Lévy*, 22.
88 Simone Kahn, 'The Exquisite Corpses', in *Surrealist Women*, 19; translator's emphasis. Originally published as 'Les Cadavres exquis', in *Le Cadavre exquis, son exaltation* (Milan: Galleria Schwarz, 1975), 30–1.
89 Kahn, 'The Exquisite Corpses', 19.
90 For example, see André Breton, 'Manifeste du surréalisme', in *Manifestes du Surréalisme* (Paris: Gallimard, 1979), 41.
91 André Breton, 'Le Cadavre exquis, son exaltation', in *Le Surréalisme et la peinture: nouvelle édition revue et corrigée, 1928–1965* (Paris: Gallimard, 1965), 290.
92 Paule Thévenin and Marguerite Bonnet, *Archives du surréalisme* (Paris: Gallimard, 1988), 25. Sowels and Colmart, *Au grand jour*, 98–115. Part III of the Nantes manuscript was the text published by 'S. B.' in the first issue of *La Révolution surréaliste*.
93 'André Breton, 42 rue Fontaine', André Breton website; my translation; original underlining.
94 *Ibid.* See the notebook from 1924.
95 Colvile, 'Introduction', 18.
96 Henri Pastoureau, *Ma vie surréaliste; suivi de, André Breton, les femmes et l'amour* (Paris: Maurice Nadeau, 1992), 297. Also see Sean O'Hanlan, 'Un foyer de la création collective', in *Au grand jour*, 70–1. Georgiana Colvile has pointed out that Simone's voluminous epistolary exchanges with André Breton, Max Morise, and Denise Lévy constitute her 'essential oeuvre'. Colvile, 'Introduction', 20.
97 Sowels and Colmart, *Au grand jour*, 21–2. See the essays by Sean O'Hanlan and Alice Ensabella in Sowels and Colmart, *Au grand jour*, 57–79. Julia Drost, 'Simone Collinet. Simone Breton: A Passionate Collector of Surrealist Art', in *Surrealism in Paris*, ed. Philippe Büttner (Basel: Foundation Beyeler, 2011), 135–66. After World War II, Simone (Breton) Collinet ran the Artistes et Artisans Galerie (1948) and then the Galerie Furstenberg (1954–65).
98 Simone Breton, *Lettres à Denise Lévy*, 76.
99 Polizzotti, *Revolution of the Mind*, 220.
100 Sowels and Colmart, *Au grand jour*, 22, 37.
101 Thévenin and Bonnet, *Archives du surréalisme*, 17.
102 *Ibid.*, 40.
103 *Ibid.*, 30.
104 *Ibid.*, 26.
105 *Ibid.*, 229. Thévenin, *Bureau de recherches surréalistes*, 75.
106 'André Breton, 42 rue Fontaine', André Breton website.
107 Hörner, *Die realen Frauen der Surrealisten*, 43–5.
108 See Albert Navarre and Hylas de Puytorac, *Cours complet de dactylographie et de machines à écrire* (Paris: Librairie Delalain, 1926), 248–9.
109 Colvile, 'Introduction', 14; my translation. Colvile has noted Simone's predilection for androgynous fashion and attitudes during the 1920s.
110 Sven Spieker, 'The Bureaucracy of the Unconscious: Early Surrealism', in *The Big Archive: Art from the Bureaucracy* (Cambridge, MA: MIT Press, 2008), 89. I have not yet had the chance to review Rachel Silveri's forthcoming chapter 'From the Marvelous to the Managerial: Life at the Surrealist Research Bureau', in *Historical Modernisms: Time, History, and Modernist Aesthetics*, ed. Jean-Michel Rabaté and

Angeliki Spiropoulou (London: Bloomsbury Academic, 2021). On the appropriation of bureaucratic language in the avant-garde, see Trevor Stark, *Total Expansion of the Letter: Avant-Garde Art and Language after Mallarmé* (Cambridge, MA: MIT Press, 2020), *passim*.

111 Breton, 'The Mediums Enter', 91–2.

112 André Breton, 'Carnet 1920–1921', in Breton, *Œuvres complètes*, 1:620. See also André Breton, *Lettres à Jacques Doucet: 1920–1926* (Paris: Gallimard, 2016), 167. Jacques Anis and Catherine Viollet, 'L'Automate et son double: Breton et Soupault, *Les Champs magnétiques*', *Manuscrits surréalistes: Aragon, Breton, Éluard, Leiris, Soupault*, ed. Béatrice Didier and Jacques Neefs (Saint-Denis: Presses Universitaires de Vincennes, 1995), 41–66.

113 Breton, 'The Mediums Enter', 90; original emphasis.

114 Polizzotti, *Revolution of the Mind*, 106. See also André Breton and Philippe Soupault, *Les Champs magnétiques: le manuscrit original fac-similé et transcription* (Paris: Lachenal & Ritter, 1988). I have been unable to review the just-published Jacqueline Chénieux-Gendron et al., *L'Invention du surréalisme: des Champs magnétiques à Nadja* (Paris: Bibliothèque nationale de France, 2020).

115 David Gascoyne, 'The Magnetic Fields', introduction to *The Automatic Message: The Magnetic Fields; the Immaculate Conception*, by André Breton, Paul Éluard, and Philippe Soupault, trans. David Gascoyne, Antony Melville, and Jon E. Graham (London: Atlas Press, 1997), 47–8.

116 Breton, 'The Mediums Enter', 91; original emphasis.

117 Michel Butor, *Éloge de la machine à écrire* (1972; Paris: *Répertoire IV*, 1974), 425; my translation.

118 Polizzotti, *Revolution of the Mind*, 107.

119 Marguerite Bonnet, 'Notice: Les Champs magnétiques', in Breton, *Œuvres complètes*, 1:1131.

120 Jacqueline Chénieux-Gendron, 'Towards a New Definition of Automatism: *L'Immaculée conception*', in *André Breton Today*, ed. Anna Balakian and Rudolf E. Kuenzli (New York: Willis Locker & Owens, 1989), 75, 89.

121 Jacqueline Chénieux-Gendron, 'Jeu de l'incipit et travail de la correction dans l'écriture automatique: l'exemple de *L'Immaculée conception*', in *Une pelle au vent*, 124–42.

122 Sue Taylor, 'The Artist and the Analyst: Jackson Pollock's Stenographic Figure', *American Art* 17, no. 3 (Fall 2003): 52–71.

123 Guillaume Apollinaire, *Zone: Selected Poems*, trans. Ron Padgett (New York: New York Review of Books, 2015), 1; my translation.

124 Ben Hecht, 'Dadafest', in *Dada Performance*, ed. Mel Gordon, trans. Annabelle Melzer and George E. Wellwarth (New York: PAJ Publications, 1987), 80. There are other dada references to typewriters that I do not discuss, such as Raoul Hausmann's mixed media collage, *A Bourgeois Precision Brain Incites a World Movement (Dada Triumphs)* (1920).

125 Louis Aragon, *'Le Mouvement perpétuel' précédé de 'Feu de joie'* (Paris: Gallimard, 1970), 29; my translation.

126 Philippe Soupault, 'Dada Typewriter', in *The Dada Reader: A Critical Anthology*, ed. Dawn Ades (Chicago, IL: University of Chicago Press, 2006), 193–4. Also see 'Vingt-trois manifestes du mouvement dada', *Littérature* 13 (May 1920): 19–20.

127 André Breton and Philippe Soupault, 'If You Please', in *Dada Performance*, 116.

128 *Ibid.*, 122.

129 *Littérature* 1 (1 March 1922): 5; my translation.

130 Benjamin Péret, 'At 125 Boulevard Saint-Germain', in *The Leg of Lamb: Its Life and Works*, trans. Marc Lowenthal (1957; Cambridge, MA: Wakefield Press, 2011), 4.

131 André Breton, 'Soluble Fish', in Breton, *Manifestoes of Surrealism*, 59.

132 I quote from the excerpt of *Traité du style* published in *La Révolution surréaliste* 11 (15 March 1928): 4; my translation. Marcella Munson, 'Eclipsing Desire: Masculine Anxiety and the Surrealist Muse', *French Forum* 29, no. 2 (Spring 2004): 22, 25.

133 Breton, 'Manifesto of Surrealism', 26.

134 *Ibid.*

135 *Ibid.*, 29–30.

136 *Ibid.*, 47.

137 Peter Bürger, *Der Französische Surrealismus; Studien zum Problem der Avantgardistischen Literatur* (Frankfurt am Main: Athenäum, 1971), 154–64. Katharine Conley, *Surrealist Ghostliness* (Lincoln: University of Nebraska Press, 2013).

138 Breton, 'Manifesto of Surrealism', 30.

139 *Ibid.*, 27–8; original emphasis.

140 *Ibid.*, 12–13.

141 *Ibid.*, 23–34.

142 André Breton, *Conversations: The Autobiography of Surrealism with André Parinaud and Others*, trans. Mark Polizzotti (New York: Marlowe & Co., 1993), 65; original emphasis.

143 *Ibid.*, 61–2.

144 *Ibid.*, 64–5.

145 *Ibid.*, 65.

146 *Ibid.*, 71.

147 *Ibid.*, 64. It is possible that Breton was thinking of Charles Baudelaire, who wrote that the artist J. J. Grandville, 'notait sous une forme plastique la succession des rêves et des cauchemars, avec la précision d'un sténographe qui écrit le discours d'un orateur'. Charles Baudelaire, *Curiosités esthétiques, œuvres complètes de Charles Baudelaire* (Paris: Michel Lévy frères, 1868), 2: 412.

148 Breton, *Conversations*, 65.

149 Thévenin, ed., *Bureau de recherches surréalistes*, 8.

150 Francis Gérard, 'L'État d'un surréaliste', *La Révolution surréaliste* 1 (1 December 1924): 30.

151 This text was recopied in 1966 and published in 1970. André Breton, 'En Marge des *Champs magnétiques*', *Change: le Groupe la Rupture* 7 (1970): 10; my translation.

152 *Ibid.*, 9–10.

153 Breton, 'The Mediums Enter', 92.

154 Giorgio de Chirico, *The Memoirs of Giorgio de Chirico*, trans. Margaret Crosland (Coral Gables: University of Miami Press, 1971), 120–1.

155 Morise, 'Les Yeux enchantés', 27.

156 Delphine Gardey, 'Mechanizing Writing and Photographing the Word: Utopias, Office Work, and Histories of Gender and Technology', *History and Technology* 17, no. 4 (2001): 327.

157 Siân Reynolds, *France Between the Wars: Gender and Politics* (London: Routledge, 1996), 93.

158 Elyce J. Rotella, *From Home to Office: U.S. Women at Work, 1870–1930* (Ann Arbor: UMI Research Press, 1981), 66–71.

159 *Ibid.*

160 Richard Nelson Current, *The Typewriter and the Men Who Made It* (Urbana: University of Illinois Press, 1954), 9, 92, and *passim*.

161 Schweitzer, *Les Femmes ont toujours travaillé*, 213–14.

162 Delphine Gardey, 'Sténodactylographe: de la naissance d'une profession à sa féminisation', *Les Cahiers du Mage* 1 (1995): 56.

163 Frader, *Breadwinners and Citizens*, 141–3.

164 Sharon Hartman Strom, *Beyond the Typewriter: Gender, Class, and the Origins of Modern American Office Work, 1900–1930* (Chicago: University of Illinois Press, 1992), 10 and *passim*.

165 Ernest Olriau, *Cours élémentaire et supérieur de sténographie* (Paris: Berger-Levrault, 1917), 134, 136; my translation.

166 *Ibid.*, 55.

167 Théodore Flournoy, C. G. Jung, and Mireille Cifali, *From India to the Planet Mars: A Case of Multiple Personality with Imaginary Languages*, ed. Sonu Shamdasani, trans. Daniel B. Virmilye (Princeton, NJ: Princeton University Press, 1994). On surrealism and scripts see Leslie Jones, Isabelle Dervaux, and Susan Laxton, *Drawing Surrealism* (Los Angeles, CA: Los Angeles County Museum of Art, 2012); Conley, *Surrealist Ghostliness*.

168 Olriau, *Cours élémentaire*, 55; my translation.

169 Gardey, 'La Standardisation d'une pratique technique', 83.

170 Navarre and de Puytorac, *Cours complet*, 42; my translation.

171 *Dactylographie: méthode des dix doigts* (Paris: M. Chevalier, 1927), 7.

172 Ellen Lane Spencer, *The Efficient Secretary* (New York: Frederick A. Stokes Co., 1916), 58–9.

173 Navarre and de Puytorac, *Cours complet*, 14–15; my translation.

174 Kittler, *Gramophone, Film, Typewriter*, 191.

175 Paul Robert, *Sexy Legs and Typewriters: Women in Office-related Advertising, Humor, Glamour, and Erotica* (Amsterdam: Virtual Typewriter Museum, 2003).

176 Rosemary Pringle, *Secretaries Talk: Sexuality, Power and Work* (London: Verso, 1988), 174–6.

177 James F. McMillan, *Housewife or Harlot: The Place of Women in French Society, 1870–1940* (New York: St Martin's Press, 1981), 116–17. Frader, *Breadwinners and Citizens*, 16.

178 Françoise Thébaud, *Les Femmes au temps de la guerre de 14* (Paris: Stock, 1986). Frader, *Breadwinners and Citizens*, 38.

179 Reynolds, *France Between the Wars*, 93. Frader, *Breadwinners and Citizens*, 35, 36.

180 Schweitzer, *Les Femmes ont toujours travaillé*, 39.

181 Frader, *Breadwinners and Citizens*, 3–4, 115–16.

182 Gardey, 'Sténodactylographie', 57.

183 Maurine Weiner Greenwald, *Women, War, and Work: The Impact of World War I on Women Workers in the United States* (Ithaca, NY: Cornell University Press, 1990), 32–40. Anne-Marie Sohn, 'Between the Wars in France and England', in *A History of Women in the West*, ed. Françoise Thébaud (Cambridge, MA: Belknap Press of Harvard University Press, 1992), 112.

184 On this subject, also see Mary Louise Roberts, *Civilization without Sexes: Reconstructing Gender in Post-war France; 1917–1927* (Chicago, IL: University of Chicago Press, 1994).

185 Frader, *Breadwinners and Citizens*, 10 and *passim*. Thébaud, 'The Great War', 69.

186 McMillan, *Housewife or Harlot*, 129. Schweitzer, *Les Femmes ont toujours travaillé*, 34–9. Jill Richards, *The Fury Archives: Female Citizenship, Human Rights, and the International Avant-Gardes* (New York: Columbia University Press, 2020).

187 Olriau, *Cours élémentaire*, 135; my translation.

188 Navarre and de Puytorac, *Cours complet de dactylographie*, 240.

189 *Ibid.*, 248.

190 Wilfred A. Beeching, *Century of the Typewriter* (London: Heinemann, 1974), 37–8.

191 Gardey, *La Dactylographe et l'expéditionnaire*, 10 and *passim*.

192 Blanchot, 'Tomorrow at Stake', 417–21.

193 Christopher Keep, 'The Cultural Work of the Type-Writer Girl', *Victorian Studies* 40, no. 3 (Spring 1997): 423.

194 David Lomas, *The Haunted Self: Surrealism, Psychoanalysis, Subjectivity* (New Haven, CT: Yale University Press, 2000); David Lomas and Jeremy Stubbs, *Simulating the Marvellous: Psychology, Surrealism, Postmodernism* (Manchester: Manchester University Press, 2013). On surrealism's continued interest in the occult after World War II, see Gavin Parkinson, *Futures of Surrealism: Myth, Science Fiction, and Fantastic Art in France, 1936–1969* (New Haven, CT: Yale University Press, 2015). Also see Susan L. Aberth, *Leonora Carrington: Surrealism, Alchemy and Art* (Aldershot: Lund Humphries, 2004).

195 Claudie Massicotte, 'Spiritual Surrealists: Séances, Automatism, and the Creative Unconscious', in *Surrealism, Occultism and Politics: In Search of the Marvellous*, ed. Tessel M. Bauduin, Victoria Ferentinou, and Daniel Zamani (London: Routledge, 2018), 23–8; Colin Rhodes, 'Four "Outsiders", Four Women: Surrealism and the Psychic Elsewhere', in *Intersections: Women Artists/Surrealism/Modernism*, ed. Patricia Allmer (Manchester: Manchester University Press, 2016), 15–32.

196 David Lomas, '"Modest Recording Instruments": Science, Surrealism and Visuality', *Art History* 27, no. 4 (21 September 2004): 627–50.

197 David Bate, *Photography and Surrealism: Sexuality, Colonialism and Social Dissent* (London: I. B. Tauris, 2003), 72–3; Lomas, '"Modest Recording Instruments"', 628–32; Bernard-Paul Robert, 'André Breton et la parole intérieure', *Revue de l'Université d'Ottawa* 44, no. 3 (July/September 1974): 281–301.

198 Kittler, *Gramophone, Film, Typewriter*, 221.

199 Gertrude Stein and Leon M. Solomons, *Motor Automatism* (New York: Phoenix Book Shop, 1969), 14. Original emphasis.

200 See, for instance, Jeffrey Sconce, *Haunted Media: Electronic Presence from Telegraphy to Television* (Durham, NC: Duke University Press, 2000).

201 Anthony Enns, 'The Undead Author: Spiritualism, Technology and Authorship', in *The Ashgate Research Companion to Nineteenth-Century Spiritualism and the Occult*, ed. Tatiana Kontou and Sarah A. Willburn (London: Routledge, 2016), 55–78. See also Alan Ramon Clinton, 'Conservative Modernism and the Automatic Response', in *Mechanical Occult: Automatism, Modernism, and the Specter of Politics* (New York: Peter Lang, 2004), 1–139.

202 Enns, 'The Undead Author', 55–78.

203 Jill Galvan, 'The Victorian Post-human: Transmission, Information and the Séance', in Kontou and Willburn, *Nineteenth-Century Spiritualism*, 79–80.

204 Christopher Keep, 'Blinded by the Type: Gender and Information Technology at the Turn of the Century', *Nineteenth Century Contexts* 23, no. 1 (2001): 164. See also Aura Satz, 'Typewriter, Pianola, Slate, Phonograph: Recording Technologies and Automatism', in *The Machine and the Ghost: Technology and Spiritualism in Nineteenth- to Twenty-first-century Art and Culture*, ed. Sas Mays and Neil Matheson (Manchester: Manchester University Press, 2013), 37–56.

205 Helen Sword, *Ghostwriting Modernism* (Ithaca, NY: Cornell University Press, 2002); Timothy Materer, *Modernist Alchemy: Poetry and the Occult* (Ithaca, NY: Cornell University Press, 1995).

206 Walter Benjamin. 'Surrealism: The Last Snapshot of the European Intelligentsia', in *Selected Writings*, ed. Michael William Jennings, trans. Edmund Jephcott (Cambridge, MA: Belknap Press of Harvard University Press, 1996), 208.

207 André Breton, 'The Automatic Message', in *The Automatic Message*, 7–36.

208 *Ibid.*, 24, 25.

209 *Ibid.*, 26.

210 Lisa Gitelman, *Scripts, Grooves, and Writing Machines: Representing Technology in the Edison Era* (Stanford, CA: Stanford University Press, 1999). Katharine Conley has provided an important example of the application of media theory to surrealism in her discussion of Robert Desnos and his work in radio broadcasting from the early 1930s onwards. She related his radio employment to his automatism and the way in which the aural experience of language in recorded sound might have influenced the surrealist experience of the inner voice as well as Desnos's own interest in telepathic communication with Rrose Sélavy, Marcel Duchamp's female alter ego. Conley, *Robert Desnos*, 87–119. Also see Yvonne Duplessis, *Surréalisme et paranormal: L'aspect expérimental du surréalisme* (Agnières: JMG Éditions, 2002).

211 Eburne, 'Approximate Life', 62–81.

212 Abigail Susik, 'Chance and Automatism: Genealogies of the Dissociative in Dada and Surrealism', in *A Companion to Dada and Surrealism*, 242–57.

213 Michel Murat, 'Jeux de l'automatisme', in *Une pelle au vent*, 7–8. Lomas and Stubbs, *Simulating the Marvellous*.

214 Robin Walz, *Pulp Surrealism: Insolent Popular Culture in Early Twentieth-century Paris* (Berkeley: University of California Press, 2000).

215 'Suicides', *La Révolution surréaliste* 1 (1 December 1924): 32; my translation.

216 Georges Sebbag, *André Breton, L'amour folie: Suzanne, Nadja, Lise, Simone* (Paris: Jean-Michel Place, 2004).

217 Bate, *Photography and Surrealism*, 82.

218 Belton, *Beribboned Bomb*, 75.

219 Conley, *Automatic Woman*, 1.

220 Linda Steer, 'Picturing Hysteria in *La Révolution surréaliste*: From Pathology to Ecstasy', in *Appropriated Photographs in French Surrealist Periodicals, 1924–1939* (London: Routledge, 2017), 40.

221 Natalya Lusty, *Surrealism, Feminism, Psychoanalysis* (Burlington, VT: Ashgate, 2007), 13.

222 Poivert, 'Images de la pensée', 311. Wyndham took many erotic images of women at 'work' throughout the 1920s.

223 On surrealism and the school, see Spector, *Surrealist Art and Writing*, 22–41.

224 *La Femme surréaliste*, special issue of *Obliques* 14–15 (1977): 207.

225 Spiteri, 'Community at Play', in *Surrealism: Key Concepts*, 112. Thévenin has argued that the automatist is both dictator and receiver in that the hand obeys the 'pulsion' of the dictation, and that this dual role results in 'narcissism' or solipsism. Paule Thévenin, 'L'Automatisme en question', in *Folie et psychanalyse dans l'expérience surréaliste*, ed. Fabienne Hulak (Nice: Z'éditions, 1992), 55–8.

226 Donna Haraway, 'A Cyborg Manifesto: Science, Technology, and Socialist-Feminism in the Late Twentieth Century', in *Simians, Cyborgs, and Women: The Reinvention of Nature* (London and New York: Routledge, 1991), 149–81. On the appropriation of femininity in Marcel Duchamp's work, see Amelia Jones, *Postmodernism and the En-gendering of Marcel Duchamp* (Cambridge: Cambridge University Press, 1994), 146–90.

227 Lomas and Stubbs, *Simulating the Marvellous*, 216–17.

228 Conley, *Automatic Woman*, 1.

229 Martine Antle, 'Breton, Portrait and Anti-Portrait: From the Figural to the Spectral', in *André Breton Today*, 50.

230 My translation.

231 Dickran Tashjian, '"Vous pour moi?" Marcel Duchamp and Transgender Coupling', in *Mirror Images: Women, Surrealism, and Self-representation*, ed. Whitney Chadwick (Cambridge, MA: MIT Press, 1998), 38.

232 Maurine Watkins, 'Demand Noose for "Prettiest" Woman Slayer: Mrs. Annan Held on Murder Charge', *Chicago Tribune*, 4 April 1924, 1.

233 Douglas Perry, *The Girls of Murder City: Fame, Lust, and the Beautiful Killers Who Inspired 'Chicago'* (New York: Viking, 2010).

234 Maurine Watkins, *Chicago: With the* Chicago Tribune *Articles That Inspired It*, ed. Thomas H. Pauly (Carbondale: Southern Illinois University Press, 1997).

235 Eburne, *Surrealism and the Art of Crime*, 66–73.

236 Abigail Susik, 'Surrealism and Jules Verne: Navigating Context, Intertext and Subtext for a Collage by Max Ernst', in *Surrealism, Science Fiction and Comics*, 16–39. See also Elza Adamowicz, *Surrealist Collage in Text and Image: Dissecting the Exquisite Corpse* (Cambridge: Cambridge University Press, 2005).

237 Hal Foster, *Compulsive Beauty* (Cambridge, MA: MIT Press, 1993), 5–6, 134–5, 150–3, and *passim*.

238 Steven Harris, *Surrealist Art and Thought in the 1930s: Art, Politics and the Psyche* (New York: Cambridge University Press, 2004), 201–2.

239 Amy Lyford, *Surrealist Masculinities: Gender Anxiety and the Aesthetics of Post-World War I Reconstruction in France* (Berkeley: University of California Press, 2007), 10 and *passim*.

240 Harris, *Surrealist Art and Thought*, 172.

241 Simone Breton, *Lettres à Denise Lévy*, 110.

242 Michelle Perrot, 'The New Eve and the Old Adam: French Women's Condition at the Turn of the Century', in *Behind the Lines: Gender and the Two World Wars*, ed. Margaret R. Higonnet, Jane Jenson, Sonya Michael, and Margaret Collins Weitz (New Haven, CT: Yale University Press, 1987), 54.

243 Jacqueline Chénieux-Gendron, *Surrealism*, trans. Vivian Folkenflik (New York: Columbia University Press, 1990), 57–8. Bonnet, *André Breton*, 182.

244 Chénieux-Gendron, *Surrealism*, 60. Michael Riffaterre, 'Semantic Incompatibilities in Automatic Writing', in *Text Production*, trans. Terese Lyons (New York: Columbia University Press, 1983), 221–39.

3 Óscar Domínguez: autonomy and autoeroticism

'These phosphorescent youths': Domínguez and surrealism, 1934–35

In a grainy photograph of the massive 24-hour general strike that took place in Paris on 12 February 1934, André Breton's face can barely be glimpsed behind the profile of a young André Wurmser, who is walking next to another prominent writer, Jules Romains (Figure 3.1).[1] Surrealist poet Paul Éluard stands slightly apart from Breton, his eyes anxiously surveying what lies ahead. The little we can see of Breton's face is a blur of action. His mouth is open in a cry of protest, and his fist is raised in a gesture of anti-fascist solidarity fitting for that day's direct action organised by one of the largest French trade unions, the Confédération générale du travail (CGT), in collaboration with other leftist factions. The banner of the newly formed group that gathered these intellectuals to march alongside roughly four million workers across France in opposition to fascism and in support of a unified left front is visible behind their heads: Comité de Vigilance des Intellectuels Antifascistes (CVIA). The CVIA had organised less than a week earlier after extreme right-wing groups swarmed into the capital, targeting the Place de la Concorde on 6 February in a violent and riotous anti-government demonstration.

Captured in haste by Arthur (Artür) Harfaux, this photograph of surrealist participation in the enormously successful grassroots counter-demonstration is a telling encapsulation of the complex social forces that shaped and modified surrealism's attitude towards wage labour and the role of work in society during the 1930s. This photographic documentation of surrealist involvement in strike action illuminates the movement's forceful anti-fascist political identity and radical *gauchisme* (far left-leaning tendencies), factors which contributed to surrealism's eventual turn away from the Communist Party, as I will discuss later. In addition, Harfaux's photograph speaks to the ways in which surrealism's anti-fascism and ultra-leftism were tied to France's highly active labour struggle during the 1930s. The general strike of workers of all kinds, including intellectual workers, was still considered to be one of the best means of sabotaging production

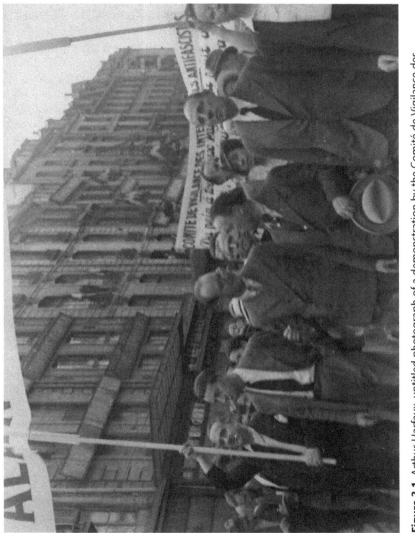

Figure 3.1 Arthur Harfaux, untitled photograph of a demonstration by the Comité de Vigilance des Intellectuels Antifascistes, Paris, 12 February 1934

and decrying unacceptable social conditions. Surrealism's 1936 strike action demonstrates that its war against capitalist wage labour remained one fought in solidarity with the cause of wage workers themselves.

Members of the surrealist group had also marched against fascism on 9 February 1934, and Yves Tanguy was consequently wounded in a confrontation.[2] 'All the surrealists were out in the streets', André Thirion recalled. 'Tanguy was at Gare de l'Est, where he was struck by a bludgeon.'[3] In response, Benjamin Péret, the surrealist poet and militant member of Leon Trotsky's Parti Ouvrier Internationaliste, wrote a satirical poem from the perspective of an ultra-right-wing Croix de feu veteran that unflinchingly describes the violence of the riots: 'Long live the sixth of February / grumbles the tobacco juice / dressed like a fleur-de-lised turd / How fine it was / Buses were burning like heretics in the old days / and horses' eyes/ torn out by our *cannes-gillettes* [swordsticks, literally, "razor-canes"] / were hitting cops who were so disgusting and greasy / that you'd think they were the Croix de feu'.[4]

As these events indicate, surrealism's direct actions were a crucial component of its pre-World War II identity, inseparable from its artistic programme and significantly determinant of it. The question of how surrealism's critique of work shifted and expanded during the 1930s is therefore fundamentally conjoined with the ways in which the movement's art strategies and practices developed in tandem with its activism. The 1930s witnessed a remarkable expansion of surrealism's ongoing attempt to forge an ideologically autonomous, pro-revolutionary art that rallied behind the cause of a proletarian overthrow of capitalism and sought to transform life in ways that exceeded the sphere of politics.[5]

In order to chart these shifts in surrealism's critique of wage labour during the 1930s, I consider – broadly in the context of the 1934 general strike against fascism and related socio-political developments – the case of surrealist Óscar Domínguez. This chapter analyses the production, reception, and significance of Domínguez's mixed-media artworks between 1934 and 1938 and the theme of work sabotage they manifested. The first section establishes the historical context; the second section undertakes an iconographic investigation of one prominent example of his symbolic sabotage in an oil on canvas from 1934–35, *Machine à coudre électro-sexuelle* (*Electrosexual Sewing Machine*) (see Plate 3); and the third section considers other artworks by this artist featuring different kinds of envisioned work sabotage.

Domínguez's surrealist works from this period present a concrete and compelling example of the ways in which surrealism paired its disparate social-critique activities with the creative transformation of quotidian reality in art, all the while maintaining a stand against the co-optation of art into propaganda. By envisioning various types of imaginative work sabotage – wherein gendered forms of labour and functionalist work-tool relations are symbolically deregulated either through pleasure or destruction, or both – Domínguez developed a powerful iconography for the surrealist subversion of the work ethic. Moreover, he did so in the era when surrealism moved away from communism and towards other

models for societal revolution. Joining the surrealist group in late summer 1934, barely half a year after Breton's participation in the general strike, Domínguez arrived just in time to participate in surrealism's rejection of Stalinism and engage in its tireless fight against fascism. The profound resonance of Domínguez's iconography of surrealist sabotage with surrealism's political positions in the mid-1930s is, therefore, a crucial factor in understanding the significance of his reception in this milieu before World War II.

My analysis has two primary goals. The first is to determine how the realm of envisioned surrealist sabotage functions as a conceptual and often camouflaged, or partially concealed, form of artistic resistance. Such symbolic sabotage catalysed the direct-action resistance that the surrealists ardently supported during this period in the form of a still-anticipated proletarian overthrow of capitalism. The second goal is to comprehend how Domínguez's iconography of surrealist sabotage speaks not only to the movement's established discourse of work refusal but also to its critique of productivism, authoritarianism, and propagandistic art in both fascism and Stalin's Communist Party. Surrealism's call for the abolition of wage labour laid some of the groundwork for its intransigent defence of art's freedom from propagandistic applications. This repudiation of paid productive *and* symbolic labour in many of Domínguez's works from this period can partly be understood as a condensation of surrealism's eventual refusal, by the mid-1930s, to commit itself to a single political faction and its insistence that art must never labour under the yoke of ideology. Surrealism's double refusal of work and political affiliation is a radical socio-political position in itself – a permanent protest or general strike against political compromise, artistic subservience, and authoritarianism.

Domínguez, surrealista

What were some of the biographical and historical factors that contributed to Domínguez's development of an influential iconography of surrealist work sabotage during the 1930s, and how did this theme speak to some of surrealism's larger concerns about work refusal during this decade? Óscar Domínguez (1906–57) came of age in privileged surroundings as the youngest child and only son of a widower whose success as the proprietor of a prosperous banana farm in Tenerife, the largest of Spain's Canary Islands, funded the family's increasingly lavish lifestyle. As was expected of him, Domínguez worked for the Paris branch of his father's company on and off between 1927 and 1931, spending many of his days reporting to his family's export office. But much of his time was also devoted to spending a generous familial allowance exploring the nightlife of Paris with his older sister and her painter husband.[6] Domínguez himself had started painting as an earnest amateur in Tenerife by 1926. This habit continued under the influence of the French capital, with his first group exhibition taking place in 1928 in Tenerife, where he returned often for extended stays.[7] Three years later, in September 1931, his father died, leaving an unexpected tangle of debts and no

inheritance for the children. By then a dedicated painter, Domínguez nevertheless returned to Tenerife to manage his father's estate. He stayed there during the early months of the new Spanish Republic, which had been declared in April 1931, with the constitution passing that December.[8] Following the collapse of his father's commercial farming venture, Domínguez took on his first steady employment as a white-collar wage worker, making illustrations as an advertising designer in Tenerife and eventually in Paris, to where he soon returned and remained for the rest of his life.

Domínguez had fully embraced surrealism in artistic style, if not yet in personal identity, by the time of his 1932 group exhibition in Tenerife.[9] Although he did not meet members of the surrealist group in France until 1934, his attraction to the movement was already established. This was thanks in part to the growing interest in surrealism in the Canary Islands, which developed around Canarian critic Eduardo Westerdahl's avant-garde review *Gaceta de arte*, first published in 1932. This publication released thirty-eight issues before it ceased with the outbreak of the Spanish Civil War in 1936.[10]

As early as autumn 1932, the socialist arts writer Domingo López Torres illustrated his article 'Surrealism and Revolution' in the *Gaceta de arte* with a reproduction of Domínguez's painting *Souvenir de Paris* (1932).[11] For López Torres, surrealism was at once an outgrowth of dialectical materialism and a form of radical advocacy for proletarian revolution. Reviews in various Spanish publications of Domínguez's first solo exhibition in Tenerife in 1933 decisively named him a proponent of the movement who was both indebted to Salvador Dalí and consumed by Freudian themes of sexuality.[12] However, Domínguez's surrealist designation was also understood by some members of his circle to be explicitly related to issues of bourgeois class critique. In June 1936, Domínguez showed the painting *Machine à coudre électro-sexuelle* (see Plate 3), as well as four other paintings, four drawings, and a surrealist object, at the Círculo de bellas artes in Santa Cruz de Tenerife. Westerdahl, an ardent Domínguez supporter, published a short essay on this display in the publication *La Prensa*, claiming, 'Before these paintings by Domínguez, the bourgeois senses that the social structure of ease and tranquil repose in which he lives is in the midst of crumbling. His outcry is logical.'[13]

Domínguez first became acquainted with members of the Paris surrealist group during late summer and early autumn 1934 while helping organise the large *Exposición surrealista*, unveiled a year later in May 1935 at the Ateneo de Santa Cruz de Tenerife. His 'Letter from Paris. Conversation with Salvador Dalí', which appeared in the *Gaceta de arte* 28 (July 1934), likely facilitated their introduction. Working under the aegis of the *Gaceta de arte* and the Círculo de bellas artes de Tenerife, Domínguez arranged the trip to Tenerife undertaken by André Breton, Benjamin Péret, and Jacqueline Lamba for the opening of the *Exposición surrealista*.[14] Seventy-six surrealist artworks by Max Ernst, Yves Tanguy, Victor Brauner, Hans Arp, and others were displayed.[15] Domínguez included two of his own paintings, although he was unable to travel to the event.[16]

As a result of these organising activities, Domínguez was invited to participate in the *Exposition internationale cubiste-surréaliste*, also called *Kubisme-surréalisme*, curated by Vilhelm Bjerke-Petersen, André Breton, and others, which opened in Copenhagen in January 1935. Domínguez showed two canvases there in advance of the surrealism group show in Tenerife.[17]

The rest of that year would prove as pivotal for surrealism as it was for Domínguez's development as a surrealist. The *Exposición surrealista* exhibition in Tenerife (11–24 May 1935) was an important contributor to surrealism's process of internationalisation, with contacts becoming more numerous in Czechoslovakia, Denmark, England, Japan, Peru, Spain, and Yugoslavia.[18] Yet this expansion of the movement in Spain was halted just a year later when the Spanish Civil War erupted in summer 1936. Some contributors to the *Gaceta de arte* were murdered by fascists, including Domingo López Torres, who was first imprisoned and then forcibly drowned in the Atlantic in 1937. Both author Agustín Espinosa and poet Adriano del Valle joined the cause of Francisco Franco's nationalist coup d'état.[19] Domínguez, who was visiting Tenerife for an exhibition when the war broke out, hid in his sister's house for two months until he could escape in disguise back to Paris. He did not take up arms on behalf of the Republic. His tentative health due to a dangerous growth disorder since childhood, which caused the progressive deformation of his bones, was likely the primary cause of his retreat from the war, despite his opposition to Franco – although he had never been a political militant.[20] He returned to France as a permanent exile.

The *Exposición surrealista* received broad coverage in the local press.[21] During his three-week stay in Tenerife, Breton was interviewed by the socialist periodical *Índice*. Breton clarified that political themes can play a role in painting as long as they are fully assimilated into freely constructed subject matter and do not appear as methodically appended propaganda elements. He also asserted that surrealism fully adhered to all theses of dialectical materialism, including the 'primacy of matter over thought' and the inevitability of social revolution as a result of class struggle; nevertheless, for Breton, art's independence remained 'indispensable'.[22] Then, in October, the second issue of the *Bulletin international du surréalisme* came out in Tenerife with bilingual articles in Spanish and French and illustrations by Domínguez and Pablo Picasso. To concretise and expand the anti-fascist critique issued by the Tenerife exhibition, excerpts from Breton's interview in *Índice* were reprinted in this second *Bulletin*.[23]

For the remainder of 1935, Domínguez was a participant in surrealist declarations, exhibitions, and events as a compatriot and collaborator who became intimately familiar with the group's cares and concerns. Around the time of the Tenerife exhibition, for example, he contributed two small drawings to the illustrated programme for the 'Systematic Cycle of Conferences on the Latest Positions in Surrealism', a series of lectures by surrealists planned for June 1935 in Paris. Although these conferences never took place, Domínguez's influence on surrealism became increasingly palpable during the second half of the 1930s,

particularly in relation to surrealism's modulating outlook on work refusal and its embrace of an aesthetics of unruly self-management.

'Their smut and their slurs on labour': surrealism's break with the PCF

Surrealism's solidarity in the February 1934 *grève générale* (general strike) with the beginnings of the left-wing alliance between the PCF and social-democratic groups (which would later evolve into the Front populaire) did not alter the tensions that had always been present in the surrealists' rapport with the Communist Party. Cohesion between surrealism and the French anti-fascist alliance in fact proved short-lived because of France's imminent collaboration with Stalin in resisting Hitler. The political and artistic ideologies that had united Breton and Paul Éluard with anti-fascist protesters on 12 February 1934 were soon to be the very factors that contributed to the eventual split of these friends in 1938 as a result of Éluard's Party commitments.[24] Breton and Éluard had joined the French Communist Party in 1927, but their relationship to it remained tentative until 1935, when the Paris group permanently severed alliances with the Party – a departure that was mutually desired by that point and had been presaged by a series of earlier ruptures.[25] After the break of 1935, however, Éluard's ties to the Party deepened independently of surrealism.

Yet, in the first months of 1934, the magnitude of the fascist threat was still enough to draw the surrealists towards another attempt at sustained collaboration with the PCF and a new level of commitment with other leftist organisations, such as the CVIA, in the form of a protest pamphlet titled *Appel à la lutte* (*Call to Struggle*). This document was drafted under Breton's initiative on the evening of the 6 February right-wing riot. It was published with nearly ninety signatures of French intellectuals and distributed to leftist organisations on 10 February.[26] *Appel à la lutte* promoted a 'unity of action' and 'conciliation' among trade unions, leftist political organisations, and intellectuals, and it agitated for the general strike that occurred shortly thereafter. But above all, *Appel à la lutte* was an appeal to workers in an era in which organised labour experienced significant growth in France after the worldwide Depression. Breton and the other surrealists who signed the call made their unshakeable solidarity with a proletarian revolution resoundingly clear. Citing the protests that had made 'brutally present' the 'awareness of the immediate fascist danger' and the 'bloody repression of workers' demonstrations', the pamphlet urgently pressed workers and intellectuals for a class unity 'not yet realised'.[27]

These developments are significant when analysing Domínguez's artistic adoption of the surrealist critique of work, but his involvement in surrealism's break with the PCF must also be considered. Domínguez was one of twenty-six signatories on Breton's tract from summer 1935, *Du temps que les surréalistes avaient raison* (*On the Time when the Surrealists Were Right*), which signalled surrealism's final rupture with the PCF.[28] Also profoundly relevant for the

surrealists' emerging political autonomy and Domínguez's work critique was the group's interest in sexual liberation, a key factor in its falling-out with the PCF. The point of intersection for these associations is exemplified in the events surrounding Breton's confrontation with the Russian communist writer Ilya Ehrenburg (also transliterated as Ilia Erenbourg), a correspondent for the daily broadsheet *Izvestia*, which deepened the ideological chasm between surrealism and the PCF in the days preceding author René Crevel's suicide.

Ehrenburg's 1934 essay 'Duhamel, Gide, Malraux, Mauriac, Morand, Romains, Unamuno vus par un écrivain de l'URSS' ('Duhamel, Gide, Malraux, Mauriac, Morand, Romains, Unamuno Seen by a Writer from the USSR') included a humiliating lambaste of the surrealists, in which their revolutionary fervour and attempts at alignment with the PCF are ridiculed and their anti-work stance is condemned, alongside their interest in sexual liberation. Ehrenburg's essay could be taken as a reaction to French philosopher Ferdinand Alquié's inflammatory comments in 1933 in *Le Surréalisme au service de la révolution* (*LSASDLR*) about the Third International (according to Alquié, communists are so moralising and machine-worshipping that they believe work, even involuntary labour, is a source of 'regeneration' for humans).[29] It may also have been a reaction to André Thirion's rearticulated critique of the bourgeois ethic of wage labour from 1929, 'À Bas le travail!' ('Down With Work!').[30] Whatever the case, 'Vus par un écrivain' lingered on surrealism's sexual libertinage, recalling an episode that took place in 1930 in which a group of surrealist members of the PCF were ordered by the Party to denounce Salvador Dalí because of a prose piece titled '*Rêverie*' the artist had just published in *LSASDLR* 4. In this text, which the surrealists refused to condemn, Dalí described a sexual fantasy in which a young girl is prepared for the sexual initiation of sodomy and masturbation.

Ehrenburg's 'Vus par un écrivain de l'URSS' reprises these occurrences, calumniating surrealism for its perverse and anti-communist decadence and its delectation of laziness and sexual profligacy. Given its relevance for my discussion in the next section about Domínguez's iconography of surrealist sabotage, I quote several passages at length here:

> Preoccupied with theories of masturbation and exhibitionist philosophies, these phosphorescent youths would make themselves out to be implacable revolutionary zealots and the champions of a proletarian purity.
> [...]
> These young 'revolutionists' will have nothing to do with work. They go in for Hegel and Marx and the revolution, but work is something to which they are not adapted. They are too busy studying pederasty and dreams. They wonder, irritatedly, 'how can anyone go into raptures over the manufacturers of saucepans'? For they, needless to state, are not in a position to manufacture anything. Their time is taken up with spending their inheritances or their wives' dowries. ... They are put out with the Soviet Union, for the same reason that people work there; and this, to their minds, is the 'wind of cretinism'.
> [...]

What is there for them to do? Well, they might at least get out and demonstrate with the unemployed. But the police are in the habit of dispersing the unemployed, and the police carry rubber billies. That is unpleasant – the whole performance is lacking in luster; who ever talks about the unemployed? For revolution, to them, means nothing more or less than a chance for self-advertisement.

[…]

They have another program to unfold, consisting of onanism, pederasty, fetishism, exhibitionism, and even bestiality.

[…]

As for the workers, they do not read poems of Japanese paper and magazines that come in outlandish covers; but if their eyes should happen to light on these publications, with their smut and their slurs on labour, they would not be able to conceive of 'service to the revolution' being associated with such ordinary street hooliganism.[31]

Along with a fraught series of events that ensued in response to Ehrenburg's publication, Breton's *Du temps que les surréalistes avaient raison* publicly denounced Ehrenburg's accusations and announced surrealism's break with communism.[32] It also condemned Ehrenburg's polemic about the anti-work ethos and sexual libertinage of surrealism's 'phosphorescent youths'. But the surrealists' primary complaint as expressed in Breton's essay was the Party's authoritarianism under Stalin. Most evident, *Du temps que les surréalistes avaient raison* makes it clear that surrealism would intractably maintain its freedom of speech, artistic autonomy, and political independence, even in the midst of its own revolutionary fervour. Trotsky's statement in *Literature and Revolution* that 'art must make its own way and by its own means' was repeatedly echoed by surrealism's insistent assertions.[33]

It is in the context of this contentious severance with the PCF and in relation to the increasing authoritarianism of the Third International that I want to consider the conspicuous themes of resexualised work and tools in Domínguez's art during the 1930s. After Domínguez's entry into the surrealist group in 1934, can the iconography of work subversion that frequently appeared in his production be understood as a statement in response to surrealism's relentless war on work? Moreover, how was surrealism's anti-work stance modulated and shaped by both the break with the Party and the outrageous slander against surrealism made by Ehrenburg? Considering that Ehrenburg's attack was rooted in the question of surrealism's perversity in the realms of both work and sexuality, these questions become all the more relevant when posed in relation to Domínguez.

Domínguez's works between 1934 and 1938 repeatedly combine the subject matter of labour sabotage with erotic themes related to masturbation, masochism, and self-generated pleasure, a correlation with Ehrenburg's comments that is too striking to ignore. In Domínguez's surrealist production during the era of the break with the PCF and immediately thereafter, a new phase of surrealism's work refusal can be glimpsed, one in which the dialectical confrontation

between production and consumption achieves a startling synthesis in the motif of autonomous sexual gratification. Conspicuously, for Domínguez, the locus for such an iconography of defiant autoeroticism was the female body.

Domínguez's Machine à coudre électro-sexuelle *(1934–35)*

Envisioning sabotage

Given surrealism's close attention to the momentous events of the French workers' struggle during the mid-1930s, it is no wonder that Domínguez was drawn to the development of a surrealist method of symbolic sabotage during his first years as a group member. The labour movement was achieving concrete results, even as the surrealists still sought total social transformation – at least until World War II made it clear that such a revolution would have to be postponed for the foreseeable future.[34] The *mouvement ouvrier* remained prominent across Europe during this era, and although he was a newly minted middle-class wage worker himself and not a member of the proletariat, Domínguez did not need surrealism to inform him of that. The significant shift in his class identity consequent to the failure of his father's business coincided with the birth of the Second Spanish Republic in spring 1931. Spain's two main syndicalist workers' unions – as well as the *Partido Socialista Obrero Español* and other socialist groups – effected a profound influence on the formation of the new government.[35] Labour issues were at the forefront of European politics at this time, and Domínguez's works of the 1930s reflect that horizon in unexpected ways.

His earliest surrealist works bear the obvious influence of Salvador Dalí and to some extent Giorgio de Chirico, Max Ernst, and Yves Tanguy. These painterly examples set the precedent for Domínguez's figurative depictions of objects, landscapes, and bodies swirled into abstract settings in a fantastic amalgam of dispersed signifiers.[36] Although themes of sensual pleasure, playful distraction, and psychological introspection populate many of these canvases, Domínguez's lifelong engagement with the emblem of the work tool or apparatus – and to a lesser degree the modern female worker – was already palpable by 1934–35.

An important demonstration of the work-tool theme in Domínguez's artistic production is the early painting *Machine à coudre électro-sexuelle* (*Electrosexual Sewing Machine*) (see Plate 3), which relies on its title for the indication of its pictorial and symbolic content: an impossible sewing machine made of wildly incongruous elements steadily at work with – or more appropriately upon – its operator. Completed at the time of his earliest acquaintance with members of the Paris surrealist group, the painting's bewildering iconography reflects both Domínguez's own painterly tendencies as well as the pressing concerns of surrealism at that time. Even so, it must be said that any relation to the subject of labour – whether domestic or waged or some combination of both – is only remotely apparent on an initial glance at this scene. This is also the case with the composition's subtle visual allusion to the morphology of the sewing machine.

The painting's display of plant, animal, human, and machine hybridity confounds stable denotative interpretation.

Work-related themes only begin to emerge more concretely when compared with the many representations Domínguez made of sewing machines and seamstresses in paintings throughout his career, and especially in the 1940s. By then, Domínguez moved away from surrealism and worked under the influence of Pablo Picasso and Paul Éluard, who both remained close to the PCF after the French Resistance to the Nazi occupation of Paris and were no longer affiliated with Breton's group.[37] Domínguez's contributions to surrealism as the organiser of the Tenerife exhibition and a collaborator on the *Bulletin international du surréalisme* had secured him an ongoing role in the movement until the end of World War II, when, in an assertion of artistic independence and allegiance to the post-cubist stylistics he was then pursuing, he distanced himself from surrealism.[38]

Domínguez titled his 1934–35 painting *Electrosexual Sewing Machine*, but no such machine is initially apparent to the viewer. What is the significance of this concurrent designation and concealment? Sewing machines were already familiar surrealist emblems in text and image by the time Domínguez commenced his own representational experiments with this iconography in the mid-1930s, and they reappear in surrealist pieces by various artists during the second half of the twentieth century.[39] We saw in Chapter 2 how the trope of the surrealist typewriter, which eventually became a collective cipher for the practice and theory of surrealist automatism, was partially rooted in texts by Guillaume Apollinaire and Jacques Vaché. These writings date from before the surrealist movement's official launch in 1924 and celebrate the novel modernity of the writing machine and its typically female operator. The typewriter's counterpart, the sewing machine, quickly took on extraliterary sociological and psychological associations for the surrealists during the era of the Great Depression.[40] It is these extraliterary connotations of the surrealist typewriter that allow for an extended application of the sewing machine as a signifier for the surrealist critique of wage labour.

Technical manual

Domínguez's initial conception of *Machine à coudre électro-sexuelle* may have been encouraged in the later stages of its conception by Czech surrealist Jindřich Štyrský's collage *Le Rêve (The Dream)*, which was featured on the front page of the first issue of *Bulletin international du surréalisme* (Figure 3.2). This publication was printed in Prague in early April 1935, just a few months before the second issue of the *Bulletin international du surréalisme* came out in Santa Cruz de Tenerife, with Domínguez's help. The ground of Štyrský's collage is composed of a black-and-white reproduction of an 1888 oil on canvas by French academic painter Édouard Detaille, also called *Le Rêve*, which depicts a battalion of soldiers dreaming collectively of avenging their country's defeat in the Franco-Prussian War of 1870–71. In Detaille's painting, ghostly fallen soldiers dating from the

Figure 3.2 *Bulletin international du surréalisme* 1, April 1935. Detail featuring front page with Jindřich Štyrský's collage, *Le Rêve*, 1935

French Revolution to the late nineteenth century march over the heads of the slumbering recruits at dawn. Štyrský occluded this patriotic supernatural manifestation, painting out the vision in the top third of the composition and adding the collage element of a massively scaled German Wertheim-brand sewing machine.

By maintaining the title of Detaille's painting and half of the original composition, Štyrský's collage emphasises that the nature of collective dreaming transformed itself after 1888. The ominous nature of the gargantuan device, with its needle bearing down on the supine men, suggests a battlefield of corpses rather than sleepers. The giant German sewing machine continues to operate steadily and autonomously on this plain of French defeat, feeding on the material of the past to more effectively execute socio-political collapse in the present.

Although aspects of Domínguez's roughly contemporaneous painting may be an iconographic response to Štyrský's collage, the Canarian artist's composition does not emphasise a comparable message. Instead, it is an exploration of the potential of the sewing machine as a symbolic tool for counterproductivity. Operating in surrealist fashion on the level of intertwined metaphor, metonymy, and association, *Machine à coudre électro-sexuelle* presents itself as a visual puzzle that the viewer must unravel in a series of cognitive digressions.

An armless nude is stretched across the lower third of the composition, held in place just below the knees by the trunk of a verdant tree or vine that springs from the flat, green ground. Small red flowers and tufts of grass sprout from the trunk's stunted form as it swallows the figure's legs. The nude is supported at the torso by the folds of a white sheet draped over her head and shoulders. Above the suspended body is a motley apparatus that slowly dribbles a thin line of thick red liquid, perhaps paint or blood, onto the centre of her back. Adjacent to this body sits a miniature version of a claw-crane arcade game filled with tiny toys waiting to be extracted with a motor-powered arm. First patented and marketed in the 1920s, claw-crane games had become popular in the United States and Europe by the 1930s. Such games were the result of mass fascination in the steam-powered machinery used in creating the Panama Canal in the early twentieth century, which the game imitated with its digging action. The top of the arcade game is surmounted by what resembles the crest of a carnivorous plant, which looms against the barely modulated blue background and leans over the magnet feature that propels the action of the claw.

The painting's title, *Machine à coudre électro-sexuelle*, provides the primary clue that the morphology of the sewing-machine apparatus serves as a latent structural framework for the camouflaged compositional structure. Various aspects of the depicted scene reveal a pictorial evocation of the anatomy of the sewing machine and resonances with the device's cultural history in Europe. Particular sewing-machine parts are subtly referenced throughout the scene. The green tree trunk on the right side of the composition crested with the dangling deer leg is a visual and verbal pun on the presser foot of the sewing machine. Known as the *pied de biche* (or *pied-presseur*; literally, doe's hoof), the small

curved implement holds the fabric firmly in place as the needle completes its rapid piercing action (Figure 3.3).[41] The tree trunk furnishes another layer of innuendo with its possible obscure reference to the *arbres* (crankshafts; also literally, trees) hidden underneath the sewing machine's base or plateau, as it was sometimes called. Domínguez's rendering of the *pied de biche* as a female animal skin exerting pressure onto the nude body as it passes from left to right through the vibratory machine is conceptually recursive; the *pied de biche* animal skin will in turn flay the naked body by submitting it to the machine's action.

This largely zoomorphic transformation of the sewing machine persists in Domínguez's painting with his exploitation of additional puns on the names and purposes of technical parts in relation to the animalistic nature of corporeality. The *griffe d'entraînement* (feed dog) – the small catches that grab the fabric as it is guided through and away from the needle apparatus – are shown literally as *griffes* (animal claws) holding up the torso. This recumbent body, then, is indicated as the operator of the machine. The flexed, white claws beneath the nude are reminiscent of the actions of a sewing-machine operator manipulating a bipedal treadle mechanism, which required precise positioning and movement of the feet. By the late nineteenth century, the bipedal treadle was also widely associated with female autoeroticism in Western nations, as I explain below. This emphasis on the grasping action of the electrosexual sewing machine apparatus and the absent hands of its nude operator is reiterated in another pun in which the claw becomes the centre of an arcade game designed to seize small prizes. The *tête* (head) – the portion of the metal body of the machine that holds the needle apparatus – finds visual homology in the black, horned form. The *bras* (arm), the horizontal beam of the sewing machine's body, transmutes into the overly thick, brown painter's palette beneath the *tête*. The palette becomes an extension of the artist's arms as he reaches towards the surface of the canvas, suggesting that the action of painting is a mimicry of the device's pressing and piercing action.

The two miniature heart-shaped palettes bearing orifices invite fantasies of penetration, which are partially materialised by the appearance of the tiny phallus and the three diminutive horns on the black form. These false needles do not achieve consummation (in vulgar French: *enfiler*) with the nude. Instead, it is the slow dribble of red liquid, a somatic paint passing through the needle-like funnel, which poses as *le fil*, the thread that will eventually connect *le tissu* (the fabric) to *la fille*, the flesh of the feminine machine operator, as she passes through. The piercing thread of liquid and the body of the pierced, the *tension du fil*, are one and the same.[42] The sewing machine and its operator fold into one another in a metonymic amalgam of zoomorphic and anthropomorphic transformation: the machine is at once animal and human while performing. The human operator assumes the form of its own material product: it is a fabric to be stitched.

The head of the prostrate body evokes clitoral stimulation, although such an association is in no way obvious. It is enveloped by a white sheet, as one staring eye peers out and a large red protuberance hangs down like a gargantuan tongue. This was a motif that Salvador Dalí also investigated around this time, in paintings such

Figure 3.3 Unknown artist, illustration of 'Le Mécanisme d'une machine à coudre', *Almanach Hachette* (1922), 97

as *The Persistence of Memory* (1931), for instance, in which a phallic nose juts out from under a humanoid form. The tongue-like body part in Domínguez's *Machine à coudre électro-sexuelle*, however, must be understood in relation to the feminised sewing-machine iconography that suffuses the rest of the scene: it can, in that case, be read as a visual metaphor for a displaced hypertrophic clitoris, a phallic clitoris. The white folds of the sheet gather around the distended and swollen appendage like a labial veil, which is about to be dragged under the rapid hammering action of the stimulating and arousing (*aiguillonnant*) needle. The machine's labour gives way to the body's sensual pleasure, its orgasmic release, and also its symbolic death.

In this elision of human and animal, natural and machinic, the autoeroticism of the metamorphosed seamstress subverts productivist ideologies. The reward, a different kind of clawing toy, is claimed by the feminine operator herself, who morphs into her machine even as she is devoured by it. The act of painting (symbolised in the dripping red liquid) is identified with furtive and subversive female masturbation with a resexualised work tool, which is also a distinct type of deregulated play and misuse taking place under the guise of productivity. The sage-green, red-lipped silhouette that can be spied smiling and smoking a cigarette behind the black form near the centre of the composition redoubles the reconfiguration of the clitoral tongue protuberance, offering yet another image of female self-pleasure.

'The great emancipator' and workplace autoeroticism

Machine à coudre électro-sexuelle builds its metaphor for self-pleasuring anti-work upon the foundations of an outmoded French medical discourse about the sewing machine's supposed psychosexual effects on female operators. This context also engages the largely nineteenth-century discourse about hysteroneurasthenic disorders, as well as the late nineteenth-century invention and marketing of the electromechanical vibrator or massager. The perception of the covert sabotage of productivism and the valorisation of self-managed pleasure in Domínguez's painting remains veiled in a manner that resonates with the labour theory of surrealist automatism discussed in Chapter 2. The painting weaves a fascinating intersection of latent sexual and social associations with the sewing machine, which in turn serves to highlight an elision of surrealist painting and automatism with women's work and self-pleasuring patterns. Ultimately, I hypothesise that Domínguez's *électro-sexuelle* sewing machine can be seen as an insurgent and hysterical work device meant to propel gratification in the hands of its own user, thereby liberating its operator through a state of self-managed and deregulated pleasure.

What is the historical context that supports such a hypothesis? Domínguez's painting appears to indirectly engage a profound reservoir of cultural references that tie female sewing-machine labour to autonomous sexual pleasure. It was the accelerated commercial distribution of the sewing machine and its gender-specific marketing to women that contributed to the birth of a major controversy about femininity and work in France during the second half of the nineteenth century.[43] By the 1860s, historian Judith Coffin has explained, the sewing machine

'was beginning to replace the needle as the icon of femininity'.[44] Since sewing was one of the earliest trades to be feminised, and *la machine à coudre* one of the first industrial tools to be conventionally gendered female, the rapid pace and widespread impact of these cultural changes meant that the social division of labour was mapped directly on to social systems and discourses related to sexual difference. Gender definitions and hierarchies were more than questions of social custom and hegemony. They were increasingly linked to who could do what kind of work and for how much pay, as determined by textile *patronat* (employers) and other bosses.

Sewing-machine manufacturing required precision machine-tools and parts whose development would pave the way for the production of typewriters starting in the 1870s and 1880s and the automobile in the early twentieth century.[45] The sewing-machine industry was also an important predecessor in the privileging of accelerated operation as a desirable convenience. The male labour force was a significant part of the sewing-machine market at first, but as more women in France purchased the mostly American-made equipment to earn meagre wages through piecework completed at home, the sewing machine became a prominent symbol that was both promising and threatening in the prospect of women's increasing agency.[46]

Sewing-machine advertising and showroom displays in France were inundated from the beginning with signifiers of extra-domestic pleasures. Belle-époque renditions of the Singer girl and other brands' images often represent the dressmaker as a confident, stylish, liberated new woman enjoying her freedom with the 'great emancipator', the personal sewing machine.[47] Coffin has argued that advertisers 'inherited cultural imagery' of eighteenth- and nineteenth-century erotic and sometimes pornographic associations between female sex workers and *lingères* (women who made, mended, and washed clothing and other textiles), *couturières* (dressmakers), *cousettes* (seamstresses), and other types of women workers in the garment trades, in that flirtatious femininity was often emphasised in promotional constructions.[48] A paradoxical mood of work-as-play infuses many of the numerous examples of the 'Vive Sainte Anne' postcards that were printed in France during the first few decades of the twentieth century to honour the July feast day of the patron of seamstresses (Plate 4). These often featured fashionable women seated at their sewing machines, demonstrating beguiling hand gestures and coquettish expressions, sometimes in the act of receiving a kiss from a gentleman suitor. Their unwaged domestic labour and their waged work were readily understood to be doubly productive.

Still, taboos against women operating machines (dating as far back as the Middle Ages) maintained a significant hold in conservative discourses about the dangers of these new tools. As early as 1860, Jules Simon's influential book *L'Ouvrière* (*The Woman Worker*) declared that the question of women's waged labour had become a weighty social issue, especially in light of the sexual tensions posed by the gender gap. Simon argued that factory work endangered domestic life and gender roles due to the intermingling of the sexes and increased

opportunity for promiscuity as well as the potential sexual harassment of female workers.[49] As Joan Wallach Scott has reminded us, Simon's book was part of a growing discourse on the subject of femininity and its social status during the Second Empire in France.[50] As a result of Simon's text and others from the late 1840s to the 1860s, the question of the *ouvrière* and the ways in which work exerted deleterious effects on her womanhood, morality, and well-being became increasingly important in these dialogues.[51] This climate, in turn, impacted the typically moralising medical discourse related to the role of women workers in the garment industry that quickly followed on the heels of the mass production and marketing of sewing machines.

Beyond romantic associations for the seamstress in French popular culture, the autoerotic scene constructed in Domínguez's *Machine à coudre électro-sexuelle* references an even more entrenched mid-nineteenth-century French medical discourse that formed around occupational health issues in mechanised garment work and persisted until sewing machines with electric motors became widely used in France during the 1930s and 1940s.[52] During the Second Empire, when Singer sewing machines began to be successfully marketed and distributed in France, doctors in that country and England started to publish concerned accounts about the sexually stimulating nature of this equipment when used by women. This discourse eventually became an international debate.[53]

In this climate of what Julie Wosk has called the 'cultural ambivalence' towards the issue of women and industrial machines in Europe and the United States, some sources insisted that the sewing machine would save women from the unliveable wages they had suffered as needleworkers or even prove to be a device promoting healthy physical activity.[54] However, the supposed labour-saving nature of the sewing machine instead supported longer work hours, and the expanding market for female garment workers did not result in higher pay. Many physicians believed that instead of helping women, the sewing machine created perilous risks. These risks resulted from the effort it required to operate the treadle, the noise and shaking vibrations of its mechanism, and the extended hours of concentration in uncomfortable conditions needed to complete the work.[55] Along with citing increased fatigue and irritation in overworked women operators, doctors fretted over the effects on the menstrual cycle and gynaecological wellness – the bipedal sewing machine was thought to heighten susceptibility to women's diseases and other disorders associated with that gender. As was the case with women workers of all kinds after World War I, this discourse worried pro-natalist doctors, who cited women's entrance into the labour force as a probable cause of France's declining birth rate.

For the most part, however, unhealthy sexual over-stimulation was far and away the most serious concern voiced, since a number of doctors reported that even in a professional setting and surrounded by other people, women operating sewing machines were subjected to frequent and involuntary orgasms.[56] This preoccupation with orgasm was partially due to fears about hysteria, which linked masturbation to mental illness and various forms of disease and also pathologised

female orgasm as a related symptom.[57] As Judith Coffin has explained, due to this connection with long-established anti-masturbation medical discourse, the issue was also a question of morality: 'Seen through such a lens, women's industrial labour readily seemed immoral as well as medically dangerous, exposing women to temptations beyond their (feeble) powers of resistance. Women were exhausted and made sick not just from overwork, but from the strain of battling their erotic impulses.'[58]

The bipedal models of the treadle machines were thought to be the primary culprit, since women had to separate their legs to execute the precise motion required, all the while sitting towards the edge of their seat, which created pressure against the bottom of their chair and friction between the thighs. In an influential Parisian medical report in 1866, Dr Eugène Gibout described the phenomenon of 'involuntary masturbation' involving the sewing machine. He claimed to have encountered eight women with the same work-related health issues of 'aphrodisiac excitement' and exhaustion related to muscular activity 'beyond the strength of a woman'. He deplored the 'demoralisation' and 'vice' of the 'vivid sensual excitement', which was thought to be a barrier to conception.[59] Other medical studies in France soon followed. Dr Émile Decaisne discounted Gibout's claims in an 1870 study, arguing that some seamstresses were deliberately engaging in masturbation while working because they already possessed the habit of this 'moral perversion', not because of any characteristic of the machine.[60]

In 1876 the French physician and sexologist Thésée Pouillet published the study *De l'Onanisme chez la femme* (*Masturbation in Women*). He described a scene in which he encountered a woman in the midst of her sewing work in a military clothing factory overcome with involuntary orgasms:

> While she was automatically occupied with the trousers she was making on the machine, her face became animated, her mouth opened slightly, her nostrils dilated, her feet moved the pedals with constantly increasing rapidity. Soon I saw a convulsive look in her eyes, her eyelids were lowered, her face turned pale and was thrown backward; hands and legs stopped and became extended; a suffocated cry, followed by a long sigh, was lost in the noise of the workroom.
>
> As I was leaving, I heard another machine at another part of the room in accelerated movement. The forewoman smiled at me, and remarked that that was so frequent that it attracted no notice.[61]

According to most doctors, male garment workers did not suffer this vulnerability with the sewing machine, thus confirming the profound ways in which gender difference informed the social division of labour by both sex and trade. In the 1860s and 1870s, tailors recommended the 'hygienic' single treadle as a possible solution, even while certain models, such as the 1880s Singer Vibrating Shuttle, touted pulsating properties as evidence of superior lockstitching.[62] The machine's rhythmic vibration, which supposedly led to involuntary orgasms in some female operators, was not fully diminished even with the addition of electrical motors. The sewing machine was one of the first home appliances to be electrified in the

Plate 1 Man Ray, *Séance de rêve éveillé* [*Waking Dream Séance*], 1924. *Left to right*: Max Morise, Roger Vitrac, Simone Breton, Jacques-André Boiffard, André Breton, Paul Éluard, Pierre Naville, Robert Desnos, Giorgio de Chirico, Philippe Soupault, Jacques Baron. Published on the cover of *La Révolution surréaliste* 1 (1 December 1924)

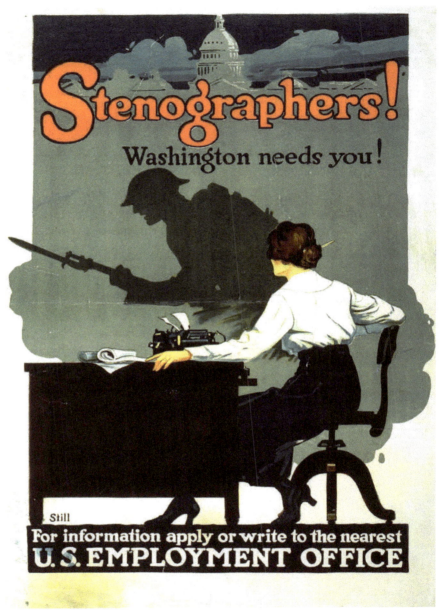

Plate 2 Roy Hull Still, *Stenographers! Washington needs you!*, c.1917

Plate 3 Óscar Domínguez, *Machine à coudre électro-sexuelle*, 1934–35

Plate 4 Unknown photographer, untitled photograph for Vive Ste. Anne postcard, France, *c.* early 1920s

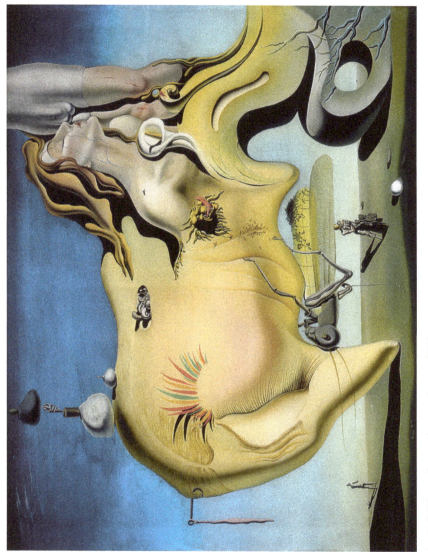

Plate 5 Salvador Dalí, *Visage du grand masturbateur*, 1929

Plate 6 Óscar Domínguez, *Le Tireur*, 1934

Plate 7 Óscar Domínguez, *La Machine à écrire*, 1938

Plate 8 Óscar Domínguez, *Untitled*, 1940

Plate 9 Conroy Maddox, *Onanistic Typewriter I*, 1940

Plate 10 Óscar Domínguez, *Brouette No. 1*, c.1936 (before 1937)

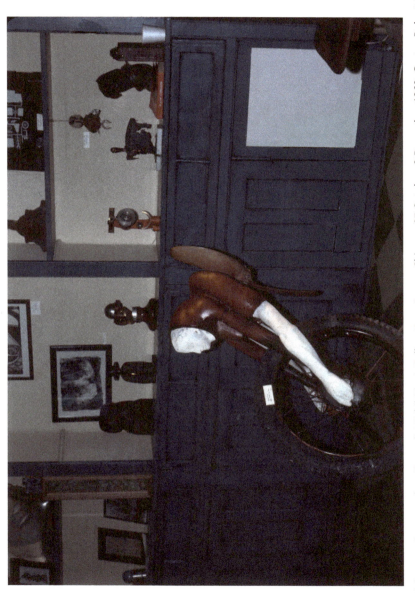

Plate 11 Unknown photographer, 'Surrealist Exhibition', Gallery Bugs Bunny, Chicago, 27 October–8 December 1968. *Centre*: Robert Green, *Long Before You Were Born*, 1968

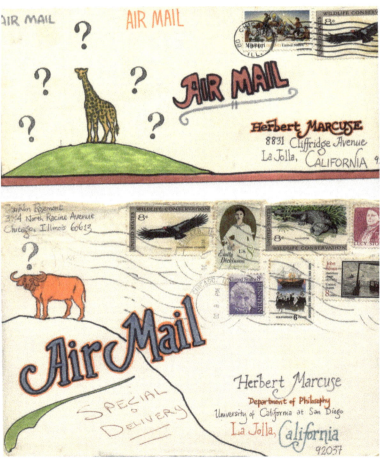

Plate 12 *Top envelope*: Franklin Rosemont, decorated envelope for Herbert Marcuse, 1975. *Bottom two envelopes*: Franklin Rosemont, two decorated envelopes for Herbert Marcuse, *c.* October 1971

Plate 13 Konrad Klapheck, *Le Visage de la terreur* (*Das Gesicht des Terrors*), 1963

Plate 14 Konrad Klapheck, *L'Intrigante* (*Die Intrigantin*), 1964

Plate 15 Giovanna, untitled typewriter drawing, *c.*1965–66

Plate 16 José Ramón Sánchez, *Concierto puntillista musical*, 1988

early twentieth century, and yet these updated models were not widely used in France until after World War I.[63] As historian Monique Peyrière argued, this delayed electrification was not simply because France's infrastructure was insufficiently equipped before the war to allow for plentiful purchases of electric home appliances.[64] For Peyrière, although it was clear that the electric sewing machine could have saved women the very effort of labour that so worried physicians and moralists, French consumers by and large rejected these design advances due to ongoing sexist biases about whether or not women should have access to electrical technology.

It was clear that the sewing machine was a site of dangerous exploitation of the female body, but the exact nature of this overexertion was debated. Coffin has related how the 'notoriously low wages of women needleworkers' and reports of the bodily exploitation of women passementerie (decorative trimming) workers 'earned them a prominent place in reform literature'.[65] In the first volume of *Das Kapital* (1876), for example, Karl Marx wrote about the industrial exploitation of workers such as weavers, milliners, and child cotton-mill workers, but he also singled out the 'unwholesome' occupation of work on the sewing machine due to the long hours it demanded. 'The new workwomen', he wrote, 'turn the machines by hand and foot, or by hand alone, sometimes sitting, sometimes standing, according to the weight, size, and special make of the machine, and expend a great deal of labour-power.' According to Marx, the sewing machine was 'decisively revolutionary', and yet the overproduction of these devices and their increasing depreciation – due to cheap manufacture and what was essentially an early version of planned obsolescence – trapped these 'new workwomen' in a life of constant overwork.[66]

For many French physicians, such overwork was specifically a gynaecological and moral issue, rather than a political one. As we have seen, in the nineteenth century, medical and social anxieties about women suffering from sexual overstimulation from work with sewing machines were largely concerned with health risks and the danger to women's fertility. Also connected to the vice of masturbation were fears linked to discourses about moral decay, lesbianism, and bisexuality, and the ways in which women's employment with sewing machines affected various social conditions.[67] The question of any deliberate or unconscious sabotage of labour or the work ethic, however, was not an evident consideration in the discourse about involuntary autoeroticism with sewing machines at this time. Most women who sewed for a wage could not afford to undermine their productivity in piecework, even if they were secondary wage workers augmenting a family member's pay.

Society desired an efficiency of the womb for women because, in the case of the working class, their ineluctable productivity in the power systems of domestic and sometimes waged labour was a given. And yet, ultimately, the problem that women's supposed autoerotic tendencies in machinic work posed also struck a nerve regarding the disturbingly close ties shared between sexual pleasure, labour productivity, and the production of human capital with the promise of future

labour output, tensions that Michel Foucault broadly related to his concept of biopower.[68] Autoeroticism, especially workplace autoeroticism, was tantamount to a form of sabotage in the patriarchal sexual economy.

It seems less than coincidental, therefore, that at the turn of the twentieth century, just as the first electromechanical vibrators for personal 'massage' (*vibromasseurs* in French) were being widely advertised as health and beauty appliances in Europe and the United States, worker sabotage was minted as a direct-action strategy in the industrial labour struggle.[69] A shift in medical and psychological attitudes towards women's autoerotic tendencies in work specifically and in life generally also manifested around the time that women began to join the labour struggle in greater numbers.[70] French historian Robert Muchembled has noted the synergy of 'the spectacular mutation of medical anti-masturbation literature after 1880' with the contemporaneous surge of proletarian movements, despite entrenched social attitudes about the conservative nature of working-class morality.[71] The proletarian body did not necessarily adhere to the bourgeois thesis regarding the imperative of maximisation in the accumulation of capital.

When English sexologist Havelock Ellis quoted the factory scene described by Thésée Pouillet twenty years later in a chapter on autoeroticism in his *Studies in the Psychology of Sex* (1897), he considered involuntary orgasm achieved with the sewing machine to be simply one manifestation of a masturbatory tendency in all humans and large mammals; it was 'inevitable'.[72] According to Ellis's then-shocking theory, humans all over the world from ancient times until the present had masturbated with nearly every imaginable object. At the time, the sewing machine's orgasmic potential was matched in this capacity by the bicycle for women and locomotive travel for both men and women.[73] In addition to the sewing machine, Ellis reported that women were known to masturbate 'in recent years with knitting and crochet needles, as well as needle cases' and a host of other practical tools.[74] Ellis, a progressive social reformer, was of the opinion that these impulses should be recognised by society in a manner that avoided 'excessive indulgence or indifference', or 'horror'.[75]

In nineteenth-century France, however, most discourses about female orgasm were linked to discussions of hysteria and the sexist idea that women were creatures who succumbed to their sexuality in an involuntary and automatic fashion. The supposedly hysterical nature of every seamstress was thus triggered by the mechanisation of alienated labour, and any resulting orgasm was largely understood as induced by these oppressive conditions rather than actively sought by the machine operator as she worked her treadle. Shortly before the development of electrotherapy as a treatment for hysteria in women (and some men) in France and elsewhere in industrialised nations during the nineteenth century, the sewing machine thus manifested as a hazardous device for exacerbating women's hysterical dispositions and other gynaecological health problems.[76] In that the woman worker's body was tied to her potentially orgasmic labour on the sewing machine, in a submission to the discipline of the wage, the *couturière* can be perceived as the antonymic counterpart of the hysterical female patient subjected to a wide

range of medical treatments in Europe during the second half of the nineteenth century. Shaken to the core by her powerful machine, the *couturière* was vulnerable to gynaecological ailments precisely because her productive work was overstimulating.

The female orgasms thought to be generated by work with sewing machines during the second half of the nineteenth century were socioculturally exceptional. Stimulating female patients to orgasm by therapeutically 'percussing' them with the application of pelvic massage and local pressure of different kinds was rarely pursued in Europe, England, and the United States as a treatment for hysteria and other gynaecological ailments. This was the case even after the above-mentioned electromechanical vibrator was developed on an international basis between the late 1860s and the early 1880s and became commercially successful with consumers by the early twentieth century.[77] General electrotherapy and vibration were employed as treatments for hysteria and other illnesses by the physician Jean-Martin Charcot at the Salpêtrière Hospital in Paris and later by neurologists in the *torpillage* (electrotherapy) of shell-shocked soldiers during World War I.[78] These vibration options included a range of hand-cranked, steam-powered, and hydrotherapy apparatuses and by the end of the nineteenth century included pedal-, battery- and electricity-powered devices. Seldom were such methods pursued to induce palliative orgasm or to cure compulsive autoeroticism, nymphomania, or other sexual 'disorders'. Judging from the sizeable discourse on gynaecological electrotherapy in Europe and the United States between the late nineteenth and early twentieth centuries, orgasm was most often understood as an involuntary symptom of an ailment rather than a sought-after cure.[79] As had purportedly been the case with female sewing-machine operators after the machine's mid-nineteenth-century invention, any sexual pleasure or orgasm derived from the new wave of electromechanical vibrators marketed in the 1880s and 1890s was largely a result of adventurous or accidental applications by device owners.[80] It was not until the turn of the twentieth century that some electric vibrators for the home began to be suggestively advertised in the United States as women's home 'appliances' – just as useful as sewing machines.[81]

The surrealist seamstress and the hypertrophic clitoris

Domínguez's artistic interest in the motif of an autoerotic seamstress was not an isolated case. Historian Thomas Laqueur has argued that from the 1920s, avant-garde circles were some of the first to begin to celebrate masturbation, a narcissistic, 'solipsistic pleasure', as a sign of virtuous '*self*-governance and *self*-control', which was at the same time a sign of the collapse of 'market discipline' and the reality principle.[82] Accordingly, Domínguez's *Machine à coudre électro-sexuelle* creates a metaphor for the surrealist work of art as autonomously self-pleasuring with fragments of the recently outdated myth about the erotogenic properties of sewing-machine work. What is the significance of this? Has the artist chosen this outmoded and reactionary medical discourse as the topic of his painting in order

to link, consciously or unconsciously, the tradition of hysteria celebrated by the surrealists to the still-contentious topic of *travail féminin* (female labour)? If so, Domínguez revealed a contemporaneous, agentic counterpart to the confined hysteric via the working woman, who, although tied to her machine and experiencing involuntary orgasmic paroxysms, nevertheless achieves some measure of self-gratification and self-mastery through a deregulated relationship to her work tool.

While the supposed autoerotic activity of the *couturière* endangered her gynaecological and moral health, it was the passivity of the hysteric during therapeutic treatments that supposedly promised recovery. Seen in this light, the *couturière* harboured threatening associations with women's sexual agency and autonomy in addition to the faint glimmer of hope that her exploitative wage labour held for the possibility of future economic independence. It was this explosive character of the sewing machine as an emblematic tool of potentially liberating labour and sexuality that may have appealed to Domínguez when he painted *Machine à coudre électro-sexuelle* in 1934–35, the period in which thousands of French seamstresses, united under a single garment workers' union of roughly 80,000 members, led another successful strike.[83] In a psychosocially symbolic scene that, on a latent or partially concealed visual plane, conflates women's labour histories and medical histories of the nineteenth and early twentieth centuries, Domínguez's *couturière* acquiesces to the erotic machinations of her stimulating apparatus. The *Machine à coudre électro-sexuelle* is a device for convulsing history, wherein the signified oppression of women's bodies in exploitative wage labour and medical science simultaneously folds over into the stirrings of women's struggle for liberation and autonomy.

The phrase *électro-sexuelle* was invented by Domínguez. Having no given meaning, it communicates in an unfamiliar phraseology the basic idea that this sewing machine is an electrical device meant for sexual stimulation, *électrostimulation sexuelle*. Even though the painting's composition evokes a treadle apparatus – with the two clawed feet placed beneath the recumbent nude – rather than an electric model from the twentieth century, the sewing machine's history of association with masturbation in France forges a conceptual link with the slightly later inception of a market for electronic massage devices that were sometimes used for sexual pleasure or orgasmic release at the end of the nineteenth century. Treadle sewing machines remained common in France before World War II, so Domínguez is not necessarily engaging in blatant anachronism by subtly indicating a non-electric model, although the painting's associations can be construed as eliding nineteenth-century and early twentieth-century histories of women's work with that of women's sexuality.[84] Although there was a well-established market for sex aids of different kinds in France before World War II, a precedent set far earlier by the Enlightenment-era introduction of the popular *godemichet* or *consolateur* (dildo), Domínguez sought to conjure outmoded methods of women's labour and their belaboured pleasure as they occurred in an equally superannuated medical sphere.[85]

The painting's sacrificial scene demonstrates the significance of the sewing machine's morphology for the composition and the embeddedness of autoerotic and masochistic themes therein.[86] The body remains locked in the discipline of routine work, and yet the very repetitive nature of this work is what allows somatic and oneiric errantry, a wandering of the mind into erotic reverie and the working up of the body into convulsive pleasure. This subversive seamstress is also therefore a stand-in for the surrealist artist, who deregulates disciplined labour with spontaneous self-gratification through the symbol of threatening female autoeroticism. The masturbatory is elided associatively with an insurrectionary discourse of female self-management as unmanageability. The apparent masochism of the reclining nude, who withstands the violence of the operation, embodies this transformation of work into pleasure and exploitation into autonomy through the very process of the subversive submission to labour, or co-optation. The autoerotic seamstress enacts an unprecedented tactic of sexual work-to-rule sabotage.

Although such surrealist emblematising of female autoeroticism does not politically demand the liberation of female sexual agency through feminist critique, it does raise questions about how surrealists engaged issues of gender and sexuality in their oppositional art practice. Regarding the topos of female autoeroticism, it is crucial to remember the insights provided by the surrealist investigations into questions of sexuality between 1928 and 1932. These recorded discussions established Breton's male homophobia – a bias that was not shared among most of the surrealists who participated in these discussions – as well as his attraction to heterosexual sodomy, lesbianism, female masturbation, and masturbation in general, including objects used for erotic purposes.[87] Breton supported the idea of cisgender female multiple orgasms as a result of self-pleasure with intra-vaginal aids (sex toys).[88] On two different occasions, Breton posed questions to the surrealist group about women sodomising men with dildos, a practice that did not appeal to him personally.[89] Yet, when Pierre Unik and Benjamin Péret signalled the possibility of a phallic woman with an engorged or hypertrophic clitoris capable of penetration in the act of lesbian frottage or tribadism, Breton replied, 'What an unusual idea some of us have of the dimensions of even an abnormal clitoris, and of the mechanical capabilities of that organ!'[90]

Breton's equivocal feelings about female sexual agency and dominance are not surprising, given the surrealist investment in Freud's psychoanalytic theories in general. In several texts written during the first three decades of the twentieth century devoted to subjects such as sexual difference, the Oedipus complex, child sexuality, and female sexuality, the supposed veiling of the female's lack of a penis became for Freud a metaphor for the obscure nature of femininity itself. It also stood for the feminine repression of the castration complex, in which the violence of sexual difference – read as the traumatic lack of a phallus – was masked by women through various repressive mechanisms.[91] For instance, as early as 1905, in *Three Essays on the Theory of Sexuality*, Freud claimed that the sexual life of women 'was still veiled in an impenetrable obscurity'.[92] This was a hypothesis that he would echo throughout the ensuing years, when he also developed a theory of

female cathexis, whereby women's lack of a penis was compensated for by psychosexual developmental phases, such as the Oedipus complex, and by socially adapting through increasing behavioural passivity. In 'Femininity' (1932), a text that assembled many of his previous thoughts on the subject, Freud went so far as to claim that one of the 'few contributions' that women had made to the history of civilisation was their invention of weaving and plaiting.[93] The weaving arts were an extension of the female tendency towards shame in the 'genital deficiency' of the clitoris and, by extension, their chagrin at a previous infantile fixation on clitoral masturbation, which, according to Freud, needed to be supplanted by vaginal pleasure through heterosexual intercourse in adulthood.[94] Like the pubic hair that covers the female genitalia, weaving was for Freud yet another way to cover, hide, and veil sexual difference; 'shame takes on other functions', he wrote.[95]

Yet, the influence of such a Freudian theory of the concealed, stunted and shameful clitoris would not persist for long in the surrealist imaginary. Just a few years after the collective surrealist inquiry into sexuality, Domínguez promoted the veiled–unveiled hypertrophic clitoris to the status of a surrealist anti-work emblem in his 1934 painting *Machine à coudre électro-sexuelle*. The coded image of a self-pleasuring sewing-machine operator or *couturière* undermining the imperative for productivity in the very act of producing may have provided for Domínguez, at least for a certain span of time in the mid-1930s, a satisfactory defence for surrealism's sustained anti-work and anti-propaganda position on both personal and social levels. Domínguez's job in advertising was a material necessity, despite the fact that commercial design was fast becoming surrealism's enemy from within. For him, the figure of the seamstress became a lifelong captivation and perhaps consolation, given this emblem's suggestion of the possibility of a surrealist subversion occurring in the midst of disciplined and alienated labour, an unworking of work. Surrealists kept producing saleable works of art and literature at a remarkable rate despite the movement's anti-work position, all the while defending the autonomy of the artist and the work of art from any obligation of ideological or professional servitude. For them, Domínguez's artworks about work and unruly self-gratification also became an important example of the uniquely surrealist approach to the problem of the artist as a producer.

'As low as a franc an hour for women'

How can *Machine à coudre électro-sexuelle* be understood in light of surrealism's call for the abolition of wage labour, which continued to be an applied practice of permanent strike, steady unemployment, or unilateral work precarity for some group members? Moreover, what can Domínguez's painting tell us about surrealist attitudes towards the issues of women's work and sexuality – and their points of intersection – at this time?

Surrealism did, it is interesting to note, protest gender-based pay disparity on a limited basis during the 1930s. André Breton raised the issue of gender inequity

in an essay attacking the egregious exploitation of male and female workers in French Renault car factories, which he published on the front page of the AEAR (Association of Revolutionary Artists and Writers) protest pamphlet *Aux neuf assassinés* (*To the Nine Who Were Assassinated*) on 8 February 1933. This was about a year before Domínguez became active in the surrealist group and started on the canvas in question. An outdated boiler had exploded in a Renault factory in the western suburbs of Paris, killing nine and wounding roughly two hundred. Beyond this, the Renault company, popularly known in France as the *bagne* (penal colony), was infamous for its deplorable working conditions. *Chronométreurs* (timekeepers) monitored the accelerated labour of assembly-line workers and hired *mouchards* (informers) to keep watch for signs of dissent. Discipline for even minor infractions was severe.[96]

In solidarity with the Renault workers, Breton and other surrealists involved in the AEAR at that time signed the pamphlet, which included illustrations memorialising the dead and defaming Renault and his company as murderers. Breton's front-page essay for the pamphlet, 'M. Renault Is Very Concerned', agitated on behalf of women workers as well as men: 'Here is a man who exploits twenty thousand at salaries that can be as low as a franc an hour for women.' He accosted readers with the following facts: 'One day, in shop 180, a worker has her hair torn out by a drilling machine. In No. 5, a worker is electrocuted. In No. 3, another has two fingers chopped off … A simple accident – right?'[97]

In light of Breton's acknowledgement of the gender division of labour despite equivalent dangers on the job, it is also important to consider surrealism's search for 'paranoiac knowledge' in relation to the question of work. Jonathan Eburne has investigated this in the context of what he called surrealism's 'noir' period in 1933, when the movement first began to grapple seriously with its doubts about the revolutionary viability of Stalin's Communist Party and confronted the surge of a fascist tide in Europe.[98] In Eburne's analysis, the sensational murders carried out by two French sisters in 1933 were of central importance to the surrealists at this time because they starkly revealed, both in the details of their perpetration and in the nature of society's response, the clear presence of a fascist tendency within the French bourgeoisie. For Eburne, this 'paranoiac knowledge', while instigating surrealism's renewed militancy in 1934–36, also ultimately uncovered for Breton and the surrealists the insufficiency of communist politics to address this fascist potential of the masses.

The Papin Affair, a case involving two *ménagères* (housekeepers) who brutally murdered their *patronnes* using implements of their labour – kitchen knives and a water jug – became a crucial symbol of violent revolt for the surrealists in this period. As Paul Éluard and Benjamin Péret wrote in defence of the sisters, 'For six years they endured surveillance, demands, and insults with the most perfect submission. Fear, fatigue, and humiliation slowly gave rise to hatred, that sweetest of liquors which consoles in secret because it promises to add physical force to violence, sooner or later.'[99] The surrealists had long been fascinated by the idea of working-class crime, especially as executed by women. They focused on

the anarchist exploits of the Bonnot Gang in the years just before World War I, as well as the fictional characters of Fantômas and Irma Vep (as seen in *La Perle* [*The Pearl*, 1929], a silent film written by Georges Hugnet and directed by Henri d'Ursel, in which housemaids and shop girls become femmes fatales through crime and illicit sexual encounters) – just a few examples of many related references. However, the Papin Affair set a far more macabre tone for the surrealist interest in scenarios of proletarian revenge against the *patronat* class and the prescribed burden of menial labour.

The surrealists were keenly aware of the explosive significance of the social symbol of gendered pay disparity, domestic labour hegemonies, and the experience of class war in 1934–35, when Domínguez painted his own version of a female worker immersed in a different species of revolt. *Machine à coudre électro-sexuelle* is just one in a string of works of art from the 1930s by Domínguez that take women's work as their theme. The painting arguably reflects Domínguez's surrealist indoctrination and the general synergy between his orientation and that of surrealism in the mid-1930s. In particular, the painting's subject can be interpreted on one level as a metaphorical retort to the PCF's demand that surrealism abandon its dedication to the non-instrumentalised work of art in favour of practical revolutionary propaganda (which, starting in 1934, was epitomised by Soviet socialist realism: Andrei Zhdanov's ideology of art as didactic communist propaganda). The PCF paired this demand with the critique, encapsulated in Ehrenburg's 1933 essay discussed above, that the surrealists should abandon their anti-work stance if they truly wanted to support the proletarian revolution. The artist should become a worker and the artwork, if it still existed at all in a workers' state, would thus exist solely as an expression of that identity. Certainly, in its titular identification as a mechanical masturbatory scene, *Machine à coudre électro-sexuelle* might be taken as an explicit counterattack to Ehrenburg's various accusations that the surrealists were degenerate and onanistic poseurs. Domínguez's painting declares that for surrealists, work and pleasure are ever commingled.

When interpreted as a pointed response to critiques by the PCF, Domínguez's painting displays fresh resonances. Surrealist automatism, as a critique of rationalised productivism and dutiful servitude, here converts into surrealist autoeroticism, a mutual refusal of the imperative of disciplined labour, submission to duty or authoritarian dominance, and the expectation to create art that idealised the worker. In Domínguez's painting, it is once again the figure of the modern female worker, with her paradoxical approach to subversive liberation through submission to capitalist-industrial labour, which emblematises these operations of resistance. The masturbatory *couturière* inadvertently sabotages discipline with pleasure on the shop floor, just as the surrealist secretary's passive typewriter transcription of automatism gradually gives way to the unconscious flow of thought. The objectified labour of the surrealist seamstress therefore combines a masochistic capitulation to the sadistic exploitation of her body by the machine's productivity. Worker and tool coalesce. Ultimately, however, her agency as

operator surmounts this submission, and implications of autonomy and libidinal agency emerge.

Operating Maldoror's vamp machine

Uncovering sublatent content

A couple of years before Domínguez completed *Machine à coudre électro-sexuelle*, André Breton confirmed in a short discussion from his 1932 book *Les Vases communicants* that, from a surrealist point of view at least, the sewing machine was an emblem of female masturbation. Breton's example of the masturbatory sewing machine appeared in the context of a discussion about the nature of the interaction between manifest and latent content in the construction and interpretation of poetic, dream-based works of art.[100] It also raised the question of the social function and import of such artistic content.

Influenced by Freud's psychoanalytic theories, surrealist aesthetics had by the 1930s developed a highly nuanced model of comparison between the work of art and the dream. The surrealists debated how best to construct works of art in various media along dream-based lines. They also wondered whether the content of a work of art should arrive passively and involuntarily or actively and purposefully, this latter category applying to the approach advocated by Salvador Dalí's paranoid-critical method as it stood in the early 1930s.

Breton's ideas about the possibilities and drawbacks of passive versus active latent content in works of art is fundamentally linked to his larger project in *Les Vases communicants*: aligning the surrealist exploration of dreams, desires, and objectives to the dialectical materialist revolutionary cause of communism. Dreams and unconscious desires constantly penetrated daily life, and life in turn constituted the essential fabric of the dream-world. Breton asserted, as he did in nearly all of his writings about art's inherent independence and autonomy from social imperatives during the 1930s, that this dream material must remain fully uncensored and uncontrolled by the artist and their social milieu if the work of art is to retain its culturally transformative potential. Breton also decided that such content is not as effective or as suggestive of the power of liberated desire and libidinal drives when it is forcibly fashioned into manifest message.[101] As Dawn Ades clarified, Breton positioned his interest in latent content in opposition to Dalí's contemporaneous development of the symbolically functioning object, which privileged the psychoanalytic concept of sexual fetishism over the language of dream symbolism.[102]

Breton's example for the successful incorporation of latent psychic content into an artistic image happens to be that most famous of surrealist similes fashioned by the movement's elected precursor, the Comte de Lautréamont, nom de plume of French-Uruguayan writer Isidore Ducasse. Lautréamont deployed this simile in the sixth and final canto of his experimental fever dream, *Les Chants de Maldoror* (*The Songs of Maldoror*) (1868–69): the comparison of a beautiful young

boy, soon to be a victim of false seduction and brutal murder, to 'the chance juxtaposition of a sewing machine and an umbrella on a dissecting table!'[103] Breton, Louis Aragon, and Philippe Soupault first explored the writings of Lautréamont in 1917. By 1920 Aragon would include in his first extended prose work, *Anicet ou le Panorama, roman* (*Anicet or the Panorama*) (1921), Maldororian lines such as 'the window of a sewing-machine maker, amongst whose savage beasts seamstresses venture like animal tamers (how I would love to see one eaten alive!)'.[104] Thereafter, Lautréamont's writings had a major impact upon the development of surrealism.[105]

For Breton and other surrealists, Lautréamont's poetic construction possesses such 'extraordinary impact … on the reader's imagination' because it alludes to overt sexual innuendos of heterosexual intercourse by constructing a dramatically haphazard poetic assemblage, the rapprochement of distant realities in a 'picture of extreme dispersion'.[106] Moreover, this latent content of the juxtaposed poetic construction, created through objective chance, has the capacity to open onto even more fully repressed content, creating possibilities for the further unmasking of the psychic significance of the phenomena and material of everyday life. Breton wrote, 'If you consult the key to the simplest sexual symbols, it will not take you long to admit that this impact consists in the ability of the umbrella to represent only man, the sewing machine only woman (like most machines, furthermore, the only possible problem being that the sewing machine, as everyone knows, is often used by woman for onanistic purposes), and the dissection table only the bed, itself the common measure of life and death.'[107] Although the coding of the sexual allusion is somewhat rote, based as it is in connotative apprehension of heterosexual gendered symbolism, for Breton it is the stark eclecticism of the poetic construction that 'is enough to provoke a thrill all by itself'.[108] The manifest content of the juxtaposition of the three utilitarian objects – sewing machine, umbrella, and dissection table – is poetically effective in his reading without, or even in spite of, the latent sexual content of the simile.[109]

Yet it is the question of latent and what might be called sublatent content that most fascinates Breton as a potential key for the development of revolutionary art. The concept of sublatency suggests that there are aspects of unconscious or repressed experiences buried to such an extent that their extraction into consciousness remains elusive. The reasons for such a depth of content beneath the threshold of consciousness could be manifold and may not necessarily pertain directly to the defended ego or the censorial pressure of social mores. Although Breton stated in *Les Vases communicants* that he had encouraged the surrealists to pursue Salvador Dalí's proposal to fabricate objects bearing erotic significance, it is nevertheless the chance manner in which everyday objects arrive at latent content that, for Breton, results in the most 'astonishingly suggestive power'.[110]

In the context of Lautréamont's construction, the sewing machine, as a European cultural symbol for woman, is for Breton the most obvious level of decoded latent content and an evocation of heterosexual intercourse. Yet, he also accounted for the sublatent connotation of female masturbation and how that

further affects the poetic image. 'As everyone knows', the sewing machine represents female masturbation, and yet although culturally notorious, this connotation remains secondary or sublatent for Breton in Lautréamont's simile due in part to the complexity of the composite juxtaposition. Sublatent content is important for Breton in this discussion because he was duly interested in the psychic effects of imposed and imagined censorship and control on the individual and the way in which the related repressive operations of condensation and displacement shape sublimated artistic production and reception. Nevertheless, his discussion does not address patriarchal and hetero-dominant reasons for the societal repression or sublimation of associations related to female masturbation, nor for that matter his own failure to acknowledge the evident theme of male homosexuality in Lautréamont's text.

In his discussion, Breton mentioned Dalí's 1929 painting *Visage du grand masturbateur* as one of several surrealist 'monsters' that serve as fantastical figures of socially repressive forces (Plate 5).[111] It was in 1929 that Breton and Georges Bataille engaged in a polemic rooted in the scatological and perverse content of paintings by Dalí, such as *Visage du grand masturbateur*. As summarised by Raymond Spiteri, this polemic fixed on Bataille's assertion that surrealism's emphasis on the transformative power of poetics, beauty, and the dream – exemplified in Breton's reception of Dalí at the time of the artist's first surrealist exhibition at the Galerie Goemans in Paris in autumn 1929 – in fact pushed the movement away from any active connection to the instigation of violent social revolution.[112] In essence, Bataille accused Breton of actively repressing the full extent of the scatological subversion in Dalí's work through poetic idealisation, a complaint that Dalí would echo in a 1952 recollection of his expulsion from surrealism.[113]

As if in answer to this debate with Bataille a few years earlier, Breton invoked Dalí in a discussion about surrealist techniques for undoing manifold layers of repression in *Les Vases communicants*. Breton asserted that the poetic image, as seen in Dalí's *Visage du grand masturbateur* or in Lautréamont's metonymic chain of similes, effects a continual unravelling of the mechanisms of autorepression that persistently beset the individual. The poetic image possesses the potential to catalyse a revolution on the micro-level of the self. Moreover, in a possibly acquiescent gesture towards Bataille's criticisms, Breton elected himself as the first example of how defensive repression establishes itself through multiple operations of psychic substitution and displacement.

To elaborate this idea of the potential for surrealist chance constructions to battle the operations of autorepression without reverting to sublimation, Breton described one of his own 'phantom objects', a mental image that occurred to him during a session of the exquisite corpse game: a blank white envelope with a red seal, eyelashes, and a handle, all associated with the word 'silence' through a homonymic comparison.[114] Via an oblique analysis that makes frequent reference to Freud, Breton eventually alluded to the idea that this silence-envelope is an image of repressed desires and drives relating to fears about sexual alienation,

incontinence, anal eroticism ('I hardly dare speak of the red seal'), and masturbatory tendencies, although the suppression of these associations remains strong in his discourse and the allusion immensely subtle.[115] Due to the covert operations of autorepressive mechanisms lodged within the self, chance constructions of objects and images are superior in their liberatory capabilities – their ability to uncover the fullest possible spectrum of latent and sublatent erotic drives and, in particular, repressed or socially marginal sexual drives. Breton's allusion to Dalí's *Visage du grand masturbateur* and to the Maldororian sewing machine in the context of his silence-envelope strongly suggests that it was the sublatent content of the 'phantom' of forbidden pleasures beyond the latent content of heterosexual intercourse that Breton thought to be the crucial discovery in these surrealist constructions.

Maldororian legacies and surrealist sewing machines

Domínguez's *Machine à coudre électro-sexuelle* highlights specific aspects of Lautréamont's aforementioned simile in order to emphasise the feminine, animalistic, machinic, and involuntary-compulsive aspects of the Maldororian textual construction. This is comparable to what Steven Harris has referred to in a discussion of the surrealist object as an operation of 'resexualization' of everyday items.[116] The full sentence containing Lautréamont's famous surrealist simile has not been quoted often in prior scholarship because it contains a graphic description of female venereal disease combined with a statement of sadistic queer desire. Lautréamont parodied the form of the novel in his sixth and final canto of *Les Chants de Maldoror*, in which the eponymous male protagonist stalks, seduces, and ferociously murders Mervyn, a 16-year-old boy. The narrator describes the unsuspecting victim: 'He is as handsome as the retractability of the claws in birds of prey; or again, as the unpredictability of the muscular movement in sores in the soft part of the posterior cervical region; or, rather, as the perpetual motion rat-trap which is always reset by the trapped animal and which can go on catching rodents indefinitely and works even when it is hidden under straw; and, above all, as the chance juxtaposition of a sewing machine and an umbrella on a dissecting table!'[117] The string of connected similes morphs into roving metonymy, eliding predators and prey with allusions to bloody entrapment with devices, and objects that cut, pin down, and capture. Along with this animal–object–human conflation, the metonymy also triggers involuntary, compulsive, and chance actions across these categories. The obsession that drives Maldoror to hunt and kill Mervyn parallels the nascent homoerotic desire that drives the boy to answer his assailant's letter and agree to an illicit romantic rendezvous on the bridge. The chance encounter of the two characters on the street in the moment of their first meeting also resonates with the token juxtaposition in the final phrase of the metonymic string, as do Mervyn's involuntary shudders of pleasurable excitement in anticipation of meeting and embracing his professed lover for the first time.

It is quite possible that Lautréamont included the sewing machine in his poetic description of Mervyn specifically to conjure the sexual associations with this apparatus, which reached the height of notoriety in France at the end of the 1860s when his book was written. Since, as we have seen, the sewing machine was by the mid-nineteenth century associated with issues in women's gynaecology, lesbianism and bisexuality, hysterical-compulsive masturbation, and malignant involuntary masturbation, Lautréamont's choice of this object in his scenario of murderous seduction is not necessarily discontinuous. Given that male masturbation and homosexuality were also widely symptomised as a potentially fatal form of diseased sexual deviance in European culture at the time of Lautréamont's writing, the positioning of what Breton assumed to be the masculine figure of the umbrella on the dissection table also becomes more understandable. When viewed in the context of the full metonymic string of the sentence that describes Mervyn's beauty, this possible allusion to the medical and moral symptomising of male and female sexual behaviours through the juxtaposition of modern objects on the dissection table is comparable to animal instincts (the bird of prey hunting for food; the trapped animal unable to resist food) and to automatic mechanical functions (the 'perpetual motion rat-trap' and the sewing machine).

The Maldororian sewing machine was an important theme in surrealist visual art from the beginning of the movement's activities. This surrealist iconography includes important works dating from the early days of the movement, such as Man Ray's photograph of an object construction titled *L'Énigme d'Isidore Ducasse* (*The Enigma of Isidore Ducasse*), made in 1920 during the Paris dada era (Figure 3.4). Consisting of a sewing machine concealed in a blanket and secured with ropes like a captured animal or a precious objet d'art, Man Ray's photograph was prominently featured on the first interior page of the initial issue of *La Révolution surréaliste* in December 1924 in conjunction with a preface declaring the movement's allegiance to dream content.[118] The cover of that inaugural issue featured three additional photographs by Man Ray, one of which showed Simone Breton, as we have seen in Chapter 2, seated at a typewriter, that other exemplary instrument of women's industrial labour. Although the concealed and bound sewing machine in Man Ray's photograph has typically been interpreted as an evocation of the mystery shrouding the biography and artistic impetus of Lautréamont himself, an understandable reading considering the work's title, I suggest a coexistent strata of signification related to the sexual repression of compulsive and involuntary drives. Such an alternate reading is connected to Breton's later theory about manifest and latent content in art and culture related to female masturbation. Ducasse's 'enigma', a veiled and bound sewing machine, is demonstrative of the full extent of cultural repression about libidinal drives, especially female and clitoral ones. The sewing machine becomes in surrealism's sphere a revolutionary literary-cultural emblem, by which submission to the discipline of productivity ultimately unleashes a radical liberation of the feminised self.

There are manifold surrealist artworks devoted to Lautréamont before 1935, and any number of these might be posed as precursors for Domínguez's *Machine*

Figure 3.4 Man Ray, *L'Énigme d'Isidore Ducasse*, 1920, photograph of a dismantled construction published in *La Révolution surréaliste* 1 (December 1924): 1

à coudre électro-sexuelle.[119] Also relevant is the larger history of the dada and surrealist interest in the trappings of the garment trades and clothing market – one of the first industries to be mechanised, resulting in early automated processes and ready-to-wear items.[120] Marcel Duchamp's occupational uniforms/malic moulds (for the roles of priest, gendarme, undertaker, delivery boy, and so on) in *The Bride Stripped Bare by Her Bachelors, Even (The Large Glass)* (1915–23) – or alternatively, Giorgio de Chirico's tailor's mannequins and Max Ernst's dress forms (in his 1920 lithographic portfolio *Fiat modes pereat ars*) – were influenced by late symbolist and Rousselian ciphers for the alienation of regimented social and work roles in industrial modernity. In contrast, surrealism's sewing machines are more intimately linked to questions of sexuality as a form of violence as a result of their partial basis in a Maldororian genealogy.

Consider, for example, two of the many Maldororian visual works from surrealism's first decade that possess notable similarities with *Machine à coudre électro-sexuelle*: American artist Joseph Cornell's collage *Untitled (The Pulse of Fashion)* (1931) (Figure 3.5) and a print from Salvador Dalí's series of forty-two etchings for the 1934 Skira edition of *Les Chants de Maldoror*, the untitled plate facing page 92 of that edition (Figure 3.6). Both works share with Domínguez's *Machine à coudre électro-sexuelle* the motif of a body being dragged under the presser foot

Figure 3.5 Joseph Cornell, *Untitled*, 1931, 'The Pulse of Fashion', *Harper's Bazaar* (February 1937), 45

and needle of a monstrous sewing machine. In the case of Cornell's collage – which Domínguez was unlikely to have been aware of before 1936 – the body of a Victorian woman in her undergarments submits to the sewing machine's operations, creating a campy visual pun on the pejorative moniker 'spinster'. The corseted figure is pulled stiffly towards the shuttle as flowers blossom and vegetables ripen, suggesting that the interaction of machine and woman relates to organic processes of fertilisation. In the background of the collage is a line of women working on their sewing machines, who, like their colleague in the foreground, are perhaps refashioning their likenesses with treadles.[121]

Turning to Dalí's etching for the 1934 Skira volume, we see the Maldororian subject of a boy, perhaps the hunted Mervyn. In a characteristically grotesque Dalínian composition, the boy's softened skull is punctured by the needle of a sewing machine operated by a cannibalistic bureaucrat figure, who monstrously bites and pulls the skin of the boy's abdomen as he holds his skull in place with an index finger (another print in the edition echoes this theme, depicting one of Dalí's Oedipal bureaucrats cradling a sewing machine). As Renée Riese Hubert pointed out, Dalí's cannibalistic bureaucrat in this etching recalls the Greek myth of the god Saturn, who devours his children to avoid the prophesied parricide he will suffer. It therefore resonates morphologically with a host of art-historical references to paintings of this subject by artists such as Goya and Rubens.[122]

However, several other layers of signification exist in this work that relate to Dalí's own complex iconography. In *The Tragic Myth of Millet's 'Angelus': Paranoiac-critical Interpretation*, written some time between 1932 and 1935 and

Figure 3.6 Salvador Dalí, *Les Chants de Maldoror* (Paris: Albert Skira, 1934).
The untitled plate facing page 92; one from an illustrated book with 42 photogravure
and drypoints after celluloid engravings

first published in 1963, Dalí elaborately compared Jean-François Millet's painting
L'Angélus (1857–59) to Lautréamont's umbrella–sewing machine–dissection table
construction.[123] David Lomas has clarified that Dalí's many works devoted to the
theme of Millet's *L'Angélus* between 1932 and 1934 are at once an attempt to sys-
tematise his own paranoiac-critical method and to establish a personalised reading
of Maldoror, emphasising 'sado-masochistic eroticism' and 'oral cannibalism'.[124]
The figures of the man and woman from Millet's painting permeate the imagery of
Dalí's *Maldoror* intaglio suite, underlining the theme of brutality and 'erotic fury'
in the surrealist artist's prints and in Lautréamont's text.[125]

For Dalí, the sewing machine, which he frequently depicted, was a sexual-
cannibal 'feminine symbol known to all', transforming the erection of the male
umbrella into a 'martyrized, flaccid and depressive victim' with the 'mortal
and cannibalistic virtue of its needle'.[126] The sewing machine further conjured
the action of heterosexual intercourse, and the bowed female figure in Millet's
L'Angélus was for Dalí comparable to a female praying mantis, which devours
her mate after coitus. All of these associations corresponded symbolically to the

arched framework of the sewing machine, according to Dalí, a schema which brings to mind the bowed silhouettes prominently depicted in paintings such as *Visage du grand masturbateur* and others. Although such arched forms were in part inspired by the distinctive boulders on the coastline of Cap de Creus in Portlligat, Spain, they may also relate to Dalí's associations of femininity with a forward-leaning form, as seen in works from his Millet series. The etching for the Skira volume, which collapses the peasant father and mother into one image of cannibalistic infanticide, therefore evokes Dalí's gynophobia and his obsession with the primal aggressions underlying the foundation of the nuclear family. In turn, the iconography of the sewing machine was for Dalí in some instances a cipher for cannibalistic female androcide.

Domínguez was heavily influenced by Dalí during the 1930s despite the fact that Dalí was nearly expelled from the surrealist group in 1934, just as Domínguez joined.[127] Yet, *Machine à coudre électro-sexuelle* is not deeply indebted to Dalí's etching of the murderous sewing machine of the same year for *Les Chants de Maldoror* beyond the motif of a body that is subjected to the action of the machine's needle. Domínguez's painting is less Maldororian than Dalí's scene, given the nearly exclusive attention that *Machine à coudre électro-sexuelle* pays to the sewing machine's associations with female masturbation. While the graphic sadism of both works is readily apparent in the motif of helpless bodies being tortured by animate machines, the electrosexual nature of Domínguez's sewing mechanism, understood in conjunction with the device's well-known historical associations with female autoeroticism, destabilises the sadistic dynamic of object dominating subject.

In that regard, Domínguez's *Machine à coudre électro-sexuelle* can be compared to other contemporary surrealist works that share the theme of a female body submitted to the operations of a machine as raw material, even if such works lack an explicitly Maldororian pedigree. Joseph Cornell's aforementioned collage of 1931, *Untitled (The Pulse of Fashion)*, falls into this category; the violence of the stitching action upon the female form is not readily apparent, and the Victorian seamstress does not succumb to the Maldororian dissection table. Other surrealist works follow on the heels of Cornell's pictorial innovation but accentuate the sadism of the machinic processing of the female body, thus heightening Maldororian associations. For instance, Man Ray's photographic series *Érotique-voilée (Veiled-erotic,* 1933), featuring artists Méret Oppenheim and Louis Marcoussis as models, depicts a sadistic *mise-en-scène* in which a nude woman is inked like a sheet of paper by a male artist and then fed into the jaws of a printing press, only to be wiped clean afterwards in order to be 'used' again (Figure 3.7). The titular indication of this reinterpreted scene of Pygmalion and his malleable raw material of woman as a *voilé* (veiled) erotic metaphor – following precepts of the *érotique-voilée* as described in Breton's *L'Amour fou* (written between 1934 and 1936; published in 1937) – is also revealed to be a scenario of *violée* (violated) womanhood or *viol* (rape) wherein female agency is savagely assaulted by phallocentric power.[128]

Figure 3.7 Man Ray, *Méret Oppenheim and Louis Marcoussis. Érotique-voilée* series, 1933

In surveying the legacies of Maldororian sewing machines and extra-Maldororian cannibalistic devices in surrealism, therefore, it becomes clear that Domínguez's *Machine à coudre électro-sexuelle* functions in conversation with an interlaced visual-textual set of surrealist references that reached a dense concentration in the period 1930–34. One final set of comparisons also can be posed, then, in the elaboration of such an iconographic archive. Domínguez's 1934 scene resonates palpably with the contents of the surrealist journal *Minotaure* from December 1933 (issue 3–4), which featured four of the forty-two etchings for Dalí's *Les Chants de Maldoror*. Domínguez therefore could have seen Dalí's illustrations in *Minotaure* in advance of the 1934 Skira volume, and thus ahead of his own acquaintance with the surrealists. The December 1933 *Minotaure* double issue may have served as an excellent introduction to the current interests of the Paris group for Domínguez, and several of its features resonate with themes relevant to *Machine à coudre électro-sexuelle*, such as women's work, sexual practices, and human–machine relations. Among other content was an essay by Benjamin Péret featuring images of automatons; a short statement by Maurice Heine on human sexuality, with an illustration linking heterosexuality to bisexuality and homosexuality and a number of erotic behaviours, including sadomasochism and fetishism; an essay by Jacques Lacan about the paranoiac crime of the live-in housekeepers of the Papin Affair; and a Maldororian photomontage by Man Ray

of a sewing machine and umbrella on a dissection table illustrating an *enquête* (general inquiry) about chance encounters. The Man Ray photomontage, constructed with cut photos of an umbrella and antique sewing machine superimposed on a signed drawing of a surgical table, was based on a staged photograph taken by Man Ray in the same year, *Hommage à Lautréamont* (reproduced in the *Dictionnaire abrégé du surréalisme*, 1938), which entangled the two objects in such a way that the metal tip of the umbrella appears to 'pierce' the needle mechanism of the sewing machine.

Perhaps most significant for this discussion is Dalí's essay in this double issue, 'Le Phénomène de l'extase' ('The Phenomenon of Ecstasy'), with its accompanying montage of the same title containing a grid filled with photographs of women's faces expressing states of extreme somatic pleasure (Figure 3.8).[129] In his essay, Dalí argued that experiences of ecstasy are comparable to dreams in their capacity to transform everyday reality and that surrealist artists should investigate the world of images triggered by overwhelming moments of physical rapture. In keeping with the active hallucination advocated by his paranoiac-critical method, Dalí's short essay urges surrealists to imitate hysterics in their cultivation of compulsive ecstasy. Neither his discussion nor the accompanying montage was explicitly autoerotic, but the array of orgasmic female faces itself was a striking attestation of the importance of female pleasure to Dalí's theory (the art-nouveau hairpin pictured also recalls Havelock Ellis's 1897 discussion of needles and masturbation in *Studies in the Psychology of Sex*). When compared with Dalí's evident preoccupation with the subject of autoeroticism, as attested to by prominent works of art in his oeuvre such as the 1929 *Visage du grand masturbateur* and also by controversial texts such as his previously mentioned 'Rêverie', it is no far leap to assume that the phenomenon of ecstasy to which Dalí referred was related to self-pleasuring as much as to any other form of sexuality.[130] Such associations become all the more suggestive of the iconography of Domínguez's *Machine à coudre électro-sexuelle* when seen in conjunction with the two obvious tributes to Lautréamont by Dalí and Man Ray elsewhere in the same double issue of *Minotaure*.

'The hand in the service of the imagination'

Many years after the publication of *Les Vases communicants* in 1932, Breton would return to this theme of Lautréamont's sewing machine as an emblem of unrepressed female autoeroticism. In a short essay from 1965 devoted to the post-World War II paintings of German surrealist Konrad Klapheck (to whom I return in the Epilogue), Breton stated that Lautréamont had achieved a 'prophetic synthesis' of Freud's theory about the sexual symbolism of everyday objects in *The Interpretation of Dreams* (1900) and Havelock Ellis's research on autoeroticism in *Studies in the Psychology of Sex* (1897), where Ellis (whom Man Ray had photographed in 1924) illuminated the 'sexual erethism' of the 'old-fashioned heavy, pedal-operated model' of the sewing machine.[131]

Figure 3.8 Salvador Dalí, *Le Phénomène de l'extase*, 1933. Photocollage

For Breton, the depiction of sewing machines by surrealist artists like Klapheck and Domínguez extends from the tradition established by dada artists such as Francis Picabia, Man Ray, and Marcel Duchamp and writers such as Auguste Villiers de l'Isle-Adam, Alfred Jarry, Raymond Roussel, Jacques Vaché, and Guillaume Apollinaire. These precursors formulate an avant-garde genealogy of unmasking or denuding the functional apparatus to reveal the insistent penetration of everyday life by psychosexual drives and the possibility of polymorphous perversity or extra-genital sexual excitement.[132] Such a discourse specifically runs counter to a progressivist machine aesthetic pursued by objectivists during the *rappel à l'ordre* (call to order) after World War I.[133] Following the nineteenth-century popular discourse that erected the dynamo as a metaphor for woman, which in itself was based on a venerable history of human-as-machine theories, surrealist depictions of domestic apparatuses expand on the dada practice of exposing the machine as a symbol for a specific type of female.

In books such as *Locus Solus* (1914), French author Raymond Roussel had set a precedent for feminised machines, such as the *demoiselle* (young lady) mosaic paver that makes an artwork out of discarded teeth, or living women who are physically tied to fantastic instruments, such as the dancer-diver Faustine, who emits a strange music underwater with her electrified hair. Heavily influenced by Roussel, Duchamp took these experiments with gendered or somatic machines further in a series of erotic artworks. In the process of constructing his mixed-media piece *The Bride Stripped Bare by Her Bachelors, Even (The Large Glass)* (1915–23), Duchamp conceptualised his onanistic bachelor machine, which grinds and pulverises sexual desire through perpetual-motion masturbation. Wearing down desire for the other through the tortuous ordeal of grinding masturbatory gears, the bachelor machine's desire becomes solipsistic in its denial of heterosexual consummation and reproductivity with the female 'bride'. The bachelor machine remains confined in a state of voluntary and solitary celibacy.[134]

Taking cues from Duchamp and his cultural references, surrealism often abandoned the depiction of celibate bachelor machines in favour of exploring the isolated autonomy of bachelorette machines that operate in the absence of masculine figures. Once again, Duchamp was the one to launch this theme by contemplating the possibility of building a mechanical, remote-controlled woman with a self-lubricating vagina: a '"machine-onanist" without hands', as he told Julien Levy in 1927.[135] In surrealism, Duchamp's line of thought tends to take on an added edge, since the surrealist female machine is typically likened to the cultural trope of the vamp – a seductress or femme fatale, who, like the silent film character Musidora (much loved by the surrealists), drains her male lovers of virility and power with a voracious and vampiric sexuality (and perhaps threatens castration via the mythic *vagina dentata*).[136]

Lautréamont's sewing machine and the surrealist invocations of vamp machines that continued to manifest in this conceptual terrain accentuate the suggestion of the sexual obsolescence of the male through an array of overt

and covert associations. Surrealist bachelorette machines promote the sexual and reproductive obsolescence of the male through the proliferation of clitoral enhancers or indefatigable prostheses that become replacements for males, resulting in the autonomy or dominance of a phallicised and accessorised female sex. The tireless, incessant 'mechanical husband' apparatus that Alberto Savinio described in his 1933 prose piece published in *LSASDLR*, 'Achille énamouré mêlé à l'Évergète' ('Enamoured Achilles Mixed with Evergete') is just the kind of vamp machine that surpasses the stamina of the outmoded male.[137]

In his 1965 Klapheck essay, Breton illustrated this idea of the usurpation of the male with a modern rebus discussed in the 1929 book *Les Demeures philosophales* (*Dwellings of the Philosophers*) by Fulcanelli, the French esoteric practitioner active during the 1920s. Fulcanelli's rebus was based on a Singer sewing-machine advertisement of that period (he did not include an illustration), which showed a seated woman at work on her treadled device in the midst of a superimposed and oversized 'S'. This construction signified that the woman was 'dans sa grossesse [grosse S]'; that is, her pleasurable 'work' with the sewing machine had rendered her pregnant in a post-male, technomorphic scenario (for a comparable example, see Figure 3.9).[138]

Briefly mentioning Domínguez's paintings of typewriters from the 1930s, Breton's Klapheck essay combined his meditations on the human tendency towards the eroticisation of machines with an account of the potential for mutual violence that also underlines this relationship. Humans seek to dominate machines by possessing greater power and agency, and yet, since humans themselves are machines of a kind, this struggle remains ever-unresolved, pitted in an endless competition for superiority. Breton's essay reminds the reader about the sexually inexhaustible character André Marcueil from Alfred Jarry's novella *The Supermale* (1902), who at the beginning of the story destroys a dynamo with his own superhuman strength only to be electrified in communion with another generator known as the 'machine-to-inspire-love' at the book's conclusion; Marcueil dies from complications suffered as a result of this techno-erotic encounter.[139]

Breton further explained in his 1965 essay on Klapheck that humans harbour rage towards the inherent threat of the industrial mechanism: 'At the dawn of the industrial "revolution", as we know, workmen in various trades organised spontaneous acts of sabotage against the sudden appearance of the machine, which they feared might take the bread out of their mouths.'[140] The human sexualisation of the machine, what Breton called Jarry's 'ultra-erotization' of this relationship, is a counterpart to the violence inflicted by and, in the instance of Luddite fury or industrial sabotage, against it.[141] Breton's re-emphasis of these key themes in surrealism in his 1965 essay were probably influenced by the recent Exposition InteRnatiOnale du Surréalisme (EROS) that took place in 1959–60 at the Galerie Daniel Cordier in Paris, which included a catalogue focusing on the subject of eroticism and a collectively authored glossary of relevant terms including definitions for homosexuality, Jarry's super-virile character Marcueil, masturbation, orgasm, pleasure, vamp, and others. Artist Mimi Parent's definition

Figure 3.9 Jules Chéret, *Avantages nouveaux machines à coudre de la Cie. "Singer" de New York, depuis 115 francs, payables 3 Fr. par semaine, au comptant prix 100 francs ...*, 1876. Detail of central panel

for 'masturbation' in the catalogue was 'la main au service de l'imagination' ('the hand in the service of the imagination').[142] Parent's conceptualisation of masturbation as a quintessentially surrealist activity, one rooted in the question of the independence and freedom of the individual mind, is also fundamentally linked to surrealism's ongoing exploration of the possibility of a non-Freudian reading of female sexuality as both actively autoerotic and autonomous from phallic envy. Beginning in the 1920s, the Maldororian sewing machine became a primary surrealist mode of expressing this tentative avenue of enquiry of autonomous female electrosexuality. Domínguez's *Machine à coudre électro-sexuelle* may have been a key factor, albeit an under-recognised one in scholarship, in the early development of such an extra-Freudian thread about the anti-patriarchal force of autonomous female sexuality. In contrast to both Dalí's patriarchal devouring apparatus and Man Ray's vision of art as sadistic heterosexual cannibalism, Domínguez's armless female nude, with a head reconfigured as a veiled vaginal fold covering a hypertrophic clitoral protuberance, is powerless only to her own masochistic-machinic labour.

Dysfunctional tools in Domínguez's anti-work oeuvre

Decalcomania and the pursuit of pleasure in the forty-hour work week

Surrealism's break with the PCF in 1935 is not the only contextual factor that must be contemplated in relation to Domínguez's anti-work iconography in this period. Breton's continued theorisation of the role of the work of art in revolution and in proletarian culture at this time, as well as the tumultuous historical developments taking place in Europe in 1936, are also crucial considerations. For Breton in the early to mid-1930s, a proletarian literature of the present was still not feasible under a capitalist bourgeois regime.[143] The possibility of a fully developed working-class culture had been systematically suppressed by the ruling class, according to Breton. Following Leon Trotsky's theories on this topic in texts such as *Literature and Revolution* (1923), in which Trotsky discussed the non-existence of proletarian art in the face of bourgeois oppression, Breton thought that proletarian literature and art were part of a transitional stage between the art of a bourgeois society and the future classless society.[144] In advance of this classless society, therefore, it was necessary to facilitate the potential of proletarian arts through what Breton called 'counterpedagogy'.[145] In France, this approach was all the more crucial. Although Breton reminded readers that it was in this country that 'the working class first conquered for itself a place in art, even if only as a theme in the work of Daumier, Courbet and Zola', French educational systems and popular news media conditioned workers into passively emulating bourgeois models.[146]

In the published version of his April 1935 Prague speech, *Position politique du surréalisme* (*Political Position of Surrealism*), Breton continued to clarify how the independence of the artist and art could operate in conjunction with revolutionary political objectives. Breton cited the nineteenth-century examples of Gustave Courbet and Arthur Rimbaud, asserting that although both of these artists were deeply affected by the Paris Commune in 1871, there is no palpable trace of revolutionary rhetoric in their works during or after this upheaval.[147] Rather than illustrating revolutionary ideals, Breton explained, avant-garde art instigates insurgent actions through its essential freedom as a distillation of leftist thought. Breton called for surrealist artists and writers to unite together for '*the creation of a collective myth*', as informed by the prior explorations of Courbet, Rimbaud, Manet, and other avant-garde artists.[148]

Domínguez's works from the second half of the 1930s follow Breton's call for a non-illustrative and non-prescriptive revolutionary art. After the completion of *Machine à coudre électro-sexuelle* from 1934–35, Domínguez created an entire series of artworks in different media that speaks to Breton's theory about non-illustrative autonomy and also highlights the theme of deregulated pleasure. In doing so, Domínguez responded to one of surrealism's greatest internal conflicts: its recalcitrant demand for political and artistic autonomy in defiance of the mass movements of authoritarianism and nationalism that swept across Europe.

At the end of May 1936, Domínguez participated in the *Exposition surréaliste d'objets* at the Galerie Charles Ratton in Paris, where six of his surrealist objects were displayed in conjunction with a selection of American and Oceanic tribal, found, natural, and scientific items, as well as other surrealist works. Then, during the first days of June, a massive general strike erupted across France. Over one million French workers from diverse trades joined in the roughly 12,000 factory occupations, wildcat strikes, and other actions ignited by the recent successes of the Popular Front coalition and election of Léon Blum – whom Breton had met briefly in 1934 – as the first socialist prime minister of France.[149] As historian Julian Jackson recounts, Blum's new government faced the largest strike movement in the history of the Third Republic, certain episodes of which endured until late summer that year. For many workers, the 'June days' of the general strike were a period of *fête* (joyful celebration and fraternity); for the socialist reformer Blum, it was a 'social explosion' that 'struck the government in the face'.[150]

It is not insignificant that, in the same month in which the Matignon Agreements were signed between French labour unions and the French state, Breton published his essay emphasising the accessibility of Domínguez's visual automatist technique, decalcomania, as a tool *'within everybody's grasp'* (Figure 3.10).[151] The Matignon Agreements, signed on 7 June 1936, marked a watershed success for the workers' movement with advances such as a 12 percent wage increase, the implementation of the forty-hour work week, and the country's first

Figure 3.10 Óscar Domínguez, *Lion-bicyclette* (*Lion-bicycle*), 1937

paid holidays.[152] The pursuit of leisure activities, such as beach trips, and the purchase of recreational commodities, in particular bicycles, skyrocketed. As Julian Jackson has stated, 'the image of working-class couples on tandems departing to the countryside is as closely associated with 1936 as the barricade with 1968'.[153] The head of the CGT, Léon Jouhaux, characterised these June victories as the greatest success ever achieved in the course of the French labour struggle (CGT membership subsequently increased five times over, to roughly five million members).[154]

In his short reflection about Domínguez's decalcomania, published in the eighth issue of the surrealist journal *Minotaure*, which came out just a week after the accords of 15 June 1936, Breton focused on this question of accessibility. He was keen to convey the way in which the pleasurable activities of childhood could be rediscovered by anyone through this technique's transfer method of wet paint or ink from one surface to another. Decalcomania creates accidental imagery through chance operations rather than conscious control.[155] This medium is 'a new source of emotional expression for *everyone*', Breton wrote, describing how the technique conjures childhood reveries of fantastic voyages to forests, mountains, grottoes, and the ocean's depths.[156] With decalcomania, one can '*open one's window at will upon the most beautiful landscapes in this or any other world*'.[157] A childlike freedom and power of imagination is granted.

It is appropriate that Domínguez's decalcomanias from 1936–37 continue to favour depictions of bicycles, considering the sweeping changes in the fabric of daily life in France as a result of the Matignon Agreements. Domínguez had already begun to explore the iconography of the bicycle in 1935, perhaps as a result of this device's Jarryesque, Duchampian, and Bataillian associations, or due to its former reputation as a convenient tool for autoerotic female pleasure, as we have seen in the *fin-de-siècle* theories of Havelock Ellis. In Domínguez's 1935 etching, *Woman with Bicycle*, for example, a nude leans her body flush against the rear wheel of a hirsute bicycle that has been warped by exaggerated perspectival rendering. Female dalliances with the pleasures of bicycle riding are amply suggested. But in the decalcomania work *Lion-bicycle* of 1937 (see Figure 3.10), Domínguez returned to a motif he had already deployed in the mixed-media piece *Peregrinations of Georges Hugnet* (1935), in which the framework of a bicycle supports the body of a trotting horse. As had been the case with *Peregrinations*, the decalcomania *Lion-bicycle* suggests that leisure time with this apparatus releases untamed desires. The silhouette of a lion leaps out of the bicycle's structure, the lion's tail forming an erect phallic appendage between the handlebars.

Typewriters and other tools by Domínguez

By mid-July 1936, the Spanish Civil War was declared, and in August Breton and the surrealists issued a tract in support of the threatened Republic, condemning France's position of neutrality under Blum's Popular Front government.[158] Given the recent birth of his daughter, Breton abstained from joining the handful of surrealist friends, such as Mary Low and Valentine Penrose, who travelled

to Spain to fight for the Republic and document events, or Péret, who joined the Unified Marxist Workers' Party in Spain and later, anarchist factions in the resistance effort.[159] Significant labour conflict and strikes continued steadily in France through the end of 1938, when nationwide strikes signalled the end of the Popular Front.[160] In his lecture of 1936, 'Limites non-frontières du sur-réalisme' ('Non-national Boundaries of Surrealism'), Breton reflected on the events of that year, comparing the French workers' struggle with the Republican resistance in the Spanish conflict. For Breton, these efforts were 'two necessar-ily successive moments of a single movement, one destined to carry the whole world forward'.[161] He began his lecture by explaining that by chance the 1936 *International Surrealist Exhibition* in London (in which Domínguez displayed four works) had opened 'at the very moment when the French workers, using totally unexpected tactics, proceeded by force to occupy the factories and, simply by making that stand collectively, succeeded overwhelmingly in getting their main demands satisfied'.[162] In contrast with the admirable 'spontaneity and suddenness' of the strikes, Breton critiqued the Popular Front government for postponing what he saw as the inevitable result of the nationwide labour turmoil: a proletarian revolution in the streets.[163] Although the strikes may have had a successful outcome, the fascist threat embodied by events in Germany, Italy, and Spain made it clear that far more than resistance to workplace exploitation by rank-and-file workers on the factory floor would be needed. Breton stated, 'If it has proved possible to overthrow certain transitory forms of exploitation by col-lective *inaction*, nothing short of *taking up arms* is necessary to prevent a return of that exploitation in forms infinitely more overt and sinister.'[164] To overcome fascism, workers' militias in Spain, and potentially some day in France, must be prepared to abandon the tactics of workplace sabotage in favour of revolutionary violence, wherever it might take place.[165]

My discussion of Maldororian visual and textual culture in surrealism during this era underscores the ways in which themes of subversive female self-pleasure were already fomenting in some of the movement's collective efforts, providing a foundation for Domínguez's sabotage iconography. What developments occur in this iconography as the surrealists headed into the pivotal year 1936, when, in the face of the rise of fascism, Breton called for radical tactics of collective violent action as well as passive resistance inaction? *Machine à coudre électro-sexuelle* established an important precedent in Domínguez's artistic practice, resulting in a series of paintings and objects from the 1930s that pursued a comparable subversion of productivity in industrial, professional, or agricultural work tools, and sometimes their operators. As we have seen, Domínguez's figurative practice tended to focus on the juxtaposition of all manner of everyday utilitarian objects or utensils in otherworldly and desolate landscapes. Plants, animals, and humans morphed and merged into one another, as did objects of both work and play – for example, small household items such as safety pins and spatulas, and on a larger scale, phonographs and pianos. All of these iconographic elements assumed new associations amid Domínguez's surreal horizons, resonating with artist Claude

Cahun's admonition in 1936 to 'Prenez garde aux objets domestiques!' ('Beware Domestic Objects!'), an essay for the *Exposition surréaliste d'objets* published in *Cahiers d'art*.[166] Domínguez's interests were certainly in keeping with the larger project of the surrealist object, which Steven Harris and several others have discussed as a major preoccupation for the group in the 1930s. Following and expanding on the example of dadaist works such as Man Ray's *Cadeau* (*Gift*, 1921) – a flatiron with brass tacks glued onto its flat surface – and other destructive or indestructible dada-assisted readymades, were works such as Salvador Dalí's *Téléphone homard* (*Lobster Telephone*, 1936; or its later versions with alternate titles) and Wolfgang Paalen's sponge-umbrella, *Nuage articulé* (*Articulated Cloud*, 1938).

In general, the functionality of everyday things is undermined in Domínguez's scenes in a distinctly post-dada manner, wherein soda siphons sprout into trees (*Les Siphons*, 1938) just as steamrollers crumble into ruins, covered with vines in a visualisation of Breton's concept from *L'Amour fou* (1937) of the fixed explosive *La Apisonadora y la rosa* (*The Steamroller and the Rose*, 1937) and *La Machine infernale* (*The Infernal Machine*, 1937). Nevertheless, in some of these mid- to late 1930s artworks that specifically depict work tools, Domínguez pursued the subversion of productivity on an even more satirical level, suggesting that he still sought to make a declarative statement about how the surrealist work of art was not a form of work at all. In 1935 Domínguez completed his first group of surrealist objects. Among these was the little-known and probably lost *Dactylo* (*Typist*), also sometimes listed with the alternative title *Dactylographe* (Figure 3.11).[167] This object, only known from a blurred black-and-white photograph, consisted of a wooden frame construction roughly resembling a seated figure with outstretched arms and hands poised on top of three sheets of glass with broken and serrated edges.[168] *Dactylo* was painted black with hints of saturated colour enlivening certain areas, as was the case with a companion object created in 1934 and shown in 1936 at the *Exposition surréaliste d'objets*, *Le Tireur* (which translates as puller, shooter, thrower, or alternatively, in a slang context, penetrator or masturbator), also sometimes listed with the alternate title *La Conversion de l'énergie* (*Energy Conversion*). This work likewise contained a sheet of glass with serrated edges and touches of brightly coloured paint, as well as parts of a shattered pocket watch (Plate 6).

Dactylo deploys a language of abstraction to drive home its bleak message of a conscripted and rote labour that is also a form of suicide, an obliteration of the subject in the act of the labour task: wrists are slit while the job is completed. Broken glass became a fateful material for Domínguez at the end of August 1938, when a drinking glass he threw in anger at Esteban Francés accidentally hit Victor Brauner, who lost his left eye from the incident.[169] Although the humanoid figure of the *dactylo* is so minimally rendered as to appear genderless, its delicate, detailed hands, as well as the overwhelming connotation that the profession of *dactylo* had with the social process of feminisation by the mid-1930s in France, suggests a feminine gendering for its depicted subject. Marcel Jean mentioned

Figure 3.11 Óscar Domínguez, *Dactylo*, 1935

the 'two beautiful, little, ivory hands (two backscratchers)' of *Dactylo*, which Domínguez constructed from items purchased at the *Marché aux puces* (flea market).[170] The subject of women writing by hand on paper also featured repeatedly in the iconography of Domínguez's paintings, but the 1935 object *Dactylo* was to be the only appearance of the typist until he revisited the subject as late as 1950 with the cubist-influenced *Trois femmes* (Figure 3.12). This oil on canvas poses a *dactylo*, who takes a telephone call while seated at her typewriter, between a *couturière* at her sewing machine and an aproned *lingère* holding scissors. These schematic female workers undertake their tasks with a modernist reserve that is far closer to classical monumentality than to any vision of surrealist sabotage.[171]

A few years after completing the object *Dactylo*, Domínguez began to deal with subject matter that configured the obliteration of the work tool through

Figure 3.12 Óscar Domínguez, *Trois femmes*, 1950

fantastic organic metamorphosis. This topic arose as a result of his interest in physics and alternate time-space dimensions, which was spurred by his friendship with Argentinian physicist and writer Ernesto Sábato. A series of three zoomorphic and/or phytoid (plant-like) oil paintings of animate typewriters show Domínguez's preoccupation with what he called in the late 1930s *paisajes cósmicos* (cosmic landscapes).[172] The chance-based cosmic landscapes broadly related to his later exploration of the pseudo-scientific phenomenon he designated, together with Sábato, as 'lithochromism', or the solidification of time.[173]

In Breton's 1939 essay 'The Most Recent Tendencies in Surrealist Painting', which was published in *Minotaure* (double issue 12–13), he discussed Domínguez's and Kurt Seligmann's lithochromism as well as frottage and other methods as automatist techniques that embody the attraction of surfaces or bodies of different kinds to one another.[174] In Domínguez's vision, a cosmic typewriter awakens to savage life, wherein this 'small and solitary object', as Marcel Jean described it, approximates the organic surfaces of nature and flourishes long after the interference of humans has vanished.[175] For instance, *Souvenir de l'avenir* (*Memory of the Future*, 1938) poses a typewriter on the edge of a high cliff, its keys twisting wildly like insect limbs, or perhaps coiling plant tendrils, in a vision of industrial modernity as a relic of the primordial past

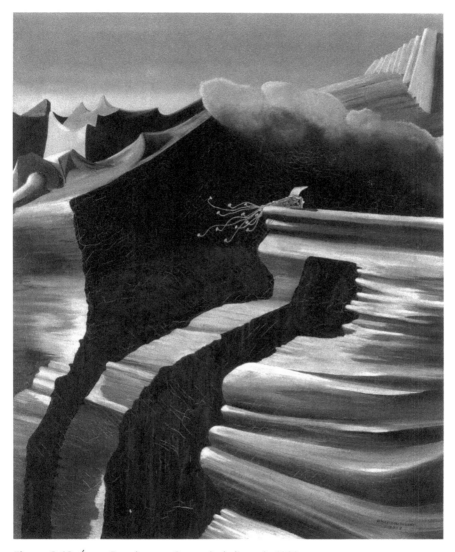

Figure 3.13 Óscar Domínguez, *Souvenir de l'avenir*, 1938

(figure 3.13).[176] *La Machine à écrire* (*The Typewriter*) of the same year mates two of these hybrid machines in a dense tangle of vines, their sheets of paper ruffling together and their keys stretching into the surrounding space (Plate 7). *Untitled* (1940) embeds a typewriter in a hallucinatory landscape filled with hybrid plant-insects (Plate 8).

Whereas in *Dactylo* the human operator escaped from the machine through the act of defeatist suicide in submission to the labour imperative, the

lithochromist typewriters of the late 1930s evade human interference altogether by surviving the apocalyptic annihilation of that species in a future world. The notion of a machine operating without the aid of humans remained an interest of Domínguez's into the 1940s, when he produced the Kafkaesque object *El Calculador autómata* (*Automatic Calculator*, 1943; destroyed), an intricate contraption with no purpose, and wrote of a perpetual-motion machine in his prose poem about objective chance, 'Les Deux qui se croisent' ('The Two Who Cross Each Other', 1946; published 1947).[177]

Such surrealist themes persisted to a significant degree in Domínguez's work. This was so even though, following his stay with surrealists in Marseille at the beginning of the German occupation of France, he began to distance himself from the movement. This separation was notwithstanding his engagement with the surrealist-affiliated Resistance collective in occupied Paris – and their eponymous journal published between 1941 and 1944, *La Main à plume*, to which Domínguez frequently contributed illustrations.[178] Other typewriters and calculating machines appear in Domínguez's body of work, but it is only with *Dactylo* and the cosmic typewriters a few years later that we witness either the deadly eradication of the worker by her work or her disappearance altogether in a posthuman sphere where tools replace workers as sentient beings. Domínguez's subversive work tools from this era may have contributed to the energy behind ongoing surrealist explorations into the joint eroticism and violence, or pleasure and sadism, of modern labour and gender roles. For example, consider works such as the 1937 surrealist film *Monsieur Fantômas* by Belgian director Ernst Moerman, which features stenographers sinking into the sea as they type, and the surrealist object *Onanistic Typewriter I* (1940) by British surrealist Conroy Maddox, where typewriter keys affixed with nails become torture devices for a 'phantom stenographer' typing on black paper (Plate 9).[179]

Whether Domínguez's suicidal *Dactylo*, whose wrists are slit in the very action of typing with her hands outstretched, should be understood as a companion piece to *Machine à coudre électro-sexuelle* of the same year rests ultimately on the viewer's interpretation of the artist's evocation of orgasm and/or self-destruction in the relationship of the worker to industrial work machine. *Machine à coudre électro-sexuelle* certainly encompasses masochistic connotations. In comparison, with the depicted suicide of *Dactylo*, a deeply satirical black-humour message can be perceived: the typist's suicide is a defiant and self-managed undermining of discipline, in which efficiency is reconfigured as the radical waste and permanent absenteeism of violent self-imposed death. Echoing the surrealist proposal of suicide as a solution in the 1920s discussed in Chapter 1, the suicidal *Dactylo* and the onanistic *couturière* both activate revolt through the submission to labour; they sabotage labour, if not the basic operations of the work tool itself, by eradicating productivity in a demonstration of extreme expenditure through self-sacrifice.

The theme of the submission and eradication of the author-creator in the act of working, and the experience of the death of that author as an acutely

pleasurable form of ludic dispersal or annihilation, is readily apparent in other aspects of Domínguez's work during the 1930s. This is not surprising, considering surrealism's own long-time investment in the theme of suicide, the mechanics of dissociation, and its repudiation of the artwork as the product of a specialised *métier*.[180] Visual automatist means also sought to remove the possibility of intention, craftsmanship, technique, and manual aura from the creation of art through tactics that promoted effortless instantaneity.[181] Domínguez's surrealist deployment of the eighteenth-century pastime of decalcomania proved a stunning and popular addition to the well-equipped surrealist toolbox for visual automatism that by then encompassed frottage, grattage, and fumage, among many other techniques pioneered by artists such as Max Ernst and Wolfgang Paalen.[182]

Decalcomania's procedure, which included applying wet paint to a surface and then pressing or sliding a glass plate or another sheet of paper on that surface repeatedly until a desired degree of random mark-making was achieved, allowed for even greater separation between the hand of the artist and the work of art than had other depersonalising techniques in surrealism, such as grattage and frottage. Frottage, which entailed rubbing a soft crayon or pencil over a surface covered by a sheet of paper or a piece of canvas, literally did separate the visual content of the work of art from the artist's touch, although of course the associations of the word 'frottage' with non-penetrative sexual rubbing nevertheless emphasised this technique's tactile pressure.[183] In comparison, decalcomania's use of the glass sheet, or any other surface that would create suction with the liquid pigment, provided an even more substantial barrier to the effort of handmade artistic labour.

However, Domínguez's approach to this subject did not necessarily reflect a collective surrealist attitude towards the semantics of gestural artistic execution. As Adam Jolles has established, certain artists and writers, such as Alberto Giacometti and Louis Aragon, began engaging in a 'tactile turn' in the late 1920s and into the early 1930s in relation to their protest of the *International Colonial Exhibition* in Paris in 1931, among other cultural phenomena.[184] For Jolles, works such as Giacometti's mute, mobile, and disagreeable objects from this period, as well as Brassaï's photographs of involuntary sculptures in *Minotaure* (December 1933, issues 3–4), correspond to a surrealist protest against the commodification and humanist fetishisation of art objects and ethnographic material occurring in the contemporary art milieu. In an argument that briefly considers Luce Irigaray's feminist theory of female autoeroticism as a liberatory and antiphallocentric activity, Jolles estimated that for a writer like Tristan Tzara, who in the 1930s was interested in the potential of ethnographic objects to heighten individual and collective feelings of intimacy and sociability, the interactivity offered by some surrealist objects was posed as an avenue for redemption from alienation.

In contrast, Domínguez's surrealist tools, whether two- or three-dimensional, typically approach tactility from a sabotaging and individualist point of view; interaction with the machine results in a solipsistic pleasure or auto-destruction that thwarts any productive end.[185] In their role as common work tools for the

nearly effortless decalcomania transfer process, the serriform glass sheets incorporated into *Dactylo* and *Le Tireur* accordingly take on new connotations in such contexts. In Domínguez's altered found object *Le Tireur*, a damaged reproduction of a Greco-Roman Hellenistic bronze statuette of a seated youth pulling a thorn out of his foot (*Tireur d'épine*) is severed in two by a serrated glass pane (Plate 6). The youth's headless and limbless body is bisected vertically by the glass sheet, just as the *Dactylo* and the electrosexual seamstress are manipulated by their apparatuses. Activating the erotic slang connotation of the title *Le Tireur* as a man who performs coitus or masturbates, black paint has been added to the support under the figure, streaming down between the legs and pooling at the statuette's base in a morass of multi-coloured ejaculate and parts of a disassembled pocket watch. The work's alternative title, *La Conversion de l'énergie* (*Energy Conversion*), further illuminates the way in which the open pocket-watch cover that replaces the figure's head equates the destruction of regimented clock time with sexual release as unproductive labour.

As Domínguez's friend Georges Hugnet said in a short essay from 1935, 'L'Objet utile: à propos d'Óscar Domínguez' ('The Utiltarian Object: Óscar Domínguez'), 'In every object, in the most insignificant manufactured object, the abandoned object, and the unusual object of forgotten use, sleeps a flame which, awakened by us, illuminates, convulses, dazzles our obsessions.'[186] In that sense, Domínguez's surrealist objects seem to possess the potential for their own liberation. Such logic follows in other important works in the artist's oeuvre, including the monochromatic white object *Jamais* (*Never*, 1937), a companion piece to *Machine à coudre électro-sexuelle*, but one in which the theme of feminine self-pleasuring pervades non-work experience (Figure 3.14). Featured prominently in a central room of the *Exposition internationale du surréalisme* at the Galerie Beaux-Arts, Paris, in winter 1938, *Jamais* confronted viewers with the startling vision of a chremamorphic-anthropomorphic (both object-like and humanoid) figure. A feminine *corps morcelé* (fragmented body) is transformed into an object, and vice versa. According to Kylie King's interpretation, the high-heeled legs are devoured cannibalistically by the phonograph and thus subjected to symbolic castration.[187] In an alternate reading, we might instead see this elision of object and feminine subject as one of ecstatic transformation. The phonograph's needle is autoerotically condensed into the fingertips of a woman caressing her breasts in a gesture of self-pleasure as the arc of the phonograph's horn morphs into the woman's billowing skirts. Lewis Kachur has reported that the phonograph's turntable rotated, and he conjectured that the recorded laughter of asylum inmates, emitted from a hidden phonograph and playing throughout the exhibition galleries, could have been construed by viewers as the soundtrack of *Jamais*.[188]

As a kinetic and electrified work that animated the action of self-caress, Domínguez's object lingers on the topic of a female autonomous pleasure that takes shape in the very moment of the recuperation of the subject into the commodity structure. Such a reification of the female body into machine in the act of

Figure 3.14 Denise Bellon, *View of the Main Hall of the International Surrealist Exhibition During Installation – in the Foreground the Object 'Jamais' by Óscar Domínguez*, Paris, 1938. *Also pictured*: Salvador Dalí's *Visage du grand masturbateur* (1929) and Marcel Duchamp's installation with coal sacks and brazier. *Foreground*: Óscar Domínguez, *Jamais*, 1937

self-pleasuring remains a trope limited by sexist objectification, and yet the representation of historically forbidden female autoeroticism persistently carries with it connotations of an insurgent autonomy. Domínguez echoed this sentiment in related works, such as the mannequin he made for the same 1938 exposition, which directs the spray of a soda siphon bottle towards herself in an act of auto-stimulation, expressed in the form of a translucent fabric spiralling around her midriff and then her ankles.[189] In comparison with Marcel Duchamp's window-display mannequin, *Lazy Hardware* (1945), in which a headless female figure wears only an apron and sports a water tap built into her thigh, Domínguez's soda-siphon girl uses her tool without incorporating it into her body.

Also relevant was the drawing of a mutated woman next to a phonograph that Domínguez made for the first publication of Breton's dream recitation, 'Accomplissement onirique et genèse d'un tableau animé' ('Oneiric Genesis and Execution of an Animated Painting'), published in March 1938 (Figure 3.15).

Figure 3.15 Óscar Domínguez, *Le Souvenir de l'avenir*, 1938. Illustration for André Breton, 'Accomplissement onirique et genèse d'un tableau animé', *Cahiers G.L.M.* 7, Paris (March 1938). Also used as an illustration for 'Les Revenants futurs', a poem by Georges Hugnet in André Breton, *La Trajectoire du rêve* (Septième cahier, Paris, 1938), 103

In this text, Breton described a dream he had in winter 1937 about Domínguez, in which a painting-in-progress by the artist becomes animated with a vision of animal fellatio. In the dream, Breton had stopped to watch Domínguez paint, and he realised that what he assumed were a series of knots depicted in the work were actually the hindquarters of several lions who were aggressively licking each other's genitalia. The hindquarters of the lions were aligned with the sun and thus created a luminous spectacle like the aurora borealis: animal as animation.[190] Domínguez chose to illustrate Breton's dream of an animated painting of genital stimulation with an already familiar trope of female self-caress from his oeuvre by creating the drawing *Le Souvenir de l'avenir* (1938). The white figure in a skirt reminiscent of a phonograph horn has transformed into a giant hand as the woman stands next to the device, her body moulded into an instrument of perfect haptic and aural receptivity.

Such an examination of Domínguez's iconography of surrealist sabotage indicates that the varying nature of human–object relations in both work and

Figure 3.16 Méret Oppenheim, *Ma gouvernante*, 1936–67

non-work remained a consistent theme over the course of the 1930s. Moreover, perhaps following Breton's own emphasis on liberatory aesthetic discourses, Domínguez's exploration of the themes of destructive work sabotage, posthuman work-tool autonomy, and autonomous female pleasure moved past the formula of protest art into prefigurative envisioning, in which a future horizon of superior possibilities for life are actively and fluidly imagined from the vantage point of the present.[191] Domínguez's surrealist sabotage often, but not exclusively, favoured narratives of revolt over those of pessimism about the co-optation of life into capital. Compare, for instance, Domínguez's drawing *Le Souvenir de l'avenir* or his object *Jamais* with the surrealist object *Ma gouvernante* (*My Governess*, 1936) by Swiss artist Méret Oppenheim (Figure 3.16). *Ma gouvernante* relegates the trappings of professional femininity to a readily consumable delectation waiting to be enjoyed by those she 'serves': the hired female assistant is trussed fodder 'served up' to the employing class. Indications of the servant's sexuality stubbornly persist in the form of the scuffed white heels bound tightly together. In comparison, although Domínguez's phonograph-woman is also subjected to the reification of object condensation and the operations of fetishism remain readily apparent, the intimation of her tactile self-pleasuring arguably destabilises this image of subjection to a more dramatic degree.

Conclusion: a tool's ultimate end

Despite Domínguez's palpable interest in themes of revolt, his artworks from the 1930s that take up the themes of work and pleasure often possess a profound ambivalence, wherein the satirical double entendre triggered by his representations render stable interpretation impossible. In the case of Domínguez's symbolically brutal object *Brouette No. 1* (*Wheelbarrow*, also sometimes called *Fauteuil* (*Armchair*)) (Plate 10) – made in 1936, the year when nationwide strikes led to the institution of France's first *congés payés* (paid holidays) – the value of both work and leisure appear commensurately grotesque. In the same year, the British economist John Maynard Keynes published his opus *The General Theory of Employment, Interest and Money* (a French translation would not appear until 1942), which demonstrated that a capitalist economy is stimulated primarily by market demand, in the form of consumption and investment, rather than supply or production.[192] The status of the labour force depended in a significant capacity upon the robustness of the consumer sphere, according to Keynes, and therefore working was dialectically enmeshed with buying. These insights about the power of consumption in relation to labour had an immediate example in some of the outcomes of France's new labour laws. The 1936 strikes not only resulted in the birth of the two-day weekend for the first time in the history of French labour, but they also ushered in an era of mass tourism and leisure consumption by the end of the decade.[193]

Domínguez accordingly sought fresh prototypes for his ongoing exploration of the curious overlap between pleasure and production. As one of the most powerful works of art ever made in response to the surrealist anti-work position, *Brouette* achieves an ingenious condensation of the quintessential labour tool, the wheelbarrow, with an emblem of bourgeois domination, the chaise longue – and more distantly, a symbol of sumptuary privilege and aristocratic primitive accumulation, the litter (sedan chair). In 1936–37, when two works by Domínguez appeared in Alfred H. Barr Jr's *Fantastic Art, Dada, Surrealism* exhibition at the Museum of Modern Art in New York, Man Ray executed a photo shoot with *Brouette* featuring a model in a designer dress by couturier Madeleine Vionnet. The model languorously reclines on the velvet wheelbarrow-chaise, emphasising the blunt delineation of the class struggle that Domínguez's black-humour object effects (Figure 3.17). Man Ray's staging of the model seated in *Brouette* further evoked his 1925 photograph from the cover of *La Révolution surréaliste* twelve years earlier, which featured a mannequin wearing a dress by couturier Paul Poiret situated between the anti-work slogan '*ET GUERRE AU TRAVAIL*' (see Figure 0.1).

Man Ray reproduced one of the *Brouette* photographs in a short photo essay titled 'Aurore des objets' ('Dawn of the Objects'), published in the tenth issue of *Minotaure* in December 1937. Notably, he chose the shot in which the model lightly caresses her neck while seated in the padded cart.[194] Soon absorbed into the collection of the Vicomte Charles de Noailles, *Brouette* was one of seven works by Domínguez featured in the January–February 1938

Figure 3.17 Man Ray, *Model wearing Vionnet evening gown with 'Brouette' by Óscar Domínguez*, 1937

Exposition internationale du surréalisme at Galerie Beaux-Arts in Paris, including the phonograph object *Jamais*. David Hopkins has reminded us that the theme of the dialectic between labour and play was the conceptual anchor for Marcel Duchamp's experimental design for the *Exposition internationale*, which

included a ceiling hung with 1,200 dirty coal sacks seeping dust and an illumi-
nated workman's brazier positioned on the floor.[195] *Brouette*, created in advance
of the exhibition, must have added palpable fuel to this coal-pit atmosphere.
Although it was just one of several pieces of surrealist 'furniture' on display at the
exhibition, along with works such as Wolfgang Paalen's *Chaise envahie de lierre*
(*Ivy Chair*, 1937) and Kurt Seligmann's erotic ottoman *Ultrameuble*, *Brouette*
nevertheless offered an incisive counterpoint, with its stark confrontation of
labour with leisure.[196] The velvet work cart was also a coffin.

The *Dictionnaire abrégé du surréalisme* of 1938 contains a brief entry for the
word 'brouette' in the form of a quotation from a deeply sardonic yet romantic
poem entitled 'Le Poète contumace' ('The Contumacious Poet'). This poem was
featured in the volume *Les Amours jaunes* (*Yellow Loves*), published in 1873
by the French *poète maudit* Tristan Corbière, and included the line: 'Mon lit
captionné de satin de brouette' ('My bed with its wheelbarrow satin sheets').[197]
Perhaps influenced by Corbière's self-deprecating phrasing, Domínguez's object
starkly juxtaposes the lifelong labour of the proletariat with the lassitude enjoyed
by a ruling class dependent upon servants or slaves – the ruby-red velvet uphol-
stery signifying listless and conspicuous consumption, or alternatively a luxuri-
ous experience of infirmity. The interdependence of these class hierarchies is
painfully exposed, as is the causality of the ties between class dominance and the
accumulation of cultural and financial capital. The plush, sanguine interior of
the chaise coaxes the pleasure of the indolent sitter, whose role is precisely not to
work but to remain a consummately possessed object of contemplation, a surplus
value bespeaking the sweetness of doing nothing, *dolce far niente*.

Domínguez also may have had in mind Salvador Dalí's fetishistic depictions of
wheelbarrows in a series of paintings from the early 1930s based on Jean-François
Millet's aforementioned painting *L'Angélus*.[198] In one prominent example, Dalí's
Les Atavismes du crépuscule (*Atavism at Twilight*, 1934), the laden wheelbarrow
depicted behind the praying woman in Millet's painting is moved to the opposite
side of the canvas, where it floats in the air and grows out of the male figure's head.
For Dalí, the wheelbarrow evoked the sexual effort, ferocity, desperation, and
impotence variously experienced by the desiring heterosexual male when con-
fronted with the castrating female, as suggested to him by the composition and
subject of Millet's painting.[199] In addition, Dalí associated the wheelbarrow with
the infatuated labour of Ferdinand Cheval, known as 'Facteur Cheval', the French
postman who built by hand an 'Ideal Palace' out of stone in Hauterives, France.[200]
Cheval's wheelbarrow was an emblem of the fetishised building process, which
was both 'regressive and libidinous' for Dalí.[201]

After World War II, Dalí became interested in what he called 'peasant
eroticism' in relation to his film project *The Wheelbarrow of Flesh* (1948–54),
an unfinished psychological drama. According to Dalí's classist formulation,
'we know that peasants, because of the severity of their labours, overwhelmed
by physical fatigue, have a tendency to eroticise all the work tools that come to
hand in a sort of "atavistic cybernetic" way, the wheelbarrow being "the supreme,

blinding phantasm", because of its anthropomorphic structure and its possibili-
ties of "functioning symbolically"'.[202] The male's work with the wheelbarrow was
in one capacity a crude metaphor for heterosexual intercourse (wheelbarrow as
vagina), but in another capacity was one of paranoiac fetishism that indicated
woman's castrating power over man and incestuous desire for her son. The con-
stant 'labour' of the male that serves to confirm his patriarchal power is subverted,
for Dalí, by the woman who transforms him through domesticity and marriage
into a 'state of a simple vehicle of social productivity'.[203] Marriage confirms her
matriarchal dominance. Therefore, Dalí's wheelbarrow is at once the work tool,
bed, and coffin of the family man.

The iconography of the wheelbarrow possessed a much less explicit set of
internally coherent meanings for Domínguez than it did for Dalí, considering the
latter's recondite personal mythographic tendencies and profound investment in
psychoanalysis. Instead, the 1936 object *Brouette* engages in the same surrealist
discourse about exploitation and autonomy, work, and pleasure that had animated
Machine à coudre électro-sexuelle. However, as a far more equivocal aesthetic
statement than the earlier painting of the sewing machine, *Brouette* approaches
these issues in a slightly different manner that satirically suggests the coexistence
of two antonymic readings. One, it posits the possibility of a supple and sensitive
masculine–feminine pleasure emerging through the subversion of male-gendered
manual labour. Two, *Brouette* simultaneously underlines the idea that the patriar-
chal gender hierarchy is partially achieved through class domination and the sexist
division of labour – or, the idea that male labour produces male authority.

In this double-pronged subversion and derision of patriarchal authority
by way of the *détournement* of an ancient symbol of human industriousness,
Brouette serves as an easily legible but scintillating attack on productivism and
submission to ideology. This work appeared just after the surrealists' break with
the PCF and in the midst of the collapse of Breton and Bataille's anti-fascist
alliance, Contre-Attaque: Union de lutte des intellectuels révolutionnaires,
at a moment when surrealism most needed such a confident articulation of
its defiantly independent anti-work position. The presence of *Brouette* in the
1938 *Exposition internationale du surréalisme* also meant it remained a promi-
nent surrealist artwork just in advance of Breton's journey to Mexico and his
extended exchange with Leon Trotsky, which resulted in the formation of the
Fédération internationale de l'art révolutionnaire indépendant (FIARI) and
its accompanying manifesto, *Pour un art révolutionnaire indépendant* (*For an
Independent Revolutionary Art*) (1938). In that sense, *Brouette* repudiates the
social responsibility expected of the work of art through a grotesque display
of indolence. Its effort lies in the sabotage of the various sociopolitical affilia-
tions to which an engaged work of art in this period typically ascribed – and the
destruction of the work of art as ideological vessel, as tool.

Over the course of the 1930s, Óscar Domínguez developed an influential iconog-
raphy of surrealist sabotage in artworks of different media that not only impacted

the movement's anti-work art practice going forward but also substantially expanded its pre-existing discourse of work refusal, updating these precepts in light of the fraught historical context of surrealism's second decade. Domínguez's artworks from this era imaginatively modulate surrealist work abolitionism into an envisioned realm wherein various types of symbolic subversion critically and often indirectly tease out repressed associations with sexuality, death, and apocalyptic annihilation. All of these arise in the human relationship with productive labour undertaken with machinic and non-machinic tools. By re-envisioning pre-industrial and postindustrial work tools as productive in the sphere of human desires and fears and unproductive in the material realm of the functional commodity, Domínguez's artworks visualise a sociopolitical autonomous discourse for surrealism's anti-work stance, and gesture towards the possible character of the social imaginary in the horizon of postwork futures.

Notes

1 Jackson, *Popular Front in France*, 5–7, 28–30.
2 Reynaud Paligot, *Parcours politique*, 156. Brian Jenkins and Chris Millington, *France and Fascism: February 1934 and the Dynamics of Political Crisis* (London: Routledge, 2016), 3, 87.
3 Thirion, *Revolutionaries Without Revolution*, 350.
4 Benjamin Péret, '6 février', in *A Marvelous World: Poems*, trans. Elizabeth R. Jackson (Baton Rouge: Louisiana State University Press, 1985), 35. The poem was originally published in the 1936 volume of *Je ne mange pas de ce pain-là* (*I Won't Stoop to That*); translation modified.
5 Harris, *Surrealist Art and Thought*, 10 and *passim*.
6 Musée Cantini, *La Part du jeu et du rêve: Óscar Domínguez et le surréalisme, 1906–1957: exposition au Musée Cantini de Marseille du 25 juin au 2 octobre 2005* (Marseille: Musées de Marseille, 2005), 188.
7 Centro Atlántico de Arte Moderno, *Óscar Domínguez: antológica 1926–1957* (Las Palmas de Gran Canaria: Centro Atlántico de Arte Moderno, 1996), 272.
8 Julián Casanova, *The Spanish Republic and Civil War* (Cambridge: Cambridge University Press, 2010), viii–ix.
9 Musée Cantini, *La Part du jeu*, 29.
10 Centro Atlántico de Arte Moderna and 'La Granja', *'Gaceta de arte' y su época, 1932–1936* (Las Palmas de Gran Canaria: Centro Atlántico de Arte Moderno, 1997).
11 Domingo López Torres, 'Surrealismo y revolución', *Gaceta de arte* 9 (October 1932): 2.
12 Centro Atlántico de Arte Moderno, *Óscar Domínguez*, 273–6.
13 Eduardo Westerdahl, quoted in Musée Cantini, *La Part du jeu*, 195.
14 Gérard Durozoi, *History of the Surrealist Movement*, trans. Alison Anderson (Chicago, IL: University of Chicago Press, 2002), 295–6.
15 Centro Atlántico de Arte Moderno, *Óscar Domínguez*, 277.
16 César Alierta and Fundación Telefónica, *Óscar Domínguez, surrealista* (Madrid: Fundación Telefónica, 2001), 234; Musée Cantini, *La Part du jeu*, 193.

17 Musée Cantini, *La Part du jeu*, 193. Hubert Van Den Berg et al., eds, *A Cultural History of the Avant-Garde in the Nordic Countries*, Avant-Garde Critical Studies 28 (Amsterdam: Rodopi, 2012), 141–2.

18 Durozoi, *History of the Surrealist Movement*, 296.

19 Robin Adèle Greeley, *Surrealism and the Spanish Civil War* (New Haven, CT: Yale University Press, 2006), 97.

20 Alierta and Fundación Telefónica, *Óscar Domínguez*, 235; Pilar Carreño Corbella, *Óscar Domínguez: en tres dimensiones: catálogo razonado de obras* (Santa Cruz de Tenerife: Pilar Carreño Corbella, 2010), 46–9; and Centro Atlántico de Arte Moderno, *El Surrealismo entre viejo y nuevo mundo: 4 diciembre–4 febrero 1990, Centro Atlántico de Arte Moderno* (Las Palmas de Gran Canaria: Cabildo Insular de Gran Canaria, 1989), 307–19.

21 Durozoi, *History of the Surrealist Movement*, 296.

22 André Breton, 'Interview with *Índice*', in *What Is Surrealism?*, 144–7.

23 Centro Atlántico de Arte Moderna and 'La Granja', *Gaceta de arte y su época*, 211–53.

24 Durozoi, *History of the Surrealist Movement*, 351; Jackson, *Popular Front in France*, 115; and Robert Soucy, *French Fascism: The Second Wave, 1933–1939* (New Haven, CT: Yale University Press, 1995), 33.

25 For instance, see Lewis, *Politics of Surrealism*, x. Also see Robert Short, 'Surrealism and the Popular Front', in *The Politics of Modernism* (Essex: University of Essex, 1979), 89–104. See also LaCoss, 'Revolutionary Politics of Surrealism'.

26 Reynaud Paligot, *Parcours politique*, 155–7; and Dudley Andrew and Steven Ungar, *Popular Front Paris and the Poetics of Culture* (Cambridge, MA: Harvard University Press, 2005), 64–6. See also Thirion, *Revolutionaries Without Revolution*, 351.

27 *Appel à la lutte*, in Pierre, *Tracts surréalistes et déclarations collectives*, 262–3; my translation.

28 Durozoi, *History of the Surrealist Movement*, 299. It does not appear that Domínguez ever became a member of the PCF. He did support the workers' movement and was drawn to communism during his trips to Czechoslovakia in 1946 and 1948. Musée Cantini, *La Part du jeu*, 206; and Fernando Castro Borrego, *Óscar Domínguez y el surrealismo* (Madrid: Cátedra, 1978), 76–7.

29 Ferdinand Alquié, 'Correspondance' (letter to André Breton, 7 March 1933), *Le Surréalisme au service de la révolution* 5 (May 1933): 43.

30 Thirion, 'À Bas le travail!', 43–6.

31 Ilya Ehrenburg, 'The Surrealists', *Partisan Review* 2, no. 9 (October–November 1935): 11–13. See also Ilia Grigorievich Erenbourg, *Duhamel, Gide, Malraux, Mauriac, Morand, Romains, Unamuno, vus par un écrivain de l'U.R.S.S* (Paris: Gallimard, 1934).

32 André Breton, 'On the Time when the Surrealists Were Right', in *Manifestoes of Surrealism*, 244. The complex events surrounding the Ehrenburg–Breton confrontation, including Breton's physical assault of Ehrenburg and Breton's subsequent expulsion from the International Conference for the Defence of Culture, are well documented elsewhere, and so I do not revisit them here. On these subjects, see Sandra Teroni and Wolfgang Klein, *Pour la défense de la culture: les textes du congrès international des écrivains, Paris, juin 1935* (Dijon: Éditions Universitaires de Dijon, 2005), 10 and *passim*.

33 Leon Trotsky, *Literature and Revolution* (1923; New York: Russell & Russell, 1957), 218.
34 Harris, *Surrealist Art and Thought*, 85, 146, 176–7, 219–29.
35 Casanova, *Spanish Republic and Civil War*, 12–14.
36 Castro Borrego, *Óscar Domínguez*, 45, 51–2.
37 These include but are not limited to paintings such as *Beau comme la rencontre fortuite d'une machine à coudre et d'un parapluie sur une table de dissection* (1943); *La Couturière* (1943); *La Machine à coudre* (1943); *La Couturière* (1946); *La Machine à coudre* (1947); *La Machine à coudre* (1949); *La Machine à coudre* (1949–50); *La Couturière* (1949–50); *Trois femmes* (1950); and *Le Mannequin et la machine à coudre* (n.d.; *c.* late 1940s). As others have noted, utilitarian objects used in both work and play interested the artist, and items such as typewriters, telephones, bicycles, revolvers, soda siphons, sardine keys, cameras, clocks, gramophones/record players, pianos, and other gadgets play a significant role in his iconography. Such an interest in the functional object also can be related to dada's anti-utilitarianism.
38 Musée Cantini, *La Part du jeu*, 206.
39 Liliane Durand-Dessert, 'Lautréamont et les arts visuels (1870–1998)', in *Les Lecteurs de Lautréamont: actes du quatrième colloque international sur Lautréamont, Montréal, 5–7 octobre 1998*, ed. Jean-Jacques Lefrère and Michel Pierssens (Tusson: Le Lérot, 1999), 81–159. Elisa Breton, Alan Glass, Maurice Henry, and Paul Duchein, for example, made notable surrealist artworks including the emblem of the sewing machine. Not all of the abundant surrealist references to sewing machines, seamstresses, or various implements associated with sewing, such as scissors, needles, buttons, and thimbles, concern the critique of work.
40 Julian Jackson, *The Politics of Depression in France, 1932–1936* (Cambridge: Cambridge University Press, 2002); and Soucy, *French Fascism*, 26, 36. Although less severe in France than it was in the United States, the Depression nevertheless had an impact on this European country from 1931 with higher rates of inflation, underemployment, unemployment, and poverty.
41 *Pied de biche* also translates as crowbar, suggesting other types of labour.
42 In France, the symbol of the *couturière* (dressmaker) was associated with someone who was a specialist in matters of the heart, and the items of *le fil* (thread) et *l'aiguille* (needle) were considered, as they often are today in Europe, romantic or sexual symbols. Yvonne Verdier, *Façons de dire, façons de faire: la laveuse, la couturière, la cuisinière* (Paris: Gallimard, 1979), 236–51.
43 Judith G. Coffin, *The Politics of Women's Work: The Paris Garment Trades, 1750–1915* (Princeton, NJ: Princeton University Press, 1996), 74; and Karen Offen, 'Powered by a "Woman's Foot": A Documentary Introduction to the Sexual Politics of the Sewing Machine in Nineteenth-Century France', *Women's Studies International Forum* 11, no. 2 (1988): 93.
44 Coffin, *Politics of Women's Work*, 14.
45 *Ibid.*, 78–9.
46 *Ibid.*, 74.
47 *Ibid.*, 101, 105; Offen, 'Powered by a "Woman's Foot"', 93; Lynn M. Alexander, *Women, Work, and Representation: Needlewomen in Victorian Art and Literature* (Athens: Ohio University Press, 2003); and Nancy Page Fernandez, 'Creating Consumers: Gender, Class and the Family Sewing Machine', in *The Culture of Sewing:*

Gender, Consumption, and Home Dressmaking, ed. Barbara Burman (New York: Berg, 1999), 161.

48 Coffin, *Politics of Women's Work*, 88. See also Joan Wallach Scott, 'Work Identities for Men and Women: The Politics of Work and Family in the Parisian Garment Trades in 1848', in *Gender and the Politics of History* (New York: Columbia University Press, 1988), 103.

49 Jules Simon, *L'Ouvrière* (Paris: Hachette, 1860), 20 and *passim*.

50 Joan Wallach Scott, '"L'Ouvrière! Mot impie, sordide …": Women Workers in the Discourse of French Political Economy, 1840–1860', in *Gender and the Politics of History*, 139–63.

51 Karen M. Offen, *The Woman Question in France, 1400–1870* (Cambridge: Cambridge University Press, 2017), 194–205.

52 Offen, 'Powered by a "Woman's Foot"', 95.

53 Coffin, *Politics of Women's Work*, 107–8; Offen, 'Powered by a "Woman's Foot"', 94; and Monique Peyrière, 'Femmes au travail, machines en chaleur: l'emprise de la machine à coudre', *Communications* 81 (2007): 71.

54 Julie Wosk, *Women and the Machine: Representations from the Spinning Wheel to the Electronic Age* (Baltimore, MD: Johns Hopkins University Press, 2001), xii, 28–9, 32.

55 Shelley Trower, 'Sexual Health: Sewing Machines, Bicycle Spine, the Vibrator', in *Senses of Vibration: A History of the Pleasure and Pain of Sound* (New York: Continuum, 2012), 126–34.

56 Coffin, *Politics of Women's Work*, 108–13.

57 Peyrière, 'Femmes au travail', 75; and Rachel Maines, *The Technology of Orgasm: 'Hysteria', the Vibrator, and Women's Sexual Satisfaction* (Baltimore, MD: Johns Hopkins University Press, 1999), 5–7, 56–9. On the 'illness' of masturbation in France, see Jean Stengers and Anne Van Neck, *Masturbation: The History of a Great Terror* (New York: Palgrave Macmillan, 2001).

58 Coffin, *Politics of Women's Work*, 109.

59 Eugène Gibout, 'De l'influence des machines à coudre à pédales sur la santé et la moralité des ouvrières', *Union médicale* (12 June 1866): 107–10, translated in Offen, 'Powered by a "Woman's Foot"', 96–7.

60 Émile Decaisne, 'La Machine à coudre et la santé des ouvrières', *Annales d'hygiène publique et de médecine légale*, 105, translated in Offen, 'Powered by a "Woman's Foot"', 99.

61 Thésée Pouillet, *Essai médico-philosophique sur les formes, les causes, les signes, les conséquences et le traitement de l'onanisme chez la femme* (Paris: Adrien Delahaye, 1876), 1:61–3, cited in Havelock Ellis, *Studies in the Psychology of Sex* (London: William Heinemann, 1942), 1:176–7.

62 Rosamond C. Cook, *Sewing Machines* (Peoria, IL: Manual Arts Press, 1922).

63 Maines, *Technology of Orgasm*, 100; and Frank P. Godfrey, *An International History of the Sewing Machine* (London: R. Hale, 1982), 209.

64 Monique Peyrière, 'Un moteur électrique pour la machine à coudre', *Bulletin d'histoire de l'électricité* 19–20 (1992): 73–86.

65 Coffin, *Politics of Women's Work*, 65. See also Wallach Scott, '"L'Ouvrière!"', 139–63.

66 Marx, *Capital*, 311–12.

67 Maines, *Technology of Orgasm*, 57; and Madeleine Guilbert, *Les Fonctions des femmes dans l'industrie* (Paris: Mouton, 1966), 35–41.
68 Michel Foucault, *The Will to Knowledge (The History of Sexuality, Volume 1)*, trans. Robert Hurley (1976; London: Penguin, 1998).
69 Hallie Lieberman, *Buzz: A Stimulating History of the Sex Toy* (New York: Pegasus Books, 2017), 25–38.
70 Maria Tamboukou, *Sewing, Fighting and Writing: Radical Practices in Work, Politics and Culture* (New York: Rowman & Littlefield, 2016). See also Wallach Scott, 'Work Identities', 102–8.
71 Robert Muchembled, *L'Orgasme et l'Occident: une histoire du plaisir du XVIe siècle à nos jours* (Paris: Éditions du Seuil, 2005), 249, 279–82; my translation.
72 Ellis, *Studies in the Psychology of Sex*, 282.
73 *Ibid.*, 176–8.
74 *Ibid.*, 171–2.
75 *Ibid.*, 282.
76 Peyrière, 'Femmes au travail', 78.
77 Lieberman, *Buzz*, 33.
78 Andreas Killen, *Berlin Electropolis: Shock, Nerves, and German Modernity* (Berkeley: University of California Press, 2006), 71–80. See also Georges Didi-Huberman, *Invention de l'hystérie: Charcot et l'iconographie photographique de la Salpêtrière* (Paris: Macula, 1982).
79 See, for instance, among several other studies in French and English, Joseph Houdart, *L'Électricité moyen de diagnostic en gynécologique* (Paris: J. B. Baillière & fils, 1894); and Samuel Sloan, *Electro-therapy in Gynaecology* (New York: Paul B. Hoeber, 1918).
80 Lieberman, *Buzz*, 25–38.
81 *Ibid.*, 35.
82 Thomas Walter Laqueur, *Solitary Sex: A Cultural History of Masturbation* (New York: Zone Books, 2003), 277, 297–8; original emphasis.
83 Nancy L. Green, *Ready-to-wear and Ready-to-work: A Century of Industry and Immigrants in Paris and New York* (Durham, NC: Duke University Press, 1997), 91–2.
84 Peyrière, 'Un moteur électrique', 73–86.
85 Lieberman, *Buzz*, 36; and Muchembled, *L'Orgasme et l'Occident*, 320–1.
86 Fernando Castro has described the painting as a vision of the forces of love and death that result in auto-destruction and sacrifice. Centro Atlántico de Arte Moderno, *Óscar Domínguez*, 337.
87 José Pierre, *Investigating Sex: Surrealist Research, 1928–1932* (New York: Verso, 1992), 8, 27–8, 127–8, 131–2, and *passim*. Note that only the first two discussions were published in 1928 in *La Révolution surréaliste*.
88 *Ibid.*, 116–17.
89 *Ibid.*, 92, 140.
90 *Ibid.*, 92. In the afterword to *Investigating Sex*, Dawn Ades has linked the discussion of the enlarged clitoris to a tradition of Sadean phallic women. *Investigating Sex*, 202. The subjects of masochism and sadism bear significance for the surrealist synthesis of work and pleasure. On the subject of Sade and surrealism, which I cannot address here given space constraints, see Alyce Mahon, *The Marquis de Sade and the Avant-Garde* (Princeton, NJ: Princeton University Press, 2020), 5–7. Also see Valerie Traub, 'Psychomorphology of the Clitoris', *GLQ* 21, no. 1–2 (1995): 81–113. See also

C. F. B. Miller's discussion of genital metaphorics, binarism, and the question of clitoral orgasm in surrealism. C. F. B. Miller, 'Surrealism's Homophobia', *October* 123 (2020): 207–29. Toyen's vulvic imagery is also relevant here.

91 Sigmund Freud, *Freud on Women: A Reader*, ed. Elisabeth Young-Bruehl (New York: W. W. Norton, 1990); and Leticia Glocer Fiorini and Graciela Abelin-Sas Rose, eds, *On Freud's 'Femininity'* (London: Karnac Books, 2010).

92 Cited in Freud, *Freud on Women*, 98. See Sigmund Freud, *Nouvelles conférences sur la psychanalyse*, trans. Anne Berman (Paris: Gallimard, 1936).

93 Freud, 'Femininity', cited in *Freud on Women*, 360. 'Femininity' was not translated into French until 1936.

94 *Ibid.*; and Laqueur, *Solitary Sex*, 70–4, 381–97. Anti-clitoral views such as Freud's are part of the reason that the label of narcissism for female masturbation must be approached with caution. *Surréalisme et sexualité* by Xavière Gauthier (1971) includes one example of the discussion of '*l'auto-satisfaction*' as narcissism. Also see Edward D. Powers, 'Bodies at Rest: Or, the Object of Surrealism', *RES: Anthropology and Aesthetics*, no. 46 (2004): 226–46.

95 Freud, 'Femininity', cited in *Freud on Women*, 360; and Luce Irigaray, *Speculum of the Other Woman* (1974; Ithaca, NY: Cornell University Press, 1985), 65–6, 115–17.

96 Jackson, *Popular Front in France*, 98.

97 André Breton, 'M. Renault Is Very Concerned', in *What Is Surrealism?*, 111, 110; original emphasis.

98 Eburne, *Surrealism and the Art of Crime*, 173–214.

99 Paul Éluard and Benjamin Péret, *Le Surréalisme au service de la révolution* 5 (15 May 1933): 27–8; my translation.

100 This passage of *Les Vases communicants* was first published in Breton's essay 'L'Objet fantôme' in the third issue of *Le Surréalisme au service de la révolution* in 1931.

101 Harris, *Surrealist Art and Thought*, 19–48.

102 Dawn Ades, 'Surrealism: Fetishism's Job', in *Fetishism: Visualising Power and Desire*, ed. Anthony Shelton (London: South Bank Centre; Royal Pavilion, Art Gallery and Museums Brighton, 1995), 73–8.

103 Comte de Lautréamont, *Maldoror; and, Poems*, trans. Paul Knight (Harmondsworth: Penguin, 1978), 216–17.

104 Louis Aragon, *Anicet or the Panorama*, trans. Antony Melville (London: Atlas Press, 2016).

105 Eburne, *Surrealism and the Art of Crime*, 49–73; Lyford, *Surrealist Masculinities*, 19–26.

106 André Breton, *Communicating Vessels*, trans. Mary Ann Caws and Geoffrey T. Harris (Lincoln: University of Nebraska Press, 1990), 52–3.

107 *Ibid.*, 53.

108 *Ibid.*

109 Haim N. Finkelstein, *Surrealism and the Crisis of the Object* (Ann Arbor: UMI Research Press, 1979), 67–75.

110 Breton, *Communicating Vessels*, 55.

111 *Ibid.*, 49.

112 Spiteri, 'Surrealism and the Question of Politics', 119. See also Roger Rothman, *Tiny Surrealism: Salvador Dalí and the Aesthetics of the Small* (Lincoln: University of Nebraska Press, 2012), 13–17.

113 Salvador Dalí, 'The Truth of the Myth of William Tell: The Whole Truth About My Expulsion from the Surrealist Group', in *The Tragic Myth of Millet's 'Angelus': Paranoiac-Critical Interpretation Including the Myth of William Tell*, ed. Albert Reynolds Morse, trans. Eleanor R. Morse (St. Petersburg, FL: Salvador Dalí Museum, 1986), 182.

114 The homonyms are eyelash = *cil*; handle = *l'anse*; cil-l'anse = *le silence*.

115 Breton, *Communicating Vessels*, 55.

116 Harris, *Surrealist Art and Thought*, 160.

117 Lautréamont, *Maldoror*, 216–17.

118 'Préface', *La Révolution surréaliste* 1 (1 December 1924): 1.

119 Durand-Dessert, 'Lautréamont et les arts visuels', 81–159. Emmanuel Guigon, *Ó. Domínguez: Óscar Domínguez* (Tenerife: Viceconsejería de Cultura y Deportes, Gobierno de Canarias, 1996), 39–41.

120 Richard Martin, *Fashion and Surrealism* (New York: Rizzoli, 1987), 11–16. Martin also mentioned Domínguez's *Machine à coudre électro-sexuelle* and discussed the lost assemblage featuring a miniature sewing machine by Louis Aragon and Breton, *Here Lies Giorgio de Chirico* (1928). Although much has been written on the subject of surrealism's relation to the fashion industry and the psychosocial significance of dressing, women's labour in the garment industry can also be seen as having a broader socio-political significance in relation to the movement's work refusal.

121 Jodi Hauptman, 'Sweepings', in *Joseph Cornell and Surrealism*, ed. Matthew Affron and Sylvie Ramond (Charlottesville: Fralin Museum of Art at the University of Virginia, 2015), 84–103. Martin, *Fashion and Surrealism*, 12. Martin's first chapter compared some of the same works featured here. Cornell's collage *Untitled (The Pulse of Fashion*, 1931) was reproduced in the *Dictionnaire abrégé du surréalisme* (1938). As one of two collages by Cornell from the late 1930s featuring sewing machines, it is unclear whether Cornell was merely interested in this motif due to his fondness for women's fashion and his employment as a textile designer in New York during the 1930s or whether he actively sought to reference *Les Chants de Maldoror*. Since both sewing machine collages were published in *Harper's Bazaar* in February 1937, they may have been produced on commission.

122 Renée Riese Hubert, *Surrealism and the Book* (Berkeley: University of California Press, 1988), 217–18.

123 Dalí, *Tragic Myth of Millet's 'Angelus'*, 149–57. Dalí first published a small portion of this text in the first issue of *Minotaure*. Salvador Dalí, 'Interprétation paranoïaque-critique de l'image obsédante "L'Angélus" de Millet', *Minotaure* 1 (1 June 1933): 65–6.

124 Lomas, *Haunted Self*, 152–4, 156–7.

125 Dalí, *Tragic Myth of Millet's 'Angelus'*, 156.

126 *Ibid.*

127 Greeley, *Surrealism and the Spanish Civil War*, 51–6.

128 Nancy Spector, 'Meret Oppenheim: Performing Identities' in *Meret Oppenheim: Beyond the Teacup*, ed. Jacqueline Burckhardt and Bice Curiger (New York: Independent Curators and D.A.P./Distributed Art Publishers, 1996), 38–9. Mary Ann Caws, 'Ladies Shot and Painted: Female Embodiment in Surrealist Art', in *The Female Body in Western Culture*, ed. Susan R. Suleiman (Cambridge, MA: Harvard University Press, 1986), 262–87.

129 Salvador Dalí, 'Le Phénomène de l'extase', *Minotaure* 3–4 (December 1933): 76–7.

130 Dalí's photogravure frontispiece for Georges Hugnet's long poem of 1934, *Onan*, can also be considered in this context. Hugnet's poem focuses on the figure of Onan from the Book of Genesis, who is slain by God for masturbating and 'spilling his seed' rather than marrying the wife of his dead brother. Dalí's frontispiece, *Espasmographisme avec la main gauche pendant qu'avec la main droite je me masturbe jusqu'au sang, jusqu'à l'os, jusqu'aux hélices du calice*, was touted as resulting from the artist's masturbation, and featured a large central stain. Georges Hugnet, *Onan* (Paris: Éditions Surréalistes, 1934).

131 André Breton, 'Konrad Klapheck', in *Surrealism and Painting*, 411–12.

132 On this genealogy, see Michel Carrouges, *Les Machines célibataires* (Paris: Arcanes, 1954). Breton owned a signed copy of the Carrouges text and thus likely wrote his 1965 essay on Klapheck under the influence of *Les Machines célibataires*. Jean Clair and Harald Szeemann, eds, *Le Macchine celibi/The Bachelor Machines* (New York: Rizzoli, 1975). *Le Macchine celibi* singles out Domínguez's work as tied to the tradition of bachelor machines and reproduces an image of *Machine à coudre électro-sexuelle*. See in particular the chapter by Peter Gorsen for a discussion of autoeroticism, 'The Humiliating Machine Escalade of a New Myth', 130–43. For a discussion of pansexuality and post-gendering in bachelor machines, see Joseph Nechvatal, 'Before and Beyond the Bachelor Machine', *Arts* 7, no. 4 (2018): 67.

133 Romy Golan, *Modernity and Nostalgia: Art and Politics in France between the Wars* (New Haven, CT: Yale University Press, 1995).

134 Clair and Szeemann, *Le Macchine celibi*, 10 and *passim*.

135 Julien Levy, *Memoir of an Art Gallery* (New York: Putnam, 1977), 20.

136 André Breton, 'Konrad Klapheck', 412; original emphasis. My use of the term vamp is influenced by Huyssen's chapter on Lang. Andreas Huyssen, 'The Vamp and the Machine: Fritz Lang's *Metropolis*', in *After the Great Divide: Modernism, Mass Culture, Postmodernism* (Bloomington: Indiana University Press, 1986), 65–81.

137 Alberto Savinio, 'Achille énamouré mêlé à l'Évegète', *Le Surréalisme au service de la révolution* 5 (1933): 32–4.

138 *Ibid.*, 411; Fulcanelli, *The Dwellings of the Philosophers = Les Demeures philosophales: et le symbolisme hermétique dans ses rapports avec l'art sacré et l'ésotérisme du grand-œuvre* (1929; Boulder, CO: Archive Press and Communications, 1999), 70.

139 Alfred Jarry, *The Supermale*, trans. Ralph Gladstone and Barbara Wright (Cambridge, MA: Exact Change, 1999), 135.

140 Breton, 'Konrad Klapheck', 411.

141 *Ibid.*

142 'Lexique succinct de l'érotisme', in *Exposition InteRnatiOnale du Surréalisme, 1959–1960* (Paris: Galerie Daniel Cordier, 1959), 132. Given my focus on the 1930s in this chapter, I do not undertake an extended discussion of the *EROS* exhibition that took place thirty years later, although certainly this event is essential for a transhistorical understanding of pleasure in surrealism.

143 André Breton, 'À propos du concours de littérature prolétarienne organisé par *L'Humanité*', *Le Surréalisme au service de la révolution* 5 (May 1933): 16–18; and André Breton, 'On Proletarian Literature', in *What Is Surrealism?*, 89–95. Breton's reservations about the presumption of a proletarian literature were echoed in the opening statement 'Immediate Action', in 'Surrealist Intervention', ed. E. L. T. Mesens, special issue, *Documents 34* (June 1934), signed by Mesens, Magritte, Nougé, Scutenaire, and

Souris. Breton, 'Second Manifesto of Surrealism', 154–7. See also Vahan D. Barooshian, 'French Surrealism and Russian Futurism', in *Russian Cubo-futurism 1910–1930: A Study in Avant-gardism* (The Hague: Mouton, 1974), 153–63.

144 Breton, 'À propos du concours de littérature prolétarienne', 167. See, for example, Trotsky, *Literature and Revolution*, 224. See also: Pierre Taminiaux, 'Breton and Trotsky: The Revolutionary Memory of Surrealism', *Yale French Studies* 109 (2006): 52–66; Harris, *Surrealist Art and Thought*, 51–61.

145 Breton, 'On Proletarian Literature', 93.

146 *Ibid.*, 91. Gavin Parkinson, 'Painting as Propaganda and Prophecy', *Oxford Art Journal* 41: 2 (2018): 249–69.

147 André Breton, 'Political Position of Surrealism', 217–20.

148 *Ibid.*, 232; original emphasis.

149 Jackson, *Popular Front in France*, 85–7; and Soucy, *French Fascism*, 33–5. On Breton and Blum, see Breton, *Conversations*, 137.

150 Jackson, *Popular Front in France*, 86, 96–7.

151 André Breton, 'Óscar Domínguez', in *Surrealism and Painting*, 128–9; original emphasis.

152 Soucy, *French Fascism*, 34. See also Torigian, *Every Factory a Fortress*, 93–120.

153 Jackson, *Popular Front in France*, 132.

154 Soucy, *French Fascism*, 34.

155 In the conclusion of Breton's special issue of the journal *La Nef* in March 1950, *Almanach surréaliste du demi-siècle*, a 'Panorama du demi-siècle' gives a table of dates ranging from 1900 to 1950 detailing occurrences significant to surrealism's development printed alongside important dates in French labour history and other historical developments. For the year 1936, under the category 'events', France's establishment of the forty-hour work week is one of ten entries, and the workers' strikes and insurrections in Paris and Vienna are also listed, while Domínguez's debut of the artistic technique of decalcomania is one of five entries for 'arts' that year. *Almanach surréaliste du demi-siècle* (Paris: Plasma, 1978), n.p.

156 Breton, 'Óscar Domínguez', 128; original emphasis.

157 *Ibid.*, 129; original emphasis.

158 'Neutralité? Non-sens, crime et trahison', 20 August 1936, in Pierre, *Tracts surréalistes et déclarations collectives*, 302–4, 508–9. See also Reynaud Paligot, *Parcours politique*, 159–60; and Greeley, *Surrealism and the Spanish Civil War*.

159 Polizzotti, *Revolution of the Mind*, 435–6.

160 Jackson, *Popular Front in France*, 104–12; and Andrew and Ungar, *Popular Front Paris*, 2–5.

161 André Breton, 'Non-national Boundaries of Surrealism', in Parmentier and d'Amboise, *Free Rein = La Clé des champs*, 8.

162 *Ibid.*, 7; and Musée Cantini, *La Part du jeu*, 196.

163 Breton, 'Non-national Boundaries', 7.

164 *Ibid.*, 8; original emphasis.

165 Susan Rubin Suleiman, 'Between the Street and the Salon: The Dilemma of Surrealist Politics in the 1930s', in *Visualizing Theory: Selected Essays from V.A.R., 1990–1994*, ed. Lucien Taylor (New York: Routledge, 1994), 149.

166 Cahun singled out manual workers rather than intellectuals as the ideal candidates to understand the irrational object. Claude Cahun, 'Prenez garde aux objets

domestiques', *Cahiers d'art* 11 (1936): 45–8. On this essay, see Harris, *Surrealist Art and Thought*, 158–77. Also see Claude Cahun, 'Surrealism and Working-class Emancipation', trans. Franklin Rosemont, in Rosemont, *Surrealist Women*, 57–8.

167 Guigon, Ó. *Domínguez*, 49–61; and Carreño Corbella, *Óscar Domínguez*, 48.

168 Domínguez's *Dactylo* (1935) is listed as part of the Georges Hugnet collection in Eduardo Westerdahl, *Óscar Domínguez* (Barcelona: G. Gili, 1968), 62.

169 Musée Cantini, *La Part du jeu*, 198. The event of Domínguez's own suicide by slashing his wrists in 1957 is worth mentioning in this context, as is the fact that the revolver became a favourite subject of his paintings during the 1940s and 1950s.

170 Marcel Jean, 'Remembering Óscar Domínguez', in *El Surrealismo entre viejo y nuevo mundo*, 318.

171 Domínguez continued to paint sewing machines and seamstresses throughout his career, but most of these works date from the 1940s, when the artist began to employ a style more cubist than surrealist.

172 Musée Cantini, *La Part du jeu*, 35–9.

173 Alierta and Fundación Telefónica, *Óscar Domínguez, surrealista*, 249–51; Carreño Corbella, *Óscar Domínguez*, 81–83; and Gavin Parkinson, *Surrealism, Art, and Modern Science: Relativity, Quantum Mechanics, Epistemology* (New Haven, CT: Yale University Press, 2008), 131–2.

174 André Breton, 'The Most Recent Tendencies in Surrealist Painting', in *Surrealism and Painting*, 145–50.

175 Marcel Jean and Arpad Mezei, *The History of Surrealist Painting*, trans. Simon Watson Taylor (New York: Grove Press, 1960), 269.

176 Gavin Parkinson, 'Surrealist Painting as Science Fiction: Considering J. G. Ballard's "Innate Releasing Mechanism"', in *Surrealism, Science Fiction and Comics*, 190–1. Domínguez may have based the title of *Souvenir de l'avenir* upon the phrase 'le souvenir du futur', which was underlined in the reproduced page of handwritten notes that became the frontispiece for Breton's pamphlet *Introduction au discours sur le peu de réalité*, published by Gallimard in 1927.

177 Musée Cantini, *La Part du jeu*, 182; and Westerdahl, *Óscar Domínguez*, 8, 62.

178 Note that the *Main à plume* group took its name from one of Arthur Rimbaud's famous lines about work critique, 'La main à plume vaut la main à charrue' ('the hand that holds the quill has the same worth as the hand that guides the plough'), from 'Mauvais sang' in *Une Saison en enfer* (1873); my translation. On Domínguez's purported business of painting forgeries of works by Picasso and other artists during the war and his final argument with Breton in 1946, see Alierta and Fundación Telefónica, *Óscar Domínguez, surrealista*, 244–6; *Óscar Domínguez: fuego de estrellas* (Málaga: Fundación Picasso, Museo Casa Natal, Ayuntamiento de Málaga, 2009), 163–5; and Durozoi, *History of the Surrealist Movement*, 384.

179 Maddox, quoted in Silvano Levy, *The Scandalous Eye: The Surrealism of Conroy Maddox* (Liverpool: Liverpool University Press, 2003), 63.

180 On this subject, see Susik, 'Chance and Automatism', 242–57.

181 Steven Harris, 'Voluntary and Involuntary Sculpture', in *Found Sculpture and Photography from Surrealism to Contemporary Art*, ed. Anna Dezeuze and Julia Kelly (Burlington, VT: Ashgate, 2013), 17.

182 Alierta and Fundación Telefónica, *Óscar Domínguez, surrealista*, 234; and Centro Atlántico de Arte Moderno, *Sueños de tinta: Óscar Domínguez y la decalcomania*

del deseo (Las Palmas de Gran Canaria: Centro Atlántico de Arte Moderno, 1993).

183 For a Freudian reading of the psychosexual trauma of phantasmal castration anxiety and infantile autoerotic drives in Max Ernst's early frottages and surrealist works in other media, see Foster, *Compulsive Beauty*, 73–95.

184 Adam Jolles, *The Curatorial Avant-garde: Surrealism and Exhibition Practice in France, 1925–1941* (University Park: Pennsylvania State University Press, 2013), 139–73. Julia Kelly, 'The Found, the Made and the Functional: Surrealism, Objects and Sculpture', in Dezeuze and Kelly, eds, *Found Sculpture and Photography*, 39–57. Janine A. Mileaf, 'Surrealist Politics of the Exhibition: Juxtaposition, Ethnography, and Revolution', in *Please Touch: Dada and Surrealist Objects after the Readymade* (Hanover, NH: Dartmouth College Press, 2010), 119–55.

185 My argument is influenced by Rosalind E. Krauss's deconstructionist reading of sculptures by Giacometti, such as *Suspended Ball* (1930), which, with its masturbatory swinging action of frottage and *glissement* (sliding), creates an apparatus for both violence and pleasure. Krauss, 'No More Play', in *The Originality of the Avant-garde and Other Modernist Myths* (Cambridge, MA: MIT Press, 1985), 56–64.

186 Georges Hugnet, 'L'objet utile: à propos d'Óscar Domínguez', *Cahiers d'art* 10, no. 5–6 (1935): 139; my translation.

187 Kylie King, 'Óscar Domínguez's *La couturière*: Contexts, Sources and Symbols', *Art Journal of the National Gallery of Victoria* 55 (6 July 2017), n.p. King also pointed out the relevance of the explicit image of female genitalia in Léo Malet's 1936 surrealist object *Ce mouvement doit être répété dix fois* for a discussion of female masturbation in Domínguez's *Machine à coudre électro-sexuelle*. Pilar Carreño Corbella likewise interpreted this work as a machine that devours a woman. Carreño Corbella, *Óscar Domínguez*, 74. There are other masturbation machines in the history of surrealism, such as Jan Švankmajer's ipsation devices. Jan Švankmajer, 'L'Avenir est aux machines ipsatrices', in *La Civilisation surréaliste*, ed. Vincent Bounoure (Paris: Payot, 1976), 197–203.

188 Lewis Kachur, *Displaying the Marvelous: Marcel Duchamp, Salvador Dalí, and Surrealist Exhibition Installations* (Cambridge, MA: MIT Press, 2001), 83. For an alternate discussion of *Jamais* as possibly representative of suicidal or lesbian impulses, see Emmanuel Guigon and Georges Sebbag, *Jamais: Óscar Domínguez & Pablo Picasso* (Barcelona: Museu Picasso, 2020), 85, 99.

189 Carreño Corbella, *Óscar Domínguez*, 78.

190 André Breton, 'Accomplissement onirique et genèse d'un tableau animé', in *Trajectoire du rêve* (Paris: G.L.M., 1938), 53–9.

191 On the prefigurative image in surrealism and its ability to create 'potentialities for existence', see the 1941 essay by Wolfgang Paalen, 'The New Image', in *Form and Sense* (New York: Arcade Publishing, 2013), 37–53.

192 John Maynard Keynes, *The General Theory of Employment* (London: Macmillan, 1936). Keynes predicted a future 15-hour work week.

193 Seidman, *Workers Against Work*, 278–80.

194 Carreño Corbella, *Óscar Domínguez*, 66. The model's dress may be by Lucien Lelong rather than by Vionnet.

195 David Hopkins, 'Duchamp, Childhood, Work and Play: The Vernissage for *First Papers of Surrealism*, New York, 1942', *Tate Papers* 22 (Autumn 2014): n.p.

196 Kachur, *Displaying the Marvelous*, 80 and *passim*.

197 Breton and Éluard, eds, *Dictionnaire abrégé du surréalisme*, 73; my translation; original emphasis.

198 Also consider the strange cart that crushes a smiling figure in an untitled 1926 oil on canvas by Yves Tanguy in the collection of the Metropolitan Museum of Art, or Man Ray's 1952 painting *La Rue Férou*, among other surrealist artworks that deploy the motif of the cart or wheelbarrow.

199 Dalí, *Tragic Myth*, XI–XII, iii–viii, 126–35.

200 *Ibid.*, 130–3.

201 *Ibid.*, 133.

202 *Ibid.*, iii.

203 *Ibid.*, v. See Elliott H. King, *Dalí, Surrealism and Cinema* (Harpenden: Kamera Books, 2007), 102–11; and Jordana Mendelson, 'Of Politics, Postcards and Pornography: Salvador Dalí's *Le Mythe tragique de "l'Angélus" de Millet*', in LaCoss and Spiteri, eds, *Surrealism, Politics and Culture*, 161–78.

4 Direct action surrealism in Chicago

Prologue: activist avant-garde

At the turn of the new millennium, Chicago surrealist Penelope Rosemont published a compact meditation, 'A Brief Rant Against Work, with Particular Attention to Relation of Work to White Supremacy, Sexism & Miserabilism'.[1] Building on four decades of surrealist activism based in Chicago and networked nationally and internationally, her essay condenses an array of positions and ideas that have characterised the Chicago Surrealist Group since its formation in 1966. According to Rosemont, 'To be effective, the struggle to abolish work must become conscious, vocal, public, organized, and international.'[2] She invokes Karl Marx and Friedrich Engels's mid-nineteenth-century call for the abolition of alienated labour and André Breton's 1956 condemnation of miserabilism as the 'deprecation of reality in place of its exaltation'.[3] Rosemont devotes particular attention to Frankfurt School philosopher Herbert Marcuse's notions of the 'pleasure principle', the 'performance principle', 'surplus repression', and 'negative thinking'. Influenced by the Black Power movement, Rosemont further underlines that the Chicago Surrealist Group critiques systemic racism and wage labour as dual systems of oppression and exploitation. The group's call for the abolition of work is tied to a commensurate demand for the abolition of the hegemonic construction of whiteness in society.[4]

As her title suggests, Rosemont argues that a host of factors beyond the free market and class hierarchy fuel the unethical ideology of workerism, namely religion, patriarchy, and white hegemony. She writes, '*Work is at the center of all these problems*. It is work that keeps the whole miserabilist system going. Without work, the death-dealing juggernaut that proclaims itself for the "free market" would grind to a halt. "Free market" means freedom for Capital, and unfreedom for those who work. Until the problem of work is solved – that is, until work is abolished – all other problems will not only remain, but will keep getting worse.'[5]

Taking these millennial remarks by Penelope Rosemont into consideration, it becomes apparent that there can be no detailed account of the surrealist work refusal without a discussion of the Chicago Surrealist Group's decisive

contributions to this discourse. Of the various manifestations of international surrealism occurring in the twentieth century, this group is one of the most directly tied to the critique of wage labour in capitalism and the activist fight for worker rights through various resistance strategies, such as strikes, protests, oppositional artistic activity, and the systematic devaluation of the work-to-live principle. In this chapter, I outline a history of and genealogy for the group's artistic-activist attack on capitalist wage labour, and I question how surrealist sabotage functions when engineered as a direct action meant to effect immediate social change. I also demonstrate the crucial importance of Marcuse's theories for their activist orientation, thereby uncovering the foundations and implications of the Chicago Surrealist Group's ethos of lived resistance. Marcuse was so important for the group's invective against work because his theories offered a link between the prewar Marxist intelligentsia in Europe and the postwar international student movement. Remarkably, he had strong affinities for both surrealism and the contemporary youth revolt in that he thought surrealism was an effective and persistent antidote to the omnipresence of the performance principle in life under capitalism. Even more impactful for the Chicago group was the fact that Marcuse agreed that surrealism remained vital to the revolutionary effort.

In advance of the formation of the Chicago Surrealist Group in the mid-1960s, future members' proto-surrealist work critique was visible in various collaborative efforts, including the Solidarity Bookshop (1964–68) and the ultra-left journal *The Rebel Worker* (7 issues; Chicago and London, 1964–66) (Figure 4.1). *The Rebel Worker* was published under the aegis of the Industrial Workers of the World (IWW), an international and general labour union founded in Chicago in 1905. Most of the students involved with this journal were interested in and engaged with 'the whole spectrum of radical, emancipatory nonconformism, in all its many-splendored contradictory diversity', from anarchism and anarcho-syndicalism to anti-Stalinist and libertarian Marxism, Trotskyism, and Black Power – with said students typically choosing to remain independent rather than espouse a single revolutionary position.[6] But the influence of the IWW call for worker control and self-management was constant for all of these 'Wobblies', the popular nickname for IWW adherents. Once certain members of this group consolidated as surrealists in the middle of the decade, they also invested their energy in collective undertakings such as the Gallery Bugs Bunny (1968–69) and the journal *Arsenal/Surrealist Subversion* (4 issues; Chicago, 1970–89). In this section, I discuss each of these four endeavours – the Solidarity Bookshop, *The Rebel Worker*, Gallery Bugs Bunny, and *Arsenal/Surrealist Subversion* – in relation to the still-developing surrealist work refusal during the second half of the twentieth century. I examine the new perspectives Chicago surrealists brought to the surrealist war on work as a result of their distinctly American approach to this issue, which was fundamentally informed by the history of the labour cause in the industrial Midwest as well as the New Left critique of technocracy during the Vietnam era.

Figure 4.1 Torvald Faegre, 'I'm organized, are you?', *The Rebel Worker* 1 (May Day 1964)

The Chicago surrealist protest against alienated wage labour continued to develop during the 1970s in large part through an epistolary dialogue with Marcuse. The philosopher, who had long been affected by the history of surrealism, had substantially influenced the French surrealists from the early 1960s before he began a correspondence with the Chicago surrealists that lasted eight years until his death in 1979. Previous publications have reprinted Marcuse's letters up to 6 March 1973, but Marcuse sent Franklin Rosemont five additional letters between 6 August 1973 and 2 March 1979.[7] Although these letters from Marcuse are short collegial notes of interest in Chicago surrealist activities, their contents are significant, demonstrating a situation of lasting mutual influence about the role of surrealism in revolutionary resistance. The letters sent by Franklin Rosemont between 1971 and 1979 as well as the extended remarks by Rosemont and former Chicago surrealists David Schanoes and John Simmons (in response to Marcuse's October 1972 statement about surrealism) remain unpublished, despite their importance for the understanding of the full scope of this historic exchange. Therefore, another task of this chapter is to consider the significance of this episode for the Chicago branch of American surrealism and its work critique during the 1970s.

Adapting a foundation established by Sigmund Freud in his 1930 book *Civilization and Its Discontents*, Marcuse defined the performance principle in his 1955 *Eros and Civilization: A Philosophical Inquiry into Freud* as 'the prevailing historical form of the *reality principle*, which in turn is reiterated as the idea that, given the fact of scarcity in the natural world, whatever human satisfaction is possible "necessitates *work*"'.[8] In the post-scarcity economic context of late capitalism, in which surplus production is the pressing goal, the performance principle becomes even more repressive for members of society – despite the fact that technology allows for material abundance. Capitalism seeks production for the sake of itself and so pressures the rank and file constantly from above and from within to continually produce more – and more efficiently. Closely connected to the performance principle is Marcuse's idea of surplus repression, a dual form of imposed and self-inflicted domination continually internalised by workers as the unconscious rationale for an alienated labour of voluntary servitude. Surplus repression operates through various processes of habituation and rationalisation, including factors related to economics, politics, education, and technology.

The voluntary servitude of workers from diverse classes persists, even as technology progresses past industrial and postindustrial advances.[9] According to Marcuse, this progression creates the potential to render as obsolete (and mark as wasteful) the need for full-time labour for all humans.[10] Under the surplus repression of the performance principle, the basic drive of the self to seek its own happiness – the pleasure principle – is repressed in the naturalised acceptance of false consciousness, the belief that one must always work more to possess a desirable lifestyle. Such a favouring of the surplus value of production over the basic quality of human life itself, Marcuse argued, leads to an extremely limited experience of gratification through regimented leisure, in which 'man exists only *part*-time, during the working days, as an instrument of alienated performance'.[11]

Marcuse's call for a 'new reality principle' in the emancipatory formulation of a non-capitalist world order found mass acclaim in the international New Left critique of technocracy after World War II. This acclaim was represented by many concurrently appearing studies on the subject, such as Henri Lefebvre's *Position: contre les technocrates* (*Taking a Position: Against the Technocrats*) (1967), as well as tomes by Marcuse's colleagues in the Frankfurt School of Critical Theory.[12] Due at least in part to the transatlantic and transtemporal bridge exemplified in Marcuse's body of work, Chicago Surrealist members were able to envision Marcuse's adaptation of Freud's pleasure principle as an overarching, habitual sabotage of the repressive performance principle. Thus, the Chicago Surrealist Group did not primarily engage point-of-production resistance against efficiency in paid labour, as was the case with forms of sabotage on the production line, such as slowdowns and work-to-rule tactics pioneered at the turn of the twentieth century by the IWW and other worker groups. Instead, along with agitational activities, including numerous protests during the second half of the 1960s – in particular at the Democratic National Convention in central Chicago in August 1968 – the group deployed a combination of creative resistance tactics

to effect cultural sabotage on a day-to-day basis.[13] These included the use of new and affordable technologies in the underground press and alternative media such as the mimeograph machine. It also encompassed the wearable protest button as well as resistance strategies such as the sit-in, street graffiti, and other forms of civil disobedience. Like other militant student factions from this era, the Chicago Surrealist Group practised a prefigurative politics in which they attempted to construct their desired future social and political reality through actions and decisions in the present that embodied their ultimate goal.[14] They also engaged a proactive interventionist art practice by which strategic societal transgression was enacted in the fight for immediate change.[15] In 'A Brief Rant Against Work', Penelope Rosemont explained, 'A poetic politics – a politics based on the pleasure principle, as surrealists have always demanded – would seek to create a non-repressive civilisation; its programme would naturally focus on freedom, equality, direct action and improvisation.'[16]

This chapter therefore continues and expands the consideration of surrealism's critical relationship to modern life under capitalism.[17] This discussion investigates the overarching ways in which surrealism, as a form of creative protest against the nature of daily life in the capitalist welfare state, proposed and prefigured some aspects of a post-capitalist society. According to the Chicago Surrealist Group (some of whom also resisted another kind of conscription, the Vietnam War draft), international surrealism is fundamentally tied to this struggle for liberation from capitalist systems. 'Indissolubly allied to the cause of working-class self-emancipation', surrealism, the Chicagoans asserted, 'has always shared the ups and downs of the global struggle for the abolition of wage slavery'.[18]

Ron Sakolsky has pointed out that Franklin Rosemont thought of surrealist automatism as a form of direct action, a demonstration of protest against the societal pressures of productivist ideologies that yoke the worker to the continual process of production as an end in itself. In such a paradigm, the surrealist automatist is aligned with the worker.[19] As a sabotage tactic against instrumentalised labour as well as bureaucratic and rationalised thinking, automatism is a form of *mental absenteeism*. It is a performative wrench in the cogs of efficiency and a break from 'the deadly grip of habit, work, production, profit, and all routine', according to Rosemont.[20] In a 1972 essay on surrealist poetry and automatism, Chicago surrealist Paul Garon argued that the American group saw their cultural sabotage as an extension of early surrealist agitation: 'We insist that the early surrealists, in their cultivation of delirium, were not behaving romantically, but desperately, in their intrusion, as it were, into the realm of cultural and mental insubordination, thus opening a path that is still being extended.'[21] By combining Breton's notion of miserabilism with their comrade Marcuse's theory of the hegemonic performance principle, along with half a century's worth of IWW sabotage theory and actions, the Chicago surrealists powerfully imposed surrealism onto a late capitalist American sphere, combining activism with theory under a unified banner of creative direct action in an 'antimiserabilist offensive'.[22]

Still active in the early twenty-first century, the Chicago Surrealist Group also encompasses a rebellion against academic historicism. Discussion of its scope and character therefore urges the application of methodological tools that exceed the limits of traditional art history as a discipline. Paul Garon, Franklin Rosemont, and Penelope Rosemont have called the surrealist movement a 'persistent', 'permanent', and 'epochal' struggle for 'revolutionary social transformation'.[23] Michael Löwy has seconded this sentiment by emphasising international surrealism's resistance to temporal fixation, its 'inopportune' and anachronistic status as ever '*engaged*'.[24] The availability and utility of radical histories as epistemologies for cultural resistance in the present day is also at stake in the assumption that surrealism is an ongoing criticism of advanced capitalism, comparable to dialectical materialism and other modes of critical theory practice, rather than a school of art.

'*Incendiary time bomb*': The Rebel Worker *(1964–66)*

A 'radical union': inception of *The Rebel Worker*

In 1962, 19-year-old Franklin Rosemont and some of his friends – all of whom were involved with student militancy at the central Chicago commuter school, Roosevelt University – envisioned a new surrealist journal for the United States, *Arsenal/Surrealist Subversion*.[25] At that moment in the post-World War II period, there was a good opportunity for Rosemont to make a bold statement about surrealism in America and the unique nature of the postwar surrealism of his generation. Charles Henri Ford's East Coast *View* magazine had ceased publication fifteen years earlier in spring 1947, and Wallace Berman's Bay Area *Semina* would soon wrap up in 1964, following production of nine hand-pressed, surrealist-influenced issues sent to mail-order customers and friends. In the 1930s and 1940s, Chicago painters such as Gertrude Abercrombie, Julia Thecla, and the young Dorothea Tanning all implemented surrealism as a stylistic idiom. However, it was not until the Chicago surrealists fused the pro-worker tenets of the IWW with surrealist art and tactics into a unified front during the era of the student movement that this American city became home to a collaborating faction of the international surrealist movement.

Yet, the Chicago surrealists did not publish the first issue of *Arsenal* until autumn 1970, after eight years of planning, delays, and much anticipation. In this interim between the conception and publication of the first issue of *Arsenal*, members of the group helped produce another journal, *The Rebel Worker*, which ran for seven mimeographed issues between 1964 and 1966. The journal was accompanied on many occasions by related pamphlets and leaflets on various leftist subjects (including, for example, *Rebel Worker* pamphlet 2, *Sabotage Anthology*, circa 1966). Although *The Rebel Worker* was one of the organs of the Chicago international headquarters of the IWW and remained unaffiliated with the surrealist movement, much of its content demonstrated a 'radical union' of

IWW protest culture with the living legacy of the surrealist revolt against bourgeois culture.[26] It was only later that a few of the rebel workers organised officially as the Chicago Surrealist Group in 1966 and began producing their first publications, such as the 1967 Black Swan Press reprint of Walker C. Smith's 1913 IWW pamphlet *Sabotage: Its History, Philosophy & Function* and the 1968 *Surrealist Insurrection*, the first of a series of five broadsides (Figure 4.2).

Published in advance of these documents, *The Rebel Worker* is key to understanding the activist nature of the Chicago Surrealist Group once it formed in 1966. *The Rebel Worker* was one of the earliest in a modest wave of periodicals directly influenced by surrealism to emerge from the United States in the 1960s that included, for example, *Resurgence* (1964–67), *Black Mask* (1966–68), and *Antinarcissus/Surrealist Conquest* (1969–70). Thus, it is arguable that *The Rebel Worker* played an influential role in shaping the small pocket of New Left affinity with surrealism that did exist in the United States, inextricably tying avant-garde aesthetics to anti-capitalist tactics through an ultra-leftist critique of wage labour.

As it was for many young Americans involved in the peace movement and the fight for civil rights, Herbert Marcuse's 1955 *Eros and Civilization*, with its discussion of surrealism as a 'critical function of phantasy', was already an important book for Rosemont and his friends at Roosevelt University by the time the first issue of *The Rebel Worker* was published on May Day 1964.[27] The cover featured a drawing by Torvald Faegre of Uncle Sam with the satirical caption, 'I'm organized, are you?' (see Figure 4.1). Antecedent to the influence of Marcuse were the legacies of surrealism, agitational leftism, and Chicago-based labour activism, all of which were already firmly in place as Rosemont's dominant ideologies while he was in high school during the early 1960s. Franklin had discovered surrealism through his interest in Beat poetry.

His father was a respected labour agitator and strike leader for a Chicago typographical union, and his mother was a minor radio personality and president of a women musicians' union.[28] His childhood exposure to proletarian protest culture influenced his reception of surrealism and fostered what would soon become the practice of Chicago surrealist 'poetic action'. Of *The Rebel Worker* and the cohort that formed around it, Rosemont later wrote, 'Our aims were simple: we wanted to abolish wage-slavery and to smash the State ... we preferred to call ourselves anarchists, or surrealists – or Wobblies.'[29]

After dropping out of high school and hitchhiking to San Francisco's North Beach to explore the Beat scene, Rosemont was admitted to Roosevelt University in Chicago in spring 1961, where he met Larry DeCoster and several students who would later contribute to *The Rebel Worker*.[30] In 1962 the two joined Roosevelt's Anti-Poetry Club, which had been recently founded by activist artists and student workers Robert Green and Lionel Bottari. As recent transfers to Roosevelt, Green and Bottari challenged traditional poetics through an aggressive pranksterism fuelled by dada techniques. The club produced one play, *Kiss What?*, an absurdist farce about workers saluting the American flag, which was performed at Ganz Hall on campus.[31] A race-diverse group of students including Penelope Bartik

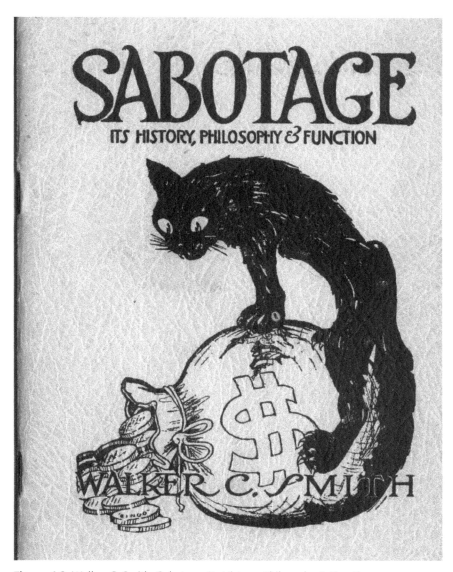

Figure 4.2 Walker C. Smith, *Sabotage: Its History, Philosophy & Function* (IWW Publishing Bureau, 1913). Cover art by Ralph Chaplin, 1913. Reprint, Chicago: Black Swan Press, *c.*1968

(Rosemont), Simone Collier, Torvald Faegre, Bernard Marszalek, Joan Smith, and Scott Spencer soon joined.[32]

That same year Franklin Rosemont and some of the other Anti-Poetry Club members joined the IWW labour union, which had its international headquarters

in the Lincoln Park neighbourhood of Chicago. They received their 'red cards', merging their student activism with the collectivism of the IWW 'One Big Union'. Most of the members of the Anti-Poetry Club were wage earners from blue-collar backgrounds, and many had connections to left-wing student groups that were highly active on Roosevelt's campus, such as Students for a Democratic Society (SDS), the Student Peace Union (SPU), and the Student Nonviolent Coordinating Committee (SNCC). The international and political inclusivity of the IWW's industrial unionism appealed to Rosemont and his friends. As opposed to most specialised craft unions, the IWW accepted workers from any trade or job, including migrant, occasional, and unemployed workers, socialists, and anarchists. They welcomed members from any race or national background and had integrated African Americans as members by the 1920s. The vivid IWW culture of direct action and a decades-old vernacular archive of humorous cartoons and songs related to rebel folklore also exerted a powerful attraction.[33] Anti-Poetry Club members rallied behind IWW 'good pay or bum work' demands via the symbol of 'Sabo-Tabby', the black sabotage cat.[34]

Rosemont and fellow students Torvald Faegre, Bernard Marszalek, and Robert Green quickly became immersed in IWW activities. As Marszalek has written, this was an era in which students and academics alike were aggressively questioning the viability of a work-based society, given the rise of 'automation and robotization of the auto assembly plants', which threatened to 'displace millions of skilled workers'.[35] This group of students formed a soon-to-be-suspended Roosevelt University Wobbly group, started writing for the union paper, the *Industrial Worker*, and opened their IWW bookshop, Solidarity, in autumn 1964. Following the lead of Robert Green, an experienced activist (who had already been subjected to government surveillance), they also helped organise an IWW blueberry pickers' strike with itinerant workers during summer 1964, which went well until scabs entered the scene and physically threatened the strikers.[36]

Before the publication of the first issue of *The Rebel Worker* in spring 1964, Rosemont heightened his pursuit of surrealism, cultivating his knowledge of those protest aspects of surrealism that would be emphasised later in an activist Wobbly context.[37] In January 1963, Rosemont and DeCoster planned a surrealist-IWW journey. They took the spring semester off from the university and hitchhiked to several American cities and then Mexico, searching for any surrealists they could find and reaching out to Wobblies at various branch headquarters. According to DeCoster, they met English surrealist Leonora Carrington at her home in Mexico City and found her receptive to their position as 'avowed libertarian socialists'.[38] Rosemont noted that the Mexican painter Alberto Gironella introduced them to Carrington and that Carrington received them and other guests by adeptly switching between three languages, all the while making puppets in plaster moulds.[39] Although a hoped-for encounter with Mexican poet Octavio Paz did not occur during their sojourn, they were able to meet with Spanish writer Fernando Arrabal and at least one union contact whose name had been given to them in advance by the Chicago Wobblies.[40] The pair also travelled

to Acapulco, where they had a brief meeting with a representative of Lázaro Cárdenas's Movimiento de Liberación Nacional.[41]

The fruits of Rosemont's attempts at correspondence in 1962 and 1963 with several internationally based surrealists and surrealist affiliates, such as Claude Tarnaud, Nicolas Calas, Jacques Brunius, E. L. T. Mesens, Juan Eduardo Cirlot, and the Welsh-American surrealism scholar J. H. Matthews, helped solidify the plan for a new surrealist journal in America.[42] In December 1962, several months before the trip to Mexico with DeCoster, Rosemont wrote to André Breton in Paris.[43] In a draft of that letter, he declared his intention to publish *Arsenal* as a collaborative journal between Chicago and the Paris group and reported that he telephoned Nicolas Calas while in New York on a short trip.[44] The contact with Carrington and others in Mexico as well as a reply to Rosemont's letter to Breton sent from Paris by French surrealist Robert Benayoun encouraged Rosemont and DeCoster's efforts to start a journal and interface with various international surrealist groups.[45]

After riding freight and hitchhiking back to the West Coast from Mexico, Rosemont found a letter from surrealist poet Claude Tarnaud waiting for him at the City Lights Bookstore in San Francisco.[46] Rosemont had written to Tarnaud on the letterhead of the Berkeley IWW branch while visiting California earlier in the trip, and Tarnaud was eager to hear about the status of the union.[47] Owing to his work as a translator at the United Nations, Tarnaud was still in New York after helping Marcel Duchamp hang the exhibition *Surrealist Intrusion in the Enchanters' Domain*, on view at the Galerie D'Arcy from November 1960 to January 1961. Tarnaud invited Rosemont to visit him and his wife Gibbsy (Henriette) at their Riverside Drive apartment on the Upper West Side before their impending departure for France.[48]

In May 1963, just weeks after returning from Mexico, Rosemont and DeCoster hitchhiked east to New York. They met with Tarnaud and Calas, as well as the Spanish surrealist Eugenio F. Granell and Carlos Luis, a poet associated with the Havana publication *Orígenes: revista de arte y literatura* (*Origins: Art and Literature Magazine*) (1944–56), over the course of a week at Tarnaud's apartment.[49] Two important documents emerged from this encounter: a letter from Tarnaud to Benayoun in Paris describing the meeting with the young Americans, published in the fifth issue of the Parisian surrealist journal *La Brèche: action surréaliste* in October 1963,[50] and Rosemont's never-published statement of intention, titled 'Declaration', about the launching of the new American surrealist journal *Arsenal*.[51] 'We were submitted … to a crossfire of questions that left us somewhat panting', Tarnaud wrote to Benayoun. The young Chicagoans harboured several misconceptions about surrealism, Tarnaud reported, not the least of which was their unfortunate attachment to the idea of 'scandal'. Nevertheless, Tarnaud told Benayoun that he supported their idea of a journal – which would be produced in some degree of collaboration with the French surrealists pending approval by the Paris group – and advised staying in close contact with the two Americans. There was also some discussion of the journal's scope and

practicalities; it was to be partly funded by advertising, printed by a friend in Chicago, and possibly trilingual (French, Spanish, and English), or printed in three separate language editions. Furthermore, *Arsenal* would espouse a politics that Tarnaud defined as 'anti-Stalinist Marxism'.[52]

Years later, Rosemont described Tarnaud as a 'close friend' and recalled their excited, extended conversations in 1963.[53] Although the meeting with Tarnaud and Calas was a pivotal one, it must be remembered that the idea and title of *Arsenal/Surrealist Subversion* pre-dated the influence of these older surrealists. 'Arsenal' was directly inspired by Toni del Renzio's single-issue *Arson/An Ardent Review*, a surrealist journal published in London in 1942 that Rosemont admired because of its trilingual contents in French, Spanish, and English.[54] The fact that Tarnaud mentioned Calas's aphorisms in the letter to Benayoun also suggests that the title *Arsenal* may have been influenced by Calas's book *Foyers d'incendie* (*Flashpoint*) (1938), which included lines about the explosiveness of art as sarcastically exemplified by the use of the Parthenon as an arsenal at the end of the eighteenth century.[55] In any case, Rosemont's prospectus was directly impacted by Calas and Tarnaud, written as it was under their tutelage. This 'Declaration' was a short statement announcing *Arsenal* and its orientation: 'Today, in 1963 … we see for the first time since the 1940s a conscious, indigenous renewal of surrealist activity in the United States.' After condemning the distortions of surrealism in academia and in American action painting, Rosemont concluded, 'The "disquieting muse" has arrived.'[56]

Despite this positive reception by members of international surrealism in Manhattan, Rosemont and DeCoster's plans for *Arsenal* lagged in the remaining months of 1963.[57] By spring 1964, the first issue of *The Rebel Worker* appeared instead. Rosemont had written to Tarnaud some time during that interim, admitting to what he felt to be the 'totally inadequate expression of our orientation' in 'Declaration' and describing financial difficulties surrounding the launch of *Arsenal*.[58] Having hoped for international participation in the new American journal, Rosemont also confessed frustration at not hearing from his new correspondents or receiving their promised contributions to the project. Scrutiny of related archival material from 1963, such as draft letters and correspondence to and from Rosemont, suggests that it was more than just thwarted plans and a lack of funds that delayed the appearance of *Arsenal* for seven years. Through their connection to the IWW, Rosemont, DeCoster, and their growing group of like-minded friends at Roosevelt University were increasingly involved in anti-racist activism and the struggle against class domination that had characterised Chicago agitation since the nineteenth century. In an undated letter to André Breton from 1962 or 1963, Rosemont recounted the effort to form a surrealist group in the face of a splintered American Left and the attempt to establish a 'Bureau of Surrealist Research' in Chicago alongside allies from socialist and anarchist circles. Rosemont wrote, 'Our main hope lies in the Negro freedom struggle which may provide the inspiration and impetus towards a new departure in the movement of working class emancipation.'[59] Before Chicago became the site of the SDS national

headquarters, which was associated with the largely white American New Left, it had been a key site for Black nationalism and early civil rights sit-ins.

Rosemont's chronicle, 'To Be Revolutionary in Everything: *The Rebel Worker* Story, 1964–68', details the ways in which, by April 1963, Rosemont began to organise the Roosevelt University IWW group and deepen his contacts with Chicago Wobblies.[60] Exactly a year later, at the end of April 1964, the Roosevelt University Wobblies were suspended by Roosevelt president Robert J. Pitchell after they hosted a guest speaker on campus, the African American poet and anarcho-pacifist Joffre Stewart, who burned a small US flag and other national flags during his lecture.[61] In the wake of the suspension, there was a flurry of political and journalistic activity on campus around the student 'Wobs'. The first issue of *The Rebel Worker* was produced just a week later.

By aligning the surrealist call for emancipation with the struggles of the civil rights movement and the transnational proletarian resistance culture of IWW figures such as Swedish American Wobbly songwriter and activist Joe Hill, the *Rebel Worker* (*RW*) group created a distinctive oppositional genealogy. It was a legacy founded as much upon local Midwestern histories as by an internationally oriented consciousness. The seven issues of *The Rebel Worker*, as well as the numerous pamphlets, leaflets, and newsletters associated with the group, represent the rhetorical foundation of this genealogical fusion. Yet, the publication of *The Rebel Worker* was more than just a question of timing in which the suspension of the anti-racist Roosevelt University Wobblies was the immediate catalyst. Rosemont and DeCoster were all the more prepared to put forth such a response to the university administration because of their extended attention to the question of a surrealist journal for the two years prior to the campus events in spring 1964. Therefore, by debuting *The Rebel Worker* instead of *Arsenal* in May 1964, Rosemont and some of the people who would help form the Chicago Surrealist Group in 1966 staked their claim as activist-artists rather than aesthetes. Key members of the *RW* group positioned international surrealism as a practice of critical experimentalism that complemented their commitment to political agitation.

The decisive nature of Franklin Rosemont's thinking about the Chicago group's approach to surrealism is reflected in a draft of an important letter to Robert Benayoun. This letter was probably written in summer 1963 following the meeting with Carrington and Gironella in Mexico and the pivotal encounter with Tarnaud and Calas in New York. Composed on stationery from the Seattle branch of the IWW, it voices Rosemont's desire for an active group that would include the publication of *Arsenal* and a future surrealist exhibition in Chicago. At the same time, Rosemont explained his intention to simultaneously revive not only surrealism in America but also 'independent revolutionary art'.[62] This statement vividly recalls the tract *Pour un art révolutionnaire indépendant* (*For an Independent Revolutionary Art*) (1938) written by André Breton and Leon Trotsky and signed by Breton and Diego Rivera in Mexico in 1938 (briefly discussed at the end of Chapter 3). It therefore indicates Rosemont's desire for full expressive freedom for art and non-sectarianism in cultural efforts related to

the revolution. After relating to Benayoun that he and his friends were granted control of the Seattle IWW office and briefly explaining the history of the union, Franklin continued:

> We hope to make the office into a bookstore dealing with left-wing literature and perhaps bring in a few paintings, surrealist books, hoping in the long run not only to reinvigorate the left-wing political scene here, but also to attempt greater dissemination of surrealist items and the reorganization of the international federation for an independent revolutionary art. We have friends in San Francisco who would help distribute our magazine, and with Calas, Tarnaud, Julien Levy and others in New York, plus our mobility, we should be able to create quite a widespread revitalization of surrealist activity in the U.S.[63]

The bookshop Rosemont mentioned was founded in autumn 1964 in Chicago by Green, Faegre, Marszalek, Rosemont, and others. Called Solidarity, it fulfilled the vision Rosemont described in his letter to Benayoun, with IWW union materials, books gifted from the defunct IWW Work People's College in Duluth, Minnesota, comic books, surrealist publications, and surrealist-influenced artworks and window displays. IWW meetings were held there regularly. *The Rebel Worker* became the IWW organ of the Solidarity Bookshop, and in its pages a theory of direct action surrealism was developed.

Sabotage I: 'history as hallucination'

The first issue of *The Rebel Worker* was planned, designed, produced, and disseminated by Faegre, Green, and Franklin Rosemont. It was mimeographed on an antique electric machine that had been owned by the IWW international headquarters in Chicago and which the rebel workers later housed at the Solidarity Bookshop on Armitage Avenue (where Marszalek and Faegre also lived).[64] The journal's title was taken from the masthead of an IWW paper of around 1919.[65] The first issue reflected this lineage by broadcasting the union affiliation on the outside and inside covers and in the table of contents.

Surrealist influences are immediately perceptible on page 4 of the initial issue. The layout includes a version of an illustration by Roland Topor, a French artist who was a member of the parasurrealist group Panique, depicting his characteristic bourgeois men in bowler hats and suits engaging in black-humour antics.[66] Redrawn from a 1961 Jean-Jacques Pauvert collection of Topor's drawings, the image is accompanied by a caption placed by the *RW* staff, 'Where will *you* be when capitalism collapses? Join the IWW'.[67] Another redrawn Topor illustration paired with a different IWW caption appears towards the end of the issue, as does a 1920s-era IWW cartoon about the 'elitism' of the various left-wing parties and ideologies of the day. The robotic bourgeois men depicted by Topor recall the early twentieth-century American comic book character Mr Block, the dim-witted, blindly loyal, and ever-patriotic worker made famous by IWW cartoonist Ernest Riebe.[68]

Such a fusion of historical and contemporary surrealism with IWW slogans and texts was fully realised in the reprint of a translated René Daumal story, 'The Great Magician', which appeared between two IWW texts, an organisational call for agricultural workers and an essay by IWW member Jack Sheridan about education for the working class. Daumal's cynical tale, about a proletarian man in Paris who suppresses his supposed magical powers and lives and dies in meagre circumstances, finds a parallel in Sheridan's remarks in the subsequent essay that 'authority has always been maintained by magic and hocus pocus'.[69] Daumal's proletarian magician comforts himself about his utter powerlessness by fantasising that at any moment, he has the ability to reveal his true being. He fancies that he stands on the moral higher ground by denying authority, and yet his life amounts to nothing more than a series of wretched circumstances. In contrast, Sheridan's critique of the ruling classes as abusing power through mystification reveals the chasm of the class divide in high definition.

By the time issue 2 of *The Rebel Worker* was published in September 1964, Penelope Bartik (Rosemont) and Bernard Marszalek had become key editorial members and contributors. Others such as Judy Johnson, Lionel Bottari, Simone Collier, Dottie DeCoster, Anna-Marie Gibson, and Joan Smith increased their involvement.[70] Franklin Rosemont did most of the transcribing and editing. Many women in the group maintained full-time jobs – a few of them at the post office – to support themselves and their partners, since working at the Solidarity Bookshop, the journal's headquarters, did not pay a wage.[71]

In summer 1964, Torvald Faegre, Franklin Rosemont, and Robert and Judy Green helped organise and energise the first IWW-led strike in decades, an IWW Agricultural Workers Industrial Union No. 110 blueberry pickers' strike at farms near Grand Junction, Michigan. The strike unsuccessfully sought higher wages and better working and living conditions for itinerant berry pickers and their families, who struggled under intolerable housing and pay.[72] Faegre recounted the strike in an essay entitled 'Organizing Blueberries' in issue 2 of *The Rebel Worker*. The issue also included two more redrawn Topor satirical images and a collage of the various news headlines devoted to the strike. The Chicago Race Riot of August 1964 is not mentioned, despite the fact that members of the Solidarity Bookshop group participated in protests and were vocal advocates of Black radicalism, but the issue's opening slogan of 'an injury to one is an injury to all' may have been an allusion to these events.[73]

In issues 4, 6, and 7, *The Rebel Worker* becomes increasingly surrealist in content, featuring reprints of texts by René Crevel, Benjamin Péret, Leonora Carrington, André Breton, and others; copied sketches of original works by Yves Tanguy and Óscar Domínguez; and Solidarity Bookshop mail-order lists featuring translations of surrealist texts alongside IWW literature and New Left theory by writers such as Herbert Marcuse. As the journal's surrealist allegiances grew, the fusion of IWW theories and tactics of worker sabotage with surrealist aesthetic strategies such as automatism, black humour, and Eros – the ethos of living for the pleasure principle – became more prominent in its pages. While the

Rosemonts were in Paris visiting the French surrealists between late December 1965 and April 1966, Faegre edited issue 5 of *The Rebel Worker*, which proved to be the journal's most cohesive argument for the abolition of wage labour. This issue included a reprint of an essay by IWW activist Joe Hill about workplace sabotage on the docks as a remedy for unemployment, an essay by Seattle IWW member Louise Crowley critiquing 'unwholesomeness of toil' in relation to Paul Lafargue's *Le Droit à la paresse* (1883), and an article by Jim Evrard about the problematics of pop music as a diversion for the worker.

In direct response to the saturation of issue 5 with traditional IWW topics, issue 6, published on May Day 1966, attempts to go beyond the pre-World War II campaign for the four-hour workday and four-day work week. This campaign occurred in the midst of the fight for the eight-hour day and potentially inspired the union's pejorative moniker 'I Won't Work'.[74] Issue 6 of *The Rebel Worker* also demonstrates that experimental art practice and underground subcultures can function as a form of sabotage. Penelope Rosemont's essay 'Humor or Not or Less or Else' draws parallels between surrealist black humour, American cartoons, slapstick cinema, and IWW sabotage pranks. She related, 'A famous incident in the history of revolutionary humor occurred when IWW construction workers, whose pay was cut in half, reported for work the following day with their shovels similarly cut in half. (The pay was raised.) "Sabotage is the soul of wit" (*Solidarity*, 1913–15).'[75] Surrealist automatism as a form of direct action also plays a larger role in the final two issues of *The Rebel Worker*. The collaborative automatic text 'The Haunted Mirror' by the Rosemonts appears in issue 6. An essay by Franklin from issue 7, 'Vengeance of the Black Swan: Notes on Poetry and Revolution', compares automatic writing and imagery to a weapon. He wrote, 'Words, freed from the bondage imposed by bureaucratic-capitalist society, can serve the cause of the liberation of the mind.'[76]

On the subject of synergy between the prewar and postwar Left, issue 6 of *The Rebel Worker* included a text by Rosemont entitled 'Souvenirs of the Future'. This essay distinguishes a bourgeois history of complacent memory and the 'genealogy of the traditional left' from a starkly revisionary approach to history engaged by the 'presently emerging movement of protest'.[77] Rosemont cited Lautréamont, Fourier, Sade, Blake, and Gothic novelists such as Horace Walpole and Matthew G. Lewis as self-selected precursors in line with international surrealism. He mused on the relationship of Gothic fiction to worker creativity in sabotage and other resistance tactics:

> It goes without saying that we reject, absolutely, both those who choose to hide themselves in the past, or attempt to impose the past upon the future … and those who manipulate the past to conceal or distort the true nature of the present … 'In matters of revolt', as André Breton once said, 'one should not need ancestors'. It is no less true that we must redefine the past according to the needs of the future determined by the situation of the present.[78]

The irony of Rosemont's repetition of surrealism's own repudiation of a French literary canon for a Chicago New Left historiography in the 1960s was not lost

upon him. He concluded the essay by rephrasing the need for a distinction between the lineages offered by the Old Left and the future horizons of radicalism suggested by surrealism.[79] He explained that texts such as Walpole's *Castle of Otranto* (1764), which were a reference for pre-World War II surrealists, could serve present and future revolutionaries through a cultivation of personal creativity and spontaneity in the labour force. According to Rosemont, workers require a sense of imagination to perform individual acts of militancy through workplace and societal sabotage.

Such an approach to the radical reuse of history by the American New Left is emphasised in another text published one year before Rosemont's 'Souvenirs of the Future'. Entitled 'History as Hallucination', it was written by a New York-based contact of the rebel workers, Jonathan Leake. Leake was a co-founder and co-editor with Walter Caughey of the twelve-issue journal *Resurgence*, the publication of the Resurgence Youth Movement (RYM). Leake's 1965 essay in *Resurgence* differentiates New Left history from what he called the hallucinatory history of the fear-ridden bourgeoisie. In his estimation, the upper class is as alienated from the chronicles of the past as from their own present and future due to their total passivity as believers in the false consciousness of capitalism and its demands upon daily life. For Leake, the New Left confrontation with history is precisely anti-hallucinatory. Conscious choices and actions in the present help shape and prophesy the future. Leake wrote, 'History is a hallucination because it derives from our fear, which derives from our inability to affect it. Revolution is the undetermined element which brings history into the focus of our own actions. We, as young Americans and Anarchists, are determined to affect history.'[80]

Accordingly, Rosemont's 'Souvenirs of the Future' states that one role of the underground press is to foment the creative sabotage of Old *and* New Left histories in the attempt to reform historiography as a revolutionary tactic in the present.[81] For some members of the *RW* group, one manner of sabotaging leftist histories was by combining aspects of surrealism with IWW abolition-of-work philosophies. This dialectical position in turn performed a simultaneous sabotage of academic and institutional art histories of surrealism, which continually sought to musealise and commodify surrealism on a timeline of avant-garde progression, regression, and predetermined obsolescence.

Issue 7, the final iteration of *The Rebel Worker*, continues the surrealist sabotage theme from number 6, with page 36 devoted to the 'Incendiary Time Bomb', interpreted as three recipes with illustrations for homemade grenades and Molotov cocktails.[82] This concluding number from the end of 1966 also offered one of the earliest situationist texts available in English in the United States, Dottie DeCoster's unauthorised translation of Jean Garnault's essay 'Elementary Structures of Reification'. Garnault's commodity critique had first appeared a few months earlier in *Internationale Situationniste* 10 (March 1966), around the time that the Rosemonts met separately with situationists Guy Debord and Mustapha Khayati in Paris. Despite the hard-line Situationist International critique of

aspects of prewar surrealism and most of contemporary surrealism as bourgeois, Debord and the Rosemonts agreed upon many issues during their discussion, such as their mutual support of 'non-Stalinist Marxism, workers' control, and the idea of the general strike'. It was also decided that the Rosemonts would distribute SI materials back in the United States.[83] The situationist call for the total abolition of alienated labour, their adoption and dispersal of the Rimbaldian-Lettrist phrase 'ne travaillez jamais' (never work), and Raoul Vaneigem's discussion of the 'decline of work' in his 1967 *Traité de savoir-vivre à l'usage des jeunes générations* (*The Revolution of Everyday Life*) were all closely aligned with the *RW* cause.[84]

Both communities were influenced by the post-World War II French Marxist group Socialisme ou Barbarie led by philosopher Cornelius Castoriadis, whose 1959 text 'Synopsis of *Modern Capitalism and Revolution*' was republished under the pseudonym Paul Cardan in issue 4 of *The Rebel Worker*.[85] Earlier in the 1960s, the Solidarity Bookshop community had absorbed the labour research conducted by the Johnson-Forest Tendency, an American radical left group that proved foundational for Socialisme ou Barbarie. Heavily influenced by books such as *The Black Jacobins: Toussaint L'Ouverture and the San Domingo Revolution* (1938) by Trinidadian Marxist historian C. L. R. James and *Marxism and Freedom: From 1776 until Today* (1958) by Raya Dunayevskaya (with a preface by Herbert Marcuse), the proto-autonomist views of the *RW* group towards worker self-management and federations resonated with Debord's own council communism.[86]

From the beginning, the rebel workers kept themselves informed about and had some correspondence with ultra-left collectives strongly influenced by worker self-management theories, such as Facing Reality, a Marxist circle in Detroit, and Solidarity, a British libertarian-socialist group that published an eponymous magazine from 1960 onwards. By 1965, before his first visit to France, Franklin Rosemont had also either heard of or seen copies of Louis Janover's surrealist-influenced Marxist journal *Front noir*, which ran for ten issues between 1963 and 1967. *Front noir* is another important point of contemporary comparison for *The Rebel Worker*, given Janover's council communist platform, despite the fact that Janover, a one-time member of the Paris group, was extremely critical of contemporary surrealism.[87]

All of these points indicate a substantial network of proponents of self-management theories circulating in the American New Left, although such concerns only occasionally overlapped with the activities of international surrealism at this time.[88] For example, Janover's *Front noir* appears at first glance to espouse a remarkably similar programme to *The Rebel Worker*, given Janover's insistence on the aesthetic ramifications of a workers' revolution, in which the dialectic of labour and idleness, rationality and ludic drives would ultimately dissolve. However, *Front noir* generally approached surrealism through a critique of this movement's assumptions about art and labour rather than reclaiming aspects of it for 1960s leftist agitation.[89] In addition, it must be remembered that despite their interest in this network of self-management theories, the rebel workers

rallied for the sabotage of the work ethic via IWW tactics above any doctrinaire identification with Marxist council communism or syndicalism. Unlike SI and Solidarity, the *RW* group argued that some instances of extra-institutional experimental art and certain popular art forms played an indispensable and central role in the process and act of revolution.[90] And, although Socialisme ou Barbarie and the Johnson-Forest Tendency certainly did influence *The Rebel Worker* in its earliest stages of publication, exposure to *Front noir*, Solidarity, and SI were arguably late associations. Nevertheless, following the meeting with Debord in 1966, the Chicago Surrealist Group distributed 300 copies of his 'Decline and Fall of the Spectacle-Commodity Economy' (1965), long excerpts of which were also issued as a 1967 *RW* pamphlet with a preface by Bernard Marszalek linking SI to Marcuse.[91]

Robert Green, Gallery Bugs Bunny, and Chicago automatism

The formation of the Chicago Surrealist Group

Writing to the Chicago Surrealist Group in 1969, Nicolas Calas recommended Herbert Marcuse's *One-Dimensional Man* and urged Penelope and Franklin Rosemont to reconsider their rapport with the past and 'create new parents for yourselves'.[92] The deliberate fusion of aspects of international surrealism with radical American unionism under the banner of the IWW was accordingly more than just a confirmation of Calas's admonishment to the Rosemonts to search out authentic progenitors. As a set of tools or tactics for grassroots organising and protest culture, the Chicago Surrealist Group was less an outgrowth of surrealism than it was an insider application of its general practices and positions for a locally inflected discourse that was simultaneously international in scope.[93] Therefore, the Chicago group differentiated its approach to a significant degree from para- or dissident surrealisms such as international Panique, the *S.NOB* group in Mexico City, and the Situationist International. Their local Chicago surrealism was steeped in the practicalities of protest and activism – actions based in the now and often directly underfoot, through dissent in the street.[94] Chicago's radical past as a hotbed for proletarian resistance – for example, via events such as the 1886 Haymarket workers' rally for an eight-hour workday – was an ever-present factor.[95]

In that regard, Chicago surrealism's fondness for what they called 'vernacular surrealism', or cultural phenomena that were unofficially surrealist in their inadvertent resonance with the movement, must be considered.[96] Franklin Rosemont accorded such an 'open-ended outlook' to the example set by nonconformist aspects of surrealism and the IWW methodology of solidarity. For Franklin, both surrealism and the IWW had refused to exacerbate political breaches on the Left – a commitment that was not always successful.[97] Nevertheless, Rosemont took pains to clarify that the Chicago group was 'not interested in the "Americanization" of surrealism', but rather the 'surrealist transformation of America'.[98]

Kirsten Strom has discussed collective-identity formation as the establishment of 'anti-canons' in international surrealism, which undergird the creation of a 'political culture' for their community.[99] I want to extend this notion of adaptable counter-histories in the context of Chicago surrealism's pluralist counterculture continuum, which makes its own local, affinity-based genealogy out of surrealism's previous self-selecting handiwork, thereby effecting a multifarious sabotage of art histories, surrealist histories, and other narrative constructions about the past.[100] As we have seen, Chicago surrealism was deeply invested in the history of American radicalism, including its pantheon of American worker rebels, revolutionaries, saboteurs, hobo bards, and proletarian poets. Their 'political culture' was distinct from French surrealism's interest in the 'collective myth' of an emancipatory Romanticism, among other things, although their admiration of anarchist radicals was commensurate.[101]

By the start of 1967, *The Rebel Worker* had ceased publication, and plans were made for a new but never-realised journal, *Ztangi!* Other publications by the rebel workers continued to appear, such as their pamphlet *Surrealism & Revolution* (September 1966). In the wake of André Breton's death in September 1966, which was briefly commemorated in the seventh and final issue of *The Rebel Worker*, and following the return of the Rosemonts from six months in France and England, some members of the editorial team officially declared themselves the Chicago Surrealist Group. As seen in statements such as *The Forecast is Hot!*, signed by 'The Surrealist Group; the Anarchist Horde; The *Rebel Worker* group', the fusion of IWW and surrealist principles was retained going forward, with 'weapons in the arsenal of freedom' being listed as 'mad love … poetry … humor … sabotage'.[102] Anti-authoritarian surrealist saboteurs in Chicago launched a 'ruthless and relentless destruction of the bureaucratic and cultural machinery of oppression'.[103] These causes are enumerated in the preface to Rosemont's volume of poetry, *The Morning of a Machine Gun*, published two years later in May 1968. Here, Marcuse is mentioned in addition to Breton, and poetry is described as a tactic for subversion: 'Poetry must create dangerous situations in the mind. Its role is analogous to that of the assassin, the mad bomber, the arsonist, the sorcerer, the wildcat striker, the guerrilla, the mad lover, the school drop-out and the saboteur.'[104]

After meeting the surrealists in France and collaborating in England with Charles Radcliffe, future editor of the London underground publication *Heatwave*, on an issue of *The Rebel Worker*, the Rosemonts and some members of their community yearned for even greater involvement with international surrealism.[105] In an essay entitled 'Situation of Surrealism in the U.S.', co-written in Paris in 1966,[106] the Rosemonts took stock of the different political situations in the United States and France and asserted that 'the surrealist movement itself cannot be identical throughout the world … It is no less true that surrealism can extend throughout the world only as the expression of the desires of the youth of *today*.'[107]

The first two years of the Chicago Surrealist Group's activities, between 1966 and 1968, focused on attempts to start their new journal *Arsenal*, the production

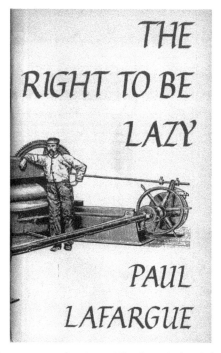

Figure 4.3 Torvald Faegre, cover for the publication of *The Right to Be Lazy*, by Paul Lafargue, trans. Charles H. Kerr, 2nd ed. (1883; Chicago: Solidarity Publications, 1969)

of leaflets and posters, and the creation of a localised surrealist network in their city. These projects were especially pivotal after the dissolution of the Solidarity Bookshop in summer 1968 following the shop's move to various locations as a result of issues with affordable rent and police interference.[108] The first number of the five-issue broadsheet series *Surrealist Insurrection* (22 January 1968) jump-started a busy period of publication for the group, including the landmark reprinting of Charles H. Kerr's 1907 translation of Paul Lafargue's *Le Droit à la paresse* (1883) as *The Right to Be Lazy* in 1969.[109] The text had not been reprinted in English since the Kerr edition. With a cover design by *RW* contributor and editor Torvald Faegre and a quotation in the front matter from Tristan Tzara about dada's demand for 'progressive unemployment', the Solidarity pamphlet proved a compelling condensation of the group's Chicagoan approach to the radical union of New Left, Old Left, and avant-garde initiatives (Figure 4.3).[110]

Bugs Bunny versus William Rubin
In May 1967 the French surrealists sent a letter of strong support for the Chicago group, along with a copy of the first issue of their new journal *L'Archibras* and

the encouraging words, 'We eagerly await a surrealist exhibition in Chicago.'[111] A year later, Robert Green – augmenting his many roles as acting IWW branch secretary, Solidarity Bookshop co-founder, and affiliate of the *RW* group – opened the Gallery Bugs Bunny in a shopfront in Lincoln Park. There the group commenced the first exhibitions sponsored by the surrealist movement in the city. Born in rural Wisconsin, Green was an expert mechanic, carpenter, and inventor who applied his skills to the creation of sculptures and two-dimensional art, beginning in the mid-1960s.[112] In 1976 Green would become instrumental in mounting the massive *Marvelous Freedom/Vigilance of Desire* world surrealist exhibition in Chicago, which included participation by the San Francisco surrealist group and members of the Columbus, Ohio, group among other participants in postwar American and international surrealism.[113]

Green's first Gallery Bugs Bunny exhibition, scheduled from 27 October to 8 December 1968 (and extended until the end of December), was organised as a protest against the *Dada, Surrealism and Their Heritage* exhibition curated by William Rubin at the Museum of Modern Art (MoMA) in New York.[114] Rubin's exhibition was on view at MoMA that spring and summer and travelled to the Art Institute of Chicago for the duration of the autumn.[115] Members of the *RW* group attacked Rubin's show at its October opening with a series of absurdist pranks and disruptive interventions at the Institute's entrance. Penelope Rosemont tossed bird seed into the crowd while Franklin Rosemont read erotic poetry; Marszalek wore a clerical collar and threw women's underwear at spectators; Gloria and Larry DeCoster fell on the floor writhing when the guards accosted them; and membership cards to the Playboy Club were passed out to attendees. As officials dragged the protesters out of the museum, they shouted 'art belongs to the people!' over and over.[116] The group also distributed a dissenting leaflet that spoke of the 'cultural imperialism' shown by the *Dada, Surrealism and Their Heritage* curators; it claimed that surrealist artworks were 'tools' for liberation rather than 'techniques'.[117] Green attended the first of the exhibition's lectures armed with a horn, which he honked repeatedly – apparently no less than a few hundred times – whenever the speaker said anything Green deemed inaccurate about surrealism.[118]

At the end of August, the Chicago Surrealist Group published the third instalment of their *Surrealist Insurrection* poster, which included the polemic 'The Heritage We Reject' against the Rubin show. This statement called for the exhibition's 'boycott' and 'sabotage' and a 'program of *cultural guerrilla warfare*'.[119] Their counter-exhibition at Bugs Bunny, entitled *Surrealist Exhibition*, took the attack further, featuring a wide selection of artworks in diverse media by Robert Green, Lester Doré, Schlechter Duvall, Eric Matheson, and the Rosemonts, as well as reproductions of artworks by international surrealists.[120] It was accompanied by a trifold catalogue including brief critical commentaries on *Dada, Surrealism and Their Heritage* by Franklin Rosemont and Eric Matheson, an artist based in Manhattan. A broadsheet designed by Franklin headlined 'Protest' also clarified the group's view of the MoMA show as a 'reprehensible fraud' designed to

'utilize the works by surrealists of the previous generation to weaken the liberating research and revolutionary combat of surrealists here and now', and reasserted that their business was not the creation of art but total social revolution (Figure 4.4).

The exhibition poster featured Green's 'dangerous doorbell' drawing, depicting an anthropomorphic device designed to bite off the fingers of unsuspecting visitors.[121] The three-dimensional version of this work, *Study for a Doorbell II* (1968), consists of a small metal assemblage in an anthropomorphic configuration on a finished wooden base. The black humour of the dissenting exhibition was also emphasised by the graphic of a hatchet on the exhibition-catalogue cover and by Franklin Rosemont's catalogue essay, 'Invisible Axe'. Employing a Bretonian metaphor, this text threatened use of the 'automatic pistol' and featured an image of Franklin's vertical assemblage from the exhibition, *Homage to the White-Haired Revolver* (1968) (Figure 4.5). The assemblage, with its array of disembodied blue mannequin hands attached to an orange and yellow framework of shutters and a propeller base, added to the shooting-gallery feel of the exhibition – especially when paired with the freestanding assemblages by Green.

The automatic weapon of industrial machinery becomes the 'automatist' weapon of violent liberation when wielded in the disembodied hands of the surrealist, who refuses subservience to the performance principle and its depersonalisation. In a contemporary interview about the exhibition with his friend Charles Radcliffe (writing under the blues-influenced pseudonym Ben Covington), Rosemont juxtaposed the Bugs Bunny show with the embalmed academy of the 'Mausoleum of Modern Art' in New York. He described the Chicago works as 'an automatic sequence of lyrical negations, in which the idols and props of imperialist culture are systematically destroyed'. For Rosemont, Green's 'infernal machines which bristle with volcanic rage and a cruel laughter against the inhibitions of commodity reality' were counter-images of Andy Warhol's 'false icons of impotent servility'.[122]

Working-class automatism

It is not surprising that in the hands of working-class Chicago surrealist and militant leftist activist Robert Green object-based surrealist automatism referenced the skilled industrial worker who diverts tools and materials towards the sabotage of functionality and productivity. Green's expertise as a joiner and carpenter, as well as the trappings of his livelihood as a car and bicycle mechanic, were apparent in all of his works for *Surrealist Exhibition*. This lent a palpable *Rebel Worker* tone to the gallery display alongside the prevalent representational theme of corporeal dismemberment. Green's experience as a point-of-production saboteur must also be considered in relation to his assemblages, all sabotaged devices of various kinds. For instance, during the IWW–*Rebel Worker* blueberry strike of 1964, Green first used his skills as a mechanic to help the itinerant workers repair their cars, but later, once the strike began, he deployed these in the sabotage of berry-picking machines.[123]

Figure 4.4 Franklin Rosemont, *Protest*, 'Surrealist Exhibition', Gallery Bugs Bunny, Chicago, 27 October–8 December 1968

Figure 4.5 Allen Koss, photograph of Franklin Rosemont with his assemblage, 1968. Rosemont assemblage: *Homage to the White-Haired Revolver*, 1968

The 1968 Gallery Bugs Bunny exhibition featured three of his large assemblages and a selection of smaller works, including paintings, a sculpture made of beaten sheet metal, and an array of other pieces. Green found most of the materials for his sculptures in the alleyways of Chicago, where a plethora of cast-off industrial materials were in constant supply. He collected remnants from the

Figure 4.6 Unknown photographer, 'Surrealist Exhibition', Gallery Bugs Bunny, Chicago, 27 October–8 December 1968. *Centre*: Robert Green, *Blue Barrelled Assumption*, 1968

ruins of the city's vacant factory buildings, which languished in the wake of the white flight to the suburbs and in the postwar automation boom that obliterated thousands of jobs. Often, Green deconstructed the assemblages so that he could reuse their parts for new artworks or in his mechanic and carpentry work. One large construction, *Blue Barrelled Assumption* (1968), features a bicycle poised on its kickstand and topped by a coffin-like box fitted with outstretched arms holding chains, a photographic face encased in glass, and built-in legs (Figure 4.6). Adjacent to this was another work that had seen its public debut earlier that spring in the window of Barbara's Bookstore (the workplace of Franklin Rosemont and Paul Garon), where it appeared in the display for the release of Rosemont's book *The Morning of a Machine Gun* (Figure 4.7). Entitled *Long Before You Were Born* (1968), Green's now-lost assemblage consisted of white statuary arms and the small, white bust of a female head grafted onto the front wheel, replacing the headlight of a motorcycle (Plate 11). A wooden aeroplane propeller was affixed at the rear, recalling Francis Picabia's scatological illustration of a propeller, *Âne* (Ass), of 1917. The sculptural elements were purchased from a religious statuary manufacturer in Chicago that was going out of business.[124] Meanwhile, the other large assemblage by Green, *Postman* (1968), stood at eye level on a wooden base and featured five mannequin heads affixed in a circle, in the centre of which was a metal-edged, glass-enclosed compartment containing pink, coiled cellophane reminiscent of intestines (Figure 4.8).

Figure 4.7 Franklin Rosemont, untitled photograph, 1968. Barbara's Bookstore
in Chicago, showing copies of Franklin Rosemont's chapbook, *Morning of
a Machine Gun*, 1968, and Robert Green's assemblage, *Long Before You Were
Born*, 1968

 Such a combination of an American machinic aesthetic and the melancholia
of cheap classical statuary fragments calls to mind early twentieth-century sur-
realist paintings by Giorgio de Chirico, which emphasised the spatial and psychic
dislocation between individuals negotiating voided cityscapes punctuated by
smokestacks. Yet Green's works generate a comparable unease from the other
end of alienation's spectrum: rather than isolating the human form and blocking
it from integration into surrounding space through painterly tricks of false illu-
sion, as did de Chirico, Green's engineering approach incorporates the human
body into the framework of industrial modernity, locking arms, legs and torsos
into place on prosthetic devices with bolts and chains (Figure 4.9). Green's works
suggest that the mechanomorphic consumer in industrial modernity is subjected
to a violent mutation in the process of interacting with both simple and complex

Figure 4.8 Unknown photographer, 'Surrealist Exhibition', Gallery Bugs Bunny, Chicago, 27 October–8 December 1968. Robert Green, *Postman*, 1968

machines, such as gears, pulleys, wheels, axles, and engines: body and device are equally ruined for functionality. Whether they are seen as anthropomorphised devices or mechanised humanoid forms, Green's assemblages indicate the monstrous hybridity of somatic and subjective experience when the body fuses with a given contraption through patterns of habit.

If hacking machines was Green's oft-revisited technique, automatism formed his guiding aesthetic principle. This is confirmed in the opening statement of the catalogue Green created for the Gallery Bugs Bunny group surrealist exhibition held in November 1969: 'All my work is totally automatic and given over to chance as a means of discovery into our liberated possibilities.'[125] Combining studio art and artisan workshop practices, Green's automatist approach to assemblage was a Midwestern industrial adaptation of a dada-surrealist lineage, the transformation of the blue-collar worker's task into the artist's playful construction. In Green's hands, the sabotage of production and productivity is legible as anti-capitalist creative labour that refuses the increasing separation of manual and intellectual labour in late capitalism.[126] The work tool and the machine part taken from the factory assembly line become found objects in an associative collage rather than components of the saleable commodity. At the same time, the accretive aesthetic of the assemblage as medium also bears the marks of Green's experience with IWW sabotage in that the works all feature deconstructed commercial items – a bicycle, a motorcycle, and shop mannequins – rendered dysfunctional. The prominent mechanical aspects of Green's three large wheel-structured assemblages in the 1968 exhibition emphasise

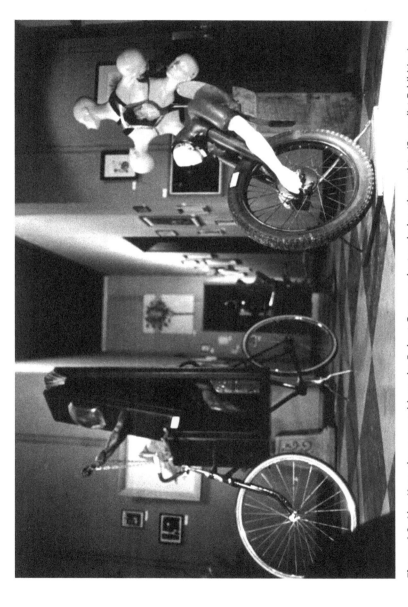

Figure 4.9 Alan Koss, three assemblages by Robert Green and artworks by other artists. 'Surrealist Exhibition', Gallery Bugs Bunny, Chicago, 27 October–8 December 1968. *Left:* Robert Green, *Blue Barrelled Assumption*, 1968. *Bottom centre:* Robert Green, *Long Before You Were Born*, 1968. *Top centre:* Robert Green, *Postman*, 1968

the preoccupation with commercial vehicle manufacturing and maintenance and how the body of the worker or the consumer is affected and altered by such devices and their modalities. Evocations of object assembly and disassembly circulate alongside associations of corporeal dismemberment and property destruction, leading to ambiguity and the lingering question of whether violence results from the artist-as-saboteur or from the process of production itself.

After the first Gallery Bugs Bunny exhibition closed in 1968, Green took his preoccupation with the automatism of the worker's tool and the industrial machine one step further. He merged the digital with the surreal through poetry, an interest dating back to his co-founding of the Anti-Poetry Club at Roosevelt University earlier in the decade. Realising that the new area of computer studies could make a significant impact on surrealist poetics, he approached a programmer working at the University of Chicago, Lynn Cole, to discuss the possibility of writing code for a computer program that could randomise speech and therefore produce algorithmic automatism. Fifteen years later, in the early 1980s, scholar Inez Hedges attempted the same thing using the now-obscure computer language Spitbol, but with the express aim of generating actual surrealist automatic writing in the absence of the psyche.[127]

Green's project, on the other hand, sought distance from psychic automatism and attempted to harness the machine's limitations to awaken its dysfunctional possibilities. After Cole agreed to create an algorithm and then used a punch-card sample on one of the university's computers, Green asked several of his friends to submit lists of words from different parts of speech; these were compiled into an anonymous document. Cole ran the final sample one night while she was alone in the laboratory. Based on the directive code she wrote, the computer generated several thousand sentences, which were printed on a ream of continuous-form paper. Examples include: 'The participant assistance toggles the autobiography. A player poses next to the addictive essence. An unavailable script shortens an intuitive track. Outside the corn storms a vacuum.'[128] Under the operative language of digital code, neither the automatist nor the transcriber need listen to external or internal voices. In the digital age, the computer obeys its own looping commands. Green's computer automatism continued to speak only to itself; the printout was never published or exhibited.

Chicago surrealism and Herbert Marcuse contra *the performance principle*

The Second *TELOS* International Conference, 1971

A Midwestern automatism directly impacted by the region's proletarian industrial culture and economy was under way in works of art by Robert Green, the Rosemonts, and others at the Gallery Bugs Bunny during the last two years of the 1960s. The first issue of *Arsenal/Surrealist Subversion* was printed in autumn 1970 and contained a manifesto declaring that 'surrealism alone has recognised

the historical mission of *laziness*'.[129] It is not insignificant that its appearance coincided with the second bombing of Johannes Gelert's 1889 statue of a Chicago policeman, which had formerly stood in Haymarket Square to memorialise the police casualties in the Haymarket Affair of May 1886. Gelert's controversial monument had already been smashed in 1927 by a radicalised streetcar driver on the anniversary of Haymarket. The man had been disgusted by the statue's gesture of a raised hand commanding the quiescence of protesters. After being relocated following the collision, the statue was vandalised with black paint in May 1968 and then destroyed in October 1969 by explosives that members of the Weather Underground claimed to have placed just prior to the three 'Days of Rage' demonstrations that the group organised. Once the statue was rebuilt and unveiled in May 1970, the Weather Underground organised the same programme of vandalism, issuing this message to the Chicago police department after the monument was obliterated: 'We just blew up Haymarket Square Statue for the second year in a row to show our allegiance to our brothers in the New York prisons and our black brothers everywhere. This is another phase of our revolution to overthrow our racist and fascist society. Power to the People.'[130]

Soon thereafter, the initial issue of *Arsenal* was advertised by the 11 × 17-inch poster 'Declaration of War', which listed the *'immediate tasks* of surrealism' as 'the systematic desecration of everything sanctified by the bureaucrats of the Reality Principle', among other initiatives. It concluded with a clause in homage to the graffiti slogans of the Paris worker and student uprising and general strike of May 1968: 'All power to the workers' councils! All power to the imagination!'[131] As Luc Boltanski and Ève Chiapello have argued, the international student movement of the 1950s and 1960s, especially in France, saw a widespread 'refusal of work' and marginalisation of labour through irregular employment of youth – with forms of expression borrowed from surrealism becoming a lingua franca for dissent cultures alongside Marxist rhetoric.[132] The same can be said for Chicago surrealism and its tactics, despite the group's criticism of many aspects of hippie counter-culture. Throughout the 1960s, the rebel workers in Chicago cultivated diverse influences and contacts that corroborate the existence of loose international networks of youth revolt united in the fight against a broadly construed societal alienation.

Sources of theory were of primary importance. Group members avidly and repeatedly read studies by Malcolm X, Paul Lafargue, Frantz Fanon, and early twentieth-century IWW sabotage theorists. Their network was also expansive; they established contact with groups such as the San Francisco Diggers, the Yippies, and the Dutch Provos. By 1967 the Chicago group began to branch out to less surrealist corners of the American New Left through increased involvement with the SDS and its journals, such as *Radical America*.[133] As seen in the case of the group's dealings with the community around the journal *Telos* in 1971, these interactions often resulted in fractious disagreements regarding politics, tactics, goals, and rhetoric – especially when tensions arose regarding the New Left affiliation to thinkers with roots in the so-called 'Old Left', such as György Lukács and

Herbert Marcuse. Here we can keep in mind Don LaCoss's point that Chicago surrealists did not think that the New Left was responsible for the revitalised revolutionary movement of the late 1960s.[134]

In 1967 at the University of Wisconsin–Madison, Paul Buhle, who was pursuing a doctorate at the time, co-founded the syndicalist, SDS-affiliated journal *Radical America*, which would continue publication for the next thirty years. Buhle was influenced by *The Rebel Worker* before commencing his eclectically Marxist *Radical America*, and he and Franklin Rosemont had begun a correspondence during the second half of the 1960s.[135] The first issue of volume 4 of *Radical America* (January 1970) was a special issue guest-edited by the Rosemonts. Titled 'Surrealism in the Service of the Revolution', it featured a number of Chicago-based and international surrealists (Figure 4.10).

Buhle was in contact with Paul Piccone, a doctoral candidate in philosophy at the State University of New York (SUNY) at Buffalo and the founding editor of the radical journal *Telos*. Thanks in part to these connections, the Rosemonts and their friends were invited to speak at the Second *TELOS* International Conference, held in mid-November 1971 at SUNY Buffalo.[136] *Telos* was founded

Figure 4.10 Franklin and Penelope Rosemont, eds, *Radical America: Special Issue, Surrealism in the Service of the Revolution* 4 (January 1970). *Cover art*: copy of a 1937 drawing by Toyen. Originally published in Toyen, *Les Spectres du désert*, with texts by Jindřich Heisler (Paris: Albert Skira Editions, 1939)

as a philosophy and critical theory journal in May 1968 and was deeply indebted to both the Marxist critical theory of the Frankfurt School and structuralism. The fourth issue of *Telos*, published in autumn 1969, opened with a translation of Marcuse's Heidegger-era 'Contributions to a Phenomenology of Historical Materialism' (1928). Other essays by Marcuse followed in subsequent issues. The *Telos* guest-edited issue of *Radical America*, published just before the Chicago surrealist issue, was replete with references to Marcuse's vast bibliography – but not without critique from his New Left admirers. For instance, Piccone's essay 'From Youth Culture to Political Praxis', while full of praise for Marcuse and brimming with spite for Theodore Roszak's concept of counter-culture, took issue with Marcuse's pessimism in *One-Dimensional Man* about the possibility for resistance in the face of bureaucratised oppression in late capitalism.[137]

Notably, the first issue of *Arsenal* ran an advertisement for *Telos*.[138] At that point, the affinities between the two groups were evident. *Telos* 5 and 6 from spring and fall 1970 featured articles on Lenin by the Marxist humanist philosopher Raya Dunayevskaya, who was much admired by the Chicagoans. However, by the time the second *TELOS* Conference took place in late autumn 1971, Chicago surrealist sentiments had changed dramatically, and a newly sectarian attitude towards the Buffalo circle had emerged. Even before that, Piccone and his editorial board were made well aware of the stance of the Chicago surrealists, given the group's searing attack of *Telos* in their printed pamphlet *In Memory of Georg Lukacs* [*sic*] (1971). In a statement signed by Paul Garon, the Rosemonts, David Schanoes, Stephen Schwartz, John Simmons, and others, *Telos* is condemned for its tribute to the Hungarian Marxist philosopher, who had died in June, and Lukács is excoriated by the surrealists in light of his accommodation of Stalinism.[139] Despite this offensive, in mid-October Piccone contacted the Chicago group to explain the critical views about Lukács actually held by the *Telos* editors.[140] He also issued an invitation to attend the summit in Buffalo the following month, offering them air tickets and free accommodation.[141]

Marcuse, then at the height of his symbolic importance for the American New Left through his ties to activists such as Angela Davis, was the most famous speaker at the second *TELOS* Conference.[142] André Gorz, an anti-work Austrian philosopher and editor of the French publication *Les Temps Modernes*, spoke about party structure in relation to revolution.[143] Franklin Rosemont's paper, 'Surrealist Point of Departure', fused the poetic play of the surrealist revolution and the utopian ideals of Charles Fourier and Edward Bellamy with a discussion of a global workers' revolution.[144]

The group distributed the papers presented by Rosemont, Schanoes, and Simmons in the form of a Surrealist Editions pamphlet called *Surrealist Intervention: Papers Presented by the Surrealist Group at the Second International TELOS Conference* (1971), which included a drawing by Guy Ducornet on the back cover and a series of collaged found images throughout the text.[145] Rosemont, Simmons, and Schanoes all paid homage to Marcuse in their *TELOS* papers; Rosemont quoted from *Reason and Revolution* (1968) and *Negations:*

Essays in Critical Theory (1968), and Simmons leaned heavily on *Eros and Civilization*. They all wore suits to the conference as a form of satirical protest against the hippie fashions of the day.[146]

Internal group documents, including an unpublished summary of the Buffalo conference probably written by Franklin Rosemont and several pages of meeting minutes, reveal ongoing ridicule of the contents of *Telos* and detail tension over the fact that a critical essay submitted by Schanoes was rejected by Piccone and his editorial staff early in 1972.[147] Despite these differences with the conference hosts and other conference participants – such as Murray Bookchin, who openly criticised the papers by the surrealists during his session – the Chicagoans hoped their attendance would facilitate the pooling of resources for the revolution with other factions of the New Left. At the conference they met Maxwell Curtis Stanford, Jr and members of the Black Revolutionary Workers group. The presentation by representatives of the Italian workers' movement Lotta Continua and a subsequent discussion of anarcho-syndicalism were of much interest.[148] And nearly two hundred copies of the *Surrealist Intervention* pamphlet and half as many of the Lukács invective were sold. Yet their main goals in attending were to affirm the 'leading role of the working class' in the United States in the proletarian revolution as well as the 'crucial strategic significance' of the point of production in the struggle; to promote a surrealist revolution; and to meet with their new correspondent, Herbert Marcuse, who took the time to convene with them privately (Figure 4.11).[149]

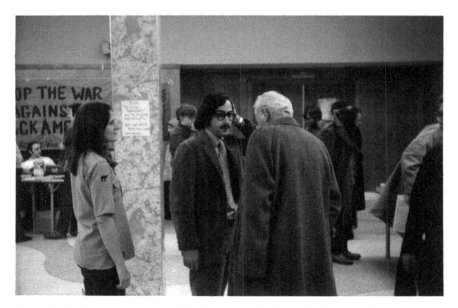

Figure 4.11 Guy Ducornet, untitled photograph. *Left to right:* Penelope Rosemont, John Simmons, Herbert Marcuse. The Second *TELOS* International Conference, 18–21 November 1971, State University of New York, Buffalo.

By the late 1960s, Marcuse was already a comrade in the eyes of the Chicago Surrealist Group. He had recently testified in the American press to the historical justification of surrealism in the May 1968 student and worker strikes in Paris. Answering his *New York Times Magazine* interlocutor, Marcuse asserted that the uprising's graffiti was the most interesting aspect of the event. He continued, 'The coming together of Karl Marx and André Breton. Imagination in power: that is truly revolutionary.'[150] Franklin Rosemont had first written to Marcuse some months in advance of the *TELOS* Conference and again that October.[151] The two made tentative plans to meet at the Buffalo event.[152] Rosemont's initial dispatch included a note typed on *Arsenal/Surrealist Subversion* letterhead, his volume of poems *The Morning of a Machine Gun*, his letter in defence of Marcuse and Freud to the editor of *New Politics* (spring 1970), and Penelope Rosemont's poetry chapbook *Athanor* (1970). The second letter, sent a few months later, included two statements published by the group: the broadside 'The Anteater's Umbrella: A Contribution to the Critique of the Ideology of Zoos' (August 1971) and the leaflet *Towards the Second Chicago Fire: Surrealism and the Housing Question* (September 1971), which had been printed for the centennial of the Great Chicago Fire. The 'Fire' pamphlet is indeed an incendiary text. It condemns modernist architecture in Chicago by Le Corbusier, Mies van der Rohe, and the 'monarchist by pretension' and 'swine by profession' Frank Lloyd Wright, and calls ironically for 'insurrectionary arson' to create a Second Chicago Fire in order to clean the slate.[153] The 'Zoos' broadside is a Fourierist condemnation of the 'performative slavery' of the 'zoological bastille'.[154] Marcuse was enthusiastic about both of these American surrealist publications, and in his reply to Franklin Rosemont he wrote, 'It is somehow comforting to see how much our lines of thought converge. I hope you will see much of your animal leaflet in my new book.'[155]

After the *TELOS* summit, Rosemont corresponded frequently with Marcuse for about a year and a half, just before the publication of Marcuse's *Counterrevolution and Revolt* in 1972. They then communicated intermittently for most of the 1970s, until Marcuse's death in 1979. Although members of the Chicago Surrealist Group only met Marcuse in person during the short duration of the second *TELOS* Conference, the eight years of correspondence that followed deepened the friendship to the extent that they were invited by Marcuse's family and the Department of Philosophy at the University of San Diego to attend Marcuse's memorial service on campus. They were also asked to submit words in memoriam.[156]

In turn, Marcuse had a profound influence upon the Chicago Surrealist Group. Disagreements over Marcuse's lengthy statement about surrealism sent to the group in an early letter polarised them, eventually contributing to a rupture in 1973 and the departure of Simmons, Schanoes, and April Zuckerman. All members of the Chicago group took issue with Marcuse's tendency to discount the contemporary revolutionary possibilities of the working class and his presumption of the all-encompassing sway of the culture industry. However, against the opinions of Schanoes and Simmons, who fully discredited Marcuse's views on surrealism, the Rosemonts and Paul Garon held that, despite their differences

with Marcuse, his confidence in the relevance of surrealism for ongoing revolution secured him a permanent position as a crucial ally.

For Marcuse, the dialogue with the Chicago Surrealist Group stoked his interest in the complex relationship between art and politics. It also eventually shaped important aspects of his argument about the role of art in revolution in his final book, *The Aesthetic Dimension: Towards a Critique of Marxist Aesthetics* (1977). Yet the impact of Chicago surrealism upon Marcuse was even more immediate. Just a month after meeting with the surrealists in Buffalo, Marcuse made one of his most definitive statements about the revolutionary potential of surrealism in a lecture at the Van Leer Jerusalem Foundation:

> If the surrealists insisted on the truth value of the dream they meant, beyond all Freudian interpretation, that the images of freedom and fulfillment not yet attained must be present as a regulative idea of reason, as [a] norm of thought and practice in the struggle with necessity – must be present in the reconstruction of society from the beginning. To sustain this dream as against the dreamless society still is the great subversive function of art, whereas the progressive realization of the dream, while preserving the dream, remains the task of the struggle for a better society where all men and women, for the first time in history, live as human beings.[157]

Marcuse's already existing preoccupation with surrealism was augmented in force and focus by the exchange with the Chicago surrealists. Apart from his early work on Romanticism as a young scholar, Marcuse's meditations on surrealism during the last decade of his life constitute one of the most sustained dialogues with a single art movement in his career.

'What is your estimate of the present and future viability of surrealism?'

Herbert Marcuse wrote approximately ten letters to Franklin Rosemont between 1971 and 1979. As a result of Rosemont's prompting, two of these contained extended remarks on the question of surrealism's revolutionary potential.[158] Although the full scope of the correspondence has received scant scholarly attention, it poses a remarkable opportunity to reassess the idea of surrealism as an important example of radical activist art in the twentieth century.[159] Franklin Rosemont wrote the best summary of this correspondence in 1989 in the fourth and final issue of *Arsenal/Surrealist Subversion*.[160] There he mused that perhaps Marcuse had recognised his inclinations towards surrealism by the time of his writings on Hegel in the early 1930s, the period when Marcuse most likely met Walter Benjamin in Paris or Berlin.[161] For Rosemont, *Eros and Civilization* (1955), with its quote from Breton's 1924 *Manifesto*, is a proclamation of Marcuse's 'surrealist affinities'. Rosemont asserted that 'at least from May '68 on ... surrealism was central to [Marcuse's] vision of revolutionary social transformation'. He called upon studies such as Jean-Michel Palmier's *Herbert Marcuse et la*

nouvelle gauche (*Herbert Marcuse and the New Left*) (1973) and Douglas Kellner's *Herbert Marcuse and the Crisis of Marxism* (1984) to demonstrate how scholars have agreed that Marcuse's concept of the 'Great Refusal' was indebted to the theories of André Breton. Rosemont felt that Marcuse's *An Essay on Liberation* (1969), with its powerful call for a return to utopian socialism, was his most surrealist text. The fact that Marcuse's knowledge of surrealism was far from complete in the end, according to the Chicago surrealists, served for Rosemont as an even deeper confirmation of the fortuitous and rich convergence between Marcuse and surrealism. Marcuse, Rosemont wrote, 'old enough to be our grandfather and whom we loved dearly', was the only member of the Frankfurt School to sustain his confidence in the feasibility of a surrealist revolution.[162]

The key question Rosemont posed to Marcuse in his letters, the envelopes of which were often decorated by hand with colourful psychedelic drawings, was '*What is your estimate of the present and future viability of surrealism?*' (Plate 12).[163] For Marcuse, the young Americans were a living example of the radicalism of surrealism and its identity as praxis rather than just theory. For the Rosemonts and their friends, Marcuse's call for a 'Great Refusal' of capitalism and its repressive way of life bolstered and strengthened their own highly specific position. In this regard, Marcuse's influence upon the Chicagoans proved even greater than upon the European surrealists, who had also recognised the compatibility of the philosopher's approach with their own in the 1960s. One of the key reasons the Chicago surrealists were so drawn to Marcuse was the fact that he linked the discoveries of psychoanalysis to a Frankfurt School critique of capitalism rooted in a discussion of revolutionary action. In an essay from 2005, Franklin Rosemont wrote, 'Our interest in psychoanalysis was greatly deepened by surrealism ... It would be no exaggeration to say that we used psychoanalysis just as we used Marxism, anarchism, anthropology and every other instrument of knowledge that came our way: that is, for explicitly surrealist purposes.'[164]

It must be remembered that in the book that made Marcuse internationally famous, *One-Dimensional Man: Studies in the Ideology of Advanced Industrial Society* (1964), he described the full integration of the working class into the capitalist system in the United States and Europe after World War II. For this reason, Marcuse thought that a largely proletarian-driven revolution was no longer feasible. Such integration, he argued, was a result of capitalism's totalitarian control, its 'total mobilization' of humans into the endless propagation of production through recuperative mechanisms such as repressive desublimation, in which gratification is granted to more people through the cheapened, shallow means of mass consumerism.[165] For the Chicago group, who were as much Wobblies as they were surrealists, the proletariat had certainly not lost its crucial role in a desired overthrow of technocratic capitalism. This was one point of staunch disagreement that arose in the letters.[166]

In *Dreams & Everyday Life* (2008), Penelope Rosemont wrote that the *RW* group was 'thinking more and more about a cultural critique, about the synthesis of Anthropology, Freud and Marxism that for us centred around surrealism'.[167]

Their point of view was that the mid-century discrediting of Freud's theory of the repressiveness of civilisation, described in *Civilization and Its Discontents*, was essentially a capitalist ploy to emphasise the one-dimensional 'freedom' allowed by a 'free market'. Rather than fully rejecting Freud's theory that the reality principle was related to the rationality of the ego as it learns in the course of maturation to find a certain pleasure in the postponement of pleasure itself, the Chicago group found resonance in the Marxist adaptation of Freud's theory as a corollary to generalised post-World War II discourses on alienation in society.[168] Franklin Rosemont characterised their position as one of conflict with the 'anti-Freudianism' of the traditional Left and emphasised that this enthusiasm for Freud and Freud's 'more radical followers', such as Wilhelm Reich, was directly connected to revolutionary praxis. Theirs was a unique form of 'working class psychoanalysis' unusual in the United States at this time.[169] A passage in an essay by Franklin Rosemont from 2005 resonates with the anti-psychiatry views of writers active in the 1970s, like Gilles Deleuze and Félix Guattari, who also paid heed to Marcuse:

> Herbert Marcuse's *Eros and Civilization*, with its surrealist emphasis on the release of erotic energy as a defining element of revolution, was a particularly important book for us, and served as a guide through the maze of psychoanalytic literature. At a time when such liberal reformists as Erik Erikson and Erich Fromm were much in fashion, we vigorously upheld a radical, non-medical, non-therapeutic analysis – a kind of Wobbly anarcho-Freudianism, with crucial strategic implications.[170]

Surrealists in France had evinced a predilection for Marcuse since at least the early 1960s, and certainly following the translation into French of *Eros and Civilization* in 1963. Marcuse's two major books on Hegel's ontology and dialectical theory (from 1932 and 1941) may also have captured surrealist attention, given the movement's interest in the nineteenth-century German philosopher, although they were not translated into French until the late 1960s and early 1970s. Marcuse was the main Frankfurt School theorist to arouse significant notice from international surrealists on a collective level during the 1960s and 1970s.[171] This was despite the fact that Theodor Adorno, like Marcuse, retained his interest in the movement – as can be seen in his correspondence with Elisabeth Lenk – and that surrealism had been a major preoccupation for Walter Benjamin starting as early as 1926.[172]

In the fifth issue of the Parisian journal *La Brèche: action surréaliste*, published in October 1963, Gérard Legrand cited a short text by Marcuse in his larger discussion of Freud, Norman O. Brown, and the concepts of Eros and Thanatos.[173] In December 1966, about a year after the closing of the exhibition *L'Écart absolu* (*Absolute Deviation*) at the Galerie de l'Œil in Paris, Michel Pierson interviewed Marcuse about revolutionary emancipation and oppression. The brief discussion was printed in the second issue of *L'Archibras* in October 1967.[174] The interview focused on *Eros and Civilization*, and Marcuse pressed Pierson on the importance of oppositional 'libertarian aggression' in the form of 'counter-intelligence',

'counter-propaganda', 'counter-images', and 'counter-language'.[175] As a concrete link between French surrealism and Marcuse, the interview in *L'Archibras* took on substantial significance for the *RW* group well before they began to correspond with the philosopher in 1971. Already by 1965, Franklin Rosemont urged Nicolas Calas to write an essay about Norman O. Brown and Marcuse for the long-anticipated first issue of *Arsenal/Surrealist Subversion*, which would not appear until five years later in 1970.[176]

It was during their trip to Paris in 1965–66 that the Rosemonts became keenly aware of French surrealist interest in Marcuse. The 1965–66 exhibition *L'Écart absolu* in Paris took as its title the Fourierist notion of 'absolute deviation', which in itself resonated with Marcuse's call for a 'Great Refusal' in *Eros and Civilization*. Marcuse repeated this call in his *One-Dimensional Man*, which was published in 1964 and translated into French in 1968. The Rosemonts noted the strong utopian and Marcusean strains of the exhibition's critique of technocracy, as embodied in collective artworks such as *Le Désordinateur* (literally, the dis-computer), which Penelope Rosemont translated as *The Disordinator*.[177] The assemblage *Le Consommateur* (*The Consumer*), orchestrated as a collective work by Jean-Claude Silbermann, also evoked the ways in which erotic desire and repression in domestic and societal roles go hand in hand in capitalism, thus forging associative links between Fourier, the theoretical spokesperson for *L'Écart absolu*, and Marcuse, a contemporary counterpart.[178]

In his retrospective essay on Marcuse and surrealism in the final issue of *Arsenal/Surrealist Subversion*, Rosemont explained that 'Marcuse's all-out assault on the ideology of the "consumer society" in his *One-Dimensional Man* provided part of the theoretical background of … *L'Écart absolu*.'[179] As if in response to *L'Écart absolu*, the Rosemonts co-wrote 'Situation of Surrealism in the U.S.' that winter while in Paris. It included a tribute to Marcuse and his call for a 'non-repressive civilization' in its opening lines and highlighted the African American 'refusal' of 'the American way of life' and the increased 'wildcat strikes, unofficial slowdowns, and sabotage' of American factory workers.[180]

The influence of a surrealist Marcuse continued to reverberate once the Rosemonts left Paris. Franklin Rosemont retrospectively characterised the fifth issue of *The Rebel Worker*, from March 1966, as a demonstration of the Marcusean idea of the power of negative thinking as a form of critical dialectics applied to the superstructure and as a deployment of the politics of the pleasure principle in the rebellion against work.[181] In 1968 the group's Black Swan Press and Paul Buhle's SDS-affiliated journal *Radical America* published a pamphlet containing unauthorised copies of an English translation by Guy Ducornet of the interview that first appeared in *L'Archibras* and Marcuse's previously unpublished lecture 'The Obsolescence of Psychoanalysis'. Marcuse's speech had been delivered at the annual meeting of the American Political Science Association in New York in September 1963. His remarks contended that Freudian psychoanalysis possesses great potential to become a 'social and political instrument … because Freud had discovered the mechanisms of social and political control in the depth

dimension of the instinctual drives and satisfactions'.[182] This countercriticism of anti-Freudianism in establishment psychoanalysis after World War II resonated deeply with the Chicago surrealists.

Significant international surrealist interest in Marcuse's work continued during the late 1960s and 1970s. In April 1968 the *Princip slasti* (*Pleasure Principle*) exhibition took place in Brno, Bratislava, and Prague. The exhibition's important manifesto, 'The Platform of Prague', salutes the Chicago surrealists and discusses the ramifications of Marcuse's *principe de rendement*, the performance principle.[183] Although it was the Chicago group that carried out correspondence with Marcuse throughout the 1970s, receiving his never-published statement on the subject of surrealism in revolution in October 1972 and March 1973, it was the *Bulletin de liaison surréaliste* that first published the fruits of this discussion in an unauthorised French translation in April 1973.[184] The issue included lengthy responses to the Marcuse statement on surrealism by Jacques Abeille, Vincent Bounoure, and Robert Guyon, all of whom questioned Marcuse's designations of surrealism as art and most of all his assertion that surrealism had failed in its revolutionary aspirations.[185] Since Marcuse had stipulated to Franklin Rosemont that his epistolary statements were not meant for publication in any form, Marcuse's texts did not appear in print in the United States until after his death.[186] When they were published finally in 1989, it was without the responses penned by Rosemont, Schanoes, and Simmons, which were sent to Marcuse some time in the last days of 1972 or early in 1973.[187]

Yet, it was the Chicago group that maintained the most profound surrealist investment in Marcuse's ideas. Chicago surrealist artworks, essays, exhibitions, and other manifestations appearing throughout the 1980s and 1990s repeatedly reveal the palpable influence of Marcuse's core idea of the early to mid-1960s, the Great Refusal of the performance principle. Victory over the repressive work ethic would be realised by means that had long attracted the IWW: a minimised working day, the reversal of the division of manual and intellectual labour, a rejection of surplus production and accumulation, and the total abolition of wage labour. In the radical union of these ideas with surrealism, the Great Refusal emphasises the revolutionary desire for a life lived under the pleasure principle.[188]

Sabotage II: cat food dyed green

Chicago historian and broadcaster Studs Terkel published his celebrated oral history *Working*, with its chapter devoted to 'idleness', in 1972.[189] The beginning of that year was a busy time for the Chicago surrealists, with the group travelling to Toronto that February to agitate at the Conference on Madness.[190] Correspondence with Marcuse was paused for seven months until Rosemont contacted him at the end of June 1972, asking for the philosopher's opinion of the group's activity and the relevance of surrealism in the ongoing process of revolution. While praising Marcuse's earlier books as well as his *TELOS* lecture, Rosemont reiterated points from their conversations in Buffalo, in which the

Chicago group had made it clear that they did not agree with Marcuse's view that the current proletarian *Weltanschauung* was no longer revolutionary. Rosemont further stated that he generally disagreed with many aspects of the discussion of art in Marcuse's just-published *Counterrevolution and Revolt*. Despite these reservations, Rosemont continued, 'There is no one else, let me say, to whom we could address ourselves in this way; no one else whose response to us would be awaited with such fervent interest ... We ask for your comments and criticism only in order that our footsteps will be guided that much more certainly in the direction of human emancipation.'[191]

Counterrevolution and Revolt clarified Marcuse's belief that not only the ontological character but the very existence of art was dialectically related to and dependent upon the continual process of social revolt against a potentially imminent state of total barbarism that could emerge even at the height of civilisation. Fascism was Marcuse's model for such barbarism. Referencing Antonin Artaud's mid-century call for an art that moves out of the studio and into lived reality, Marcuse stated in his essay 'Art and Liberation', also published in spring 1972, 'The fate of art remains linked to that of the revolution ... it is indeed an internal exigency of art which drives the artist to the streets.'[192] For Marcuse, the 'end of art' was probable in the event that civilisation reverted to barbarism. For art to survive long-term, therefore, the artist needed to subsume art into 'radical practice' – although this process was in itself antagonistic to the autonomy of art, an autonomy which in turn prevented art from actively changing reality. The relationship between art and revolution was therefore a tragic, contradictory, and self-defeating one for Marcuse.

As had been the case in the meeting with Marcuse at the second *TELOS* Conference, Marcuse's 14-page typed response to Rosemont's enquiry about the present and future viability of surrealism in October 1972 was a pivotal event in the Chicago group's development. Marcuse described surrealism's admirable attempt to restore individuality through an art that used alienation as a form of critical negation or refusal – and its inevitably failed attempt to unite art and revolution. He also discussed what he deemed the fallacious foundations of automatism as a futile attempt to retrieve the inaccessible unconscious.[193] For Marcuse, no art form could truly be united to the masses and their desire for freedom until the entire capitalist sphere came to an end in a post-revolutionary society wherein art and life would be harmoniously fused. Surrealism, like all other attempts at a desublimating revolutionary art, was doomed in the end to fall short when it came to actually stimulating the revolution and dealing with the requisite practicalities. Marcuse claimed that authentic art cannot be instrumentalised into hybrid aesthetic propaganda, a point underlined by his reminder to the Chicago group that French surrealism refused to submit to the bureaucratic demands of the revolution under the Parti communiste français.[194] Even so, Marcuse believed surrealism's uncompromising autonomy and purity of critical negation offered society a crucial, if fleeting, glimpse of what freedom could embody and so contributed to the development of a pre-revolutionary consciousness and an intuitive social drive for resistance.[195]

Surrealism's failure was also its success. As he claimed in *Counterrevolution and Revolt*, the 'political potential of art' is 'blocked by an *unsolved contradiction*': how does *'praxis'* link with art's *'internal* subversive force?'[196]

Arriving fairly closely on the heels of Marcuse's positive response to the leaflets they had sent out, and after years of interpreting Marcuse's books as statements of support for the viability of a surrealist cause, this new prognosis of necessary futility came as a blow to the Chicago surrealists. In their view, authentic art was not autonomous but oppositional. Authentic oppositional art was inherently a protest against capitalism in its identity as a form of non-alienated labour that was not dependent upon capitalist use and exchange value. To the Chicago surrealists, oppositional art was also a political event of social dissent activated through group solidarity.

Minutes of the group's weekly or bi-weekly meetings during the autumn and winter of 1972 reveal that the Marcuse statement and the replies crafted by Simmons, Schanoes, and Franklin Rosemont were heatedly discussed and analysed for months.[197] Simmons in particular took issue with what he felt to be Rosemont's overly critical and yet simultaneously evasive response to Marcuse. Simmons's 'attack' on Rosemont was read aloud at one of the meetings.[198] All of the Chicago surrealists agreed, however, that Marcuse was mistaken about the context, import, and aim of surrealism and in his belief that the embrace of radical art by the masses would be postponed to a post-revolutionary era.

The response to Marcuse constructed by Simmons set out to distinguish the surrealist revolution from a proletarian socialist revolution. According to Simmons, even if a workers' revolution was accomplished and alienated labour came to an end, the surrealist revolution – an ideological liberation as much as a material one – would not necessarily have been achieved. Meanwhile, Schanoes lambasted what he believed to be Marcuse's misunderstandings in a polemical account that poised surrealism as the aesthetic counterpart of Bolshevism. Rosemont's statement, on the other hand, gently discussed Marcuse's 'professorial limitations' while debunking *Telos*'s Trotskyist critique of Marcuse. He corrected Marcuse's assumption that surrealism and the cause of revolution were 'irreconcilable'. Like Simmons, Rosemont asserted that there was more to the revolution than just the abolition of the class system and wage labour; the worker's limitless imagination for the ways in which life can be lived in a state of the fullness of experience and pleasure should also be considered. Rosemont's core example was one of sabotage rather than art history: workers in an American factory had recently poured green dye into a huge vat of cat food, damaging thousands of dollars of the employer's property. Rosemont upheld that the worker should use irrational, humour-laden, and imaginative means when necessary to provoke revolt and that this workplace vandalism already proves a revolutionary surrealism in action.[199] Surrealism already exists in the working-class struggle against the performance principle of labour efficiency and profitability, in the creative sabotage of production means and ends, and via the mundane popular cultural means of coping with the oppressive capitalist status quo.

Rosemont did not share Marcuse's lasting concerns about the problematics of affirmative culture in bourgeois or mass art forms, ideas that were heavily influenced by the work of his Frankfurt School colleague Theodor Adorno. Marcuse surmised that affirmative culture supported the continuation of the repressive regime through various kinds of catharsis and palliation (versus the assumed purity of negation in oppositional art).[200] Rosemont countered that by merging with direct action as a daily and revolutionary practice, certain forms of authentic popular culture (such as modern types of folklore) and avant-garde culture could activate revolutionary impulses.

The surrealist responses were sent in late 1972 or early 1973, and by early March 1973 Marcuse's reply arrived, accompanied by a request for a meeting with the surrealists in Chicago in late spring.[201] By that time, Schanoes and Simmons had already broken with the Chicago group over bitter arguments against doctrinaire surrealism, dissatisfaction with the responses to Marcuse, and interpersonal issues. In March 1973 they, together with April Zuckerman, published their dissident pamphlet *Surrealism? I Don't Play that Game; No More Room Service.* As a result of the group's internal strife, Marcuse's requested meeting in Chicago never took place.

Marcuse had taken the rebuttals mailed by Simmons, Schanoes, and Rosemont in stride. His detailed answer sent in return stands firm by his original points that surrealism exists in a permanent antinomy with revolution. According to Marcuse, surrealism fights for art's total autonomy while promoting materialist revolution, only reaching the masses – burdened by 'lifelong servitude' – from 'without' as autonomous art rather than emerging from 'within', as Rosemont had argued. Citing André Breton's *Légitime défense* (1926) and Breton and Trotsky's manifesto *Pour un art révolutionnaire indépendant* (1938), both of which oppose the instrumentalisation and restriction of art in and by propaganda or bureaucracy of any kind, even radical propaganda, Marcuse found surrealist confirmation of his own critique of Marxist aesthetics.[202] Surrealism must hold itself separate from the masses as a form of pre-revolutionary libertarianism to maintain its negative potential as unassimilable to the performance principle in any regard. In this capacity, Marcuse viewed surrealism as a stubborn and partially successful assertion of freedom at all costs, an assertion composed of a kernel of idealism, a 'prerequisite for the development of a revolutionary consciousness at large'.[203] At the heart of the debate between Marcuse and the Chicago surrealists, therefore, is the question of the worker and the worker's subjectivity before and after the revolution. For Marcuse, surrealism was always a helpful teacher for the worker in advance of revolution rather than the worker's own native tool before, during, or after revolution. No amount of aesthetic experimentalism could remove the privilege inherent in art's system, according to Marcuse. Solely the final abolition of the 'social division of labor' could result in art made by all.[204]

Franklin Rosemont and Marcuse continued to correspond after this final rebuttal by Marcuse, but with much less frequency. However, it is certain that Marcuse intended to stay in contact with Rosemont and proceed with the

conversation about surrealism. The collegial tone in the correspondence clearly demonstrates that there was no break in the relationship and that Marcuse's interest in surrealism and the Chicago group remained vivid. In summer 1973, just six days after Marcuse's wife, Inge, died following a long illness, Marcuse wrote to Rosemont explaining that he had been forced to stop work during his wife's decline.[205] In an important letter of 1974, Marcuse requested that Rosemont send him the address of the surrealists in Paris and noted, 'I have also tried to elaborate on the letters I wrote you. Perhaps I shall succeed in getting something ready for publication in the near future.'[206]

That hoped-for publication may have turned into Marcuse's critique of socialist realism, *The Aesthetic Dimension: Towards a Critique of Marxist Aesthetics*, published three years later in 1977. In this final book, Marcuse continued the discussion of what he saw as the irreparable contradictions between art and revolution and between art and the masses. These are the key issues already present in *Counterrevolution and Revolt*, in his statements for the Chicago surrealists, and, indeed, in most of his previous writings on aesthetics. Arguably, his exchange with the Chicago surrealists, as a living group of far-left activists, was a contributing factor to his lasting interest in the perceived dichotomy – an essential dichotomy in the dialectics of art's negative resistance to authority – between surrealist aesthetics and its politics. In *The Aesthetic Dimension*, Marcuse repeated that 'surrealism in its revolutionary period testified to this inherent conflict between art and political realism'.[207] Similar to his statements on surrealism to the Chicago group, *The Aesthetic Dimension* advances a comparable tragic-heroic conception of art's revolutionary potential. Authentic art is bound to the transcendence of autonomy, and is only capable of stimulating a conceptual experience of enduring freedom and happiness for humans in the face of societal limitations and inevitable death.[208]

Although this conception of art as an invaluable prefigurative simulacrum of freedom was entirely at odds with the directly transformative power of art espoused by surrealism as a utopian premise, the remaining members of the Chicago Surrealist Group were able to recognise and persistently celebrate a core of mutual agreement between themselves and Marcuse. Surrealism was an effective emancipatory art. 'Thus, expressionism and surrealism anticipated the destructiveness of monopoly capitalism, and the emergence of new goals of radical change', Marcuse wrote in the preface to *The Aesthetic Dimension*.[209]

Their last letters were exchanged as late as four months before Marcuse's death in 1979. Marcuse wrote to congratulate Rosemont on the publication of his new edited volume, *André Breton: What Is Surrealism?*, and decline an invitation from the Chicago surrealists to a symposium on surrealism.[210] Rosemont's lengthy introduction to *What Is Surrealism?* remained indebted to Marcusean positions, highlighting the pleasure principle as a ready-to-hand subterfuge against the dominant reality principle.[211] In 1978, in the preface for the catalogue of the 100th Anniversary of Hysteria surrealist exhibition taking place in Milwaukee, Rosemont gave a final salute to Marcuse with an expression of 'fraternal regards, and our warm gratitude to this venerable friend and comrade'.[212]

Surrealism without conclusion

In 1989, a decade after Marcuse's death, Franklin Rosemont stated, 'The letters are a militant defense, no less, of the revolutionary character of what he [Marcuse] calls "the surrealist effort".'[213] Rosemont wrote with palpable regret about 'our great friend' and the misunderstandings that ensued over questions of Marxism; he realised they were saying the same thing but not speaking the same language.[214] Nevertheless, Rosemont insisted that surrealism was a concern of lasting importance for Marcuse, who valorised surrealism's struggle to merge art and revolution and its attempt to recuperate or co-opt pleasure and subjectivity back into the wasteland of alienated labour. In *Counterrevolution and Revolt* (1972), which Marcuse was still writing when he began his early correspondence with Rosemont in 1971, he anticipated the question Rosemont asked a few months after the book was published: '*What is your estimate of the present and future viability of surrealism?*'[215] In the pages of *Counterrevolution and Revolt*, Marcuse had already affirmed the relevance and utility of surrealism in a sentence that satisfies Rosemont's subsequent prompt and also recalls Walter Benjamin's writings from the 1930s: 'If art dreams of liberation within the spectrum of history, dream realization through revolution must be possible – the surrealist programme must be valid. Does the cultural revolution testify to this possibility?'[216]

In the late stages of the New Left during the waning years of the 1970s, surrealism was still in the present tense for Marcuse. It had not become irrelevant but rather encompassed one continuous thread of this proposition.[217] Marcuse signed his last letter to Franklin Rosemont with the closing words 'in solidarity'.[218] For Rosemont's part, he continued to converse with Marcuse's ideas in the decades following the philosopher's death, repeatedly returning to his comrade's rhetorical query – 'does the cultural revolution testify to this possibility' of a valid surrealist programme? – with patient affirmation. At the narrow confluence of the 'cultural revolution' of the international New Left and the ongoing surrealist revolution, the Chicago Surrealist Group passionately located an active and explosive core of resistance. As late as 1998, in his essay 'Surrealists on Whiteness: From 1925 to the Present', Franklin Rosemont wrote, 'What is called surrealist revolution is nothing less than a permanent potlatch festival, the Pleasure Principle's global supersession of alienated labor as well as alienated leisure and art.'

Notes

1 On Chicago surrealism's work critique, also see Paul Garon, 'Love of Work and the Fear of Play', *Arsenal/Surrealist Subversion* 3 (Spring 1976): 28–31; Joseph Jablonski, 'Introduction: The War on Leisure', in Lafargue, *The Right to Be Lazy*; Franklin Rosemont, Penelope Rosemont, and Paul Garon, eds, *The Forecast Is Hot!: Tracts and Other Collective Declarations of the Surrealist Movement in the United States, 1966–1976* (Chicago, IL: Black Swan Press, 1997), xxi; Franklin Rosemont, 'André

Breton and the First Principles of Surrealism', in Breton, *What Is Surrealism?*, 66–73; and Penelope Rosemont, 'Disobedience: The Antidote for Miserabilism', *Fifth Estate* 47, no. 1 (Spring 2012): 25. Paul Garon's two books on the blues both consider the issue of toil in relation to African American identity. See Paul Garon, *Blues and the Poetic Spirit*, 2nd ed. (San Francisco, CA: City Lights Books, 1996); and Paul Garon and Beth Garon, *Woman with Guitar: Memphis Minnie's Blues*, 2nd ed. (San Francisco, CA: City Lights Books, 2014).

2 Penelope Rosemont, 'A Brief Rant Against Work, with Particular Attention to Relation of Work to White Supremacy, Sexism & Miserabilism', in *Surrealist Experiences: 1001 Dawns, 221 Midnights* (Chicago, IL: Black Swan Press, 2000), 172.

3 Marx and Engels explored the abolition of labour for the most part in earlier texts such as *Die deutsche Ideologie* (1846) and in Marx's *Grundrisse der Kritik der Politischen Ökonomie* (1857–58). Zilbersheid, 'The Idea of Abolition of Labor', 348.

4 On Chicago surrealism and the abolition of whiteness, see, among other texts, Franklin Rosemont and Robin D. G. Kelley, eds, *Black, Brown, and Beige: Surrealist Writings from Africa and the Diaspora* (Austin: University of Texas Press, 2009), 237–84; and Rosemont et al., *The Forecast Is Hot!*, 23–4, 32–3, 52–5, 71.

5 Penelope Rosemont, 'A Brief Rant Against Work', 168; original emphasis.

6 Rosemont et al., *The Forecast Is Hot!*, xiii, xxxiii.

7 For the complete publication history of Marcuse's letters to the Chicago surrealists, see the editor's note in Herbert Marcuse, 'Letters to the Chicago Surrealists', in *Art and Liberation: Collected Papers of Herbert Marcuse*, ed. Douglas Kellner (London: Routledge, 2007), 4:178. For the Chicago surrealist correspondence with Marcuse, see the University of Michigan Library, Joseph A. Labadie Collection, Franklin and Penelope Rosemont Papers (hereafter Rosemont Papers). On Marcuse and the New Left, see Robert Zwarg, *Die Kritische Theorie in Amerika: das Nachleben einer Tradition* (Göttingen: Vandenhoeck & Ruprecht, 2017).

8 Marcuse, *Eros and Civilization*, 35; original emphasis.

9 For an anarcho-surrealist interpretation of voluntary servitude, a concept developed by Étienne de La Boétie and transformed by Gustav Landauer, see Ron Sakolsky's discussion of mutual acquiescence in *Breaking Loose: Mutual Acquiescence or Mutual Aid?* (Berkeley, CA: LBC Books, 2015).

10 Marcuse, *Eros and Civilization*, 35.

11 *Ibid.*, 47; original emphasis.

12 Douglas Kellner, *Herbert Marcuse and the Crisis of Marxism* (Berkeley: University of California Press, 1984), 172–91. Kellner argues that, as a result of Marcuse's extensive studies in Romanticism, theories of play propounded by Friedrich Schiller were also key to Marcuse's definition of the pleasure principle. Also see Michael Löwy and Robert Sayre, *Romanticism Against the Tide of Modernity*, trans. Catherine Porter (Durham, NC: Duke University Press, 2001).

13 On the Chicago Surrealist Group's role in the Chicago Democratic National Convention protests in August 1968, see Abigail Susik, 'Points of Convergence: Chicago 1960s', in *Surrealism Beyond Borders*, ed. Stephanie D'Alessandro and Matthew Gale (New York and London: Tate Modern; Metropolitan Museum of Art, 2021), 112–15.

14 I take my definition of prefiguration from Carl Boggs, 'Marxism, Prefigurative Communism, and the Problem of Workers' Control', *Radical America* 11, no. 6 (November 1977): 100.

15 My argument is influenced by Paula Serafini's discussion of art activism in relation to social movement theory and the sociological reading of how collective action generates and dissipates through specific strategies, tactics, and tools. See Serafini, *Performance Action: The Politics of Art Activism* (New York: Routledge, 2018). Also important for my account are Luc Boltanski and Ève Chiapello, *Le Nouvel esprit du capitalisme*, repr. ed. (Paris: Gallimard, 1999); and Stevphen Shukaitis, *Imaginal Machines: Autonomy and Self-organization in the Revolutions of Everyday Life* (New York: Autonomedia, 2009), 111, 126–38.

16 Rosemont tied what she called 'poetic politics' to the work of James Baldwin and David Roediger. Penelope Rosemont, 'A Brief Rant Against Work', 167.

17 Jacques Rancière's recent work on this question and his assertion that aesthetics and politics both have the potential to effect disruption in common experience (dissensus within consensus) resonates significantly with the Chicago surrealist idea of poetic politics as creative direct action that is at the same time non-instrumentalised. See *Dissensus: On Politics and Aesthetics*, trans. Steven Corcoran (London: Continuum, 2010). Also important for my account are Kenneth H. Tucker, *Workers of the World, Enjoy! Aesthetic Politics from Revolutionary Syndicalism to the Global Justice Movement* (Philadelphia, PA: Temple University Press, 2010); Gregory Sholette, *Delirium and Resistance: Activist Art and the Crisis of Capitalism*, ed. Kim Charnley (London: Pluto Press, 2017); and Lucy P. Lippard, 'Trojan Horses: Activist Art and Power', in *Art after Modernism: Rethinking Representation*, ed. Brian Wallis (Boston, MA: New Museum of Contemporary Art, 1984), 341–58.

18 Rosemont et al., *The Forecast Is Hot!*, xiii.

19 Ron Sakolsky, 'The Surrealist Adventure and the Poetry of Direct Action: Passionate Encounters Between the Chicago Surrealist Group, the Wobblies and Earth First!', in *Scratching the Tiger's Belly* (Portland, OR: Eberhardt Press, 2012), 30–63.

20 Franklin Rosemont, 'Introduction: Raising the Stakes', in *Revolution in the Service of the Marvelous: Surrealist Contributions to the Critique of Miserabilism* (Chicago, IL: Charles H. Kerr, 2004), 7–8.

21 Rosemont et al., *The Forecast Is Hot!*, 165.

22 Franklin Rosemont, foreword to Breton, *What Is Surrealism?*, xiv.

23 Rosemont et al., *The Forecast Is Hot!*, xi–xiii, 215–16.

24 Michael Löwy, 'International Surrealism Since 1969', in *Morning Star: Surrealism, Marxism, Anarchism, Situationism, Utopia* (Austin: University of Texas Press, 2009), 115–16; original emphasis.

25 Rosemont et al., *The Forecast Is Hot!*, 74. In the introduction to Breton's *What Is Surrealism?*, Rosemont stated that it was as early as 1963 that the journal *Arsenal* was envisioned and planned, but his unpublished texts and notes in the Rosemont Papers reveal that the earliest date for the conception of *Arsenal* is 1962. Franklin Rosemont, 'André Breton', 123.

26 Ron Sakolsky, email to author, 23 June 2018.

27 Marcuse, *Eros and Civilization*, 149. Douglas Kellner, 'Introduction: Radical Politics, Marcuse and the New Left', in *The New Left and the 1960s: Collected Papers of Herbert Marcuse*, ed. Douglas Kellner (London: Routledge, 2005), 3.

28 Franklin Rosemont and Charles Radcliffe, eds, *Dancin' in the Streets!: Anarchists, IWWs, Surrealists, Situationists & Provos in the 1960s as Recorded in the Pages of 'The Rebel Worker' and 'Heatwave'* (Chicago, IL: Charles H. Kerr, 2005), 6–8; and Kate

Khatib, 'Surrealism's America: Notes on a Vernacular Epistemology' (PhD dissertation, Johns Hopkins University, 2013), 13.

29 Rosemont and Radcliffe, *Dancin' in the Streets*, 1.

30 *Ibid.*, 8–9, 16–17.

31 Lionel Bottari, email to author, 1 December 2018.

32 Penelope Rosemont, email to author, 27 December 2018; and (Nyala) Joan Smith Cooper, 'Rebel Worker about Change: Person to Nation', in *Rise of the Phoenix: Voices from Chicago's Black Struggle, 1960–1975*, ed. Useni Eugene Perkins (Chicago, IL: Third World Press Foundation, 2017), 162–73. John Bracey, Jr also associated with this group of students at Roosevelt University.

33 Rosemont and Radcliffe, *Dancin' in the Streets!*, 17. On the subject of vernacular surrealism, see Joanna Pawlik, 'Cartooning the Marvelous: Word and Image in Chicago Surrealism', in *Mixed Messages: American Correspondences in Visual and Verbal Practices*, ed. Catherine Gander and Sarah Garland (Manchester: Manchester University Press, 2016), 67–84; and Khatib, 'Surrealism's America', 29. On the rebel workers' attraction to the IWW culture, see Franklin Rosemont, 'The Seismograph of Subversion: Notes on Some American Precursors', in 'Surrealism in the Service of the Revolution', special issue, *Radical America* 4, no. 1 (January 1970): 50–63.

34 Cooper, 'Rebel Worker about Change', 17; Paul Buhle and Edmund B. Sullivan, *Images of American Radicalism* (Hanover, MA: Christopher Publishing House, 1998), 126–36; Dan Georgakas, 'Direct Action', in *Encyclopedia of the American Left*, ed. Mari Jo Buhle, Paul Buhle, and Dan Georgakas, 2nd ed. (New York: Oxford University Press, 1998), 189–90; and Franklin Rosemont, *Joe Hill*, 403.

35 Marszalek, introduction to *The Right to Be Lazy*, 13.

36 Penelope Rosemont, *Dreams & Everyday Life: André Breton, Surrealism, the IWW, Rebel Worker Students for a Democratic Society and the Seven Cities of Cibola in Chicago, Paris and London: A 1960s Notebook* (Chicago, IL: Charles H. Kerr, 2008), 8–9; and Robert Green, interview with author, 5 April 2018.

37 Rosemont and Radcliffe, *Dancin' in the Streets*, 7–8.

38 Lawrence DeCoster, email to author, 12 April 2018; and Ron Sakolsky, 'Introduction: Surrealist Subversion in Chicago', in *Surrealist Subversions: Rants, Writings and Images by the Surrealist Movement in the United States* (New York: Autonomedia, 2003), 33–4.

39 Franklin Rosemont, undated and unpublished notes regarding initial meeting with Leonora Carrington in Mexico City, 1963, Rosemont Papers.

40 Regarding the meeting with Arrabal: Lawrence DeCoster, email to author, 12 April 2018.

41 Rosemont and Radcliffe, *Dancin' in the Streets!*, 26; and Lawrence DeCoster, email to author, 13 June 2018.

42 Rosemont et al., *The Forecast Is Hot!*, 74. Matthews commented on Franklin Rosemont's plans for *Arsenal* 'throughout the early sixties'. See J. H. Matthews, 'Forty Years of Surrealism (1924–1964): A Preliminary Bibliography', *Comparative Literature Studies* 3, no. 3 (1966): 316.

43 Franklin Rosemont, 'André Breton', 122–23.

44 Draft letter from Franklin Rosemont to André Breton, December 1962, Rosemont Papers.

45 Draft letter from Franklin Rosemont to Robert Benayoun, undated (with tentative date '1962?' in margin appended at later date), Rosemont Papers; and Franklin Rosemont, *An Open Entrance to the Shut Place of Wrong Numbers* (Chicago, IL: Surrealist Editions, 2003), 45.

46 Sakolsky, *Surrealist Subversions*, 34.

47 Rosemont and Radcliffe, *Dancin' in the Streets!*, 47–8.

48 Sakolsky, *Surrealist Subversions*, 34.

49 Notes by Franklin Rosemont, undated, Rosemont Papers.

50 Penelope Rosemont, *Dreams & Everyday Life*, 48. The Rosemonts would later befriend Benayoun in Paris in 1966. On this friendship, see 61, 77, 81, and 90.

51 DeCoster confirmed that the unpublished 1963 'Declaration' was solely authored by Franklin Rosemont. Decoster, email to author, 24 June 2018.

52 Claude Tarnaud, 'Correspondance: d'une lettre de Claude Tarnaud à Robert Benayoun', *La Brèche: action surréaliste* 5 (October 1963): 68; my translations.

53 Franklin Rosemont, *An Open Entrance*, 46–7.

54 Penelope Rosemont, email to author, 22 June 2018.

55 Lena Hoff, *Nicolas Calas and the Challenge of Surrealism* (Copenhagen: Museum Tusculanum Press, 2014), 253.

56 Franklin Rosemont, 'Declaration' (2 drafts: 1 handwritten, 1 typed), 1963, Rosemont Papers. 'Disquieting muse' is a reference to a painting by Giorgio de Chirico, *Le Muse inquietanti, c.*1916–18.

57 Lawrence DeCoster, email to author, 26 June 2018.

58 Draft letter from Franklin Rosemont to Claude Tarnaud, undated, *c.*1963, Rosemont Papers.

59 Draft letter from Franklin Rosemont to André Breton, undated, *c.*1962–63, Rosemont Papers; and Rosemont and Radcliffe, *Dancin' in the Streets!*, 20–2.

60 Rosemont and Radcliffe, *Dancin' in the Streets!*, 1–80.

61 *Ibid.*, 43–8.

62 Draft letter from Franklin Rosemont to Robert Benayoun, undated, *c.*1963, Rosemont Papers.

63 *Ibid.*

64 Bernard Marszalek, interview with author, 17 April 2018.

65 Rosemont and Radcliffe, *Dancin' in the Streets!*, 22.

66 Joanna Pawlik, 'The Comic Book Conditions of Chicago Surrealism', in Parkinson, *Surrealism, Science Fiction and Comics*, 129–54. Also see her forthcoming book, which I have not had the chance to review, *Remade in America: Transnational Surrealism, 1940–1978* (Berkeley: University of California Press, 2021).

67 Both of the drawings in *The Rebel Worker* 1 were copied from Roland Topor, *Anthologie* (Paris: Jean-Jacques Pauvert, 1961).

68 Jesse S. Cohn, *Underground Passages: Anarchist Resistance Culture, 1848–2011* (Oakland, CA: AK Press, 2014), 308–11.

69 Jack Sheridan, 'Education: What Is It?', *The Rebel Worker* 1 (May 1964): 15.

70 Rosemont and Radcliffe, *Dancin' in the Streets*, 31.

71 *Ibid.*, 32, 36.

72 Franklin Rosemont, 'Berry Picking Pay Too Low, Wobblies Strike for More: IWW Probe of Michigan Farm Labor Shows Many Welcome Union', *Industrial Worker*, 5 August 1964, 1–2.

73 Rosemont and Radcliffe, *Dancin' in the Streets!*, 35. In issue four, *The Rebel Worker* did include an account by Robert S. Calese of the Harlem Race Riots.

74 Sidney Lens, *Working Men: The Story of Labor* (New York: Putnam, 1960), 96.

75 Penelope Rosemont, 'Humor or Not or Less or Else', *The Rebel Worker* 6 (June 1966): 9.

76 Franklin Rosemont, 'Vengeance of the Black Swan: Notes on Poetry and Revolution', *The Rebel Worker* 7 (December 1966): 15.

77 Franklin Rosemont, 'Souvenirs of the Future: Precursors of the Theory and Practice of Total Liberation', *The Rebel Worker* 6, Chicago edition (June 1966): 5. The quote from Breton is taken from *Second manifeste du surréalisme* (1930).

78 Franklin Rosemont, 'Souvenirs of the Future', 5–6.

79 *Ibid.*, 20.

80 Jonathan Leake, 'History as Hallucination', *Resurgence* 3 (1965): n.p. Reprinted in Rosemont and Radcliffe, *Dancin' in the Streets!*, 305–6. Also see Abigail Susik, 'Subcultural Receptions of Surrealism in the 1960s International Underground Press: *Resurgence* and Other Publications', in *Cambridge Critical Concepts: Surrealism*, ed. Natalya Lusty (Cambridge: Cambridge University Press, 2021), 380–400.

81 John Campbell McMillian, *Smoking Typewriters: The Sixties Underground Press and the Rise of Alternative Media in America* (New York: Oxford University Press, 2011).

82 Although the rebel workers advocated some forms of violent direct action, as exemplified in their recipes for bombs, later in life Franklin Rosemont emphasised the Chicago surrealist belief in non-violent direct action. Franklin Rosemont, *Joe Hill*, 577.

83 The Rosemonts also disagreed with the situationists on the issue of György Lukács, whom the Chicago surrealists later attacked as a Stalinist. Penelope Rosemont, *Dreams & Everyday Life*, 106; and Rosemont et al., *The Forecast Is Hot!*, 173. For a polemical account of the connections between surrealism, SI, and Socialisme ou Barbarie, see Russell Berman, David Pan, and Paul Piccone, 'The Society of the Spectacle 20 Years Later: A Discussion', *Telos: A Quarterly Journal of Critical Thought* 86 (Winter 1990–91): 84–5.

84 Sam Cooper, *The Situationist International in Britain: Modernism, Surrealism, and the Avant-gardes* (New York: Routledge, 2017), 56–60; and Raoul Vaneigem, *The Revolution of Everyday Life*, trans. Donald Nicholson-Smith (Oakland, CA: PM Press, 2012), 37–40.

85 Paul Cardan and Bob Potter, 'Synopsis of *Modern Capitalism and Revolution*', *The Rebel Worker* 4 (July 1965): 4–7; and Franklin Rosemont, 'Everything Must be Made Anew: Paul Cardan's *Modern Capitalism and Revolution*', *The Rebel Worker* 4 (July 1965): 32.

86 Rosemont and Radcliffe, *Dancin' in the Streets!*, 40; C. L. R. James, *The Black Jacobins: Toussaint L'Ouverture and the San Domingo Revolution*, 2nd ed. (1938; New York: Vintage Books, 1963); and Raya Dunayevskaya, *Marxism and Freedom: From 1776 until Today*, 3rd ed. (1958; London: Pluto Press, 1971). Wollen, 'Bitter Victory', 20–61. On SI as 'post-surrealism', see Bolt Rasmussen, 'The Situationist International', 365–87. Also see Jérôme Duwa, *Surréalistes et situationnistes vies parallèles* (Paris: Dilecta, 2008); and Donald LaCoss, 'Conflicting Views of Surrealism & Revolution, Raoul Vaneigem vs. Robin D. G. Kelley', in 'Surrealism in the USA', special issue, *Race Traitor* 13–14 (Summer 2001): 125–34.

87 Janover, *Surréalisme, art et politique*; Louis Janover, *Surréalisme et situationnistes au rendez-vous des avant-gardes* (Paris: Sens & Tonka, 2013); and Louis Janover and Maxime Morel, eds, *Front noir, 1963–1967: surréalisme et socialisme de conseils* (Paris: Non-lieu, 2019). In an undated letter from *c*.1965, before the Rosemonts travelled to Paris, Franklin asked Calas for his opinion of *Front noir* and Socialisme ou Barbarie. Franklin Rosemont to Nicolas Calas, *c*.1965, Rosemont Papers.

88 I agree with Andrew Cornell in his discussion of Chicago surrealism, SI, and ultra-left groups that the *RW* group's engagement with autonomist Marxist currents is significant in light of the development of Italian *operaismo* and *autonomia* movements. See Andrew Cornell, *Unruly Equality: U.S. Anarchism in the Twentieth Century* (Oakland: University of California Press, 2016), 244–51, 357–8.

89 See, for example, Louis Janover, 'Réflexions sur l'art et le travail', *Front noir* 9 (April 1966): n.p.

90 In a comparison of surrealism and SI that also encompasses a critique of SI and a brief discussion of the influence of Marcuse upon 1960s surrealism, Janover argued that a primary difference between Breton and SI was that Breton did not critique art itself as alienated. Louis Janover, *La Révolution surréaliste* (Paris: Librairie Plon, 1989), 188, 204.

91 Bernard Marszalek, preface to *The Decline and Fall of the Spectacle-Commodity Economy*, by Guy Debord, trans. Donald Nicholson-Smith (Chicago, IL: Solidarity Press, 1967), 1. Preface reprinted in Rosemont and Radcliffe, *Dancin' in the Streets!*, 278–79. Debord's tract was first issued in English and then later reprinted in French in *Internationale Situationniste* 10 (1966): 3–11. Penelope Rosemont, 'Surrealism and Situationism: An Attempt at a Comparison and Critique by an Admirer and Participant', in *No Gods, No Masters, No Peripheries: Global Anarchism*, ed. Barry Maxwell and Raymond Craib (Oakland, CA: PM Press, 2015), 244–62.

92 Nicolas Calas to Franklin Rosemont, 27 September 1969, file 18.2.1, Calas Archive, Nordic Library at Athens. Quote from transcript published in Hoff, *Nicolas Calas*, 355.

93 Joanna Pawlik, 'Ted Joans' Surrealist History Lesson', *International Journal of Francophone Studies* 14, nos 1–2 (May 2011): 225.

94 Rosemont et al., *The Forecast Is Hot!*, xx–xxi.

95 Franklin Rosemont and David R. Roediger, *Haymarket Scrapbook: 125th Anniversary Edition* (Oakland, CA: AK Press and Charles H. Kerr, 2012); and Roediger and Foner, *Our Own Time*.

96 Rosemont and Radcliffe, *Dancin' in the Streets!*, 44.

97 *Ibid.*, 41.

98 Franklin Rosemont, 'André Breton', 120.

99 Kirsten Strom, *Making History: Surrealism and the Invention of a Political Culture* (Lanham, MD: University Press of America, 2002).

100 On surrealism and counterculture, see James Boaden, 'Dada, Surrealism and their Heritage? The North American Reception of Dada and Surrealism', in *A Companion to Dada and Surrealism*, 400–15; Elliott H. King, 'Surrealism and Counterculture', in Hopkins, *A Companion to Dada and Surrealism,* 416–30; and Abigail Susik and Elliott H. King, 'Surrealism as Radicalism', in King and Susik, *Radical Dreams*.

101 Löwy and Sayre, *Romanticism against the Tide*, 217–18.

102 *The Forecast is Hot!* (issued as a leaflet in summer 1965 and included as an insert in *The Rebel Worker* 7 [January 1966]). Reprinted in Rosemont and Radcliffe, *Dancin'*

in the Streets!, 433–34. 'The Surrealist Group; the Anarchist Horde; The *Rebel Worker* group' were not interchangeable names for the same group but rather distinct groups that gathered at the Solidarity Bookshop and shared many of the same members. See also Rosemont et al., *The Forecast Is Hot!*, 11–12.

103 Rosemont et al., *The Forecast Is Hot!*, 433.

104 Franklin Rosemont, 'Revolution by Night: Surrealism Here and Now', in *The Morning of a Machine Gun* (Chicago, IL: Liberation Press, 1968), 7.

105 *Heatwave*, launched as the British version of *The Rebel Worker*, ran for two issues, both published in 1966. See Sam Cooper, 'Heatwave: Mod, Cultural Studies, and the Counterculture', in *Quadrophenia and Mod(ern) Culture*, ed. Pamela Thurschwell (New York: Palgrave Macmillan, 2018), 67–81.

106 The essay was published in an abridged French translation in the Parisian surrealist journal *L'Archibras*. Franklin Rosemont and Penelope Rosemont, 'Situation du sur-réalisme aux U.S.A', *L'Archibras* 2 (October 1967): 73–5.

107 Franklin Rosemont and Penelope Rosemont, 'Situation of Surrealism in the U.S.', in Franklin Rosemont, *Morning of a Machine Gun*, 48; original emphasis.

108 Harvey Pekar, Gary Dumm, and Paul Buhle, *Students for a Democratic Society: A Graphic History* (New York: Hill & Wang, 2008), 78.

109 Paul Lafargue, *The Right to Be Lazy*, trans. Charles H. Kerr, 2nd ed. (1883; Chicago, IL: Solidarity Publications, 1969). On Charles Hope Kerr and Chicago surrealism, see Khatib, 'Surrealism's America', 43–4.

110 The group took the Tzara quote from his response to a questionnaire issued by the Paris-based English-language journal *transition*. Tristan Tzara, 'Inquiry among European Writers into the Spirit of America', *transition* 14 (Summer 1928): 252–3.

111 Rosemont et al., *The Forecast Is Hot!*, 234.

112 Penelope Rosemont, *Dreams & Everyday Life*, 20–1, 211–16.

113 Thom Burns and Allan Graubard, eds, *Invisible Heads: Surrealists in North America, An Untold Story* (Flagstaff, AZ: Anon, 2014).

114 Rosemont et al., *The Forecast Is Hot!*, 46.

115 The *Dada, Surrealism and Their Heritage* exhibition was held at the Art Institute from 19 October to 8 December 1968. The initial Gallery Bugs Bunny show moved to Madison, Wisconsin, after the Chicago show closed. On the first Bugs Bunny exhibition, see Donald LaCoss, 'Surrealism in '68: Paris, Prague, Chicago: Dreams of Arson & the Arson of Dreams', *Surrealist Research & Development Monograph Series* 1 (2008): 16–17.

116 Bernard Marszalek, 'Bugs Bunny's Surrealist Revenge', *Kaleidoscope* (Nov. 22–Dec. 5, 1968): n.p.

117 Penelope Rosemont, *Dreams & Everyday Life*, 214. For the leaflet quotations, see 'Statement Issued by Those Who Disrupted the "Dada, Surrealism and Their Heritage" Exhibition at the Art Institute 17 October', n.d. (1968), Rosemont Papers.

118 'What's Up Doc?', *Daily News*, Chicago, 2 November 1968, n.p.; and Penelope Rosemont, *Dreams & Everyday Life*, 213. Robert Green again attacked art institutions a decade later in an essay in which he quoted Marcuse's definition of revolutionary art as an indictment of society: 'Against the Art Racket', *Surrealism: The Octopus-Typewriter* 1 (October 1978): 5.

119 Chicago Surrealist Group, 'The Heritage We Reject: A Critique of the Museum of Modern Art "Surrealism Exhibition"', *Surrealist Insurrection* 3 (26 August 1968); original emphasis.

120 Robb Baker, 'Protesters of Dada Art Make Ironic Contribution', *Chicago Tribune*, 27 November 1968, n.p.
121 Penelope Rosemont, *Dreams & Everyday Life*, 212.
122 Ben Covington, 'Chicago Surrealists Redefine Genre', *Grey City Journal*, 15 November 1968, 1.
123 Robert Green, interview with author, 5 April 2018.
124 Information in this paragraph from Robert Green, email to author, 2 July 2018.
125 Robert Green, untitled exhibition catalogue, Gallery Bugs Bunny, n.d. (marked in pencil as 1969 on last page), Rosemont Papers.
126 Pawlik, 'Cartooning the Marvelous', 75, 77. Franklin Rosemont, 'André Breton', 2; and Gavin Grindon, 'Poetry Written in Gasoline: Black Mask and Up Against the Wall Motherfucker', *Art History* 38, no. 1 (February 2015): 170–209.
127 Inez Hedges, 'Appendix: A Computer Program for Generating Surrealist "Automatic Writing"', in *Languages of Revolt: Dada and Surrealist Literature and Film* (Durham, NC: Duke University Press, 1983), 139–46. Green's automatist computer program worked much like the engine device described in Jonathan Swift's *Gulliver's Travels* (1726). For a situationist commentary on robotic automatism, and a warning about the possible applications of automatism for managerial impositions upon employees, such as brainstorming, see Situationist International, 'Amère victoire du surréalisme', *Internationale Situationniste* 1 (1958): 3.
128 R. R. Green, 'Library of Random Thoughts', in *Legends of Heresy* (Laguna Woods, CA: Smashwords, 2018); and Robert Green, interview with author, 5 April 2018.
129 Franklin Rosemont, 'Manifesto on the Position & Direction of the Surrealist Movement in the United States', *Arsenal/Surrealist Subversion* 1 (Autumn 1970): 18; original emphasis.
130 'Landmark Was Hit 1 Year Ago', *Chicago Tribune*, 5 October 1970, 1.
131 Rosemont et al., *The Forecast Is Hot!*, 91–2; original emphasis.
132 Boltanski and Chiapello, *Le Nouvel esprit du capitalisme*, 170, 174–5.
133 Khatib, 'Surrealism's America', 41. Penelope Rosemont was a member of the SDS national staff, working as a printer in collaboration with *New Left Notes* at Liberation Press, the print shop of the SDS national headquarters in Chicago, between the end of 1967 and 1969. Penelope Rosemont, *Dreams & Everyday Life*, 173–228.
134 LaCoss, 'Surrealism in '68', 18; Pawlik, 'Cartooning the Marvelous', 70; and John McMillian, '"You Didn't Have to Be There": Revisiting the New Left Consensus', in *The New Left Revisited*, ed. John McMillian and Paul Buhle (Philadelphia, PA: Temple University Press, 2003), 1–8.
135 Paul Buhle, interview with author, 23 March 2018.
136 *Ibid.*
137 Paul Piccone, 'From Youth Culture to Political Praxis', *Radical America* 3, no. 6 (November 1969): 20.
138 *Arsenal/Surrealist Subversion* 1 (Autumn 1970): 80.
139 Paul Garon, Franklin Rosemont, and Penelope Rosemont, 'Letter to the Editors of *Telos*', in *In Memory of Georg Lukacs* [sic] (Chicago, IL: Surrealist Editions/Black Swan Press, 1971). Both *Telos* issues from 1970 and the winter issue from 1971 contain submissions devoted to Lukács.
140 Paul Piccone to Franklin Rosemont, 12 October 1971, Rosemont Papers.

141 *TELOS* group to conference attendees, 1 November 1971, personal archives of Penelope Rosemont.

142 Unpublished conference schedule, Second *TELOS* International Conference, 18–21 November 1971, Rosemont Papers.

143 André Gorz, *Strategy for Labor: A Radical Proposal*, trans. Martin A. Nicolaus and Victoria Ortiz (Boston, MA: Beacon Press, 1967). André Gorz, *Paths to Paradise: On the Liberation from Work*, trans. Malcolm Imrie (Boston, MA: South End Press, 1985).

144 Sakolsky, *Surrealist Subversions*, 45.

145 About eighteen months after the *TELOS* conference, in March 1973, Simmons and Schanoes, along with April Zuckerman, broke with the Chicago surrealists and published a dissenting pamphlet. See David Schanoes, John Simmons, and April Zuckerman, *Surrealism? I Don't Play That Game; No More Room Service* (Chicago, 1973). Peter Manti was also briefly a Chicago surrealist in this period.

146 John Simmons, email to author, 11 April 2018. Guy and Rikki Ducornet and Paul Buhle were also present at the conference.

147 Franklin Rosemont, 'Marcuse's Epigones', *Arsenal/Surrealist Subversion* 2 (1973): 59. See 'Minutes: Friday, 28 January 1972', Rosemont Papers.

148 Anonymous (Franklin Rosemont?), 'The Surrealists at the TELOS Conference', undated and unpublished essay, Rosemont Papers.

149 *Ibid.*; and Rikki Ducornet, email to author, 28 July 2020.

150 'Marcuse Defends His New Left Line', *New York Times Magazine*, 27 October 1968, n.p. Three years later, Peter Bürger would extend this sentiment in the opening lines of his *Der französische Surrealismus: Studien zum Problem der avantgardistischen Literatur* (Frankfurt am Main: Athenäum, 1971).

151 Franklin Rosemont to Herbert Marcuse, Rosemont Papers.

152 Marcuse, 'Letters to the Chicago Surrealists', 178–99.

153 Chicago Surrealist Group, *Towards the Second Chicago Fire: Surrealism and the Housing Question* (Chicago, IL: Ztangi!, 1971), n.p. Reprinted in Rosemont et al., *The Forecast Is Hot!*, 126–9.

154 Chicago Surrealist Group, 'The Anteater's Umbrella: A Contribution to the Critique of the Ideology of Zoos' (Chicago, IL: Ztangi!, 1971). Reprinted in Sakolsky, *Surrealist Subversions*, 374–5.

155 Marcuse, 'Letters to the Chicago Surrealists', 179. Also see Kristoffer Noheden, 'Seven Surrealist Animals: Ecology in International Surrealism', in *Wounded Galaxies 1968*, ed. Charles Cannon and Joan Hawkins (Bloomington: Indiana University Press, forthcoming).

156 Unpublished memorial letters for Herbert Marcuse, Rosemont Papers.

157 Herbert Marcuse, 'Transcript of an Untitled Lecture at the Van Leer Jerusalem Foundation', in Kellner, *Art and Liberation: Collected Papers of Herbert Marcuse*, 4:165.

158 The Rosemont Papers contain ten letters from Herbert Marcuse. Franklin Rosemont republished six of the ten letters in 'Herbert Marcuse and Surrealism', *Arsenal* 4 (1989): 39–46.

159 One of the earliest discussions of the links between Marcuse and surrealism in secondary scholarship was that of Xavière Gauthier in *Surréalisme et sexualité* (Paris: Gallimard, 1971).

160 Franklin Rosemont, 'Herbert Marcuse and Surrealism', 31–47.

161 Michael Löwy, 'Under the Star of Romanticism: Walter Benjamin and Herbert Marcuse', in *Revolutionary Romanticism: A Drunken Boat Anthology*, ed. Max Blechman (San Francisco, CA: City Lights Books, 1999).

162 Franklin Rosemont, 'Herbert Marcuse and Surrealism', 31, 35–6.

163 *Ibid.*, 33; original emphasis.

164 Rosemont and Radcliffe, *Dancin' in the Streets!*, 47.

165 Herbert Marcuse, *One-Dimensional Man: Studies in the Ideology of Advanced Industrial Society* (1964; Boston, MA: Beacon Press, 1991), 19. Susan Rubin Suleiman, 'The Fate of the Surrealist Imagination in the Society of the Spectacle', in *Risking Who One Is: Encounters with Contemporary Art and Literature* (Cambridge, MA: Harvard University Press, 1994), 133–6.

166 On this point, Jean-Michel Palmier's discussion of the transformation of class revolt into a rebellion against civilisation in general in the New Left is helpful, as is his contextualisation of Marcuse's work in relation to Henri Lefebvre's theories of everyday life, which also play an important role in the New Left and in late 1960s surrealism. Jean-Michel Palmier, *Herbert Marcuse et la nouvelle gauche* (Paris: Éditions Pierre Belfond, 1973), 509–18, 584–619.

167 Penelope Rosemont, *Dreams & Everyday Life*, 47.

168 LaCoss, 'Surrealism in '68', 4–5.

169 Rosemont and Radcliffe, *Dancin' in the Streets!*, 46.

170 *Ibid.*

171 Löwy, *Morning Star*, 22.

172 Theodor W. Adorno, Elisabeth Lenk, and Susan H. Gillespie, *The Challenge of Surrealism: The Correspondence of Theodor W. Adorno and Elisabeth Lenk* (Minneapolis: University of Minnesota Press, 2015).

173 Gérard Legrand, 'De L'Histoire, de la voluptué, et de la mort', *La Brèche: action sur-réaliste* 5 (October 1963): 7–17.

174 Michel Pierson, untitled interview with Herbert Marcuse (15 December 1966), *L'Archibras* 2 (October 1967): 17. It can safely be assumed that it is the Pierson interview that is referred to in *Surrealist Insurrection* 1 (22 January 1968) when a forthcoming interview with Marcuse in issue 2 is mentioned (no such interview ever appeared). Also see the article by Jean Schuster in *L'Archibras* for a reference to Marcuse. Jean Schuster, 'À l'ordre de la nuit, au désordre du jour', *L'Archibras* 1 (April 1967): 4–9.

175 Guy Ducornet, trans., 'Herbert Marcuse: Interview with *L'Archibras*', *Cultural Correspondence* 12–14 (Summer 1981): 63.

176 Undated letter from Franklin Rosemont to Nicolas Calas (*c.*1965), Rosemont Papers.

177 Penelope Rosemont, *Dreams & Everyday Life*, 51. See also Alyce Mahon, *Surrealism and the Politics of Eros, 1938–1968* (New York: Thames & Hudson, 2005), 176–81; and Donald LaCoss, 'Attacks of the Fantastic', in LaCoss and Spiteri, eds, *Surrealism, Politics and Culture*, 267–99.

178 For a discussion of *L'Écart absolu* and a brief characterisation of the Chicago surrealists in light of contemporary surrealism, see Alain Joubert, *Le Mouvement des surréalistes ou le fin mot de l'histoire: mort d'un groupe, naissance d'un mythe* (Paris: Maurice Nadeau, 2001), 295–329.

179 Franklin Rosemont, 'Herbert Marcuse and Surrealism', 33.

180 Rosemont and Rosemont, 'Situation of Surrealism in the U.S.', 45.

181 Rosemont and Radcliffe, *Dancin' in the Streets!*, 165. Marcuse developed the dialectical notion of negative thinking in *Reason and Revolution: Hegel and the Rise of Social Theory* (1941) and *One-Dimensional Man*.

182 Herbert Marcuse, *The Obsolescence of Psychoanalysis* (Chicago, IL: Black Swan Press, 1968), 1.

183 LaCoss, 'Surrealism in '68', 9–13. The key text for this exhibition, 'La plateforme de Prague', was a co-written manifesto signed by European surrealists and published in *L'Archibras* 5 (September 1968): 11–25. 'La plateforme de Prague' mentions Marcuse's performance or efficiency principle in its discussion of anti-repression aims. The essay also salutes the Chicago surrealists. On the *Princip slasti* exhibition, see Claude Courtot, Marie-Claire Dumas, and Petr Kral, 'Le Principe de Plaisir exposition surréaliste en Tchécoslovaquie, 1968', in *Du surréalisme et du plaisir*, ed. Jacqueline Chénieux-Gendron (Paris: José Corti, 1987); Gérard Durozoi, *History of the Surrealist Movement*, trans. Alison Anderson (Chicago, IL: University of Chicago Press, 2002), 640–2; Jérôme Duwa, *1968, Année surréaliste: Cuba, Prague, Paris. Collection 'pièces d'archives'* (Paris: Institut Mémoires de l'édition contemporaine, 2008); and Derek Sayer, *Prague, Capital of the Twentieth Century: A Surrealist History* (Princeton, NJ: Princeton University Press, 2013), 433–4.

184 Herbert Marcuse, 'Sur le surréalisme et la révolution', *Bulletin de liaison surréaliste* 6 (April 1973): 20–9. This journal was established after the dissolution of the Paris surrealist group in 1969.

185 Jacques Abeille, Vincent Bounoure, and Robert Guyon, 'Libre échange avec Herbert Marcuse', *Bulletin de liaison surréaliste* 7 (December 1973): 1–23. On 7 June 2018, at the 'Revolutionary Imagination: Chicago Surrealism from Object to Activism' conference at the University of Chicago, Michael Stone-Richards presented the relevant paper 'Critical Theory and Practice: Marcuse Between Paris and Chicago'. See also Michael Stone-Richards, 'Critical Theory', in Michael Richardson et al., *The International Encyclopedia of Surrealism* (London: Bloomsbury), 1:503–6.

186 Letter from Herbert Marcuse to Franklin Rosemont, 6 March 1973, Rosemont Papers.

187 Franklin Rosemont, 'Herbert Marcuse and Surrealism', 39–46.

188 Kellner, *Herbert Marcuse*, 154–96. See also Marcuse, *One-Dimensional Man*, 1–18.

189 Studs Terkel, *Working: People Talk About What They Do All Day and How They Feel About What They Do* (1972; New York: Pantheon Books, 1974).

190 Paul Garon, interview with author, 23 March 2018.

191 Letter from Franklin Rosemont to Herbert Marcuse, 21 June 1972, Rosemont Papers.

192 Herbert Marcuse, 'Art and Liberation', *Partisan Review* 39, no. 2 (Spring 1972): n.p.

193 Marcuse, 'Letters to the Chicago Surrealists', 181–8.

194 Douglas Kellner, 'Introduction: Marcuse, Art and Liberation', in Marcuse, *Art and Liberation*, 55–7.

195 Marcuse's letter to the Chicago surrealists in 1972 is just one glimpse of his ever-changing and often contradictory social theory of art. Kellner, *Herbert Marcuse*, 347–62; and Herbert Marcuse, *An Essay on Liberation* (Boston, MA: Beacon Press, 1969). See also Stephen Eric Bronner, 'Between Art and Utopia: Reconsidering the Aesthetic Theory of Herbert Marcuse', in *Marcuse: Critical Theory and the Promise of Utopia*, ed. Andrew Feenberg, Robert B. Pippin, and Charles P. Webel (South Hadley,

MA: Bergin & Garvey, 1988); and Charles Reitz, *Art, Alienation, and the Humanities: A Critical Engagement with Herbert Marcuse* (New York: State University of New York Press, 2000).

196 Herbert Marcuse, *Counterrevolution and Revolt* (Boston, MA: Beacon Press, 1972), 103; original emphasis.

197 Penelope Rosemont, email to author, 27 December 2018.

198 Various meeting minutes from 1972, Rosemont Papers.

199 Untitled, undated, and unpublished statements addressed to Herbert Marcuse by John Simmons, David Schanoes, and Franklin Rosemont, *c.* November 1972–January 1973, Rosemont Papers.

200 Herbert Marcuse, *Negations: Essays in Critical Theory* (Boston, MA: Beacon Press, 1968). On affirmative culture, see Theodor W. Adorno, *Aesthetic Theory*, ed. Gretel Adorno and Rolf Tiedemann, trans. Robert Hullot-Kentor (London: Bloomsbury, 1997); Peter Bürger, *Theory of the Avant-Garde*, trans. Michael Shaw (Minneapolis: University of Minnesota Press, 1984), 10–14, 49–53; and Anthony Iles and Marina Vishmidt, 'Work, Work Your Thoughts, and Therein See a Siege', in *Communization and Its Discontents: Contestation, Critique, and Contemporary Struggles*, ed. Benjamin Noys (New York: Autonomedia, 2012).

201 Marcuse, 'Letters to the Chicago Surrealists', 188.

202 Barry Katz, *Herbert Marcuse and the Art of Liberation: An Intellectual Biography* (London: NLB, 1982), 194–205.

203 Marcuse, 'Letters to the Chicago Surrealists', 190.

204 *Ibid.*

205 Herbert Marcuse to Franklin Rosemont, 6 August 1973, Rosemont Papers.

206 Herbert Marcuse to Franklin Rosemont, 13 February 1974, Rosemont Papers.

207 Herbert Marcuse, *The Aesthetic Dimension: Towards a Critique of Marxist Aesthetics* (1977; Boston, MA: Beacon Press, 2003), 37.

208 Kellner, *Herbert Marcuse*, 353–7.

209 Marcuse, *Aesthetic Dimension*, xi.

210 This letter from Marcuse to Rosemont is dated 2 March 1979, and is reprinted alongside Paul Buhle, 'Herbert Marcuse, Surrealism & Us', *Cultural Correspondence* 12–14 (Summer 1981): 62–3.

211 Franklin Rosemont, 'André Breton', 24.

212 Franklin Rosemont, 'The 100th Anniversary of Hysteria', in *Revolution in the Service of the Marvelous* (Chicago: Charles H. Kerr, 2004), 123–4.

213 Rosemont, 'Herbert Marcuse and Surrealism', 33.

214 *Ibid.*, 34.

215 *Ibid.*; original emphasis.

216 Marcuse, *Counterrevolution and Revolt*, 102.

217 On this point I am at odds with Fredric Jameson in *Marxism and Form* (published in advance of the Marcuse exchange with the Chicago surrealists), for whom the hermeneutics of the utopian idea in Marcuse's thought fully subsumes and 'replaces' the past efforts of revolutionary arts, including surrealism. See Fredric Jameson, *Marxism and Form: Twentieth-century Dialectical Theories of Literature* (Princeton, NJ: Princeton University Press, 1971), 111.

218 Buhle, 'Herbert Marcuse, Surrealism & Us', 62.

Epilogue:
override dysfunctions and
the 'Klapheck computer'

In early February 1965, some months before Franklin and Penelope Rosemont arrived in Paris from Chicago and found themselves by chance at *L'Écart absolu* surrealist exhibition being held at the Galerie de l'Œil, André Breton penned a short essay devoted to one of the movement's newest associates, the German painter Konrad Klapheck.[1] Klapheck had become acquainted with the editors of the parasurrealist journal *Phases* during his semester abroad in Paris in 1956–57, and began to interact with Breton's group by 1961.[2] With a painterly practice that consisted of unsettling still lifes of sewing machines, typewriters, adding machines, and other modern devices and implements, he quickly gained the attention of group members. José Pierre, Édouard Jaguer, and Robert Benayoun all wrote about Klapheck in the first years of the 1960s, just in advance of Breton's essay, and helped establish the surrealist discourse about this artist that laid the groundwork for Breton's remarks in 1965.[3]

As I describe in my account of artworks by Óscar Domínguez in Chapter 3, Breton's 1965 essay situates Klapheck's still lifes of modern gadgets in the context of a timeline of self-proclaimed surrealist predecessors in avant-garde art and literature. Breton mentions figures such as Alfred Jarry and Auguste Villiers de l'Isle-Adam as well as the theoretical writings and research of Julien Offray de La Mettrie, Sigmund Freud, and Havelock Ellis. Domínguez, who left the surrealist group in the 1940s and died in the late 1950s, also plays an important role in Breton's remarks, in that his representations of subverted utensils and devices operate as a bridge between surrealist precursors such as Apollinaire, an early advocate for the eroticisation of modern life, and Klapheck, whom Breton positions as a soothsayer of contemporary object–human relations.[4]

It is to Breton's brief remarks about Klapheck that I now return, so as to fashion an epigrammatic reflection about how the surrealist war on work and its development of artistic forms of symbolic sabotage may have resonated for Breton in the last few months of his life, before his death in September 1966. Additionally, I hope to speak broadly to the manner in which surrealist work refusal continued to affect the movement's contested relationship to the role of the artist in society, as well as the production and dissemination of the work of art itself, in the

decades following World War II. If Domínguez's surrealist artworks frequently revealed how humans can unravel obedience to both internally and externally imposed work disciplines through autoerotic or autodestructive interactions with the means of production, Klapheck's paintings indicated an even more direct route to the sabotage of the work ethic, according to Breton in this late statement. In Klapheck's transformation of machine still lifes into anthropomorphic machine portraits or even machinic self-portraits – through what Breton called the process of 'analogy' or 'correspondences' – the painter showed that humans themselves are, following La Mettrie's philosophical proposition in *L'Homme machine* (*Man A Machine*) (1748), already 'rampant' animal-machines.[5] As living machines and work tools, humans constantly reproduce paradoxically unproductive desires even under the aegis of instrumentalised labour power.[6] To sabotage instrumentality, then, humans should start by changing themselves.

Breton's theory of the humanisation of machines verges on a posthuman perspective. By subtly and seductively eroticising mundane office machines, Klapheck's paintings of this period, examples of which were exhibited in *L'Écart absolu* and reproduced in the catalogue at the end of 1965, demonstrate that the primary approach to the revolution of the working world must come from the transformation of our understanding of humanity itself as a type of tool, at once productive and unproductive. Therefore, we can infer from this late essay that for Breton, the ultimate sabotage of the work ethic and exploitation under capitalism depended neither on the destruction of material objects nor even the obstruction of the means of production. Instead, when humans realise the extent of their alienation and objectification in the process of selling their labour or imitating machines in their efforts towards super-productive output – and when, in turn, they connote the very nature of human life as inherently tied to the ontologies of both animal and machine – then both worker and work tool might exceed or overcome the production cycle through the irrepressible forces of desire. All tools of labour – human, animal, and object alike – can mutiny against exploitation towards a horizon of potential for the full nature of being.

For Breton in the Klapheck essay, the process and symbolism of work was fundamentally tied to Eros. Human desires develop libidinally via the machine just as the machine secures human submission to its functions. The human animal and the functional tool are in this regard simulacra of one another. The human sexualises the tool, endowing it with affect, and the tool reduces the human to automatic application and motor function. This is more than just a question of mutual reification. Such interchange of affect and objectification also has the potential for dual subversion through interpenetration and exchange. Breton wrote:

> It is at the heart of this 'powerful analogy' that Konrad Klapheck positions his glittering shuttle. The instruments he depicts are chosen from among our closest auxiliaries, but the aim is to override the specific use for which they are intended in such a way as to reveal their magnified image. The achievement of this particular aim demands that the object's structure should be recorded with an – as

it were – theoretical strictness and denudation, while at the same time exalting it and the space inside which it fits with all the lights of the prism. It is this collision against sharp edges alternating with the caress of beautiful curves, graced by a light deriving its source from the inner life, which enables Klapheck to raise himself, by means of correspondences, to a new level at which he has a sure hold on the psychological and the sociological.[7]

The 'glittering shuttle' of the machine, too, shows the seams of an inner life when its 'magnified image' is 'unmasked' (*démasquée*) and its function becomes rather to *override*, to pass beyond, to ignore or bypass (*passer outre*).[8] This sequestered inner life of the machine is at once intertwined with human desire and a reflection of it: 'so long as the world is impelled by the hunger for technical progress the machine cannot be expected to renounce its role of *vamp*', Breton stated.[9] The machine irresistibly calls to the human through this 'hunger' for a better life, seducing and exploiting human toil in efficiency or ambition. Machine and human are therefore dependent prostheses of one another. The 'infernal machine' accordingly becomes a familiar monster that reflects the scope of human desire back onto itself.

Breton's theory of a surrealist sabotage of the work ethic and the workaday world, alive in his thinking since the 1920s in evolving formulas influenced by Duchamp, anarchism, socialism, and other sources, therefore shifted in tenor to some degree by the last decade of his life. The abolitionist strategy of the artist's permanent strike in a principled refusal of the wage system had by the 1960s come to encompass a highly nuanced ontological insinuation of human-as-machine – tangled in a contradictory set of expectations and desires at once limited and enabled by social structures and psychosexual drives. Since the World War II era, Breton's views about the role of work in life had been shaped by the nineteenth-century socialist utopian writings of Charles Fourier, which discuss the possibility of attractive or harmonious labour (*travail attrayant*) in books such as *Traité de l'association domestique agricole* (*A Treatise on a Domestic and Agricultural Association*) of 1822. Breton may have also been influenced to some degree by the works of Herbert Marcuse, whose Fourier-indebted theories about libidinal work relations in *Eros and Civilization* were acknowledged by the Paris surrealists by the early 1960s, in some measure because, as we saw in Chapter 4, Breton himself was quoted there. As Georges Sebbag explained, post-World War II surrealism was profoundly influenced by Fourier's vision of a future society of 'luxury and abundance' and 'free and harmonious association', based on a culture of pleasure and passionate attraction.[10] Aligning Klapheck with Domínguez's poetic subversions of white-collar work tools such as the typewriter, as well as lessons from Fourier and Marcuse, Breton's essay affirmed that in 1965, surrealism still aimed to reveal how human life can exceed instrumentalisation.

In Klapheck's case, this desired excess is achieved by deploying the artistic medium of a strangely abstracted figurative painting to convey messages about how the operations of power and desire inevitably supersede functionality, a

position that avoids both technophilia and technophobia. Klapheck's general-ised and 'denuded' depictions of machines simultaneously undermine the objec-tive premise of the still-life genre and the denotative goal of figurative rendering. According to Édouard Jaguer in an essay devoted to what he wryly calls the 'Klapheck computer', published in the surrealist journal *La Brèche: action surré-aliste* in September 1962, such representational code-switching between pictorial languages of abstraction and figuration was tantamount to painterly sabotage. Jaguer stated that Klapheck's canvases 'cannot accommodate the traditional and sacrosanct partition between "cold" abstraction and "figurative" surrealism', and are 'like the dashboards of a power station destined from the moment of its construction to permanent sabotage'.[11] For the surrealists, Klapheck's paintings not only sabotaged utility and productivism but also the broadly communica-tive function of art and its formal languages. The straightforward representation of everyday objects was merely a screen for the transmission of a more unset-tling message about the obstacles and possibilities inherent in human–object relations.

When Penelope and Franklin Rosemont arrived at the exhibition *L'Écart absolu* on Christmas Eve 1965, they encountered Klapheck's work for the first time in the form of paintings such as *Le Visage de la terreur* (*The Face of Terror*; 1963) and *Le Législateur* (*The Legislator*; 1963). *Le Visage de la terreur*, an image of which was reproduced in the catalogue for *L'Écart absolu*, depicts a microphone coiling expressively and beckoning to the viewer in a gesture of direct address, a manifestation of the amplification function of this device and its relation to various communications intentions, including those of authoritarianism (Plate 13).[12] Beginning in the mid-1950s, when he began to read Lautréamont and Raymond Roussel – thanks to his acquaintance with the editors of *Phases* and their recommendations – Klapheck forged a practice by which the still-life depic-tion of an everyday device was also a theatrical act.[13] Works such as *L'Intrigante* (*Intriguing Woman*; 1962), featuring a streamlined and eroticised depiction of a sewing machine, paired stylised rendering with an evocative title as a means of effecting the sought-after transformation of the objective into intimate reflection: the sleek form of the sewing machine is infused with the sexuality of its operator; human and machine co-eroticise and co-impersonate (Plate 14). For Klapheck, the sewing machine in *L'Intrigante* was evocative of mythological traitresses such as Clytemnestra, who murders her husband: the rapid needle is both a weapon and the tool that weaves a web of lies.[14] The artist's works from later in the decade maintain this preoccupation with dominating or vengeful gendered machines: a six-foot-high canvas called *The Dictator* (1967) depicts a towering typewriter, while *Female Tyrant* (1967) spotlights the colossal needle of a Singer sewing machine.

This notion of the surrealist amplification of the potentially autocratic voice of the anthropomorphised apparatus was also perceptible in a number of art-works and installations featured in *L'Écart absolu*. Jean-Claude Silbermann's collectively organised assemblage, *Le Consommateur* (*The Consumer*), which I

mentioned in the discussion of Marcuse in Chapter 4, conjoined various appliances and objects in a monstrous body attempting to communicate an urgent but nonsensical message. When the Rosemonts visited the exhibition, they noticed the police sirens attached to the 'head' of the monumental mattress figure with its television face and washing-machine belly, emitting the frantic message 'BIP … BIP … BIP' that ran in flashing white lights around the circumference of the room (Figure 4.12).[15] *Le Désordinateur* (*The Disordinator*), another collective artwork, allowed visitors to pose questions to a cynical 'computer' featuring light-up compartments that corresponded to various social myths.[16] On the subject of '*travail*', for instance, *Le Désordinateur* illuminated a compartment showing a linked chain made out of loaves of bread (baguettes), thus evoking human bondage to a life of work in a continual task of alimentary survival. Just as Klapheck's *Le Visage de la terreur* broadcast a warning about the ways in which technology can be routed towards attempts at domination, the theme of expressive machines in *L'Écart absolu* suggested a narrative of surrealist technopessimism about the dangers of mutual exploitation as a result of the human–machine symbiosis. Surrealism had

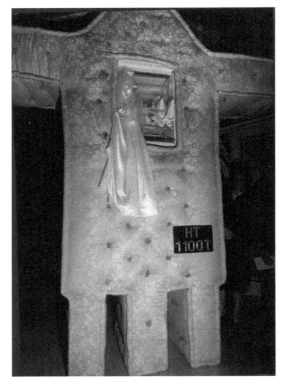

Figure 4.12 Radovan Ivšić, Jean-Claude Silbermann's *Le Consommateur* (*L'Écart absolu* exhibition, Galerie de l'Œil, Paris, 1965–66), 1965

been concerned already with such themes for an extended period, as is traceable in the anti-technocratic sociological writings from the 1950s by Nora Mitrani, as well as texts by other group members.[17] If Breton had referred to the machinic instruments of daily use as 'among our closest auxiliaries' in his Klapheck essay of February 1965, the role of the machine counterpart in *L'Écart absolu* just under a year later is nearly an oracular one, in which machines attempt to awaken human anxiety to the grave risks of living under technocracy.[18]

This is not far from Robert Benayoun's conception of Klapheck's work as a training ground for the constant rejection of authority within the realm of the quotidian that had become imperative in the continual struggle for liberation in contemporary life. As expressed in his 1963 essay on the artist, 'The Watchmaker of Freedom', Benayoun explained that Klapheck's wildly monumentalised interpretations of terrifyingly powerful sewing machines and typewriters bore contradictory significance. To be sure, these devices signified the unique kinds of agency that machines had the potential to grant humans – in particular, women, who had recently benefited from the process of the feminisation of labour with apparatuses such as the sewing machine and the typewriter. However, Benayoun also warned that this hard-won agency for women resulting from the human–machine collaboration could just as easily lead to authoritative domination and wilful subjugation in other social scenarios.[19] This dialectical understanding of human–machine relations in the postwar period directed the surrealists towards a more nuanced and multifarious approach to the subversion of productivity by both producer and device.

In the wake of Breton's Klapheck essay, *L'Écart absolu*, and other manifestations, surrealist artists and affiliates from subsequent generations would continue to explore the possibilities of liberating the desires of the hybrid man–animal–machine through what Breton had theorised as the *unmasking* of human–machine intimacy and the *overriding* of human–machine functions.[20] During the 1960s and 1970s American artists Jim Dine and William N. Copley, both closely associated with surrealism, interrogated the aesthetics of the gendered work tool.[21] For the Paris-based artist duo Jean-Michel Goutier and Giovanna (Anna Voggi), the key to unhinging instrumentalised work for the 'new woman' on which *L'Écart absolu* focused was to *détourner* the machinic by literally liberating its function.[22] The automatist typewriter drawings that Giovanna made between 1964 and 1966 – while stealing time from her secretarial job at the comic magazine *Pilote* – offer a delicately sensuous incarnation of her own personal sabotage of disciplined work and the instrumentalisation of language: the regulated lines of type and predetermined symbols rotate and blur so as to construct fantastic creatures, figures, and forms (Plate 15). Directly inspired by Fourier's concept of 'absolute deviation' in *Le Nouveau monde industriel et sociétaire* (*The New Communitarian and Industrial World*) (1829), which had been taken as the title of the 1965–66 surrealist exhibition, as well as the symbolic black and red tape of the typewriter, evocative of communist and anarchist radical traditions, Giovanna undertook to 'counteract the triviality of daily work'.[23] She did so by

'permitting' a new synergy of the typically antonymic categories of '*l'activité imposée et l'activité ludique*' (compulsory activity and playful activity).[24]

Two decades later, in New York in 1986, the Venezuelan surrealist José Ramón Sánchez (1938–2016) used a sewing machine to collage thread in meandering, automatist designs onto burlap and other fabrics, an innovative technique he referred to obliquely as 'the ferrous veins of Lautréamont's sewing machine' (Plate 16).[25] In the early 1960s, Sánchez began making a series of mechanical boxes devoted to Lautréamont's *Maldoror*. His enthusiasm for this sadistic text, paired with his involvement in Parisian surrealism during the late 1960s and probable exposure to works such as Giovanna's typewriter drawings, may have influenced his automatist application of the sewing machine twenty years later. In his 1972 pocket dictionary, *Le Surréalisme*, José Pierre singled out Sánchez's 'erotic or libertarian impulses'.[26] Although Sánchez's body of work remains obscure in surrealist histories, his 'overriding' of the typical application of a sewing machine between 1986 and the late 1990s suggests that, following the examples of surrealist practitioners such as Domínguez, the Chicago surrealists, Klapheck, and Giovanna, contemporary surrealists extended the anti-work discourse of the liberatory misappropriation of the machine and its effects.

In a projected sphere of uninhibited Eros, machines could become human allies in a reimagined panorama of worldly activity, in which the nature and purpose of the human lifespan would be experimentally relayed towards new modes of being and consciousness. Georges Sebbag echoed this sentiment when he discussed the *transmutation* of work in a short statement written for the '*travail*' compartment of the *Désordinateur* in the catalogue for *L'Écart absolu*, 'Travail qui vaille?' ('Work that Works?'):

> The reality: work is repugnant. Even so, the dream of creative impulse and poetic art still arises in us. Nevertheless, the transmutation of work should aim at something else. Beyond the dialectic which poses leisure or freedom as the opposite of daily alienation, lie the essential questions of human activity; what to do, how to do it, and for what purpose? More than just answering these questions, it is a matter of inserting oneself into the unconscious dislocations between body and mind … that is the work that awaits us … perhaps one day we will witness the results of this work; perhaps we are working on it already.[27]

Indeed, the surrealists had been unworking work for half a century, and this endeavour continued to unfold in international surrealist developments through the final decades of the twentieth century. By developing a dynamic critical praxis of work refusal and symbolic sabotage, and *principled desertion* from the status quo, surrealism has insistently communicated the unacceptability of passive compliance to a life of waged work. Rather than fashioning a didactic or predetermined answer to the 'essential questions of human activity' – as Sebbag put it, of 'what to do' with existence and why – surrealism has left potential futures open to the unknown limitlessness of imagination, knowing full well that a life free from work conscription would be nearly impossible for those already embedded in its

system to envision. As Maurice Blanchot wrote in 'Tomorrow at Stake', shortly after Breton's death, *désœuvrement* (unworking) must be ongoing for a future milieu of free producers, since the very possibility of the absence of work 'is also always walled up in the work'.[28]

Notes

1 André Breton, 'Konrad Klapheck', in *Surrealism and Painting*, 411–12. This essay was published first as a catalogue essay for a Klapheck exhibition at the Galerie Ileana Sonnabend in Paris in 1965 and was then gathered in later editions of *Surrealism and Painting*.

2 Keith Aspley, 'Konrad Klapheck', in *Historical Dictionary of Surrealism*, 282. In 1957, Klapheck published *Die Kleinen*, a suite of drawings influenced by Max Ernst.

3 Konrad Klapheck and Museum Kunstpalast, *Klapheck: Bilder und Texte* (Düsseldorf: Museum Kunstpalast, 2013), 167. José Pierre wrote the preface for the Klapheck exhibition at Galleria Arturo Schwarz, Milan, December 1960. See also Robert Benayoun, 'The Watchmaker of Freedom', in *Konrad Klapheck: mostra personale* (Milan: Galleria Arturo Schwarz, 1963), n.p.

4 Giovanna Angeli, *Macchine meravigliose: surrealismo e tecnologia* (Florence: Le Lettere, 2009), 6.

5 Breton, 'Konrad Klapheck', 412.

6 *Ibid.*

7 *Ibid.*; I have modified the translation for '*passer outre*'. Breton's theory of the relationship between work and Eros can be contrasted with that of Georges Bataille in *L'Érotisme* (1957). Bataille claims that the mid-century findings of the Kinsey Reports show that work increases the human consciousness of objectivity, including the objectification of the self in work, just as work stifles the libido, the very instinctual drive which prevents humans from becoming reduced to things.

8 *Ibid.*

9 *Ibid.*; original emphasis.

10 Georges Sebbag, 'Utopia: The Revolution in Question', in *Surrealism: Key Concepts*, 66.

11 Édouard Jaguer, 'Plan et démontage de l'ordinateur Klapheck ou les œillades d'Argus', *La Brèche: action surréaliste* 3 (September 1962): 48; my translation. Two paintings by Klapheck were reproduced in this issue of *La Brèche*.

12 Penelope Rosemont reported seeing this painting while viewing the exhibition *L'Écart absolu*. Penelope Rosemont, *Dreams & Everyday Life*, 60. However, it should be noted that, although *Le Visage de la terreur* was reproduced in the *L'Écart absolu* exhibition catalogue, it was not listed in the catalogue's checklist (also in the catalogue), whereas *Le Législateur* (1963) was. *L'Écart absolu* (Paris: Galerie de l'Œil, 1965).

13 Klapheck and Museum Kunstpalast, *Klapheck: Bilder und Texte*, 165.

14 Konrad Klapheck et al., *Konrad Klapheck, Retrospektive 1955–1985* (Munich: Prestel-Verlag, 1985), 72.

15 Penelope Rosemont, *Dreams & Everyday Life*, 59.

16 Mahon, *Surrealism and the Politics of Eros*, 180.

17 See, for example, Nora Mitrani, 'Réflexions sur l'opération technique, les techniciens et les technocrates', *Cahiers Internationaux de Sociologie* XIX (1955): 157–70. Also see

Eburne, 'Approximate Life', 62–81. On surrealist sensibility of pessimism in general see Raihan Kadri, *Reimagining Life: Philosophical Pessimism and the Revolution of Surrealism* (Madison, NJ: Fairleigh Dickinson University Press, 2011).

18 Breton, 'Konrad Klapheck', 412.

19 Benayoun, 'The Watchmaker of Freedom', n.p.

20 For a surrealist rereading of the man–machine concept in response to Deleuze and Guattari's *L'Anti-Œdipe* (1972), for instance, see Bernard Caburet, 'Homme-machine toujours tu chériras tes ratés', in *La Civilisation surréaliste*, ed. Vincent Bounoure (Paris: Payot, 1976), 261–72.

21 In the early 1960s, the surrealist discourse on the painterly representation of the functional tool was also influenced by the movement's positive reception of the American artist Jim Dine, and also by the critics Alain Jouffroy and Nicolas Calas. Dine's early pop-art works from the early 1960s often incorporated representations and/or readymades of carpentry tools such as saws, hammers, and screwdrivers. For Jouffroy and Calas, Dine's discourse about the real versus the simulacral tool recalled the object lessons of René Magritte, which on occasion featured work tools such as the hammer. Dine's pop art could thus be distanced from the naturalist pictorial language of Realism for Jouffroy and Calas. I am grateful to Gavin Parkinson for pointing out the relevance of the surrealist reception of Jim Dine.

22 Jean-Michel Goutier, 'Le Mulhiou ou comment Giovanna détourne la machine à écrire', *L'Archibras* 1 (April 1967), 46. See also Laura Santone, *Écouter, écrire, signifier: sur l'art verbal de la créatrice surréaliste Giovanna* (Rome: Artemide, 2018). Giovanna was featured in a photograph by Marcel Lannoy on the cover of *L'Archibras* 2 (October 1967).

23 Giovanna, email to author, 3 December 2018.

24 *Ibid.* For surrealist interactions with Citroën strikers in May, 1968, see Chris Marker's *A Grin Without a Cat*, 1977.

25 José Ramón Sánchez and Nassau County Museum of Fine Art, *José Ramón Sánchez–Works: August 17 through October 19, 1986* (Roslyn Harbor, NY: Nassau County Museum of Fine Art, 1986), 6. Sánchez began to participate in surrealism in 1968, the year that Jean-Louis Bédouin discussed his drawings in a feature for *L'Archibras*. Jean-Louis Bédouin, 'José Sánchez', *L'Archibras* 6 (December 1968), 23–5. In 1969, he completed the illustrations for a French edition of the seventeenth–eighteenth-century Mayan text, the *Chumayel Chilám Balám*, with a foreword by Benjamin Péret (Paris: Denoël). He remained active in international surrealism throughout the 1970s and 1980s. See also José Ramón Sánchez, Susana Benko, and Museo de Arte Contemporáneo del Zulia, *José Ramón Sánchez: los fantasmas desde el estanque vivo* (Maracaibo: Museo de Arte Contemporáneo del Zulia, 2002).

26 José Pierre, *An Illustrated Dictionary of Surrealism* (Woodbury, NY: Barron's Educational Series, 1979), 146.

27 Georges Sebbag, 'Travail qui vaille?', in *L'Écart absolu* (Paris: Galerie de l'Œil, 1965), n.p.; my translation. On the role of work in prompting human desires toward a different future horizon, see Pierre Mabille, 'Le Paradis', *VVV* 4 (February 1944): 33–6.

28 Blanchot, 'Tomorrow at Stake', 420.

Select bibliography

This select bibliography highlights key sources and is far from exhaustive. See the endnotes for a full list of sources cited.

Aberth, Susan L. *Leonora Carrington: Surrealism, Alchemy and Art*. Aldershot: Lund Humphries, 2004.

Adamowicz, Elza. *Surrealist Collage in Text and Image: Dissecting the Exquisite Corpse*. Cambridge: Cambridge University Press, 2005.

Ades, Dawn. 'Surrealism: Fetishism's Job'. In *Fetishism: Visualising Power and Desire*, edited by Anthony Shelton, 67–87. London: South Bank Centre; Royal Pavilion, Art Gallery and Museums Brighton, 1995.

Adorno, Theodor W., Elisabeth Lenk, and Susan H. Gillespie. *The Challenge of Surrealism: The Correspondence of Theodor W. Adorno and Elisabeth Lenk*. Minneapolis: University of Minnesota Press, 2015.

Agamben, Giorgio. *The Use of Bodies, Homo Sacer*. Translated by Adam Kotsko. Vol. 4, no. 2. Stanford, CA: Stanford University Press, 2015.

Allmer, Patricia, ed. *Angels of Anarchy: Women Artists and Surrealism*. New York: Prestel, 2009.

Andrew, Dudley, and Steven Ungar. *Popular Front Paris and the Poetics of Culture*. Cambridge, MA: Harvard University Press, 2005.

Ansell, Christopher K. *Schism and Solidarity in Social Movements: The Politics of Labor in the French Third Republic*. Cambridge: Cambridge University Press, 2008.

Baker, Simon. *Surrealism, History and Revolution*. Oxford: Peter Lang, 2012.

Bandier, Norbert. *Sociologie du surréalisme*. Paris: La Dispute, 1999.

Barthes, Roland. 'The Surrealists Overlooked the Body'. In *The Grain of the Voice: Interviews, 1962–1980*, translated by Linda Coverdale, 243–5. Berkeley: University of California Press, 1991.

Bataille, Georges. *Inner Experience*. Translated by Leslie Anne Boldt. Albany: State University of New York Press, 1988.

Bate, David. *Photography and Surrealism: Sexuality, Colonialism and Social Dissent*. London: I. B. Tauris, 2003.

Bauduin, Tessel M. *Surrealism and the Occult: Occultism and Western Esotericism in the Work and Movement of André Breton*. Amsterdam: Amsterdam University Press, 2014.

———. 'The "Continuing Misfortune" of Automatism in Early Surrealism', *communication +1* 4, no. 10 (2016).

Baugh, Bruce. *French Hegel: From Surrealism to Postmodernism*. New York: Routledge, 2003.

Belton, Robert J. *The Beribboned Bomb: The Image of Woman in Male Surrealist Art*. Calgary: University of Calgary Press, 1995.

Benjamin, Walter. 'Critique of Violence'. In *Reflections: Essays, Aphorisms, Autobiographical Writing*, translated by Edmund Jephcott, 277–300. New York: Schocken Books, 1986.

Blanchot, Maurice. 'Réflexions sur le surréalisme'. In *La Part du feu*, 90–102. Paris: Gallimard, 1949.

———. *The Unavowable Community*. Translated by Pierre Joris. Barrytown, NY: Station Hill Press, 1988.

———. *The Infinite Conversation*. Translated by Susan Hanson. Minneapolis: University of Minnesota Press, 1993.

Boaden, James. 'Dada, Surrealism and their Heritage? The North American Reception of Dada and Surrealism'. In *A Companion to Dada and Surrealism*, edited by David Hopkins, 400–15. Hoboken, NJ: Wiley Blackwell, 2016.

Bohn, Frank. 'Some Definitions: Direct Action – Sabotage'. In *Theories of the Labor Movement*, edited by Simeon Larson and Bruce Nissen, 85. Detroit, MI: Wayne State University Press, 1987.

Bolt Rasmussen, Mikkel. 'The Situationist International, Surrealism, and the Difficult Fusion of Art and Politics'. *Oxford Art Journal* 27, no. 3 (2004): 365–87.

Boltanski, Luc, and Ève Chiapello. *Le Nouvel esprit du capitalisme*. Paris: Gallimard, 1999.

Bonnet, Marguerite. *André Breton: Naissance de l'aventure surréaliste*. Paris: Librarie José Corti, 1975.

Brandon, Ruth. *Surreal Lives: The Surrealists 1917–1945*. New York: Grove Press, 1999.

Breton, André. *Manifestoes of Surrealism*. Translated by Richard Seaver and Helen R. Lane. Ann Arbor: University of Michigan Press, 1972.

———. *What Is Surrealism? Selected Writings*. Edited by Franklin Rosemont. New York: Monad Press, 1978.

———. *Œuvres complètes*. Edited by Marguerite Bonnet et al. Vols 1–2. Paris: Gallimard, 1988–92.

———. 'Away with Miserabilism!' In *Surrealism and Painting*, 347–8. Translated by Simon Watson Taylor. Boston, MA: MFA Publications, 2002.

———. *Communicating Vessels*. Translated by Mary Ann Caws and Geoffrey T. Harris. Lincoln: University of Nebraska Press, 1990.

———. *Free Rein = La Clé des champs*. Translated by Michel Parmentier and Jacqueline d'Amboise. Lincoln: University of Nebraska Press, 1995.

Breton, André, and Simone Breton. *Lettres à Simone Kahn: 1920–1960*. Edited by Jean-Michel Goutier. Paris: Gallimard, 2016.

Breton, André, and Philippe Soupault. *Les Champs magnétiques: le manuscrit original fac-similé et transcription*. Paris: Lachenal & Ritter, 1988.

Breton, Simone. *Lettres à Denise Lévy*. Edited by Georgiana Colvile. Paris: Gallimard, 2006.

Browder, Clifford. *André Breton: Arbiter of Surrealism*. Geneva: Droz, 1967.

Buhle, Paul. 'Herbert Marcuse, Surrealism & Us'. *Cultural Correspondence* 12–14 (Summer 1981): 62–3.

Bürger, Peter. *Der französische Surrealismus: Studien zum Problem der avantgardistischen Literatur*. Frankfurt am Main: Athenäum, 1971.

Burns, Thom, and Allan Graubard, eds. *Invisible Heads: Surrealists in North America, An Untold Story*. Flagstaff, AZ: Anon, 2014.

Cardinal, Roger. 'André Masson and Automatic Drawing'. In *Surrealism: Surrealist Visuality*, edited by Silvano Levy, 79–93. New York: New York University Press, 1996.

Carrouges, Michel. *Les Machines célibataires*. Paris: Arcanes, 1954.

Caws, Mary Ann, Rudolf E. Kuenzli, and Gwen Raaberg, eds. *Surrealism and Women*. Cambridge, MA: MIT Press, 1990.

Centro Atlántico de Arte Moderno. *Sueños de tinta: Óscar Domínguez y la decalcomania del deseo*. Las Palmas de Gran Canaria: Centro Atlántico de Arte Moderno, 1993.

———. *Óscar Domínguez: antología 1926–1957*. Las Palmas de Gran Canaria: Centro Atlántico de Arte Moderno, 1996.

Cheng, Joyce Suechun. 'Paris Dada and the Transfiguration of Boredom'. *Modernism/modernity* 24, no. 3 (2017): 599–628.

Chénieux-Gendron, Jacqueline. 'Jeu de l'incipit et travail de la correction dans l'écriture automatique: l'exemple de *L'Immaculée conception*'. In *Une pelle au vent dans les sables du rêve: les écritures automatiques*, edited by Michel Murat and Marie-Paule Berranger, 124–42. Lyon: Presses Universitaires de Lyon, 1992.

———. *Surrealism*. Translated by Vivian Folkenflik. New York: Columbia University Press, 1990.

Chéroux, Clément. 'La Photographie par tous, non par un'. In *La Subversion des images: surréalisme, photographie, film*, ed. Quentin Bajac et al., 23–8. Paris: Éditions du Centre Pompidou, 2009.

Clair, Jean, and Harald Szeemann. *Le Macchine Celibi/The Bachelor Machines*. New York: Rizzoli, 1975.

Coffin, Judith G. *The Politics of Women's Work: The Paris Garment Trades, 1750–1915*. Princeton, NJ: Princeton University Press, 1996.

Cohen, Margaret. 'The Ghosts of Paris'. In *Profane Illumination: Walter Benjamin and the Paris of Surrealist Revolution*, 77–119. Berkeley: University of California Press, 1993.

Colvile, Georgiana. 'Introduction'. Introduction to Breton, *Lettres à Denise Lévy*, 13–27.

Conley, Katharine. *Automatic Woman: The Representation of Woman in Surrealism*. Lincoln: University of Nebraska Press, 1996.

———. '"Not a Nervous Woman": Robert Desnos and Surrealist Literary History'. *South Central Review* 20, nos 2/4 (Summer/Winter 2003): 111–30.

———. *Robert Desnos, Surrealism, and the Marvelous in Everyday Life*. Lincoln: University of Nebraska Press, 2003.

———. *Surrealist Ghostliness*. Lincoln: University of Nebraska Press, 2013.

Crary, Jonathan. *24/7: Late Capitalism and the Ends of Sleep*. London: Verso, 2013.

Dicker, Barnaby. 'André Breton, Rodolphe Töpffer and the Automatic Message'. In *Surrealism, Science Fiction and Comics*, edited by Gavin Parkinson, 40–61. Liverpool: Liverpool University Press, 2015.

Doyle, Laura, ed. *Bodies of Resistance: New Phenomenologies of Politics, Agency, and Culture*. Evanston, IL: Northwestern University Press, 2001.

Drost, Julia. 'Simone Collinet. Simone Breton: A Passionate Collector of Surrealist Art'. In *Surrealism in Paris*, edited by Philippe Büttner, 135–66. Basel: Foundation Beyeler, 2011.

Drost, Julia, Fabrice Flahutez, Anne Helmreich, and Martin Schieder. *Networking Surrealism in the USA: Agents, Artists, and the Market*. Heidelberg: arthistoricum.net, 2020.

Dubois, Pierre. *Sabotage in Industry*. Harmondsworth: Penguin, 1979.

Dunayevskaya, Raya. *Marxism and Freedom: From 1776 until Today*. London: Pluto Press, 1971.

Duplessis, Yvonne. *Surréalisme et paranormal: l'aspect expérimental du surréalisme*. Agnières: JMG Éditions, 2002.

Durand-Dessert, Liliane. 'Lautréamont et les arts visuels (1870–1998)'. In *Les Lecteurs de Lautréamont: Actes du quatrième colloque international sur Lautréamont, Montréal, 5–7 octobre 1998*, edited by Jean-Jacques Lefrère and Michel Pierssens, 81–159. Tusson: Le Lérot, 1999.

Durozoi, Gérard. *History of the Surrealist Movement*. Translated by Alison Anderson. Chicago, IL: University of Chicago Press, 2002.

Duwa, Jérôme. *1968, Année surréaliste: Cuba, Prague, Paris. Collection 'pièces d'archives'*. Paris: Institut Mémoires de l'édition contemporaine, 2008.

———. *Surréalistes et situationnistes, vies parallèles*. Paris: Dilecta, 2008.

Eburne, Jonathan P. *Surrealism and the Art of Crime*. Ithaca, NY: Cornell University Press, 2008.

———. 'Approximate Life: The Cybernetic Adventures of Monsieur Wzz…' In *Surrealism, Science Fiction and Comics*, edited by Gavin Parkinson, 62–81. Liverpool: Liverpool University Press, 2015.

Ellis, Havelock. *Studies in the Psychology of Sex*. Vol. 1. London: William Heinemann, 1942.

Fayol, Henri. *General and Industrial Management*. Edited by Irwin Gray. New York: Institute of Electrical and Electronics Engineers, 1984.

Federici, Silvia. *Revolution at Point Zero: Housework, Reproduction, and Feminist Struggle*. 2nd ed. Oakland, CA: PM Press, 2020.

Finkelstein, Haim N. *Surrealism and the Crisis of the Object*. Ann Arbor: UMI Research Press, 1979.

Flusser, Vilém. *Does Writing Have a Future?* Translated by Nancy Ann Roth. Minneapolis: University of Minnesota Press, 1987.

Fort, Ilene Susan, Teresa Arcq, and Dawn Ades, eds. *In Wonderland: The Surrealist Adventures of Women Artists in Mexico and the United States*. New York: Prestel, 2012.

Foster, Hal. *Compulsive Beauty*. Cambridge, MA: MIT Press, 1993.

Foucault, Michel. *Discipline and Punish: The Birth of the Prison*. Translated by Alan Sheridan. 2nd ed. New York: Vintage Books, 1995.

———. *The Will to Knowledge (The History of Sexuality, Volume 1)*. Translated by Robert Hurley. 2nd ed. London: Penguin, 1998.

Frader, Laura Levine. *Breadwinners and Citizens: Gender in the Making of the French Social Model*. Durham, NC: Duke University Press, 2008.

Gallo, Rubén. 'Typewriters'. In *Mexican Modernity: The Avant-garde and the Technological Revolution*, 67–117. Cambridge, MA: MIT Press, 2005.

Gardey, Delphine. *La Dactylographe et l'expéditionnaire: Histoire des employés de bureau: 1890–1930*. Paris: Belin, 2002.

Garon, Paul. *Blues and the Poetic Spirit*. New York: Da Capo Press, 1979.

Garon, Paul, and Beth Garon. *Woman with Guitar: Memphis Minnie's Blues*. 2nd ed. San Francisco: City Lights Books, 2014.

Gascoyne, David. 'The Magnetic Fields'. Introduction to *The Automatic Message: The Magnetic Fields; the Immaculate Conception*, by André Breton, Paul Éluard, and Philippe Soupault, 39–54. Translated by David Gascoyne, Antony Melville, and Jon E. Graham. London: Atlas Press, 1997.

Gauthier, Xavière. *Surréalisme et sexualité*. Paris: Gallimard, 1971.

Gitelman, Lisa. *Scripts, Grooves, and Writing Machines: Representing Technology in the Edison Era*. Stanford, CA: Stanford University Press, 1999.

Golan, Romy. *Modernity and Nostalgia: Art and Politics in France between the Wars*. New Haven, CT: Yale University Press, 1995.

Greeley, Robin Adèle. *Surrealism and the Spanish Civil War*. New Haven, CT: Yale University Press, 2006.

Grindon, Gavin. 'Surrealism, Dada, and the Refusal of Work: Autonomy, Activism, and Social Participation in the Radical Avant-Garde'. *Oxford Art Journal* 34, no. 1 (2011): 79–96.

———. 'Poetry Written in Gasoline: Black Mask and Up Against the Wall Motherfucker'. *Art History* 38, no. 1 (February 2015): 170–209.

Hardt, Michael, and Antonio Negri. *Commonwealth*. Cambridge, MA: Harvard University Press, 2009.

Harris, Steven. *Surrealist Art and Thought in the 1930s: Art, Politics and the Psyche*. New York: Cambridge University Press, 2004.

———. 'Voluntary and Involuntary Sculpture'. In *Found Sculpture and Photography from Surrealism to Contemporary Art*, edited by Anna Dezeuze and Julia Kelly, 13–37. Burlington, VT: Ashgate, 2013.

Hemmens, Alastair. *The Critique of Work in Modern French Thought: From Charles Fourier to Guy Debord*. New York: Palgrave Macmillan, 2019.

Hoff, Lena. *Nicolas Calas and the Challenge of Surrealism*. Copenhagen: Museum Tusculanum Press, 2014.

Hopkins, David. 'Duchamp, Childhood, Work and Play: The Vernissage for *First Papers of Surrealism*, New York, 1942'. *Tate Papers* 22 (Autumn 2014): n.p.

———. *Dark Toys: Surrealism and the Culture of Childhood*. New Haven, CT: Yale University Press, 2021.

Hörner, Unda. *Die realen Frauen der Surréalisten: Simone Breton, Gala Éluard, Elsa Triolet*. Berlin: Suhrkamp Taschenbuch Verlag, 2002.

Howard, Claire. 'Passionate Attraction: Fourier, Feminism, Free Love, and *L'Écart absolu*'. In *Radical Dreams: Surrealism, Counterculture, Resistance*, edited by Elliott H. King and Abigail Susik. University Park: Penn State University Press, 2022.

Huyssen, Andreas. 'The Vamp and the Machine'. In *After the Great Divide: Modernism, Mass Culture, Postmodernism*, 65–81. Bloomington: Indiana University Press, 1986.

Jackson, Julian. *The Popular Front in France: Defending Democracy, 1934–38*. Cambridge: Cambridge University Press, 1988.

———. *The Politics of Depression in France, 1932–1936*. Cambridge: Cambridge University Press, 2002.

Janover, Louis. *Surréalisme, art et politique*. Paris: Éditions Galilée, 1980.

———. *La Révolution surréaliste*. Paris: Librairie Plon, 1989.

Janover, Louis, and Maxime Morel, eds. *Front noir, 1963–1967: Surréalisme et socialisme de conseils*. Paris: Non-lieu, 2019.

Jolles, Adam. *The Curatorial Avant-garde: Surrealism and Exhibition Practice in France, 1925–1941*. University Park: Pennsylvania State University Press, 2013.

Jones, Amelia. *Postmodernism and the En-gendering of Marcel Duchamp*. Cambridge: Cambridge University Press, 1994.

Jones, Leslie, Isabelle Dervaux, and Susan Laxton. *Drawing Surrealism*. Los Angeles, CA: Los Angeles County Museum of Art, 2012.

Joubert, Alain. *Le Mouvement des surréalistes ou le fin mot de l'histoire: mort d'un groupe, naissance d'un mythe*. Paris: Maurice Nadeau, 2001.

Kachur, Lewis. *Displaying the Marvelous: Marcel Duchamp, Salvador Dalí, and Surrealist Exhibition Installations*. Cambridge, MA: MIT Press, 2001.

Kahn, Simone. 'Les Cadavres exquis'. In *Le Cadavre exquis, son exaltation*, 30–31. Milan: Galleria Schwarz, 1975.

———. 'The Exquisite Corpses'. In *Surrealist Women: An International Anthology*, edited by Penelope Rosemont, 18–20. Translated by Franklin Rosemont. Austin: University of Texas Press, 1998.

———. 'Surrealist Text: This Took Place in Springtime'. In *Surrealist Women: An International Anthology*, edited by Penelope Rosemont, 17–18. Translated by Guy Ducornet. Austin: University of Texas Press, 1998.

Kellner, Douglas. *Herbert Marcuse and the Crisis of Marxism*. Berkeley: University of California Press, 1984.

Kelly, Julia. 'Centrale'. In *Bureau of the Centre for the Study of Surrealism and Its Legacy*, edited by Mark Dion et al., 111–14. Manchester: AHRB Research Centre for Studies of Surrealism and its Legacies, 2005.

———. 'The Found, the Made and the Functional: Surrealism, Objects and Sculpture'. In *Found Sculpture and Photography from Surrealism to Contemporary Art*, edited by Anna Dezeuze and Julia Kelly, 39–57. Burlington, VT: Ashgate, 2013.

Kelley, Robin D. G. *Race Rebels: Culture, Politics, and the Black Working Class*. New York: Free Press, 1994.

King, Elliott. *Dalí, Surrealism and Cinema*. Harpenden: Kamera Books, 2007.

Kittler, Friedrich A. *Discourse Networks 1800/1900*. Translated by Michael Metteer and Chris Cullens. Stanford, CA: Stanford University Press, 1990.

———. *Gramophone, Film, Typewriter*. Translated by Geoffrey Winthrop-Young and Michael Wutz. Stanford, CA: Stanford University Press, 1999.

Klapheck, Konrad, and Museum Kunstpalast. *Klapheck: Bilder und Texte*. Düsseldorf: Museum Kunstpalast, 2013.

Krauss, Rosalind E. 'Corpus Delicti'. In *L'Amour fou: Photography and Surrealism*, by Rosalind E. Krauss and Jane Livingston, 55–100. New York: Abbeville, 1985.

———. 'No More Play'. In *The Originality of the Avant-garde and Other Modernist Myths*, 43–85. Cambridge, MA: MIT Press, 1985.

———. 'Photography in the Service of Surrealism'. In *L'Amour fou: Photography and Surrealism*, by Rosalind E. Krauss and Jane Livingston, 15–42. New York: Abbeville Press, 1985.

Kuenzli, Rudolf E. 'Surrealism and Misogyny'. In *Surrealism and Women*, edited by Mary Ann Caws, Rudolf E. Kuenzli, and Gwen Raaberg, 17–26. Cambridge, MA: MIT Press, 1990.

LaCoss, Donald. 'Attacks of the Fantastic'. In *Surrealism, Politics and Culture*, edited by Donald LaCoss and Raymond Spiteri, 267–99. Burlington, VT: Ashgate, 2003.

———. 'Surrealism in '68: Paris, Prague, Chicago: Dreams of Arson & the Arson of Dreams'. *Surrealist Research & Development Monograph Series* 1 (2008): 16–17.

Lafargue, Paul. *The Right to Be Lazy*. Translated by Charles H. Kerr. 2nd ed. Chicago, IL: Solidarity Publications, 1969.

Laqueur, Thomas Walter. *Solitary Sex: A Cultural History of Masturbation*. New York: Zone Books, 2003.

Large, Alix. *L'Esprit libertaire du surréalisme*. Lyon: Atelier de Création Libertaire, 1999.

Laxton, Susan. *Surrealism at Play*. Durham, NC: Duke University Press, 2019.

Lazzarato, Maurizio. 'Immaterial Labor'. In *Radical Thought in Italy*, edited by Paolo Virno and Michael Hardt, 133–47. Minneapolis: University of Minnesota Press, 1996.

———. *Marcel Duchamp and the Refusal of Work*. Translated by Joshua David Jordan. Los Angeles, CA: Semiotext(e) and the Whitney Biennial, 2014.

Lehmann, Ulrich. 'Assimilation: Objects; Commodities; Fashion'. In *A Companion to Dada and Surrealism*, edited by David Hopkins, 431–48. Hoboken, NJ: Wiley Blackwell, 2016.

Levy, Silvano. *The Scandalous Eye: The Surrealism of Conroy Maddox*. Liverpool: Liverpool University Press, 2003.

Lewis, Helena. *The Politics of Surrealism*. New York: Paragon House, 1988.

Lomas, David. *The Haunted Self: Surrealism, Psychoanalysis, Subjectivity*. New Haven, CT: Yale University Press, 2000.

Lomas, David, and Jeremy Stubbs. *Simulating the Marvellous: Psychology, Surrealism, Postmodernism*. Manchester: Manchester University Press, 2013.

Löwy, Michael. 'Under the Star of Romanticism: Walter Benjamin and Herbert Marcuse'. In *Revolutionary Romanticism: A Drunken Boat Anthology*, edited by Max Blechman, 197–214. San Francisco, CA: City Lights Books, 1999.

———. 'International Surrealism Since 1969'. In *Morning Star: Surrealism, Marxism, Anarchism, Situationism, Utopia*, 107–16. Austin: University of Texas Press, 2009.

Löwy, Michael, and Robert Sayre. *Romanticism Against the Tide of Modernity*. Translated by Catherine Porter. Durham, NC: Duke University Press, 2001.

Lusty, Natalya. *Surrealism, Feminism, Psychoanalysis*. Burlington, VT: Ashgate, 2007.

Lyford, Amy. *Surrealist Masculinities: Gender Anxiety and the Aesthetics of Post-World War I Reconstruction in France*. Berkeley: University of California Press, 2007.

Mahon, Alyce. *Surrealism and the Politics of Eros, 1938–1968*. New York: Thames & Hudson, 2005.

———. *The Marquis de Sade and the Avant-Garde*. Princeton, NJ: Princeton University Press, 2020.

Malt, Johanna. *Obscure Objects of Desire: Surrealism, Fetishism, and Politics*. Oxford: Oxford University Press, 2004.

Marcadé, Bernard. *Laisser pisser le mérinos: la paresse de Marcel Duchamp*. Paris: L'Échoppe, 2006.

Marcuse, Herbert. *Eros and Civilization: A Philosophical Inquiry into Freud*. Boston, MA: Beacon Press, 1966.

———. *Negations: Essays in Critical Theory*. Boston, MA: Beacon Press, 1968.

———. *The Obsolescence of Psychoanalysis*. Chicago, IL: Black Swan Press, 1968.

———. *An Essay on Liberation*. Boston, MA: Beacon Press, 1969.

———. *Counterrevolution and Revolt*. Boston, MA: Beacon Press, 1972.

———. 'Sur le surréalisme et la révolution'. *Bulletin de liaison surréaliste* 6 (April 1973): 20–9.

———. *Reason and Revolution: Hegel and the Rise of Social Theory*. London: Humanities Press, 1981.

———. *One-Dimensional Man: Studies in the Ideology of Advanced Industrial Society*. Boston, MA: Beacon Press, 1991.

———. *The Aesthetic Dimension: Towards a Critique of Marxist Aesthetics*. Boston, MA: Beacon Press, 2003.

———. 'Letters to the Chicago Surrealists'. In *Art and Liberation: Collected Papers of Herbert Marcuse*, edited by Douglas Kellner, 178–93. Vol. 4. London: Routledge, 2007.

Marszalek, Bernard. 'Introduction' to *The Right to Be Lazy*, by Paul Lafargue, 3–22. Oakland, CA: Charles H. Kerr and AK Press, 2011.

Martin, Richard. *Fashion and Surrealism*. New York: Rizzoli, 1987.

Massicotte, Claudie. 'Spiritual Surrealists: Séances, Automatism, and the Creative Unconscious'. In *Surrealism, Occultism and Politics: In Search of the Marvellous*, edited by Tessel M. Bauduin, Victoria Ferentinou, and Daniel Zamani, 23–8. London: Routledge, 2018.

McKinlay, Alan, and Ken Starkey, eds. *Foucault, Management and Organization Theory: From Panopticon to Technologies of Self*. Newbury Park, CA: Sage, 1998.

Mendelson, Jordana. 'Of Politics, Postcards and Pornography: Salvador Dalí's *Le Mythe tragique de "l'Angélus" de Millet*'. In *Surrealism, Politics and Culture*, edited by Donald LaCoss and Raymond Spiteri, 161–78. Burlington, VT: Ashgate, 2003.

Molesworth, Helen, et al. *Work Ethic*. Baltimore, MD: Baltimore Museum of Art, 2003.

Mundy, Jennifer, Vincent Gille, and Dawn Ades, eds. *Surrealism: Desire Unbound*. Princeton, NJ: Princeton University Press, 2001.

Nancy, Jean-Luc. *The Inoperative Community*. Translated by Peter Connor et al. Minneapolis: University of Minnesota Press, 1990.

Naville, Pierre. *La Vie de travail et ses problèmes*. Paris: Armand Colin, 1954.

Negri, Antonio. 'Capitalist Domination and Sabotage'. In *Working Class Autonomy and the Crisis: Italian Marxist Texts of the Theory and Practice of a Class Movement, 1964–79*, 93–117. London: Red Notes, 1979.

O'Hanlan, Sean. 'Un foyer de la création collective'. In *Au grand jour: lettres (1920–1930): un album: André à Simone Breton*, edited by Katia Sowels and Jules Colmart, 70–1. Paris: Rue d'Ulm, 2020.

Papanikolas, Theresa. *Anarchism and the Advent of Paris Dada: Art and Criticism, 1914–1924*. Burlington, VT: Ashgate, 2009.

Parkinson, Gavin. *Surrealism, Art, and Modern Science: Relativity, Quantum Mechanics, Epistemology*. New Haven, CT: Yale University Press, 2008.

———. *Futures of Surrealism: Myth, Science Fiction, and Fantastic Art in France, 1936–1969*. New Haven, CT: Yale University Press, 2015.

———. 'Surrealist Painting as Science Fiction: Considering J. G. Ballard's "Innate Releasing Mechanism"'. In *Surrealism, Science Fiction and Comics*, edited by Gavin Parkinson, 174–93. Liverpool: Liverpool University Press, 2015.

Pawlik, Joanna. 'The Comic Book Conditions of Chicago Surrealism'. In *Surrealism, Science Fiction and Comics*, edited by Gavin Parkinson, 129–54. Liverpool: Liverpool University Press, 2015.

————. 'Cartooning the Marvelous: Word and Image in Chicago Surrealism'. In *Mixed Messages: American Correspondences in Visual and Verbal Practices*, edited by Catherine Gander and Sarah Garland. Manchester: Manchester University Press, 2016.

————. *Remade in America: Transnational Surrealism, 1940–1978*. Berkeley: University of California Press, 2021.

Pianca, Jean-Michel. 'Et Guerre au travail'. *Mélusine* 5 (1983): 37–50.

Pierre, José. *Surréalisme et anarchie: les 'billets surréalistes' du 'Libertaire', 12 octobre 1951–8 janvier 1953*. Paris: Plasma, 1983.

————. *Investigating Sex: Surrealist Research, 1928–1932*. New York: Verso, 1992.

Poivert, Michel. 'Images de la pensée'. In *La Subversion des images: Surréalisme, photographie, film*, by Quentin Bajac et al., 309–13. Paris: Éditions du Centre Pompidou, 2009.

Polizzotti, Mark. *Revolution of the Mind: The Life of André Breton*. New York: Da Capo, 1997.

Rabinbach, Anson. *The Human Motor: Energy, Fatigue, and the Origins of Modernity*. Berkeley: University of California Press, 1992.

Rentzou, Effie. *Littérature malgré elle: Le surréalisme et la transformation du littéraire*. Paris: Éditions Pleine Marge, 2010.

Reynaud Paligot, Carole. *Parcours politique des surréalistes, 1919–1969*. Paris: CNRS Éditions, 1995.

Reynolds, Siân. *France Between the Wars: Gender and Politics*. London: Routledge, 1996.

Rhodes, Colin. 'Four "Outsiders", Four Women: Surrealism and the Psychic Elsewhere'. In *Intersections: Women Artists/Surrealism/Modernism*, edited by Patricia Allmer, 15–32. Manchester: Manchester University Press, 2016.

Richardson, Michael. 'Communism'. In *The International Encyclopedia of Surrealism*, edited by Michael Richardson et al., 189–92. London: Bloomsbury, 2019.

Richardson, Michael and Krzysztof Fijałkowski. *Surrealism Against the Current: Tracts and Declarations*. London: Pluto Press, 2001.

Roberts, John. *The Intangibilities of Form: Skill and Deskilling in Art after the Readymade*. New York: Verso, 2007.

Roediger, David R., and Philip S. Foner. *Our Own Time: A History of American Labor and the Working Day*. New York: Greenwood Press, 1989.

Rose, Alan. *Surrealism and Communism: The Early Years*. New York: Peter Lang, 1991.

Rosemont, Franklin. 'André Breton and the First Principles of Surrealism'. In *What Is Surrealism? Selected Writings*, by André Breton, 1–139. Edited by Franklin Rosemont. New York: Monad Press, 1978.

————. 'Herbert Marcuse and Surrealism', *Arsenal* 4 (1989): 31–47.

————. 'Surrealists on Whiteness: From 1925 to the Present'. *Race Traitor. Special issue: Surrealism: Revolution Against Whiteness* 9 (Summer 1998): 5–18.

————. *Joe Hill: The IWW and the Making of a Revolutionary Workingclass Counterculture*. Chicago, IL: Charles H. Kerr, 2003.

————. 'The 100th Anniversary of Hysteria'. In *Revolution in the Service of the Marvelous: Surrealist Contributions to the Critique of Miserabilism*, 113–25. Chicago, IL: Charles H. Kerr, 2004.

————. 'Introduction: Raising the Stakes'. Introduction to *Revolution in the Service of the Marvelous: Surrealist Contributions to the Critique of Miserabilism*, 7–8. Chicago, IL: Charles H. Kerr, 2004.

———. *Jacques Vaché and the Roots of Surrealism: Including Vaché's War Letters & Other Writings*. Chicago, IL: Charles H. Kerr, 2008.

Rosemont, Franklin, and Robin D. G. Kelley, eds. *Black, Brown, and Beige: Surrealist Writings from Africa and the Diaspora*. Austin: University of Texas Press, 2009.

Rosemont, Franklin, and Charles Radcliffe, eds. *Dancin' in the Streets!: Anarchists, IWWs, Surrealists, Situationists & Provos in the 1960s as Recorded in the Pages of 'The Rebel Worker' and 'Heatwave'*. Chicago, IL: Charles H. Kerr, 2005.

Rosemont, Franklin, and David R. Roediger. *Haymarket Scrapbook: 125th Anniversary Edition*. Oakland, CA: AK Press and Charles H. Kerr, 2012.

Rosemont, Franklin, and Penelope Rosemont. 'Situation of Surrealism in the U.S.' In *The Morning of a Machine Gun*, by Franklin Rosemont, 45–53. Chicago, IL: Liberation Press, 1968.

Rosemont, Franklin, Penelope Rosemont, and Paul Garon, eds. *The Forecast Is Hot!: Tracts and Other Collective Declarations of the Surrealist Movement in the United States, 1966–1976*. Chicago, IL: Black Swan Press, 1997.

Rosemont, Penelope. 'Introduction: All My Names Know Your Leap, Surrealist Women and Their Challenge'. In *Surrealist Women: An International Anthology*, ed. Penelope Rosemont, xxix–lvii. Austin: University of Texas Press, 1998.

———. 'A Brief Rant Against Work, with Particular Attention to Relation of Work to White Supremacy, Sexism & Miserabilism'. In *Surrealist Experiences: 1001 Dawns, 221 Midnights*, 165–78. Chicago, IL: Black Swan Press, 2000.

———. *Dreams & Everyday Life: André Breton, Surrealism, the IWW, Rebel Worker Students for a Democratic Society and the Seven Cities of Cibola in Chicago, Paris and London: A 1960s Notebook*. Chicago, IL: Charles H. Kerr, 2008.

———. 'Disobedience: The Antidote for Miserabilism'. *Fifth Estate* 47, no. 1 (Spring 2012): 25.

———. 'Surrealism and Situationism: An Attempt at a Comparison and Critique by an Admirer and Participant'. In *No Gods, No Masters, No Peripheries: Global Anarchism*, ed. Barry Maxwell and Raymond Craib, 244–62. Oakland, CA: PM Press, 2015.

Ross, Kristin. *The Emergence of Social Space: Rimbaud and the Paris Commune*. Minneapolis: University of Minnesota Press, 1988.

Rothman, Roger. *Tiny Surrealism: Salvador Dalí and the Aesthetics of the Small*. Lincoln: University of Nebraska Press, 2012.

Sakolsky, Ron. 'The Surrealist Adventure and the Poetry of Direct Action: Passionate Encounters Between the Chicago Surrealist Group, the Wobblies and Earth First!' In *Scratching the Tiger's Belly*, 30–63. Portland, OR: Eberhardt Press, 2012.

———. *Breaking Loose: Mutual Acquiescence or Mutual Aid?* Berkeley, CA: LBC Books, 2015.

———. *Dreams of Anarchy and the Anarchy of Dreams: Adventures at the Intersection of Anarchy and Surrealism*. New York: Autonomedia, 2021.

———, ed. *Surrealist Subversions: Rants, Writings and Images by the Surrealist Movement in the United States*. New York: Autonomedia, 2003.

Sánchez, José Ramón, and Nassau County Museum of Fine Art. *José Ramón Sánchez-Works: August 17 through October 19, 1986*. Roslyn Harbor, NY: Nassau County Museum of Fine Art, 1986.

Santone, Laura. *Écouter, écrire, signifier: sur l'art verbal de la créatrice surréaliste Giovanna*. Rome: Artemide, 2018.

Sebbag, Georges. *André Breton, L'amour folie: Suzanne, Nadja, Lise, Simone*. Paris: Jean-Michel Place, 2004.

———. *Foucault Deleuze: nouvelles impressions du surréalisme*. Paris: Les Éditions Hermann, 2015.

———. 'Utopia: The Revolution in Question'. In *Surrealism: Key Concepts*, edited by Krzysztof Fijalkowski and Michael Richardson, 58–70. London: Routledge, 2016.

Seidman, Michael. *Workers Against Work: Labor in Paris and Barcelona during the Popular Fronts*. Berkeley: University of California Press, 1991.

Short, Robert. 'The Politics of Surrealism, 1920–36'. *Journal of Contemporary History* 1, no. 2 (September 1966): 3–25.

———. 'Surrealism and the Popular Front'. In *The Politics of Modernism*, 89–104. Essex: University of Essex, 1979.

Sorel, Georges. *Reflections on Violence*. New York: Cambridge University Press, 1999.

Soucy, Robert. *French Fascism: The Second Wave, 1933–1939*. New Haven, CT: Yale University Press, 1995.

Sowels, Katia and Jules Colmart. *Au grand jour: lettres (1920–1930): un album: André à Simone Breton*. Paris: Rue d'Ulm, 2020.

Spector, Jack J. *Surrealist Art and Writing, 1919–1939: The Gold of Time*. Cambridge: Cambridge University Press, 1997.

Spieker, Sven. 'The Bureaucracy of the Unconscious: Early Surrealism'. In *The Big Archive: Art from the Bureaucracy*, 85–204. Cambridge, MA: MIT Press, 2008.

Spiteri, Raymond. 'Surrealism and the Political: The Case of *Nadja*'. In *The Invention of Politics*, edited by Sascha Bru and Gunther Martens, 183–200. Amsterdam: Rodopi, 2006.

———. 'Community at Play'. In *Surrealism: Key Concepts*, edited by Krzysztof Fijalkowski and Michael Richardson, 107–119. London: Routledge, 2016.

———. 'Surrealism and the Question of Politics, 1925–1939'. In *A Companion to Dada and Surrealism*, edited by David Hopkins, 110–30. Hoboken, NJ: Wiley Blackwell, 2016.

Steer, Linda. 'Picturing Hysteria in *La Révolution surréaliste*: From Pathology to Ecstasy'. In *Appropriated Photographs in French Surrealist Periodicals, 1924–1939*, 15–50. London: Routledge, 2017.

Stone Richards, Michael. 'Failure and Community: Preliminary Questions on the Political in the Culture of Surrealism'. In *Surrealism, Politics and Culture*, edited by Donald LaCoss and Raymond Spiteri, 300–36. Burlington, VT: Ashgate, 2003.

———. 'Critical Theory'. In *The International Encyclopedia of Surrealism*, edited by Michael Richardson et al., Vol. 1, 503–6. London: Bloomsbury Press, 2019.

Strom, Kirsten. *Making History: Surrealism and the Invention of a Political Culture*. Lanham, MD: University Press of America, 2002.

Suleiman, Susan Rubin. *Subversive Intent: Gender, Politics, and the Avant-garde*. Cambridge, MA: Harvard University Press, 1990.

Susik, Abigail. 'The Vertigo of the Modern: Surrealism and the Outmoded'. PhD dissertation, Columbia University, 2009.

———. 'Surrealism and Jules Verne: Navigating Context, Intertext and Subtext for a Collage by Max Ernst'. In *Surrealism, Science Fiction and Comics*, edited by Gavin Parkinson, 16–39. Liverpool: Liverpool University Press, 2015.

———. 'Chance and Automatism: Genealogies of the Dissociative in Dada and Surrealism'. In *A Companion to Dada and Surrealism*, edited by David Hopkins, 242–57. Hoboken, NJ: Wiley Blackwell, 2016.

———. 'Points of Convergence: Chicago 1960s'. In *Surrealism Beyond Borders*, ed. Stephanie D'Alessandro and Matthew Gale, 112–15. London and New York: Tate Modern; Metropolitan Museum of Art, 2021.

———. 'Subcultural Receptions of Surrealism in the 1960s International Underground Press: *Resurgence* and Other Publications'. In *Cambridge Critical Concepts: Surrealism*, edited by Natalya Lusty, 380–400. Cambridge: Cambridge University Press, 2021.

Susik, Abigail and Elliott H. King. 'Surrealism as Radicalism'. In *Radical Dreams: Surrealism, Counterculture, Resistance*, edited by Elliott H. King and Abigail Susik. State College: Penn State University Press, 2022.

Sword, Helen. *Ghostwriting Modernism*. Ithaca, NY: Cornell University Press, 2002.

Taminiaux, Pierre. 'Breton and Trotsky: The Revolutionary Memory of Surrealism'. *Yale French Studies* 109 (2006): 52–66.

Taylor, Sue. 'The Artist and the Analyst: Jackson Pollock's Stenographic Figure'. *American Art* 17, no. 3 (Fall 2003): 52–71.

Thévenin, Paule, ed. *Bureau de recherches surréalistes: cahier de la permanence, octobre 1924–avril 1925*. Paris: Gallimard, 1988.

Thévenin, Paule, and Marguerite Bonnet. *Archives du surréalisme*. Paris: Gallimard, 1988.

Thirion, André. 'À Bas le travail!', *Variétés: le surréalisme en 1929*, edited by André Breton and Louis Aragon (June 1929): 43–6.

———. *Revolutionaries Without Revolution*. Translated by Joachim Neugroschel. New York: Macmillan, 1975.

Thurschwell, Pamela. *Literature, Technology and Magical Thinking 1880–1920*. Cambridge: Cambridge University Press, 2001.

Torigian, Michael. *Every Factory a Fortress: The French Labor Movement in the Age of Ford and Hitler*. Athens: Ohio University Press, 1999.

Trautmann, W. E., et al. *Direct Action & Sabotage: Three Classic IWW Pamphlets from the 1910s*. Edited by Salvatore Salerno. Chicago, IL: Charles H. Kerr, 1997.

Tronti, Mario. *Operai e Capitale*. Turin: G. Einaudi, 1966.

———. 'The Strategy of Refusal'. *Semiotext(e)* 3, no. 3 (1980): 28–35.

Veblen, Thorstein. *On the Nature and Uses of Sabotage*. New York: Oriole Editions, 1971.

Weeks, Kathi. *The Problem with Work: Feminism, Marxism, Anti-work Politics, and Postwork Imaginaries*. Durham, NC: Duke University Press, 2011.

Zalman, Sandra. *Consuming Surrealism in American Culture: Dissident Modernism*. Farnham: Ashgate, 2015.

Zilbersheid, Uri. 'The Idea of Abolition of Labor in Socialist Utopian Thought'. *Utopian Studies* 13, no. 1 (2002): 21–42.

Index

EU authorised representative for GPSR:
Easy Access System Europe, Mustamäe tee 50,
10621 Tallinn, Estonia
gpsr.requests@easproject.com

www.ingramcontent.com/pod-product-compliance
Lightning Source LLC
Chambersburg PA
CBHW041425060326
40783CB00040B/6326